Leonardo's Machines

Da Vinci's Inventions Revealed

Leonardo's Machines

Da Vinci's Inventions Revealed

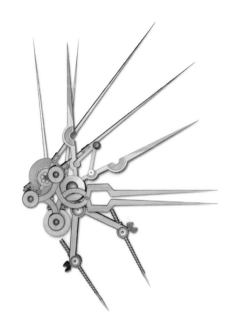

Domenico Laurenza
Mario Taddei
Edoardo Zanon

D&C
David and Charles

A DAVID & CHARLES BOOK
Copyright © David & Charles Limited 2006

David & Charles is an F+W Publications Inc. company
4700 East Galbraith Road
Cincinnati, OH 45236

First published in the UK in 2006
Originally published in Italy in 2005© Giunti Editore S.p.A.,
Florence-Milan
Copyright © 2005 Giunti Editore S.p.A., Florence-Milan
Copyright © 2005 Studioddm S.n.c. Milano

A catalogue record for this book is available from the British Library.

ISBN-13: 978-0-7153-2444-8
ISBN-10: 0-7153-2444-6

Printed in Italy by Giunti Industrie Grafiche
for David & Charles
Brunel House Newton Abbot Devon

Reprinted in 2006, 2007, 2008

Visit our website at www.davidandcharles.co.uk

David & Charles books are available from all good bookshops;
alternatively you can contact our Orderline on 0870 9908222
or write to us at FREEPOST EX2 110, D&C Direct, Newton Abbot,
TQ12 4ZZ (no stamp required UK only); US customers call
800-289-0963 and Canadian customers call 800-840-5220.

Translation
Joan M. Reifsnyder

The translation of this work has been funded by SEPS SEGRETARIATO
EUROPEO PER LE PUBBLICAZIONI SCIENTIFICHE

Leonardo's manuscripts and drawings, all available in the Edizione
Nazionale Vinciana (Giunti), are cited according to usual practice
as follows:

Codex Atlanticus	Codex Atlanticus in the Biblioteca Ambrosiana, Milan
Windsor RL	Anatomical manuscripts and drawings in the Royal Library at Windsor Castle
Codex Arundel	Codex Ardunel 263 in the British Library, London (formerly the British Museum Library)
Codex Forster I–III	Notebooks in the library at the Victoria and Albert Museum, London
Manuscripts Madrid I & II	Codices in the Biblioteca Nacional, Madrid
Manuscripts A–M	Codices and notebooks in the library of the Institute de France, Paris
Codex Hammer	Manuscript (formerly Codex Leicester) owned by Bill Gates, Seattle, Washington, USA
Codex Trivulzianus	Manuscript in the Biblioteca Trivulziana at the Castello Sforzesco, Milan
Codex 'On the Flight of Birds'	Manuscript at the Biblioteca Reale, Turin

The chronology of Leonardo's notes and drawings varies even within a
single manuscript; thus, the exact or approximate date is given for each
reproduced image.

front cover
Helical structure covered with cloth.

back cover
Barrage cannon.

frontispiece
Dividers reconstructed from folio 696r in the Codex Atlanticus.

Contents

Foreword

Over the past century, the extraordinary machines designed by Leonardo have been the object of growing interest, often to the point of obsession. In recent years, numerous books, catalogues and articles have been published that promised to reveal the sensational technological advances made by the genius from Vinci. At the same time there has been a proliferation of haphazard and out-of-context exhibitions presenting 'Leonardo the confused inventor' (not to mention the pseudo Leonardo 'museums' that spring up with increasing frequency in historic cities), produced by ill-qualified curators who dare to challenge the intricacies of the complex da Vincian world.

In the context of the rise of 'Leonardo-mania' signalled by all the intense but generally unscholarly activity that has been spurred by the success of the novelist Dan Brown's whimsical journey into an imaginary da Vincian world, the contributions made in this volume by Domenico Laurenza, Mario Taddei and Edoardo Zanon are clearly different, for a number of significant reasons.

The first of these is the translation of Leonardo's technical drawings into the extraordinarily effective visual language of computer graphics. While these translations have inevitably led to a complete transformation of the original drawings, the process is justified because it allows us to gain a clearer understanding of the complex technological processes envisaged by Leonardo. We are speaking of transfiguration, but we should bear in mind that this reconfiguring, or metamorphosis, of the original drawings using a superior means of graphic perspective can be seen as a development of Leonardo's own method of communicating his ideas.

The extraordinary mechanical graphics that have been perfected by Mario Taddei and Edoardo Zanon will enable everyone to understand fully how these machines were designed to work. At last, Leonardo's experiments in graphic communication, conceived in his manuscripts in order to express in visual terms the results of his thought processes and his innovative concepts in relation to machines and mechanical devices, can be clearly understood and appreciated. In fact, the mechanical iconography that gives this volume its unique character fully realizes Leonardo's own goal of supplying a complete and absolutely clear representation of the structure and workings of extremely complex devices.

In drawing his inventions, Leonardo resorted to a series of graphic conventions, including plans and overhead views, transparent and exploded views, simulations of sequences of movement, the use of *chiaroscuro* to highlight contact surfaces, and the schematic representation of force lines. No one before him had conceived of using such

conventions in such a systematic way, and above all, no one had used them with the intention of communicating ideas in the complex sphere of technology. The beautiful da Vincian machines, translated into a digital language and laid out on the pages of this evocative book, therefore reflect Leonardo's own ideal concept of nature and his goals in representing them graphically. These 'dissected' machines, presented in transparent views or 'exploded' to reveal the hidden mechanisms, vie with Leonardo's original, masterly drawings, both in fascination and in beauty. Even though they may lack the magical, resonant character of the documents drawn in the Maestro's inimitable hand, they nonetheless surpass them in clarity and explanatory detail.

The translation of Leonardo's original drawings into these three-dimensional visualizations is bold but essentially respectful. In addition, the selection of the mechanical devices that has been made for illustration in this volume is neither hackneyed nor repetitive.

The vast majority of existing publications dedicated to Leonardo's machines have as a common trait the obsessive replication of a fairly circumscribed selection of his designs. These are the machines upon which his reputation rests as the sensationally precocious inventor of some of the most important discoveries of the modern era: the flying machine, the submarine, the helicopter, the armoured tank, the automobile, and, more recently, even the much-discussed 'bicycle'.

In our volume the horizon broadens. As a result of very careful examination of the da Vincian manuscripts by Mario Taddei and Edoardo Zanon, supported by the essential critical and scholarly contributions of Domenico Laurenza, this book presents a range of machines that differs significantly from that illustrated in other publications. Readers will discover devices new to them, which, though they may not always be sensational inventions or the precursors of later technological achievements, are emblematic of the technical problems that Leonardo encountered and strove to deal with, employing solutions that were ingenious even if extremely difficult to put into practice.

In those cases where Leonardo's most universally celebrated inventions are presented, they are critically illustrated, put in context and above all technically analysed in a way that is not at all commonplace. The studies for the flying machine, for example, as well as the series in which Leonardo's so-called 'automobile' is presented, offer eloquent illustrations of this approach, based on a combination of historical rigour and the goal of effective visual communication.

The success of this presentation depends on the interaction between the evocative visualizations of the machines and the introductions and scholarly descriptions by Domenico Laurenza, in which the original

documents are placed in context, given a chronology clearly illustrating their purposes, and related to analogous studies in other da Vinci manuscripts. In the visual interpretations of Taddei and Zanon, Leonardo's often cryptic sketches are morphed into transparent representations that show the operating mechanisms and clearly simulate the complex functions of the machines, using sequences with a cinematic quality. They take on the tangible form of real models, thanks to their three-dimensional perspective.

In the case of the so-called 'automobile', the incredible work of translating Leonardo's complex drawing of this innovative device into an understandable representation, exact in every minute detail, simulates with extraordinary clarity the complex process of transmitting energy produced by spring-driven motors. This is a result of lengthy research sparked by Carlo Pedretti's intuition and transformed by Mark Rosheim into the first plausible interpretation of the vehicle based on engineering principles. The work of Taddei and Zanon has definitively clarified not only the structure and workings of the programmable cart, which was conceived by Leonardo around 1478, but also confirms that this bold device should almost certainly be understood as a self-propelled cart, an invention designed to produce amazing effects at Renaissance court festivals. Through the co-operation between Taddei and Zanon and the Istituto e Museo di Storia della Scienza in Florence (along with the vital support of the Banca di Credito Cooperativo di Cambiano), it has been possible to make perfectly functioning models, both real and virtual, of Leonardo's automobile, and these have been displayed worldwide in a scientifically rigorous and enormously successful travelling exhibition (to see the virtual model go to http://brunelleschi.imss.fi.it/automobile).

The pages of this book dedicated to the 'automobile' are a perfect example of the extraordinary power of the graphic code that Taddei and Zanon have developed and realized. Thanks to this code, even a reader who is not an expert in mechanical structures can grasp the complex processes and the refined technological solutions behind the workings of the da Vincian device. The integration of Domenico Laurenza's detailed introductions and descriptive text with the digitally elaborated matrix of visuals by Taddei and Zanon makes all the machines illustrated in the book equally accessible. The images are not intended to show only three-dimensional representations; they also provide a careful and minute breakdown of each device, isolating all the parts and components, with each one distinctly represented. The reader is provided with an effective pictorial kit, which facilitates an imaginary assembling and disassembling of the devices.

In addition to the aesthetic fascination and the extraordinary effectiveness of this method in furthering our understanding, it must be

stressed that the approach corresponds to the aspirations of Leonardo himself. He conceived of the drawing of a machine as an instrument for analysing the most complex device down to the smallest part, accurately 'dissecting' it in order to obtain a representation that showed both its component parts and the composition as a whole.

With the same lucidity, Leonardo achieved the unprecedented task of drawing the machines not simply as static, statue-like objects, but also to suggest the dynamics of their workings, simulating with static images the transmission of their movements using their various mechanical components. The da Vincian representations of machines make a revolutionary contribution to technical illustration, above all because they are configured as 'almost dynamic' images. They are extraordinary precursors of the drawing methods used in animation, and especially of the kinematic modelling used in computer graphics. The transposition of Leonardo's original drawings into the context of the representations of new media completes Leonardo's own aspirations. His were the first drawings to express the need for a new concept in technological imaging, understood as the design of an integrated circuit of knowledge, able to show how the machine appears externally, the mechanical principles that govern its workings and the analytical construction of its organs.

In this new concept of design, one of Leonardo's most groundbreaking achievements must be acknowledged, more concrete and plausible than all the amazing inventions boldly attributed to him: he was the first to conceive of machine design as a refined tool for analysis and research, to be used even before its visualization for purely demonstrative ends. This book helps us to understand that one of the essential aspects of Leonardo's fundamental contribution to the modern culture of machines is the mature elaboration of a specific technical language: an exquisitely visual language that he forced himself to articulate using strict grammar and syntax.

Paolo Galluzzi
Director of the Istituto e Museo di Storia della Scienza, Florence

Introduction

Today, only the drawings of Leonardo's machines remain in existence. Even if any of his mechanical designs were translated into actual objects, none of these has survived. Nor do we have any three-dimensional models, which he surely must have constructed in the design phase between the drawing and the actual machine. The same is true for some of his paintings, such as *The Battle of Anghiari*: we have numerous drawings but not the final work.

Nevertheless, if time had preserved one of his machines instead of the relevant drawings, our loss would have been far greater. For Leonardo, mechanical design belonged to a very cerebral dimension, which through drawing found its ideal, and virtually complete, form of expression. The understanding of the intrinsic content of a mechanical drawing – the purpose of the machine and the way it was meant to work, the relationship between its parts – may have been enough for many inventors in the past. In Leonardo's case it was only one of the two aspects of the game – and not the main one. For him, what really mattered was to grasp the entire meaning behind the drawn forms: the theories that generated a mechanical design and the graphic means that gave shape to those theories. Many of the machines designed by Leonardo – the most spectacular ones – are nothing more than the visual or material forms of his scientific experiments: theories expressed not in words but in images. For example, the so-called flying ship drawn on one of the sheets in Manuscript B (f. 80r, in the same group of drawings as the flying machines), is the culmination of a series of studies Leonardo devoted to the dynamic potential of the human body – that is, its capacity to generate force. Before it is a design for a flying machine, this drawing is the design of a device that would allow a man enclosed in a cockpit to generate force using every part of his body. From this point of view, the dreamlike character of some of the machines, the technological dream of actually working many da Vincian devices, finds partial explanation. In fact, the dimension that Leonardo's machines occupy is not so much real space as drawn space – the image and its virtual dimension.

The intellectual value of drawing was widely affirmed during the *Quattrocento*. Roberto Valturio (1405-75), in his *De re militari*, reconstructed the war machines of the ancients by resorting extensively to the use of images, so much so that they became a means of expressing classical scholarship. Francesco di Giorgio (1439-1501) clearly identified mechanical drawing as a tool for intellectual expression and a means of affirming the professional emancipation of technicians and engineers, who until that time had been considered artisans. But he also affirmed the irreplaceable role of the three-dimensional model

during the design phases of a machine. In his *Treatise on Architecture* he wrote: 'It is difficult to show everything in a drawing because so many components are interrupted and on top of one another that to draw them all is impossible, and so it is necessary to make a model of practically everything.'

This limitation was certainly overcome by Leonardo who, even though he used three-dimensional models in various aspects of his research (machines, painting, anatomy), appears to have given drawing pre-eminence over models, recognizing its value both in terms of design and as a means of expression.

A famous section in the *Lives* of Giorgio Vasari describes the nature of drawing and cites a Greek proverb: a skilful draughtsman, observing the depiction of only a single part of an object, is perfectly able to reconstruct the whole in form and dimension; for example, the vision of a fragment of sculpture representing only the claw of a lion is sufficient to reconstruct the entire lion perfectly. According to Vasari, this is manifestation and proof of the mental strength of those who practise drawing. He sets out to show that even though achieved manually, drawing is primarily an intellectual activity. Vasari writes: 'From this cognisance a certain concept and judgment of the thing is created in the mind, and that which is then expressed through the hands is called drawing.' Thus in the mid-sixteenth century Vasari defined a lofty concept of graphic art, an activity that was Leonardo's greatest form of expression if only because of the many areas where he applied it: not only in his art, but in scienctific and technical fields as well.

In order to understand the intellectual value of Leonardo's drawings, the contrast between drawing and Leonardo's concept of painting is very significant. It is well known that Leonardo was the inventor of the *sfumato* technique in painting, which involves making gradual transitions between areas of different colours and the avoidance of sharp outlines. From his optical observations (in reality the eye never sees hard outlines) as well as more philosophical considerations, he concluded that it is impossible to render the edge or the outline of a body in a defined way. He wrote: 'The external limits of a thing are not at all part of the thing itself, because the end of one thing is the beginning of another [...] and thus these ends occupy nothing.' Where the body ends is where the air surrounding it begins: thus the external limits of a body, from a theoretical viewpoint, do not exist as part of it.

If the external limits of things themselves do not exist, this means that in his drawings Leonardo is well aware that he is doing more than portraying reality 'photographically': he studies reality or reinvents it – he makes an abstraction. His painted figures, in imitating reality, show

no trace of drawing; a machine, in its drawn state, belongs to a mental, abstract dimension, and judging from the 'realism' of his designs, this merits consideration.

While he was in Rome (around 1513-16) as a guest of the Florentine Pope Leo X, Leonardo's life was afflicted by a difficult relationship with a technician employed by Giuliano de' Medici, brother to the pontiff and Leonardo's patron. 'Giorgio Tedesco' (George the German) – this was the name of the assistant – insisted on a higher salary than had already been agreed upon. Instead of working in the workshop, he went about wasting time, and worst of all he revealed to others the secrets and inventions of the maestro. As a result, in a shrewd letter addressed to Giuliano de' Medici, Leonardo included a very interesting passage: 'Then the request of this person was to have *models made of wood* just as they were to be made in iron, which he wanted to take back to his own country. I refused him this, saying that I would give him the *drawing* of the width, length, height and shape of what he had to do; and thus we did not remain on good terms.' (Codex Atlanticus, f. 671r, author's italics.)

This account is very important, and if correctly deciphered it can furnish some interesting information. Tedesco asked Leonardo to provide him with three-dimensional wooden models of a few of the mechanical devices, which would then be made in iron. Leonardo refused to give him the models, offering instead drawings indicating the 'width, length, height and shape' of the machines – drawings that were probably in perspective and/or multiple views – from which the information on how to make the machine could be obtained. Still, in view of the circumstances, and given Leonardo's mistrust for Tedesco, the fact that Leonardo intended to supply drawings instead of three-dimensional models may indicate something else. Giorgio Tedesco had asked for three-dimensional wooden models because he would be able to copy these in order to reconstruct the machines in metal. It would have been more difficult for him to interpret scale drawings. In order to understand them he would need the help of the maestro, of Leonardo. By giving Tedesco drawings instead of models, Leonardo could let him work without revealing too much about the designs. This gives us another indication of the value Leonardo placed on drawing: it is something more than a simple three-dimensional model; to be understood it requires a special theoretical background (for example, an understanding of the proportional relationships between the parts). The use of drawings instead of models made the difference between an evolved engineering studio, where the engineer considered himself to be a man with a mind in addition to his hands, and a traditional workshop.

The machines that Leonardo designed can be studied and presented as three-dimensional reconstructions, even as interactive models, as they are in some museums and exhibitions. These reconstructions have to do with the intrinsic content of the machine, its practical side. Up to now studies have generally given preference to understanding only the practical side of Leonardo's inventions. Less attention has been paid to the intellectual significance of Leonardo's drawing, which, as stated before, is its most important aspect. Is it possible to present and reconstruct Leonardo's mechanical designs highlighting the graphic side as well? In this book Mario Taddei and Edoardo Zanon have made reconstructions of Leonardo's machines which, although they are virtually three-dimensional models (thus demonstrating the mechanical significance of each design), use a wide spectrum of visual solutions (such as multiple viewpoints, exploded views and directional arrows) that emphasize the drawing aspect of Leonardo's elaborations. The introduction to each design (provided by this writer) which describes the formal aspects of the drawings, takes this same direction.

With regard to the presentation of da Vincian inventions in museums (and in exhibitions, books and other media), Paolo Galluzzi has recently spoken about the need for a 'Copernican revolution', which would establish Leonardo's drawings as the central axis with the models taking on a subordinate role. Without losing sight of the mechanical significance of each design, it is the intention of this book to demonstrate the possibility of just such a revolution.

Domenico Laurenza

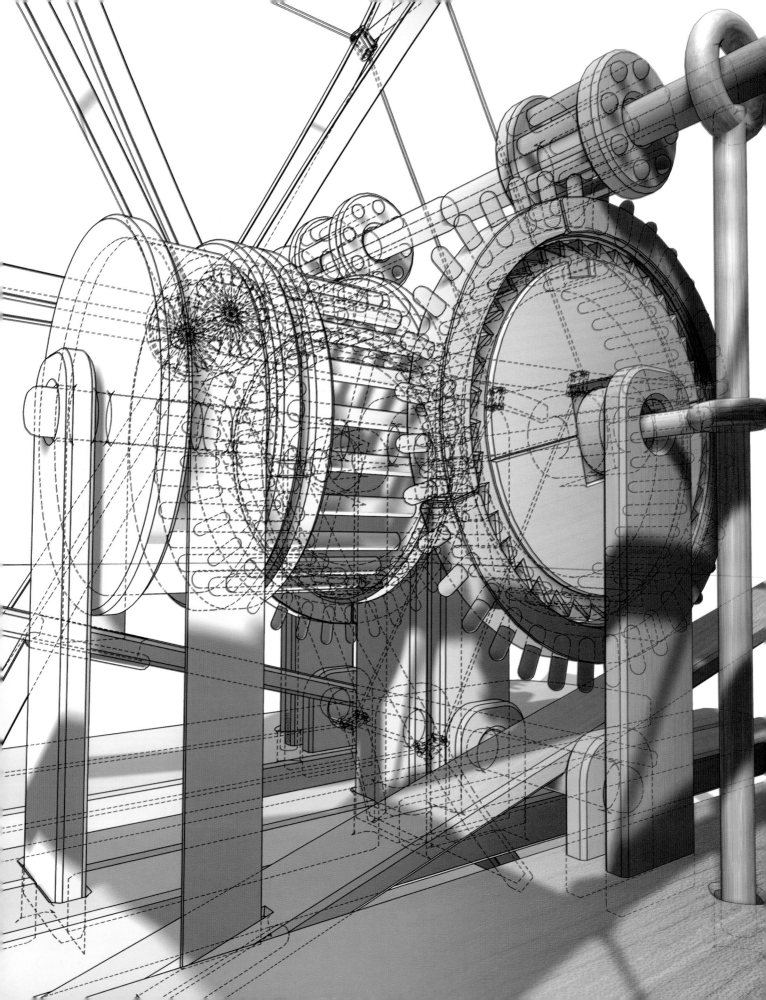

About this Book

left

*Technical detail
of the paddleboat
using pedal propulsion
(see p. 141).*

A new book on Leonardo's machines? Does the best-known scientific figure of all time really need a new volume illustrating his designs? Just another of the same kind of book describing the same machines everyone knows?

Leonardo's scientific and technical legacy is an endless resource and treasure trove of ideas and insights, and it is difficult to imagine that the full *oeuvre* of this scientist can ever be completely grasped. Even the best-known machines and the most carefully reconstructed models on display in the most important exhibitions still hide secrets waiting to be extracted. Even today these Renaissance designs continue to amaze those who study and analyse them. Anyone who, like ourselves, begins to discover Leonardo is especially drawn to him by the realization that they will never truly reach the end of a project, as we often found while preparing this book. Even when it seemed that the correct interpretation of a mechanism or an entire design had been reached, another squiggle on the page or a similar drawing from another manuscript opened up new possibilities, providing further clarification and leading to surprising evolutions. It can also happen that a totally convincing idea about a machine's structure or a particular function can be thrown into doubt by a single detail discovered at the last moment, which changes the entire interpretation of a mechanism or sends the whole machine in a completely different direction.

This type of discovery occurred during the work on Leonardo's so-called 'automobile', presented in our joint project with the Istituto e Museo di Storia della Scienza in Florence and published in this volume. The interpretation of the machine was unravelled after almost a century of attempts made by numerous da Vincian scholars, such as Guido Semenza and Giovanni Canestrini, to mention only a couple. When we began our work with the museum on interpreting the machine, we were inevitably fascinated by the fact that by correctly following all Leonardo's sketches and lines, everything fitted precisely into place in the drawn design; a realization that probably did not occur in previously developed solutions. One has to keep in mind that models made before 2004, and presented in many museums, do not reflect Leonardo's true idea and, essentially, they do not work. We began from a very solid base: the correct interpretation made by Mark Rosheim on the one hand, and invaluable advice from Paolo Galluzzi and Carlo Pedretti on the other, making it possible to prepare our first study models for the prototype and to construct the final models accurately; they were perhaps not aesthetically outstanding, but were completely functional from their very first assembly. The work was almost completed, and the functioning exhibition automobile was already in the

fig. 1

*Folio 812r
in the Codex Atlanticus.*

production phase at the Laboratori Fiorentini, when almost by chance we looked at a drawing in the margin of the manuscript and realized that it represented a brake. What a memorable moment! A very quick sketch on the lower part of the page showed this small device. As testimony to the importance of even a small set of lines by Leonardo, this detail added a new element to the design, and even more important, it further verified its interpretation. It was not an 'automobile' as we understand it today, meant to transport people or things, but a theatrical device. It was probably a more ambitious and certainly a more complex project: a machine that could be programmed and was intended to be used for special scenic effects. The very same detail also revealed how the machine was operated. Hidden in the wings, the operator could pull on a cord to release the brake so that the machine moved towards the audience on its own.

In putting this book together we had to make more than fifty interpretations, bringing to them all the same critical spirit as in the episode described above and always waiting for the surprising detail confirming our ideas or revealing possible new solutions for a design. Often we realized that some of the machines, even the most famous, had not yet been completely understood. The mechanisms and designs in this book are a distillation of all the material under examination. It required more than a year to identify the subjects, understand them, reconstruct them and depict them.

Computer graphics, and more generally, computer technology are certainly not new to the technical world; however, we believe that this language can be used in a very original way to render the maestro's ideas visible. The tools used to create the images are very similar, and in some cases the same, as those used to create commercial video games or for special effects in movies and digital animations. The novelty of this volume is that these techniques have been adapted to construct a new visual language. We have set out not to create a revolutionary new system but to link the institutional world of culture – the world of the interpretation of Vinciana, the learned books on Leonardo, the latest exhibitions – with today's world of young people, the same individuals who spend hours playing games on the computer or the PlayStation.

One wonders what Leonardo might have been able to do with modern multimedia and design tools. Perhaps the distance between him and the world of video games is shorter than we think: looking at some of his designs, such as the crane for canals, the file-cutting machine, the swing bridge and many others, one inevitably becomes enchanted by the immediacy of the drawing, Leonardo's simple and direct way of

figs. 2 and 3
*Folio CA 1r drawn by Leonardo
and the 3D model of the barrage
cannon superimposed on the
original drawing.*

communicating, springing from each page. 'Oh poet, what letters will you use to write that have the same perfection as drawing in describing the whole figure?' the maestro wrote (on Windsor 19071r, RL).

As soon as a model is finished, we superimpose it on the original drawing, and often we observe a surprising correspondence in the parts. This operation takes on great importance for those of us who draw without a pencil, using intangible instruments. It is precisely at this moment that we understand that we are using the correct tools to disclose the workings of the machine, that we are on the right path, a path Leonardo would certainly have shared. With computer and digital technology we move towards his way of designing; the third dimension was certainly in Leonardo's mind while he drew, hence the name of our website dedicated to him – www.leonardo3.net.

This book visually 'narrates' more than thirty machines by Leonardo da Vinci, some of them never before published. However, many more manuscripts were involved in the work and in the production of this volume than the number of actual machines shown on its pages, because a true understanding of the workings of a machine requires an in-depth study of the documentation and a broad vision of all the works by Leonardo.

A special word of thanks must go to Sergio Giunti, Paolo Galluzzi, Carlo Pedretti and Claudio Pescio, who believed in this book, and to the individuals who worked with us and contributed to the project: Felice Mancino, Gabriele Perni, Giacomo Giannella, Cristina Caramori and Michela Baldessari.

Mario Taddei
Edoardo Zanon

Figurative Index

001 Flying Machines

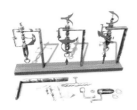

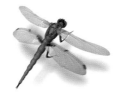

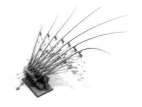

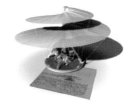

Mechanisms for Mechanical Wings

Codex Atlanticus, f. 1051v
1480-1485

Mechanisms for transforming reciprocating or circular motion in the mechanical movements of the various wing parts. Many of these are described on this folio in the Codex Atlanticus: these and other drawings are the basis for understanding the complex functioning of Leonardo's projects for flight.

Dragonfly

Ashburnham I, f. 10v
circa 1487

This was originally the first folio in Manuscript B, the work Leonardo dedicated primarily to the study of possible flying machines. It is presumed that the genius from Vinci began studies for these machines inspired by nature, observing insects and flying creatures, in this case the dragonfly.

Flapping Wing

Manuscript B, f. 88v
1487-1489

An experimental machine used to verify the capacity of human force to flap with enough energy to move the wing. Another interpretation is that the machine could have been useful in verifying the behaviour of the wing itself during the powerful movements required for its use.

Aerial Screw

Manuscript B, f. 83v
circa 1489

Usually held to be the forerunner of the modern helicopter, this project is interesting not as much for the mechanical solutions as for the simile made to water; Leonardo perceived air as a thinner dynamic fluid through which the machine could 'screw' or twist itself: for this reason a more correct term is 'aerial screw' rather than 'helicopter'.

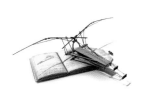

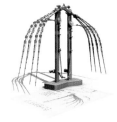

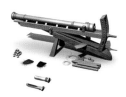

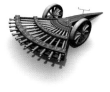

Flying Machine	**Mechanical Wings**	**Springald**	**Multi-barrelled Machine Gun**
Manuscript B, f. 74v 1488-1489	Codex Atlanticus, f. 844r 1493-1495	Codex Atlanticus, f. 32r circa 1482	Codex Atlanticus, f. 157r circa 1482

A complete study for the flying machine: after studying many devices, Leonardo began more than one design for a flying machine. This drawing clearly shows the position of the pilot-driver as well as the operations that must be carried out in order to manoeuvre and (presumably) keep the device in flight.

A small-scale model for studying the flapping of wings. The machine itself is quite complex due to the fact that various mechanisms are used to convert the rotating motion of a hand crank into the reciprocating linear motion of the flapping wing. This mechanical wing faithfully simulates the articulations and movement dynamics of the wing in nature, where the extremities of the wings make curving movements different from those at the base of the wing.

Among the many plans for military projects an entire portion was dedicated to the concept and development of cannons. These springalds allowed the gunner to position the cannon before firing without having to move the entire structure: in fact, the cannon could be swung around and inclined as desired in order to aim in different directions. A protective, wooden housing was also designed to cover the weapon.

This machine gun had considerable firepower. Once the cannons were loaded and ready to be fired a broad range of fire was ensured. Because the gun carriage was easily moveable, it could be aimed at different objectives as necessary. The altitude of the cannon fire could be adjusted using a hand crank on the rear of the carriage.

-| page 54 |- -| page 62 |- -| page 74 |- -| page 80 |-

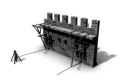 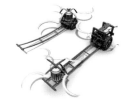 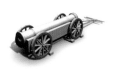 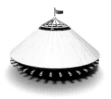

Defence of the Walls	Scythed Chariots	Dismountable Cannon	Armoured Car
Codex Atlanticus, f. 139r 1482-1485	Turin, Bibl. Reale, f. 15583r circa 1485	Codex Atlanticus, f. 154br 1478-1485	London, British Museum, Popham no. 1030 circa 1485

Defence of the Walls

Leonardo designed not only attack artillery, but also complex and ingenious methods of defence. Here, when the walls are under attack, the soldiers hidden behind the battlements could quickly and easily ward-off enemies and their attack structures in a single movement by using a system of levers.

Scythed Chariots

Perhaps made to impress Ludovico il Moro, this is one of Leonardo's most beautiful manuscripts. These plans show scythed chariots for use in battle. Drawn by running horses, these machines with their sharp, cutting blades moved in the thick of the battle slashing through all in their wake.

Dismountable Cannon

Cannons were very heavy and the carriages used to transport them were often unwieldy. Leonardo designed a structure that could be easily dismantled and transported, thus permitting the cannon to be easily moved.

Armoured Car

This is one of Leonardo's most well-known projects. The idea of an armoured car protected by a giant shield, having notable firepower and easily positioned on the battlefield was an ambitious project even for the genius from Vinci. Even with modifications the plan still had a number of unresolved problems. Faced with practically insurmountable difficulties, Leonardo abandoned the project.

- | page 84 | - - | page 88 | - - | page 94 | - - | page 98 | -

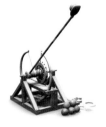	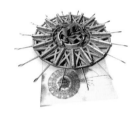	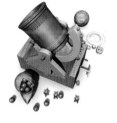	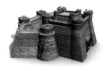
Catapult	**Barrage Cannon**	**Bombards in action**	**Fortress**
Codex Atlanticus, f. 140ar e 140br 1485-1490	Codex Atlanticus, f. 1ar 1503-1505	Codex Atlanticus, f. 33r circa 1504	Codex Atlanticus, f. 117r 1507-1510

There are many plans for catapults. This particular design uses a double leaf spring to produce an enormous amount of energy for propelling stone projectiles or incendiary materials, over great distances. The loading of the two large leaf springs was accomplished using a hand crank on the side of the catapult.

This drawing is on the first page of the Codex Atlanticus. The drawing itself is very complete and quite fascinating; it illustrates the plan of a bombard with sixteen radial cannons. The most interesting aspect of the project is the centre of the bombard itself, housing a pair of mechanical paddles and gear wheels, providing only a partial idea of the possibilities of this huge structure. There can certainly be more than one interpretation.

This is a drawing of rare beauty and extreme clarity. The folio shows two bombards at the moment they are being fired. In addition to the plan for the bombard, a weapon already known at the time, Leonardo also designed the large projectiles, which once they were fired exploded into many fragments with greater range and impact than the cannonball itself.

Leonardo designed this very compact fortress with the idea of rendering it safe from attack: the elaborate shape is innovative and presumably could have been an effective defence against the impact of the new, deadly artillery projectiles.

- | page 102 | - - | page 108 | - - | page 118 | - - | page 126 | -

003 Hydraulic Machines

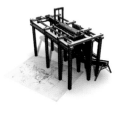

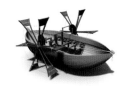

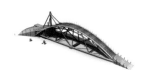

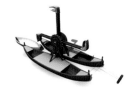

Mechanical Saw	Paddleboat	Swing Bridge	Dredger
Codex Atlanticus, f. 1078ar circa 1478	Codex Atlanticus, f. 945r 1487-1489	Codex Atlanticus, f. 855r 1487-1489	Manuscript E, f. 75v 1513-1514

This machine is used for cutting large tree-trunks; the movement of water, presumably channelled through a mill, worked the large paddle wheel that furnished the energy required to move the blade. At the same time the water-propelled wheel moved a series of pulleys that pulled the heavy trunk on a moveable bed through the saw.

Leonardo designed a boat that could easily navigate using a system more practical than oars. In fact, oars need to be moved using a repetitive action producing discontinuous energy. With paddles however, the operators use their feet (or, in other models, their arms) to move the large side wheels, making the craft move without interruption.

This bridge is beautifully designed. A support structure constructed around a large pivot pin positioned on one of the riverbanks permitted the passage of both land and water transport. The bridge rotated around the main pivot pin, and was set into motion by one or more persons operating the winches positioned on land.

The dredger was used to widen and clean riverbeds. The idea for this machine already existed prior to this project, but Leonardo introduced important technical enhancements. For example, he gave the craft more stability by equipping it with two hulls instead of just one.

- | page 134 | - - | page 140 | - - | page 146 | - - | page 156 | -

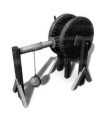	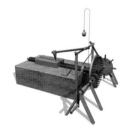	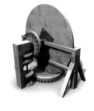	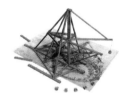

Reciprocating Motion Machine	**File-cutter**	**Device for Grinding Concave Mirrors**	**Canal Excavating Crane**
Codex Atlanticus, f. 30v 1478-1480	Codex Atlanticus, f. 24r circa 1480	Codex Atlanticus, f. 87r circa 1480	Codex Atlanticus, f. 4r 1503-1504

This project studies the transformation of reciprocating motion into continuous motion. In this machine power is produced to lift a heavy body from the ground. By moving a lever back and forth, the operator activates the mechanism that allows the line to wind around the centre-rotating shaft.

This machine automatically cut files. Due to its weight and thus the force of gravity, a weight suspended from a line made it move. By activating various mechanisms, the file advanced and at the same time was struck by an attached hammer. With every blow by the iron hammer, a cut was made in the metal file.

By activating a single hand crank, the rotating motion was transferred simultaneously onto two stone disks positioned on two different axes. The respective rotary motion of the disks hollowed and smoothed out the mirror placed on the horizontal disk.

With this project, Leonardo meant to excavate riverbeds in order to change the course of the water using a crane having greater efficiency than contemporary machines. In fact, this device could slowly advance forward as the excavation proceeded and rendered the transportation of the material from the canal very fast and practical.

- | page 164 | - - | page 168 | - - | page 172 | - - | page 176 | -

005 Theatrical Machines

006 Musical Instruments

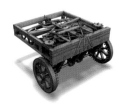

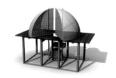

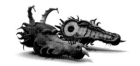

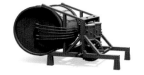

Self-propelled Cart

Codex Atlanticus, f. 812r
1478-1480

This was not an automobile destined to transport persons or things; it was even more ambitious. It was a theatrical device that could be programmed, capable of moving on its own, not only in a straight-line but also following a curved path. This object is certainly one of Leonardo's most fascinating devices, appearing on stage alone before the audience's eyes, without a driver and without anyone pushing it.

Theatrical Staging for Orpheus

Codex Arundel, f. 231v
circa 1507

Leonardo designed many theatrical devices. In this project ingenious stage sets appeared during the theatrical scenes. This particular set was used in staging *Orpheus*.

Skull-shaped Lyre

Ashburnham I, f. Cr
1485-1487

A design for a lyre that was most probably meant for use on stage rather than an instrument to be actually played. The idea of using animal parts as sound boxes in musical instruments has prehistoric origins.

Mechanical Drum

Codex Atlanticus, f. 837r
1503-1505

The mechanical drum was most likely conceived for use in parades and processions along the city streets. But it may have been used in military parades or even in war, inciting the soldiers to battle or in intimidating the enemy. In fact, Leonardo's design has some variations on the basic project: a person or animal could draw the cart and a simple crank could also work it.

- | page 188 | -

- | page 196 | -

- | page 206 | -

- | page 210 | -

007 Other types of Machines

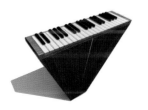

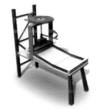

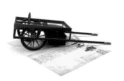

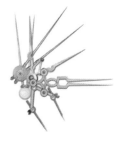

Viola Organista

Codex Atlanticus, f. 93r
1493-1495

This is a very complex project for an instrument that is difficult to categorise. It could be worn using a simple harness and is played with a keyboard. An internal, continually moving bow made from horsehair touches the cords moved by the keyboard. The sliding action of the looping bow on the strings emitted a sound more like a violin than a harpsichord.

- | page 216 | -

Printing Press

Codex Atlanticus, f. 995r
1478-1482

An automatic bed connected to a pressure system permitted the printer to print and advance the sheet of paper in a single operation by moving a large lever on the front.

- | page 226 | -

Odometer

Codex Atlanticus, f. 1br
circa 1504

This strange vehicle was drawn by a person over a specific area in order to measure distances. A complex mechanism let a metal or wooden sphere drop into a container every time a given distance was travelled. Once the course was completed, the operator had only to count the number of spheres in the container in order to calculate the distance covered.

- | page 230 | -

Compasses & Dividers

Codex Atlanticus, f. 696b
1514-1515

This is a small collection of work instruments, among them some dividers and compasses. One of the most fascinating aspects of Leonardo's work is the marriage between function and aesthetics in many of the devices he invented. These beautiful objects are perfect examples.

- | page 234 | -

001 Flying Machines

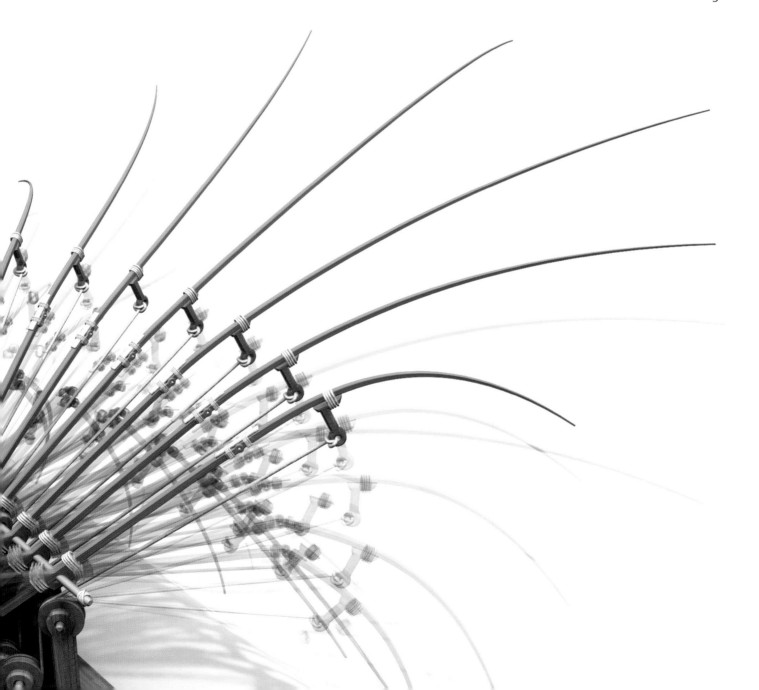

Perhaps the oldest group of studies by Leonardo related to a flying machine is found on a folio in the Uffizi (447E). It is most likely that these, as well as similar ones from the same period, are all part of his designs for *ingegni*, or theatrical machines, designed in Florentine workshops. In Florence, engineers and artists such as Brunelleschi and Verrocchio had great success with projects of this type. Leonardo is strongly dependent on their work, but equally strong is his intention to surpass it. On the same folio from the Uffizi we find a trace of his intent – a small but very clear trace. On the back of the page, Leonardo has drawn the diving trajectory of a bird in flight, adding annotations. His study thus moves away from the experimental and mechanical dimension to a different level, more theoretical and zoological.

When Leonardo decided to go to Milan, offering his services as engineer to Ludovico il Moro, he made no mention of flying machines in his letter of presentation. We can perhaps glean from this that at least in his mind the project was still part of the realm of theatrical sets. Or more simply, perhaps, that a flying machine would have seemed useless or something totally mad. What is certain, however, is that human flight was already on the minds of the most advanced engineers centuries before. There are records of more or less experimental attempts at flight, which from a scientific viewpoint had little significance. It should be remembered, however, that in the thirteenth century the great natural philosopher, Roger Bacon, mentioned the possibility of men flying with mechanical wings, and the fourteenth-century sculpted panels at the base of Giotto's Campanile in Florence, which depict various creative activities, include the inventor Daedalus, a human being with wings tied to his shoulders. Certainly, he was a mythical figure, but the idea of human flight, even though utopian in character, existed in the vibrant environment in which Florentine engineers were immersed; it was Leonardo who would take it seriously and develop it into scientific form.

This development took place after his move to Milan. Unexpectedly, perhaps, the main scientific impetus for Leonardo's designs for flying machines during the 1480s and 1490s was not zoology. During this period he temporarily set aside his studies on the animal world, taking them up again after 1500. At the close of the fifteenth century, Leonardo's designs for his flying machine began with man. His designs were rooted in the convergence of two fields of study: anatomy and mechanics (the study of weights and movement). On one hand, he studied the anatomical structure of the human body and its proportions. On the other, he studied the behaviour of weights and the characteristics of motion, both dynamic (relating to force) and kinematic (independent of force). The science of weights, *de ponderibus,* already had an illustrious

tradition, but remained an abstract discipline, rarely applied to real life objects. By the 1480s Leonardo was already studying and measuring the dynamic potentialities of the human body. He compiled pages and pages of drawings showing the body in various postures and spatial situations, all with the purpose of sampling its capacity to generate force.

Many of the drawings for the flying machine from this period are applications of these studies relating to the dynamic potential of the human body. For example, the famous design for the 'ornithopter' (Manuscript B, f. 80r) has very little to do with the animal world. The alternating flapping of the wings was certainly similar to that found in some insects, but the shape of this machine alone (a motorized mechanism with a pilot and wings placed in a hemispherical hull) makes clear that it had very little to do with zoology. The key is in understanding how it operates. Leonardo uses a complex mechanical system for maximizing the dynamic potential of the pilot's body, which has to generate force not only with the arms but also using the legs and head. There is no trace of a steering mechanism. The operator becomes almost an 'automatic pilot', whose only function is to generate sufficient force to flap the wings and lift the device off the ground. Turning manoeuvres are problems dealt with in another group of studies in which the pilot is in a horizontal position (for example, Codex Atlanticus f. 824v and Manuscript B f. 79r). In this group greater attention is also given to natural flight, but it is important to note that despite some drawings (for example, Codex Atlanticus ff. 70br and 846v), Leonardo rarely proposed a synthesis between designs centred on the generation of force for flying and those dealing with turning manoeuvres.

In Florence during the early 1500s, Leonardo resumed the study of human flight in a systematic fashion. Nature, zoology and the study of the natural flight of birds now took on a new importance for him. He spent hour after hour outdoors observing the flight techniques of birds. Some of his codices dating from this time period are in fact pocket notebooks, in which he was quickly and directly jotting down notes and sketches on what he was observing. Manuscript L and Manuscript K1 are small codices of this type. It is therefore not surprising that some of the notes in Manuscript K1 are duplicates: rapid notes that once in the calm of his studio, he further developed. The Codex 'On the Flight of Birds' (in a format slightly larger than that of the others) dates from this period and is a rare example of a manuscript by Leonardo dedicated (almost)

exclusively to a single topic: flight, both in its natural form and the imitation of natural flight with the flying machine. Now more than ever, the design for the flying machine became a radical attempt to imitate nature, the natural flight of birds in all its forms and actions. This can be seen immediately by analysing the Codex 'On the Flight of Birds', which consists of two main sections: one centred primarily on flapping or active flight (propulsion obtained by the beating of wings), and the other dealing with in-flight manoeuvres designed to maintain equilibrium in the presence of wind. It is interesting that each section is composed of two types of study: naturalistic studies relating to flight techniques in birds, having as their basis the laws of anatomy and aerodynamics, and mechanical studies in which Leonardo attempted to perfect a model of the flying machine capable of imitating what he observed in nature.

It is important to underline how strongly Leonardo believed in the possibility that man could imitate the flight of birds. His confidence derived from his general conception of the world of nature, which was so important to him during these years. He was convinced of a profound analogy between all living beings. In his studies on comparative anatomy he attempted to demonstrate a series of similarities between man and, for example, four-legged animals. Leonardo noted that when man is a baby he, too, 'walks' on four legs. As he grows, the dynamic relationship in the human carriage between the upper and lower limbs is comparable with that between the fore and hind legs of the quadrupeds. Leonardo's conviction regarding the possibility of human flight was founded on this general analogy between man and animals.

Leonardo continued to believe in the possibility of active human flight resulting from the force generated in the muscles. However, during the final phase of his life, while aerostatic flight occupied more of his thoughts (as in the famous study of the descent of man attached to a plank in Manuscript G, f. 74r), there was a decline in the number of mechanical projects he pursued and an increase in studies dedicated purely to theory (many of which are contained in Manuscript E). During this period, even the flight acrobatics of birds are studied not so much for research on the flying machine as for indirectly studying the laws behind air currents and wind. Even in this phase, however, mention of artificial flight is not totally absent. The traditional sources (Vasari, Lomazzo) relate very different outcomes of Leonardo's research. For example, Leonardo dedicated himself to making birds and other flying objects using automatic mechanisms or by inflating elastic materials. His work in this field became an epilogue of pastimes and amusements – a destiny that would touch other aspects of Leonardo's research into mechanics.

Vinci, 1452

1460

1470

1480-1485

1490

1500

1510

Amboise, 1519

Codex Atlanticus, f. 1051v

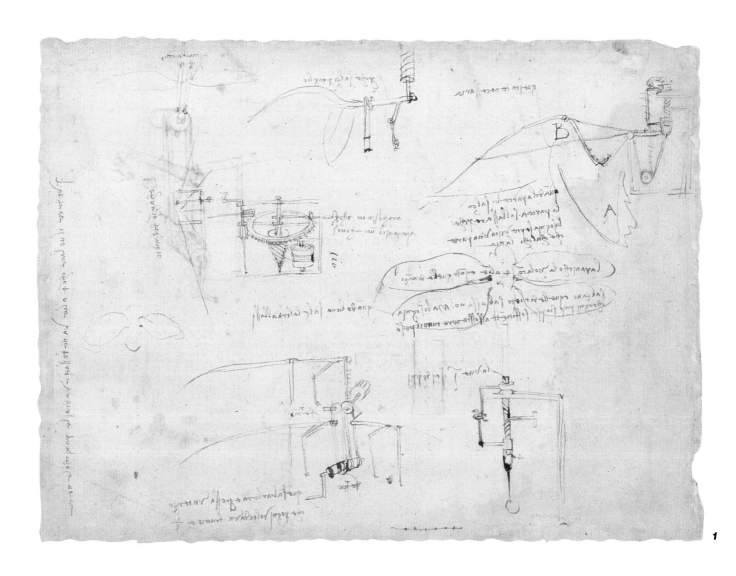

Mechanisms for Mechanical Wings

Leonardo worked on this folio from the Codex Atlanticus when he was about thirty years old, during the time he was still in Florence or immediately after leaving for Milan in 1482. It is interesting for two reasons: first, because it is a typical work sheet, and second, because it is one of the oldest examples demonstrating the link between a flying machine and studies on natural flight. It represents one of the most original aspects of Leonardo's research in this area, and perhaps even the most fascinating.

Leonardo left precious autobiographical testimony in his writings. His manuscripts are like a personal diary, not of day-to-day events, but events tied to his work, his scientific or artistic research. He used his written notes, and especially his drawings, to record every movement of his thoughts on a given problem systematically. Thus, by analysing the page with its notes and drawings, it is possible to reconstruct the concrete development of his research, observations, doubts, work projects and so on.

We cannot identify with any certainty the order of his thoughts and the notes he made on the page. Perhaps the dragonfly (on the right) and the other flying insect (on the left) were among the first of the drawings. In both cases, they are barely more than quick sketches. Certainly, Leonardo did not intend to portray these small animals in full detail, but to simply to give an impression, a thought, referred to in the written note that he made over the main drawing. By observing the flight of these insects, Leonardo deduced that when the front pair of wings go up (preparing for a downstroke), the back pair go down, ensuring a surface for support on the air. Thus, we have a first group of notes and drawings on the study of natural flight.

On the other hand, there is a different group of drawings and notes that address mechanical flight. Specifically, the drawing in the upper left section of the page represents a mechanical wing comprised of two parts, an inner section (A), and an outer section (B). During the wing beat, when the outer section goes up, the inner section remains lowered on the air supporting the machine in flight. The mechanism of this artificial wing results, therefore, from an imitation of what is observed in natural flight.

A long note along the left margin of the page is testimony to another phase in Leonardo's research. As often occurs on Leonardo's pages, it deals with a work project: 'To see four-winged flight, go around the ditches and you will see the black net-wings.' It is impossible to tell whether Leonardo meant to develop further the zoological observations he had already made and noted on this page, or if these are the fruit of the expedition he had in mind.

fig. 1
In the centre of the page there is the faint drawing of a dragonfly, while surrounding it Leonardo draws mechanisms that attempt to reproduce movements for flight.

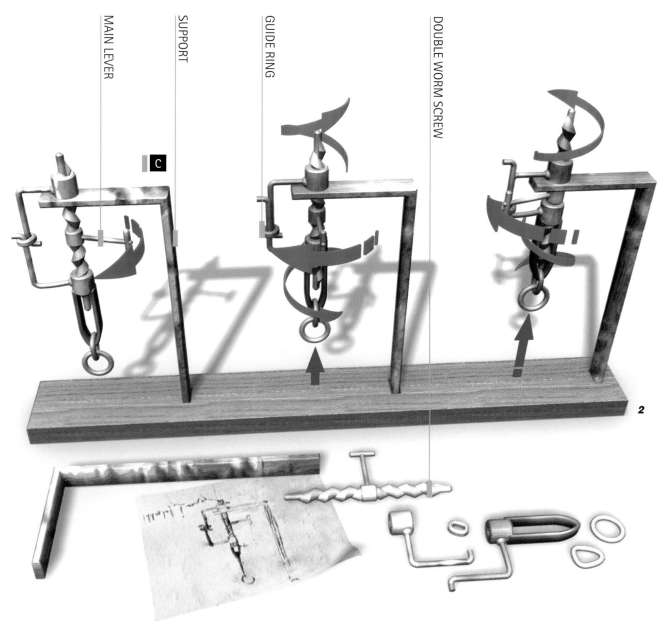

MAIN LEVER

SUPPORT

GUIDE RING

DOUBLE WORM SCREW

C

2

 Leonardo himself clearly described the workings of the device, and used the letters A and B to indicate the points where the mechanical wing should flex. The wing function on this machine serves to fold a mechanical wing. By activating the motor mechanism, point A should lower while point B moves in the opposite direction. The sum of these movements will give a wing motion very similar to that found in animals.

C In the study model for the mechanical wing the fundamental part is the propulsory mechanism. It is a complex instrument, and even while he was designing it Leonardo changed his mind. This is seen in the sketch in the upper right (fig. 1) where he crossed out a technical solution that he considered to be wrong. In the final configuration the mechanism has a double worm screw that puts the entire wing in movement by activating a small lever.

D The final movement of the wing generated by the continual motion of the lever imitates nature: in fact, the wing behaves much like the wing beat of an animal where the extremities complete a longer and different trajectory than the wing near the body, almost closing up on itself.

fig. 2
Workings of the drive motor.

fig. 3
Automatic system for folding in the mechanical wing. An operator works the lever putting the mechanisms in motion; in turn these produce the motion and rotation of the wing supports.

fig. 4
A dynamic sequence of the motion.

STUDY MODEL FOR THE MECHANICAL WING

DRAGONFLY USED FOR REFERENCE

DRIVE MECHANISM

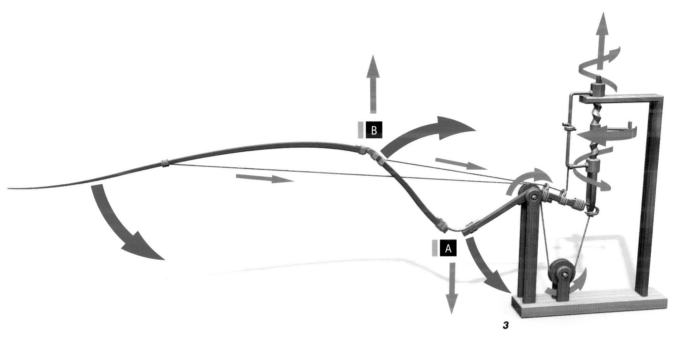

3

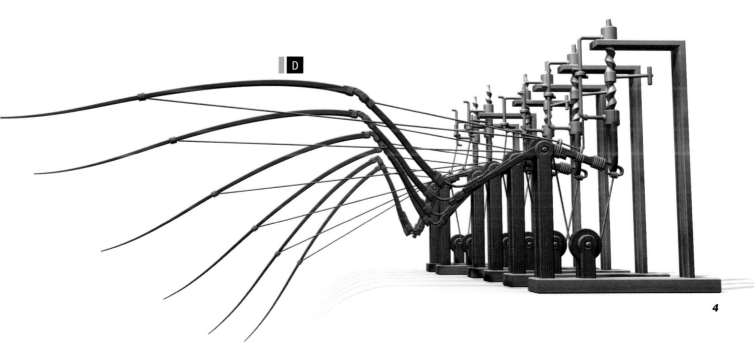

4

Vinci, 1452

1460

1470

1480

circa 1487

1490

1500

1510

Amboise, 1519

Ashburnham I, f. 10v

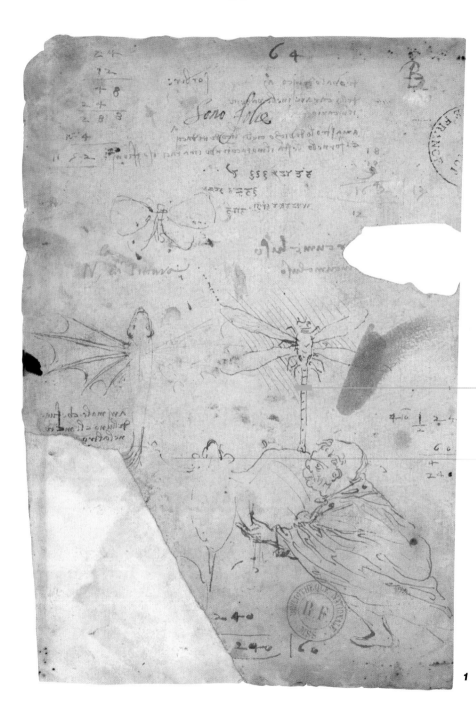

1

Dragonfly

The manuscript today known as Ashburnham I was originally part of Manuscript B. In the nineteenth century it was stolen from the latter, but was later recovered. Thus, the drawings and notes on this page date from the time Manuscript B was being compiled; this was around 1485-1490, when Leonardo was in Milan.

During this period, Leonardo was pursuing two main paths in his research on human flight: studies on the fundamental laws of natural flight and its imitation, and studies on the dynamic potential of the human body and the elaboration of the mechanisms able to use this potential to the fullest. This latter branch of his research seemed prevalent, but it never overrode the fundamental idea behind the flying machine: the imitation of the flight of winged creatures. Some of the studies on this folio deal with flight as found in nature. Here, Leonardo depicted various airborne creatures: a flying fish, a bat, a dragonfly (or in a different interpretation, an ant-lion – a winged insect similar to a dragonfly), and another flying insect. On one level it is a study of animals; on a more specific level it is a comparative study of the morphology of various animals seen from the perspective of Aristotelian biology, a vantage point to which Leonardo would remain faithful until the end.

Leonardo compared four-winged flying animals with animals with membrane-covered wings. He was interested in the differences, but above all in the similarities. He demonstrated this by including and giving particular attention to the flying fish, which, as he specified in a note, is an animal capable of flitting through both air and water. Through this analogy Leonardo studied water and its whirlpools in order to grasp the laws underlying the behaviour of the invisible element air. The flying fish is almost the incarnation of the basic similarity of animals, humans included, in the various elements. In Leonardo's eyes this analogy was fundamental to the possibility of human flight.

The comparative zoological studies are thus connected to those on the flying machine. The types of mechanical wings Leonardo designed during this period, many of which are in Manuscript B, are either double wings (as seen in two of the animals depicted on the page) or membrane-covered wings, in imitation of the bat or flying fish.

2

fig. 1
*The folio from
the Codex Ashburnham I,
originally part of Manuscript B.*

fig. 2
*Three-dimensional reconstruction
of a dragonfly in the centre of the page
in a sketch by Leonardo.*

**overleaf, following page,
fig. 3**
*A hypothetical reconstruction of the way
Manuscript B, a notebook containing a hundred
pages, may have looked when Leonardo
began it. This folio was later removed
from the original manuscript.
Part of the drawings in this volume are dedicated
to mechanical flight, and also take their inspiration
from this first dragonfly.*

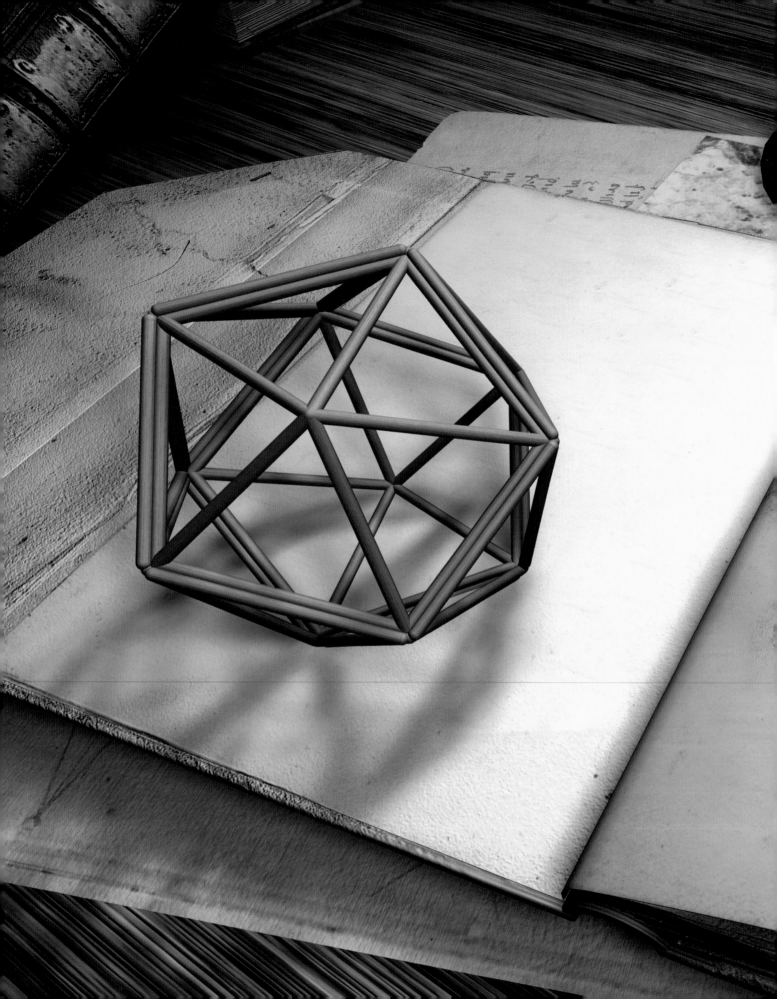

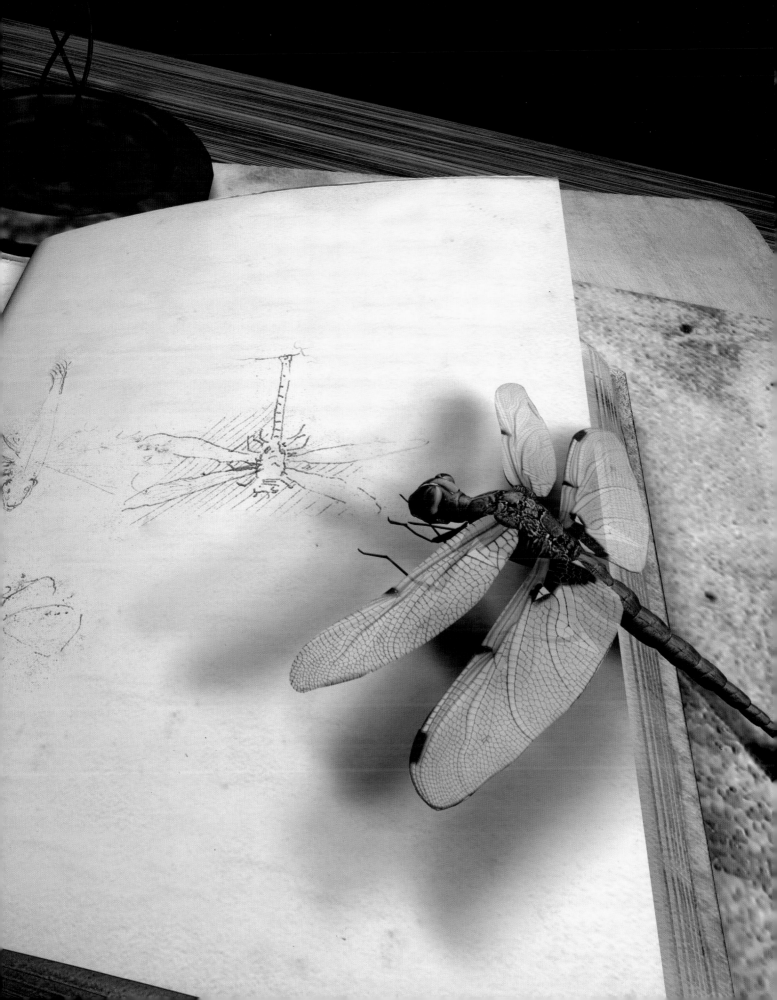

Vinci, 1452

1460

1470

1480

1487-1489

1490

1500

1510

Amboise, 1519

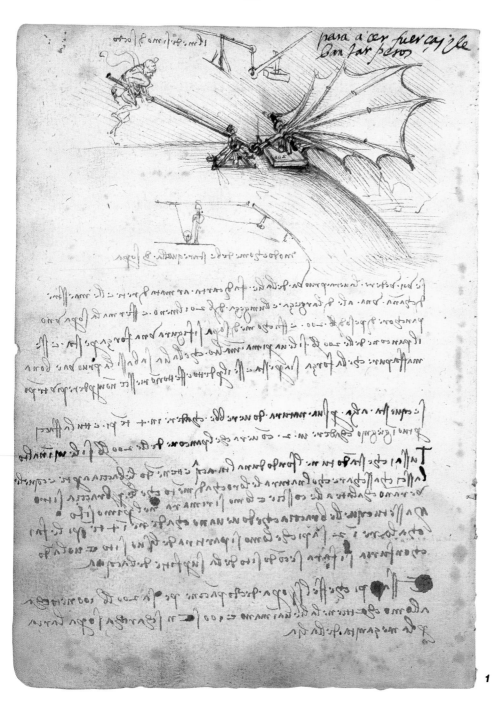

1

Flapping Wing

Leonardo conceived of the flying machine, especially in a first phase, as a dynamic challenge that man would hurl against nature. He reasoned that air, unlike water, can be compressed. Man could keep himself in flight with an artificial wing compressing the air, just as if he were navigating on water. The problem lay in flapping the wing with sufficient speed to prevent the compressed air escaping from under it. The problem of the speed was a question of dynamics, of adequate force being generated by a man. The design on this folio of Manuscript B is meant to test the capacity of the human body and a wing of a given amplitude in raising a board weighing two hundred Florentine *libbre* (about 68 kg or 150lb). It is the plan for an actual experiment to be undertaken on a hillside, which Leonardo indeed could have carried out. The experimental dimension of the study is made apparent by the very complete drawing, containing details not only of the machine and how it works, but also of the type of landscape necessary for the test.

Leonardo used the tools common to every designer working between the Middle Ages and the Renaissance: a notebook and pen. His pen, however, was not limited to jotting down notes or a rapid visual diagram. It was used to create a remarkably complex drawing, even if only in the form of notation. The image was made first; the text underneath is a caption added later, a further explanation. In addition to presenting the form of the mechanism under experimentation, the drawing also shows its dynamics: the lever activated by a man is in a raised position. The hatching around the external limits of the wing seems to reproduce the variable curvilinear profile of the wing, almost visualizing the quivering part of the compressed air. Before carrying out his experiment, Leonardo was rehearsing it in his visual and graphic imagination. Although it is not the case here, the force of Leonardo's drawing at times is such that the project does not need, nor was it meant, to be physically carried out. On the board, we can see the figure '200', signifying the weight to be used (200 *libbre*). On the right is the slope of a hill, a few quickly drawn landscape elements (a mountain and a slope showing the opposite valley, a building in the distance). It is possible that Leonardo had a specific site in mind. Above and below the main drawing there are studies for devices related to it. The note wrtten in the top right corner was inserted at a later date and is not by Leonardo.

fig. 1
Design for a flapping wing on folio 88v from Manuscript B; the folio contains the main drawing and the notations on the design, but there are also two important ideas for eventual modifications.

fig. 2
Side view of the design for the articulated version of the experiment for the flapping wing.

2

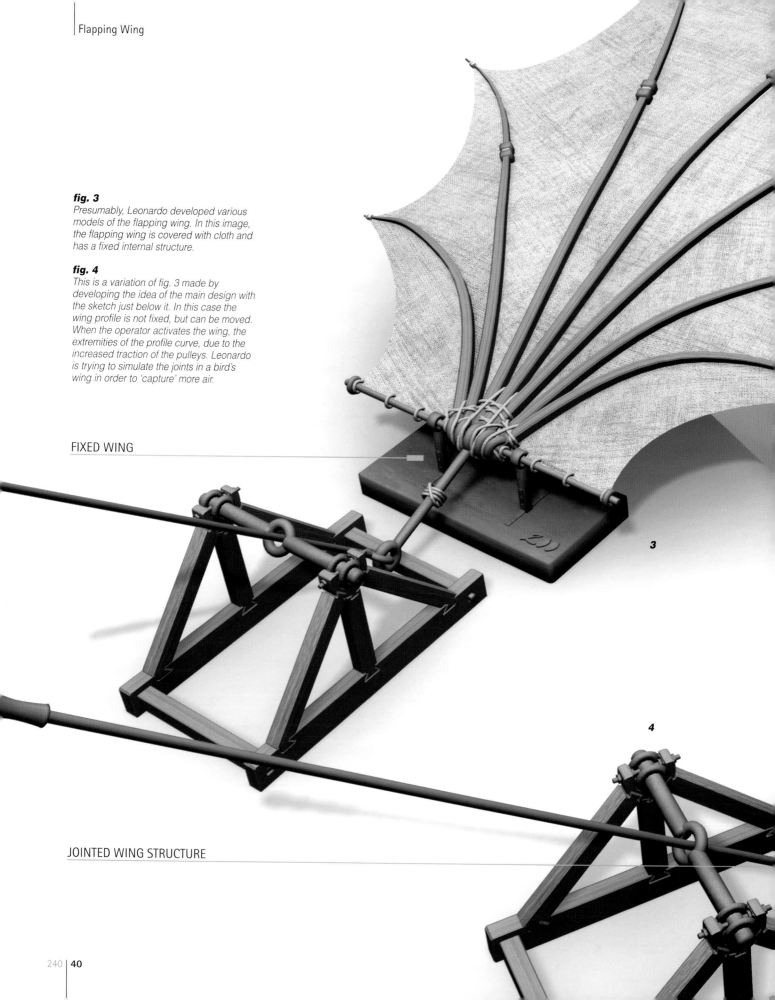

fig. 3
Presumably, Leonardo developed various models of the flapping wing. In this image, the flapping wing is covered with cloth and has a fixed internal structure.

fig. 4
This is a variation of fig. 3 made by developing the idea of the main design with the sketch just below it. In this case the wing profile is not fixed, but can be moved. When the operator activates the wing, the extremities of the profile curve, due to the increased traction of the pulleys. Leonardo is trying to simulate the joints in a bird's wing in order to 'capture' more air.

FIXED WING

JOINTED WING STRUCTURE

3

4

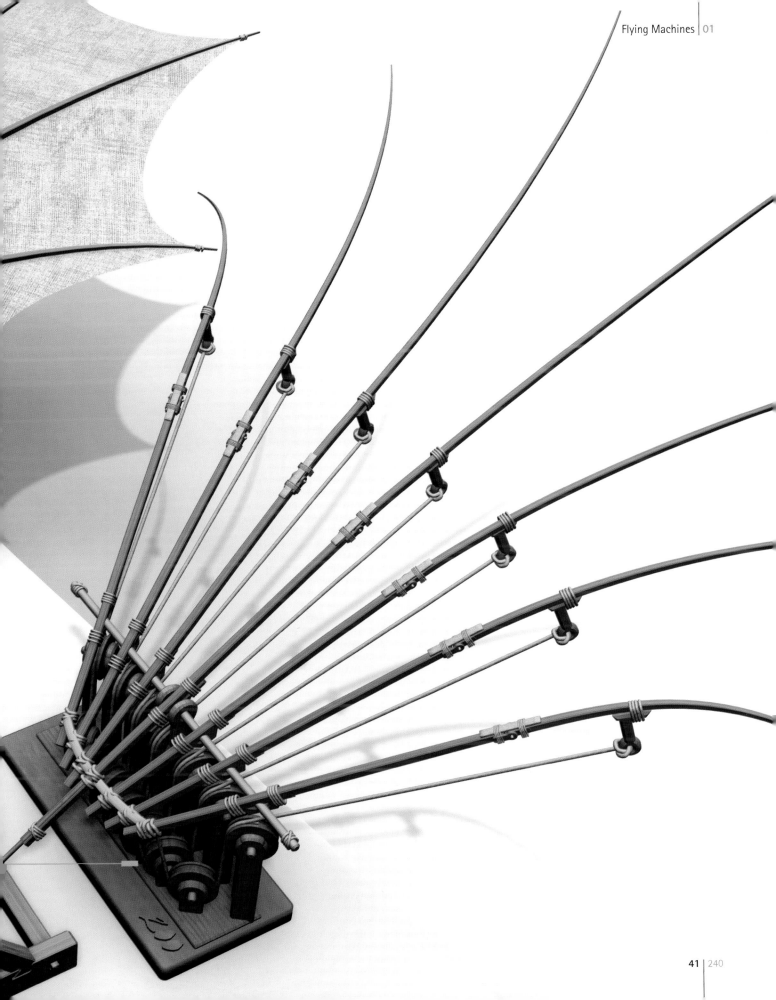

5

LEVER

SUPPORT STRUCTURE

200 *LIBBRE* WEIGHT

WING STRUCTURE

6

figs. 5 and 6
*Reconstruction of the functioning flapping
wing. If the wing were well constructed
and the man exerted sufficient force,
the 200-libbre weight would be lifted.*

fig. 7
The flapping view viewed from above.

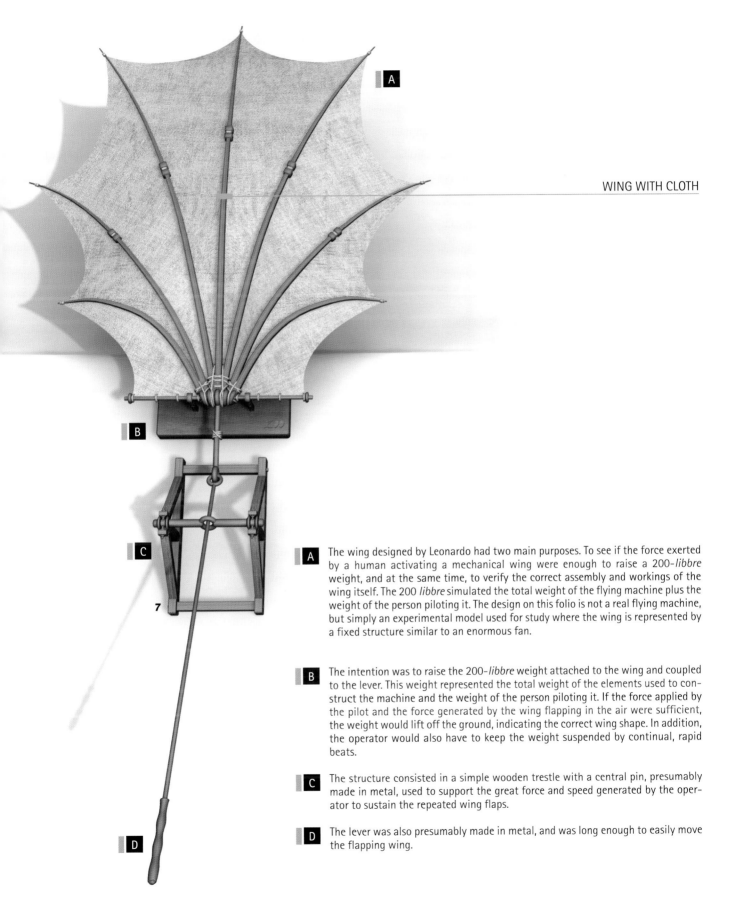

WING WITH CLOTH

7

A The wing designed by Leonardo had two main purposes. To see if the force exerted by a human activating a mechanical wing were enough to raise a 200-*libbre* weight, and at the same time, to verify the correct assembly and workings of the wing itself. The 200 *libbre* simulated the total weight of the flying machine plus the weight of the person piloting it. The design on this folio is not a real flying machine, but simply an experimental model used for study where the wing is represented by a fixed structure similar to an enormous fan.

B The intention was to raise the 200-*libbre* weight attached to the wing and coupled to the lever. This weight represented the total weight of the elements used to construct the machine and the weight of the person piloting it. If the force applied by the pilot and the force generated by the wing flapping in the air were sufficient, the weight would lift off the ground, indicating the correct wing shape. In addition, the operator would also have to keep the weight suspended by continual, rapid beats.

C The structure consisted in a simple wooden trestle with a central pin, presumably made in metal, used to support the great force and speed generated by the operator to sustain the repeated wing flaps.

D The lever was also presumably made in metal, and was long enough to easily move the flapping wing.

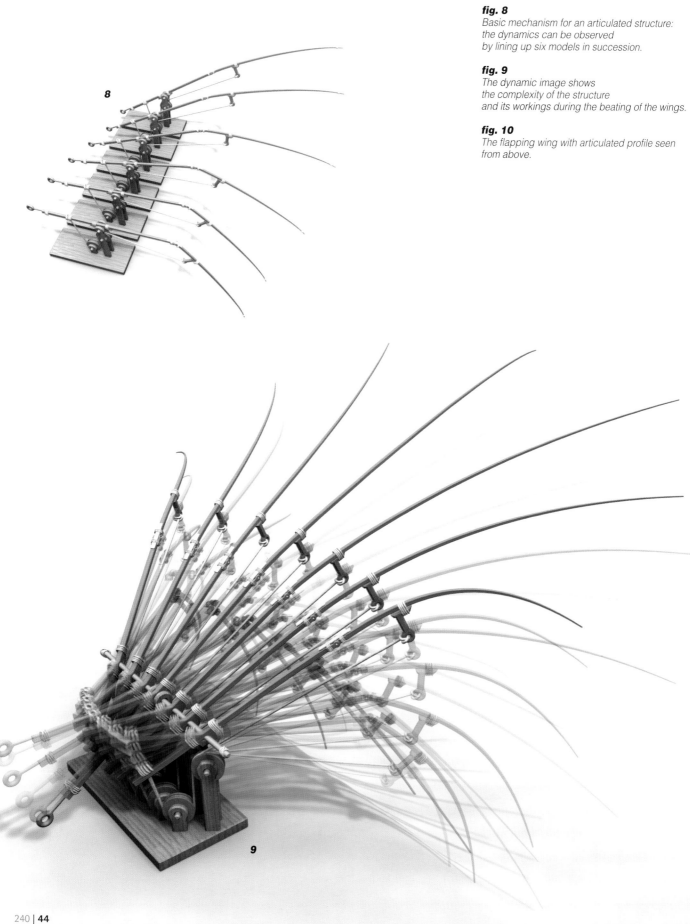

fig. 8
*Basic mechanism for an articulated structure:
the dynamics can be observed
by lining up six models in succession.*

fig. 9
*The dynamic image shows
the complexity of the structure
and its workings during the beating of the wings.*

fig. 10
*The flapping wing with articulated profile seen
from above.*

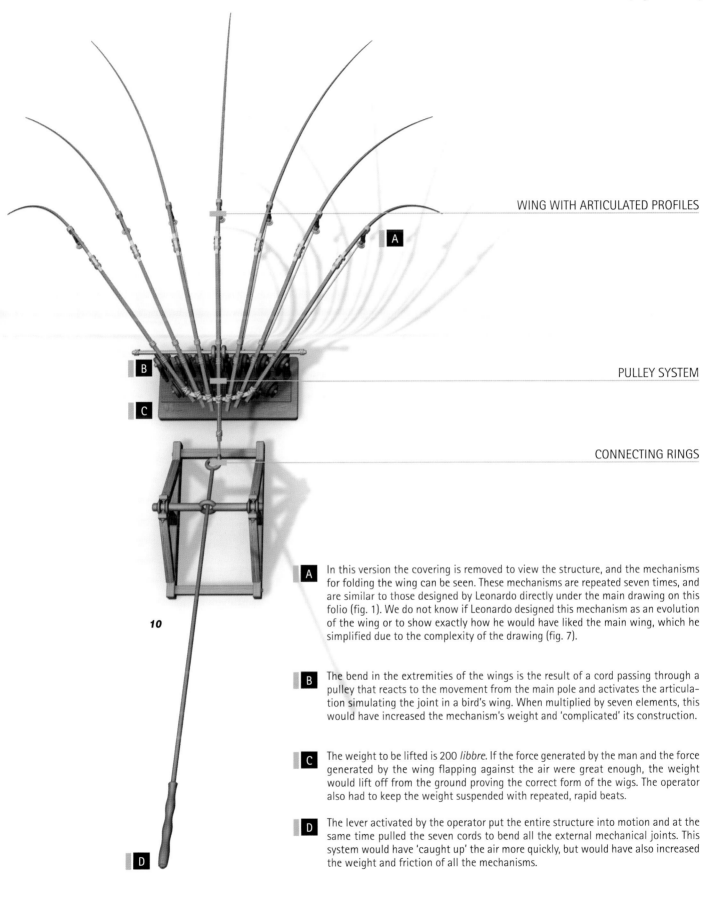

WING WITH ARTICULATED PROFILES

PULLEY SYSTEM

CONNECTING RINGS

10

A In this version the covering is removed to view the structure, and the mechanisms for folding the wing can be seen. These mechanisms are repeated seven times, and are similar to those designed by Leonardo directly under the main drawing on this folio (fig. 1). We do not know if Leonardo designed this mechanism as an evolution of the wing or to show exactly how he would have liked the main wing, which he simplified due to the complexity of the drawing (fig. 7).

B The bend in the extremities of the wings is the result of a cord passing through a pulley that reacts to the movement from the main pole and activates the articulation simulating the joint in a bird's wing. When multiplied by seven elements, this would have increased the mechanism's weight and 'complicated' its construction.

C The weight to be lifted is 200 *libbre*. If the force generated by the man and the force generated by the wing flapping against the air were great enough, the weight would lift off from the ground proving the correct form of the wigs. The operator also had to keep the weight suspended with repeated, rapid beats.

D The lever activated by the operator put the entire structure into motion and at the same time pulled the seven cords to bend all the external mechanical joints. This system would have 'caught up' the air more quickly, but would have also increased the weight and friction of all the mechanisms.

Vinci, 1452

1460

1470

1480

circa 1489

1490

1500

1510

Amboise, 1519

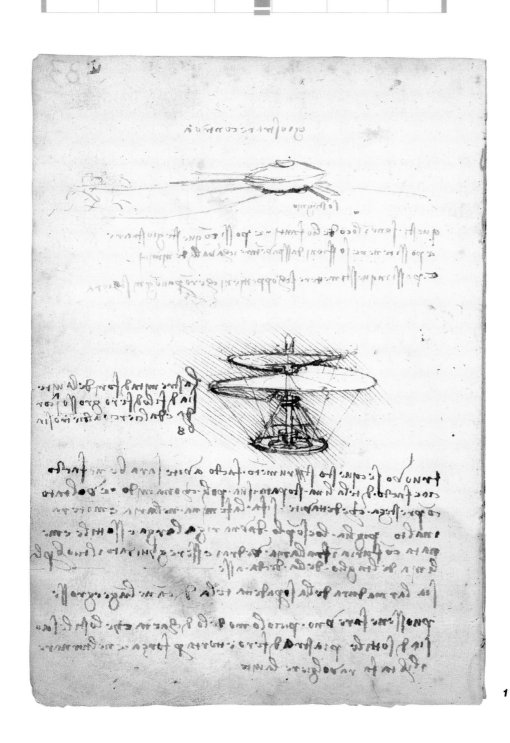

1

Aerial Screw

This study for an aerial screw appears in one of the folios from Manuscript B, alongside other flying machines. It is a device that when rotated is supposed to lift off in flight. This drawing, like the others in this codex, is made with pen and ink, a technique that allows for rapid, accurate execution. With his eye towards human flight, Leonardo dedicated much of his attention to the dynamic potential of the human body (the driving force behind the flying machine), as well as to another aspect of the problem: the air, the element in which the flying machine had to operate. The idea of an aerial screw was conceived in this context of his scientific studies.

This was an important step. Putting aside the theoretical and scientific dimension of this design for the moment, in the best of hypotheses it appears to be only a utopian anticipation of modern advances. Leonardo studied the air, and reached the conclusion that unlike water, it can be compressed if enough energy is exerted upon it. One of the most extraordinary studies in Manuscript B (folio 88v) is the notes on an experiment verifying this action. The aerial screw developed from the very same order of ideas. The hatched areas around the machine, just as for the experimental wing on folio 88v, very effectively render the tangible, even though invisible, presence of the air. If air can be compressed, then it follows that it has material density. Based on this conclusion, Leonardo deduced that a device in the form of a screw, rotating very quickly, can lift itself up in flight. His device would bore into the fluid density of the air just as a screw does into other materials. The possibility of achieving this movement was obviously dependent on achieving a high enough rotating speed. Thus, in the final analysis, the problem was tied to another area under investigation: how to obtain adequate force. As often in Leonardo's designs, this aspect of the problem was not fully developed. It is not clear whether the screw would have been rotated by men or by a line quickly unwound, like a spinning top. Conversely, Leonardo dealt only with generating force in his amazing design for the flying ship (folio 80r in Manuscript B).

As usual, our impression is that rather than following a systematic path in designing a machine capable of flight, Leonardo investigated different theoretical problems such as man's dynamic potential and the physical characteristics of air. Within each area he investigated, he elaborated a design for a machine that allowed him to 'visualize' his theoretical conclusions. The spiral form has been omnipresent in the field of hydraulics (the systems based on the Archimedean screw, or the worm screw, come to mind), but it should be noted that this was the first time a spiral form had been applied to flight and air.

fig. 1
The central portion of folio 83v in Manuscript B shows the design for the aerial screw along with notes on its construction.

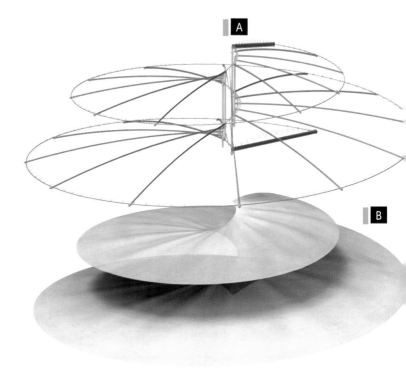

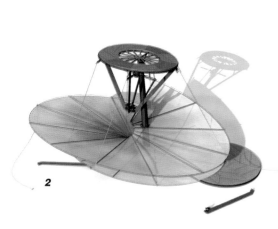

fig. 2
The inevitable result of Leonardo's helicopter. In fact, the design for the aerial screw is notoriously called Leonardo's helicopter. In reality, given its structural and constructive characteristics, it would not have functioned correctly, nor would it have made use of the dynamic principles of the modern-day helicopter. One only needs to turn back three pages in Manuscript B to find something more technically similar to a machine that flies like a helicopter.

fig. 3
Exploded view of the aerial screw, with dismantled elements and connections.

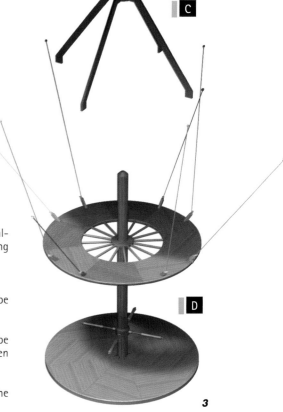

A The flying structure conceived for the aerial screw design consists of a helical-shaped iron stay attached to a central mast with a series of wooden ribs, allowing the 'wing' to be covered in cloth and fixed to the main structure.

B Leonardo suggested that linen, sized with starch to reduce its porosity, should be used to cover the helical structure.

C A system of wooden trestles allows the 'wing' structure of the aerial screw to be attached to the central mast and consequently the operating base where men would work the rotating mechanism.

D The circular, wooden operating platform houses the men used to produce the energy necessary for the screw to bore into the density of the air and fly.

BLOCK A - FLYING STRUCTURE

BLOCK B - PILOTING DECK

figs. 4 and 5
*The images show the aerial screw sitting
on the manuscript page as if it were a mock-up
in paper and wood suggested by Leonardo.
Helical structure covered
with cloth (fig. 5) and the version
without covering (fig. 4)*

CLOTH COVERING

HELICAL STRUCTURE

OPERATING PLATFORM

4

5

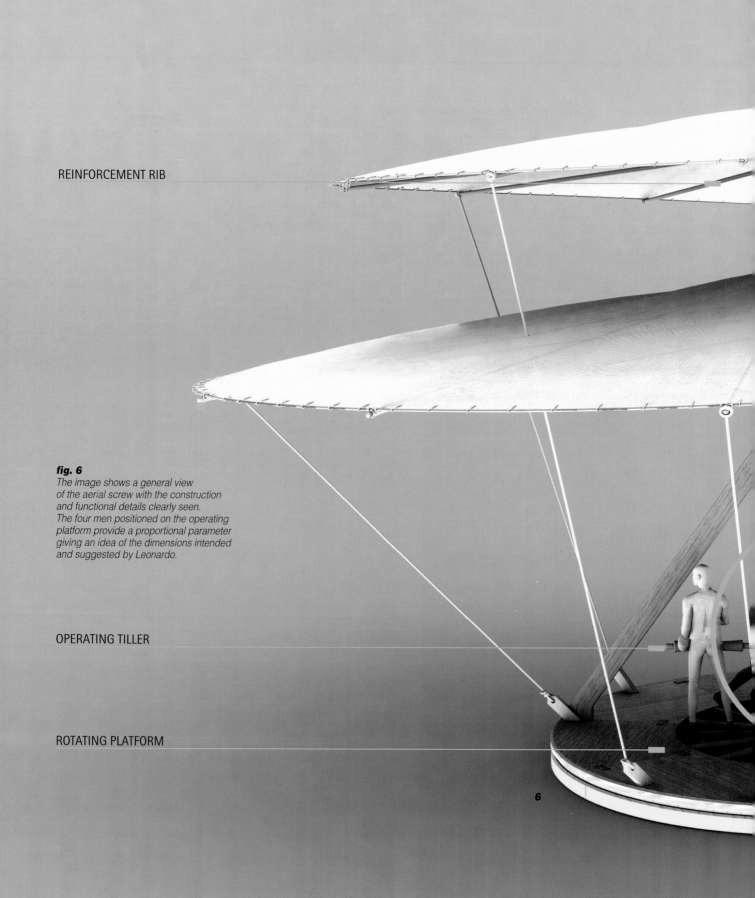

REINFORCEMENT RIB

fig. 6
*The image shows a general view
of the aerial screw with the construction
and functional details clearly seen.
The four men positioned on the operating
platform provide a proportional parameter
giving an idea of the dimensions intended
and suggested by Leonardo.*

OPERATING TILLER

ROTATING PLATFORM

6

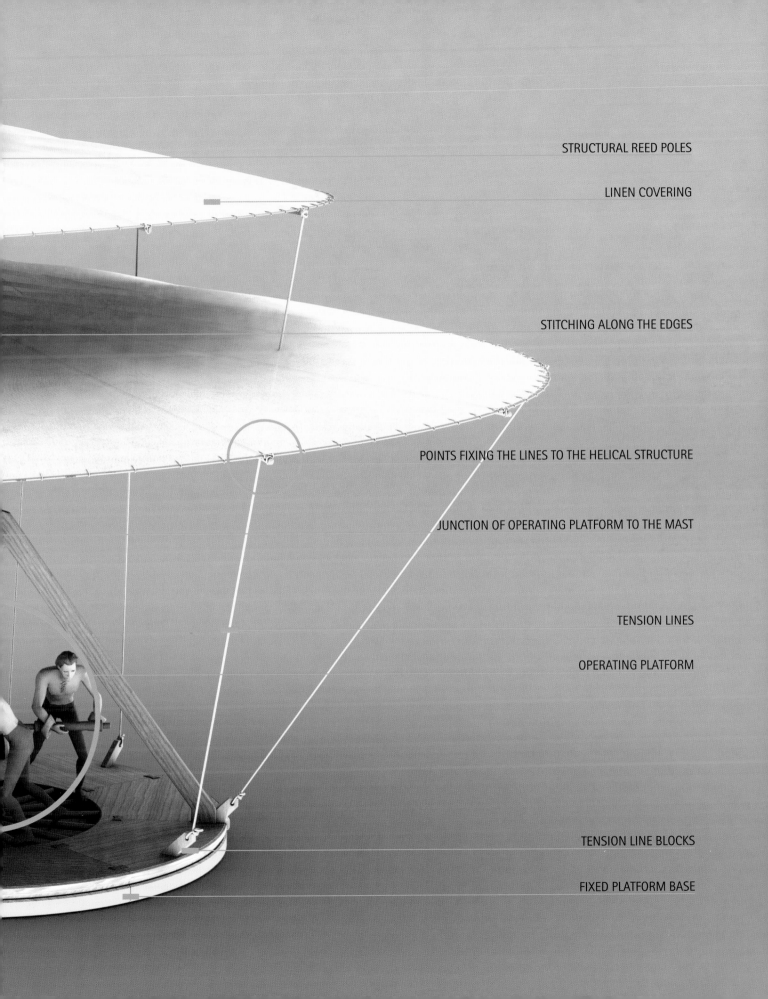

STRUCTURAL REED POLES

LINEN COVERING

STITCHING ALONG THE EDGES

POINTS FIXING THE LINES TO THE HELICAL STRUCTURE

JUNCTION OF OPERATING PLATFORM TO THE MAST

TENSION LINES

OPERATING PLATFORM

TENSION LINE BLOCKS

FIXED PLATFORM BASE

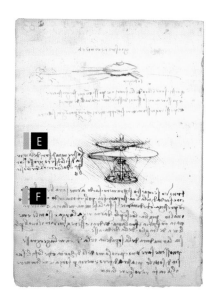

E In the note Leonardo made for himself, he suggested that the helical structure should be made with thick iron wire, and also indicated that the diameter should be 8 *braccia* (1 *braccio* is about 5cm, or 2ft).

F In the notes on the page, he indicated that a linen cloth should be used to cover the structure and that it should be sized with starch to close the pores. In order to lighten the structure he suggested long, sturdy reed canes. Finally, he noted (perhaps to himself) that a small paper mock-up should be made in order to study the functional aspects.

7

fig. 7
The folio with two types of annotations:
lateral dimensions (E), constructional dimensions
below (F).

fig. 8
Technical image of the aerial screw,
showing the morphological complexity
and elegance of design.

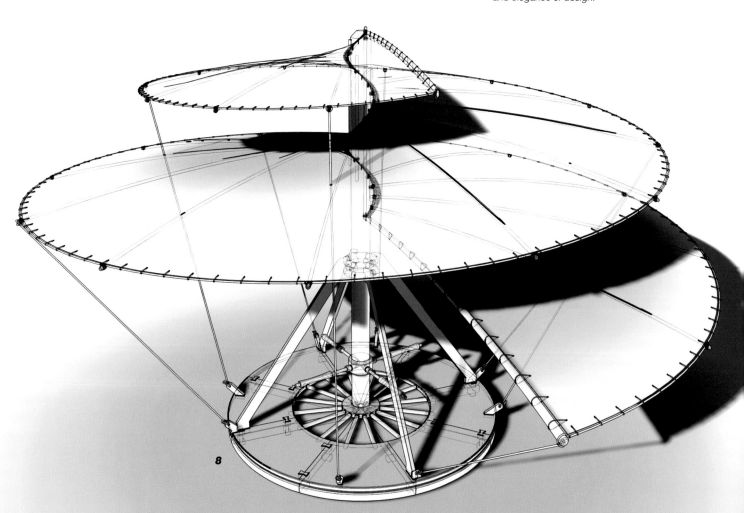

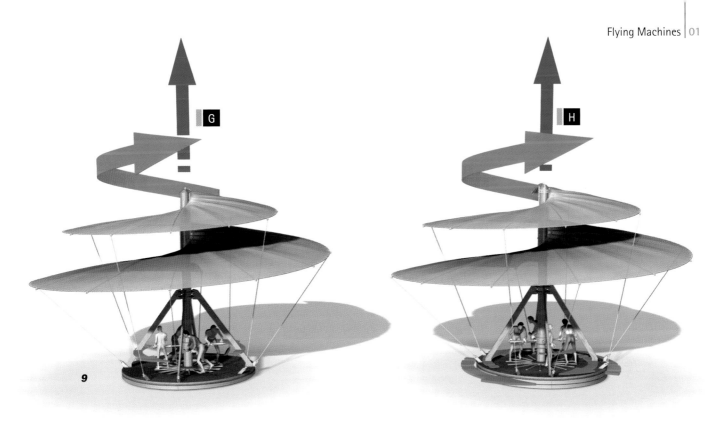

9

G Four men grasp the four poles on the operating tiller. They remain stationary while they push with their feet against the structure (red arrow) firmly attached to the propeller. Thus, the propeller begins to move and once a hypothetical 'boring' of the air is achieved the main structure and the rotating platform lift up, leaving the men and the central mooring used as a starter to direct the rotation on the ground.

H In the second hypothesis, the structures are placed differently. The four men are part of the flying 'vehicle', and by pushing with their feet they begin to turn like a merry-go-round on the playground (red arrow). When the screw turns fast enough to bore into the air (clockwise), theoretically the structure should begin to fly. The base against which the men push, however, would begin to turn in the opposite direction. Thus, even if the structure were initially pushed upwards, it would not be able to fly because there would be nothing for the feet to push against and the two opposite rotations would clash.

In whatever case and combination, the final result would certainly be as depicted in fig. 2. The modern helicopter solves the problem of rotational stability by using a small propeller on the end of the tail that prevents it from circling around on itself. Additionally, its principle of flight is based on aerodynamic lift rather than boring through the air as Leonardo had imagined.

figs. 9 and 10
These images show two different hypotheses for working the machine. In both cases the helical canvas is made to turn in a clockwise (when viewed from above) direction, boring itself into the air just as Leonardo describes. The rotary motion could be generated in two ways.

10

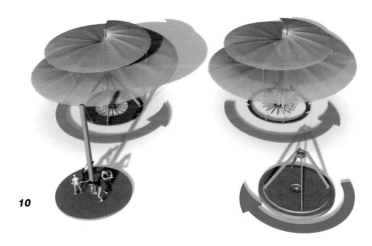

Vinci, 1452

1460

1470

1480

1488-1489

1490

1500

1510

Amboise, 1519

Manuscript B, f. 74v

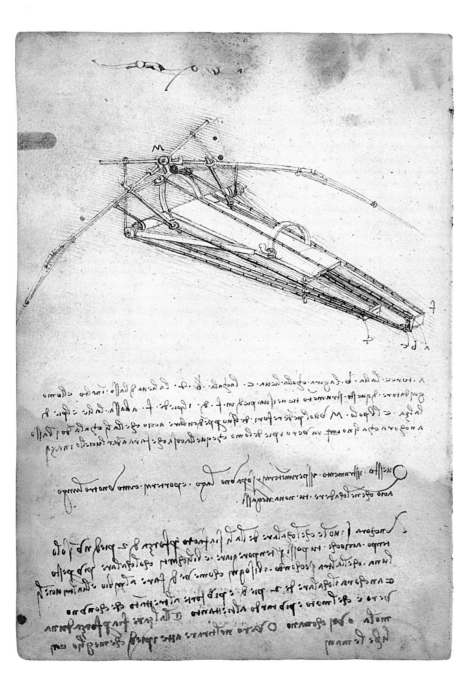

1

Flying Machine

2

The drawing on this page of Manuscript B, with the three notes written underneath, make up a very complex unit. In fact, all the notes refer to the machine in the drawing. This impression of organic unity is strengthened by the style of the drawing and the note immediately under it. The drawing is highly finished and delineated by a very precise, clean line, while the layout of the written note is very regular. Both characteristics are typical of the years around the 1490s, when Leonardo reached a remarkable intellectual equilibrium which, in a sense, is manifested in his graphic style. It must be stated, however, that this was not something that happened effortlessly. Even if the page looks well organized, it is still fundamentally a working note made for himself. The different writing styles contribute to this impression. Initially, Leonardo made the drawing and wrote the first note underneath it. In a later phase, he went back to the page and added the other two notes. This was almost always his way of working. For him, the sheet of paper was like a painting; he continued to apply his 'brushstrokes', sometimes in the form of notes, at other times as drawings, as long as there was empty space on the 'canvas'.

Just as in the other projects he took up during this period, Leonardo was attempting to harness the dynamic potential of the human body in the most efficient way possible. This was a fundamental part of his research in this period, and it generated a series of designs for the flying machine in which the pilot is standing up. At the same time, however, Leonardo did not lose sight of the theme of the imitation of natural flight, and this is especially evident in the group of designs we are looking at here, where the pilot is in a horizontal position. Leonardo's notes clearly reveal this mimetic idea: he cites the kite and other birds as models to imitate, and even at one point refers to the flying machine as a 'bird'. Nature and technology were overlapping in his mind. This concept would be even more strongly evident later on, during the period of the Codex 'On the Flight of Birds'.

One of the three notes is about an experiment to be carried out using the flying machine: Leonardo planned to use the machine on a lake, in order to reduce the risks from a fall.

fig. 1
The image on the folio 74v of Manuscript B puts the design for the flying machine in a central position.

fig. 2
Model of the flying machine placed on top of a reconstruction of Manuscript B, opened to folio 74v.

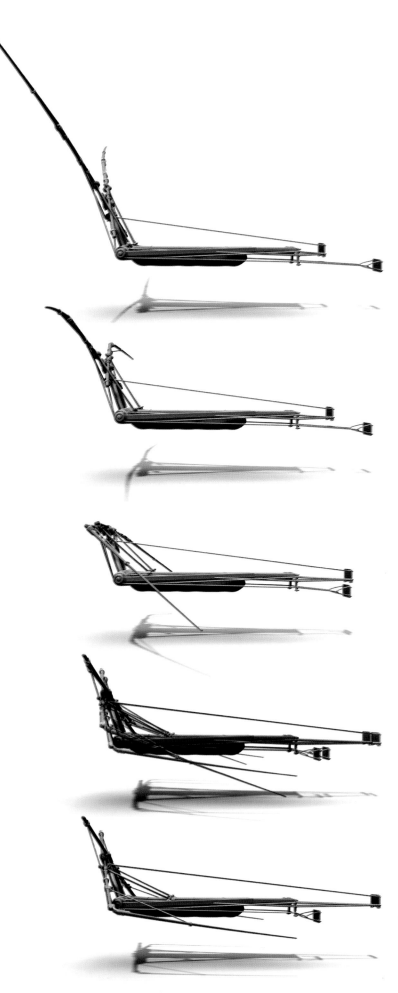

figs. 3 and 4

*The sequence of images, seen from the side
(fig. 3) and front (fig. 4), shows the development
and the dynamics of the workings of the flying
machine.*

*The sequence, from top to bottom, synthesizes
the folding in of the wings. Going from bottom
to top, the wings open.*

*Each frame in the series helps to understand the
type of movements made by the machine and the
components of each movement. The image is
indicative of the complexity of the fundamental
working principle in this da Vincian design.*

3

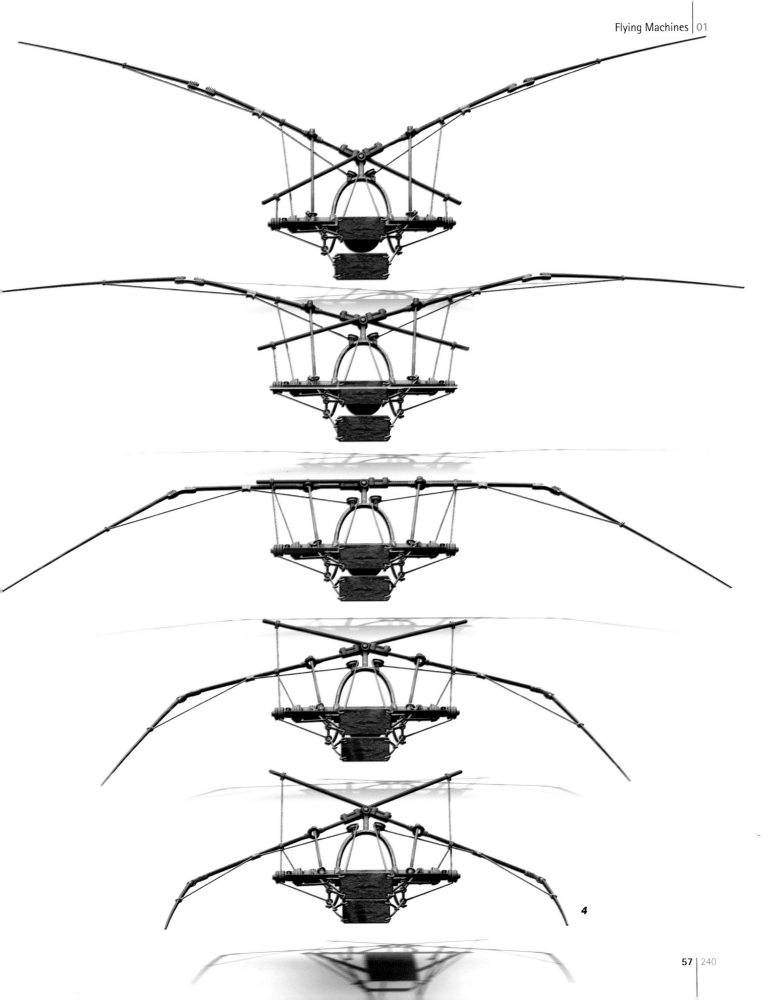

4

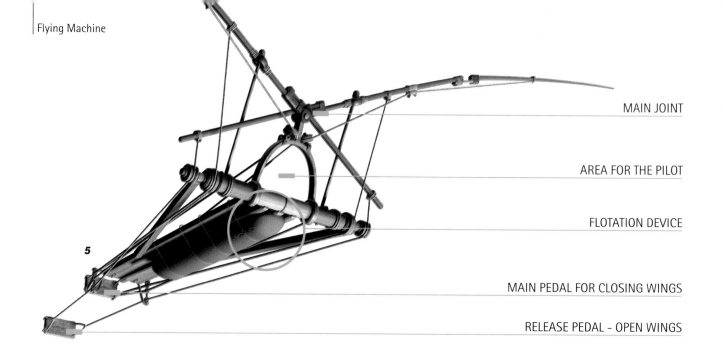

MAIN JOINT

AREA FOR THE PILOT

FLOTATION DEVICE

MAIN PEDAL FOR CLOSING WINGS

RELEASE PEDAL - OPEN WINGS

5

fig. 5
This image shows the main components of the flying machine, seen from underneath.

fig. 6
The dynamic sequence in six steps (digitally superimposed) of the wing movement can be seen in this image.
It should be noted that, in addition to completing a rotatory movement, when the wings bend they make a flexing movement towards the interior. The result is a compound motion that totally imitates bird flight.

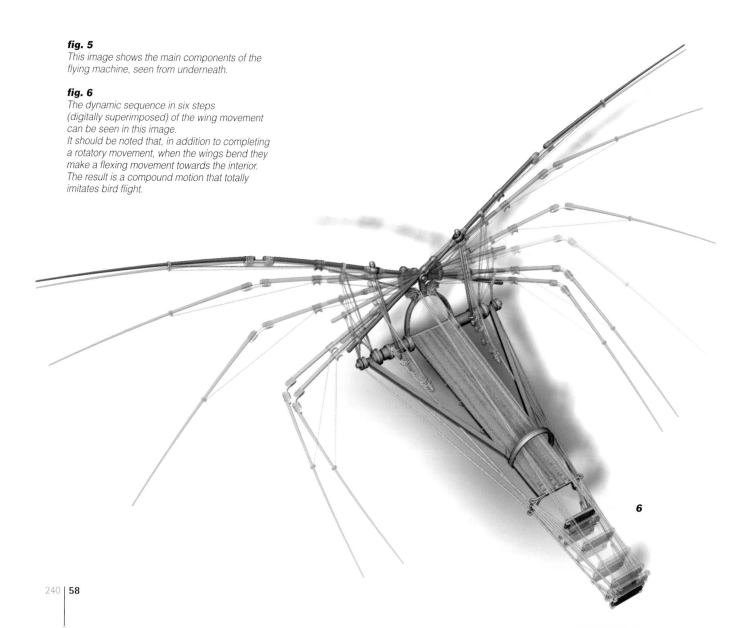

6

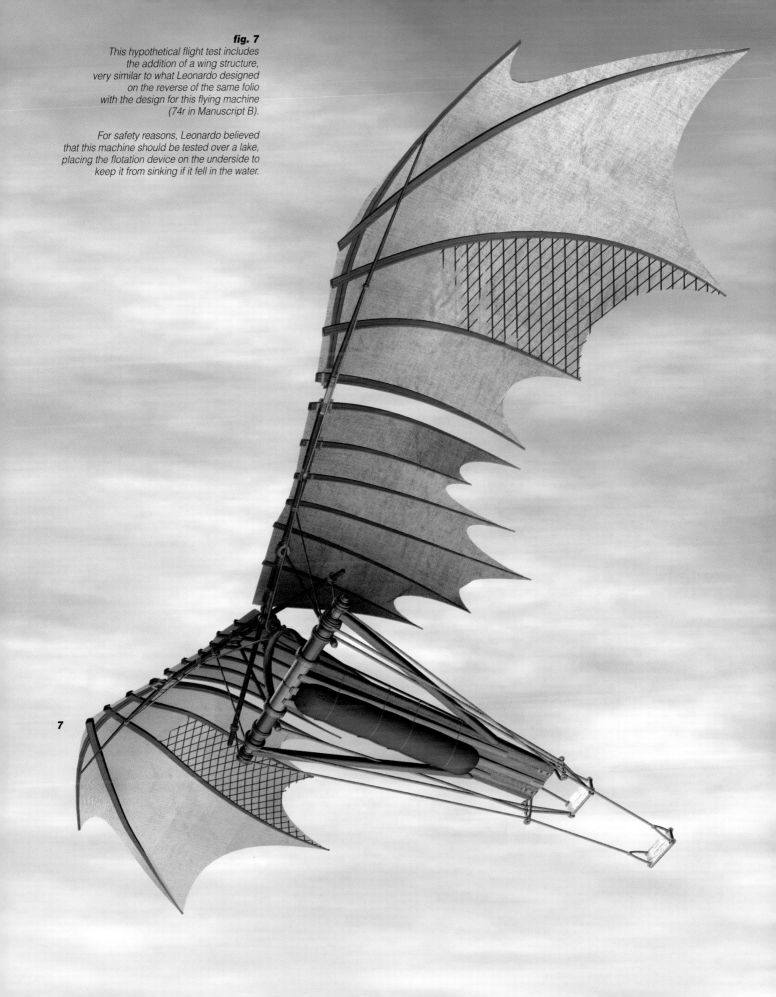

fig. 7
This hypothetical flight test includes
the addition of a wing structure,
very similar to what Leonardo designed
on the reverse of the same folio
with the design for this flying machine
(74r in Manuscript B).

For safety reasons, Leonardo believed
that this machine should be tested over a lake,
placing the flotation device on the underside to
keep it from sinking if it fell in the water.

7

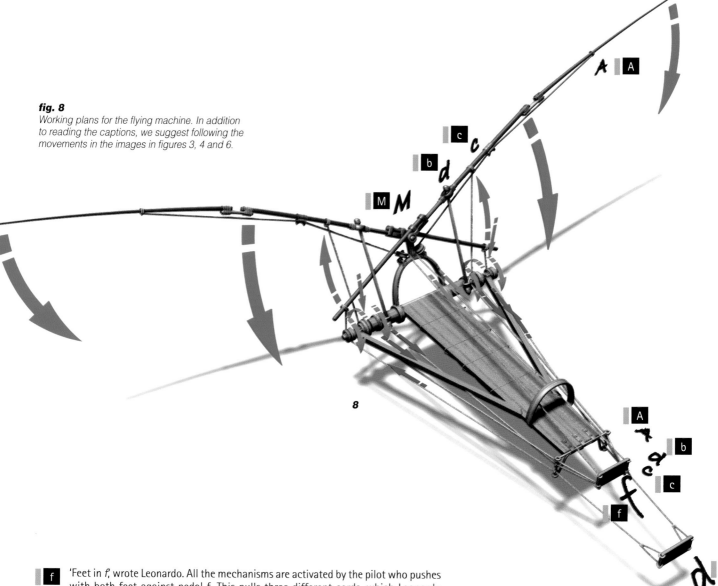

fig. 8
Working plans for the flying machine. In addition to reading the captions, we suggest following the movements in the images in figures 3, 4 and 6.

f 'Feet in *f*,' wrote Leonardo. All the mechanisms are activated by the pilot who pushes with both feet against pedal f. This pulls three different cords, which Leonardo referred to as a, b, c.

A '*A* twists the wing.' Line *A* passing through a pulley system is connected to the extremity of the wing. The wing tip folds when it is pulled.

b '*b* turns it with a lever.' Line *b* runs through a metal ring that moves the bar attached to the wing giving it a rotatory motion.

c '*c* lowers it.' Line c by using a system of pulleys produces the main up-down flapping movement in the wings.

M 'The pivot *M* should have its centre of gravity just off the perpendicular so that as the wings fall they also fall towards the man's feet.' The metal structure supporting pivot *M* is bent forward to allow for the correct movement in the wings.

d 'the foot *d* raises the wings [...] *d* moves from bottom to top.' Once the wings are spread using pedal *f*, the pilot re-opens the wings by pushing the other pedal, pedal *d*. Leonardo suggested that this movement could be helped by the use of a series of springs.

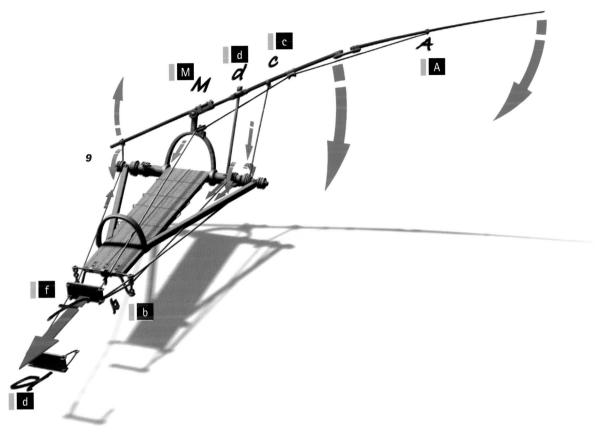

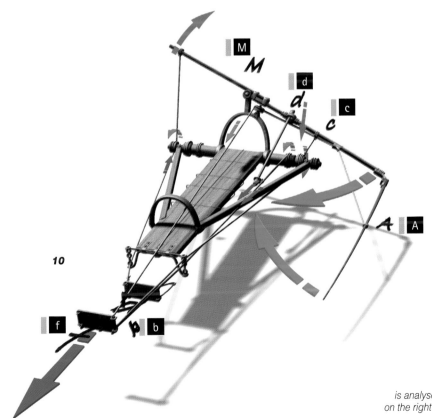

figs. 9 and 10
In these two images the machine
is analysed looking only at the mechanism
on the right wing. Above, the wing is closing;
below, the wing opens.

Vinci, 1452

1460

1470

1480

1490

1493-1495

1500

1510

Amboise, 1519

Codex Atlanticus, f. 844r

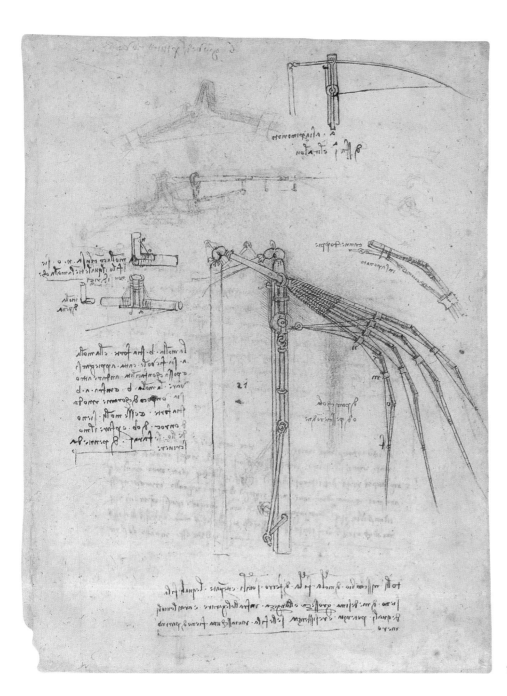

1

Mechanical Wings

2

This folio was made in Milan around 1494. It is more than just a work sheet with a few hasty notes. The design on this page for a mechanical wing is very mature in character. It is the point of arrival and the synthesis of a series of studies. Here, Leonardo intended to execute a fairly complete and finished drawing. We know this not only from the nature of the drawing, rich with details on the functioning of the wing and its various parts, but also from its intrinsic style. Except for the small drawing in the upper right (which was perhaps a later addition), this is not a series of quick pen and ink sketches, but in some cases was preceded by a preparatory pencil drawing that was later drawn over in ink for the final version. These preparatory drawings are proof that Leonardo was aiming at a well-finished representation. Apart from the sketches added in the upper part of the page (some of which are not complete and which were perhaps added at another time), the sum of all the notes and images on this folio is complete in itself. There is the main image of the entire wing, right and left, and some enlarged details. Even the two main blocks of text are singularly regular. All this recalls the typical character of the mechanical studies Leonardo made in the Madrid I manuscript, and in general, it recalls the type of studies undertaken during the 1490s in all aspects of his research. This was a period of great intellectual equilibrium, dominated by a geometrical and mathematical concept of natural phenomena, reflected not only in the content of his research but also by the clear graphic organization of the pages and the regularity in line and hatching – very close and fine – an example of which is seen in the main drawing on this folio.

Leonardo's work on flight during these years was largely a product of his research into the dynamic potential of the human body. The study and imitation of birds seems to have fallen into second place. Some of his studies and designs are an exception to this, and among these are the contents of this page: the wing is made up of various segments jointed together and moved by cables. Leonardo has provided us with an imitation of the anatomical joints of the natural wing. In this case, the various parts are at right angles to each other. Later, when he was working on the Codex 'On the Flight of Birds' and the observation and imitation of natural flight were once again in the forefront, the structural segments even took on the shape of animal bones, pushing the idea of human flight as an imitation of nature to its utmost.

fig. 1
Folio 844r in the Codex Atlanticus, with its well-defined drawings, shows the centre part of a design for a mechanical wing that seems to imitate the anatomy and workings of animal wings.

fig. 2
The image shows the reconstruction of the detail found in the upper right of the folio in fig. 1.

overleaf, following page
fig. 3
This image shows the digital reconstruction of the design on folio 844r from the Codex Atlanticus in its entirety and placed on top of the drawing itself.

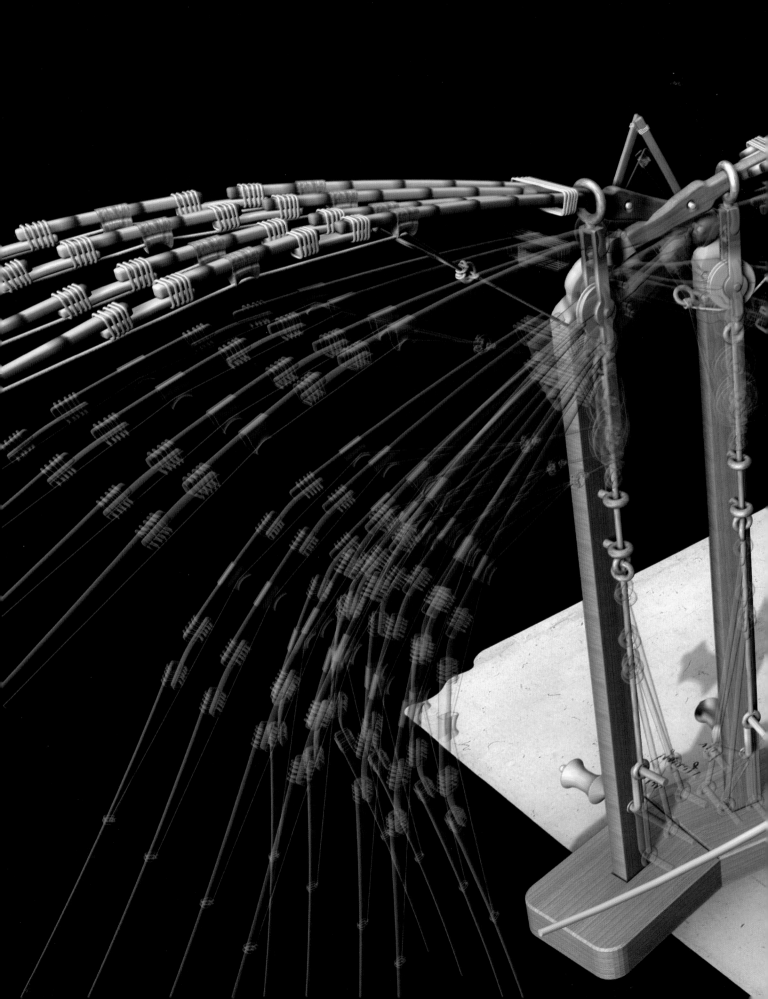

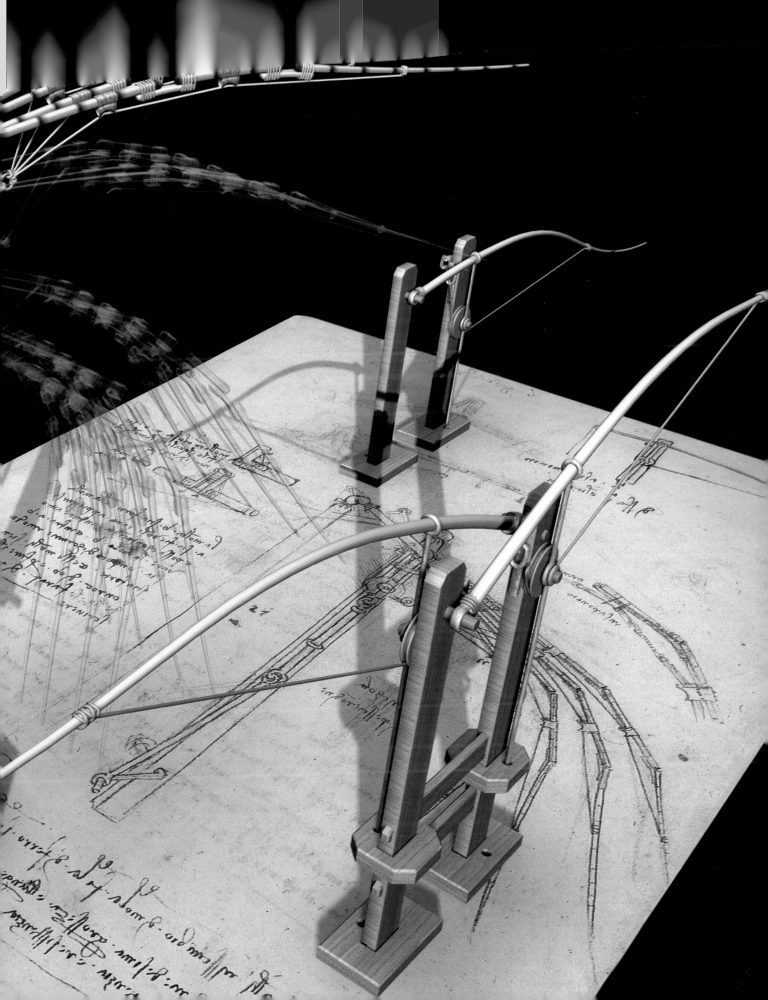

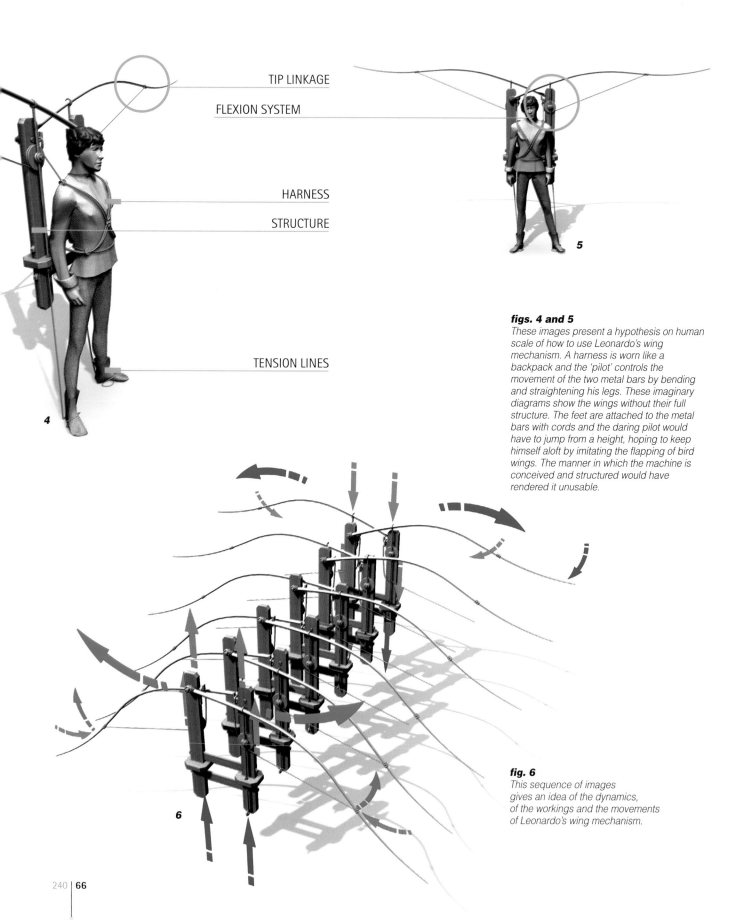

TIP LINKAGE

FLEXION SYSTEM

HARNESS

STRUCTURE

TENSION LINES

4

5

figs. 4 and 5
These images present a hypothesis on human scale of how to use Leonardo's wing mechanism. A harness is worn like a backpack and the 'pilot' controls the movement of the two metal bars by bending and straightening his legs. These imaginary diagrams show the wings without their full structure. The feet are attached to the metal bars with cords and the daring pilot would have to jump from a height, hoping to keep himself aloft by imitating the flapping of bird wings. The manner in which the machine is conceived and structured would have rendered it unusable.

6

fig. 6
This sequence of images gives an idea of the dynamics, of the workings and the movements of Leonardo's wing mechanism.

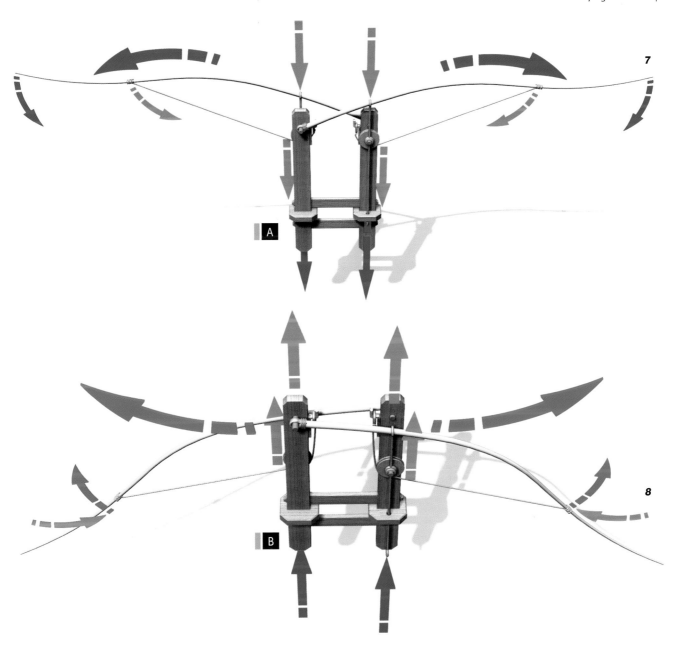

7

8

figs. 7 and 8
*The images schematically show
the operating principle of the mechanical arm
in the two phases of folding-flexion
and spreading-extension of the wings.*

A This first image outlines the dynamics behind the operation of the wing in the flexion phase. The two metals arms are pulled down (blue arrows) along the parallel support stays, the wing slides through the end rings on the arms. This movement results in a downward rotation of the wing itself. The pulley system used to move the metal arms pulls a line connected to the wing tip. As they rotate, the pulleys wind the line that folds in the end of the wing (red arrows).

B In the second phase, the wing is re-opened and extended using the same flexion principle in reverse. The metal arms move upward; the wings slide through the end rings on the arms, they re-open and the pulleys let out the line so that the wing, from a folded position, can now be extended.

fig. 9
*The image shows the disassembled model
of the wing machine with all its parts.*

JOINTS

STRUCTURAL AXES

METAL HOOK

JOINTS

PULLEYS

LEATHER JOINTS

CRANK

SUPPORT BASE

9

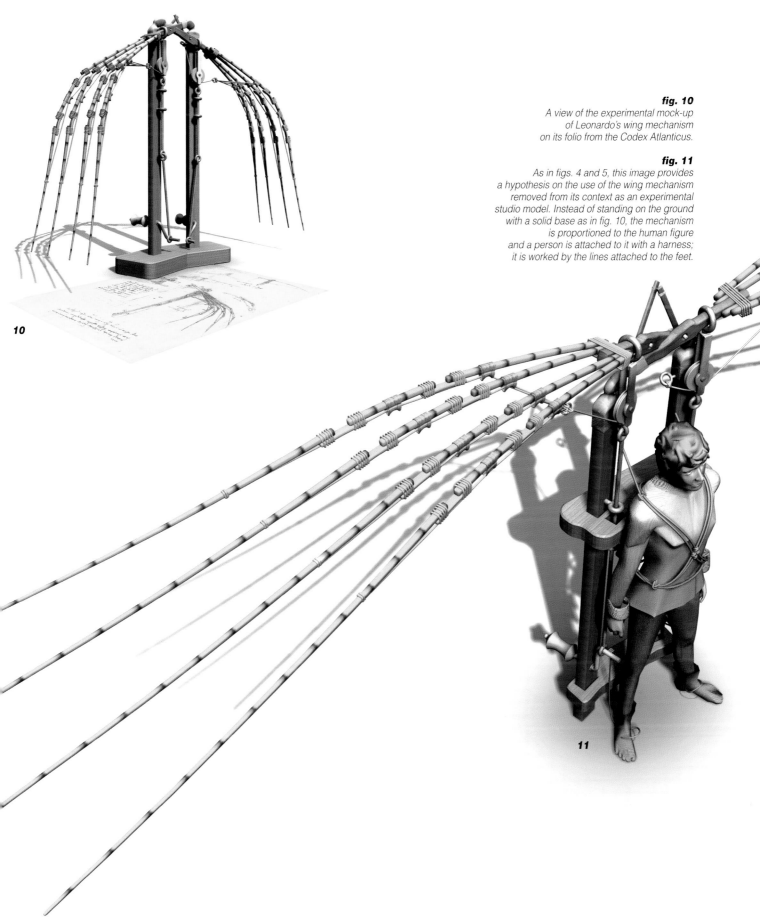

fig. 10
A view of the experimental mock-up
of Leonardo's wing mechanism
on its folio from the Codex Atlanticus.

fig. 11
As in figs. 4 and 5, this image provides
a hypothesis on the use of the wing mechanism
removed from its context as an experimental
studio model. Instead of standing on the ground
with a solid base as in fig. 10, the mechanism
is proportioned to the human figure
and a person is attached to it with a harness;
it is worked by the lines attached to the feet.

10

11

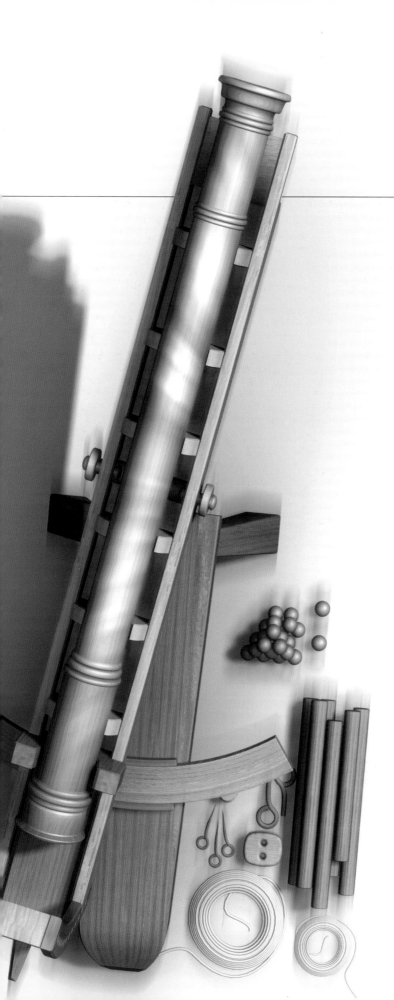

Leonardo designed and worked on war machines mainly during his first few years in Milan (between about 1483–90), and upon his return to Florence around 1502–4. The projects he designed in Milan are more varied and spectacular than the later works, but they are often at the very limits of feasibility. His later designs in this field are more rigorous, concentrating on what was at the time the main concern of military strategy, both defensive and offensive: firearms.

A large portion of Leonardo's letter of introduction to Ludovico il Moro (Codex Atlanticus, f. 1082r) deals with military engineering: bridges, assault ladders, bombards, carriages and mortars. Leonardo was about thirty years old when he decided to make a change in his career and composed this letter, requesting assistance from a man of letters who would put it in *bella forma*. He had already left, or was about to leave, Florence, offering his services to the warrior price Ludovico Sforza. It would not be far-fetched to assume that the letter may have been accompanied by some drawings. The Codex Atlanticus (a collection of originally loose sheets, improperly defined as a 'codex') contains some magnificent, highly finished drawings of war machines that could have been part of a sumptuous album to be presented to il Moro. This may help to explain the spectacular, extraordinary character of some of the designs: gigantic machines with terrifying effects that would have been difficult or impossible to build.

If, as is almost certain, Leonardo's letter was written while he was moving from Florence to Milan, it is clear that in his earlier years in Florence he must have dedicated some time to studying war machines. In the past, other Tuscan engineers, such as Mariano di Jacopo (called 'il Taccola') and Francesco di Giorgio, had dealt with this subject. The young Leonardo was aware of this tradition, and it certainly influenced his initial designs made in Florence and during the early part of his stay in Milan. For example, his drawings for siege machines intended to assail fortress walls, reflecting to some degree the studies of other engineers, reflect the sensitivity to and interest in antiquity that was typical of the Renaissance. In addition to being an actual art practised on the battlefield, war was also seen as an aspect of culture, part of the general rediscovery of the classical world. One of the most successful military treatises to come out of the Renaissance, *De re militari*, written around 1450–5 by Roberto Valturio, included reconstructions of the main war machines used by the ancients, and Valturio was a humanist, not an engineer. In Urbino, war machines were the subjects of architectural decoration, as demonstrated by their inclusion in the bas-relief frieze of the ducal palace. Siege machines were among the most typical manifestations of the art of war during classical times and in designing some of these himself, Leonardo was participating in the rediscovery of classicism. Even his confidence in the value of

drawing as a means of communication connects Leonardo with Taccola or Francesco di Giorgio. Leonardo, however, transcends tradition, not only because of the superior quality of his drawings or the varied and innovative visual means of presenting the design (such as images from various viewpoints, full and exploded views), but also in the complexity of conceptual content expressed through the visual language of the machine.

If we compare the drawings of machines that Francesco di Giorgio inserted in his treatises with drawings made for artistic purposes, the difference between the two types is evident. Like those by Leonardo, the mechanical drawings by Francesco demonstrate, through theoretical declarations, his absolute confidence in drawing as a means of communicating knowledge. From the viewpoint of description and perspective his drawings are very precise. Nevertheless, because they are an integral part of the treatise they have a didactic, scholarly character. This 'gap' between mechanical and artistic drawing is completely surpassed by Leonardo, as is evident in his drawing depicting a device for pushing away the ladders of assault troops scaling a fortress wall (Codex Atlanticus, f. 139r) or, even more clearly, in the drawing of an enormous cannon in a foundry (Windsor 12647) where, in addition to the mechanical concept, Leonardo depicts the actions of the human labourers. The nudity of many of the figures in the foundry can be explained only by a movement away from solely technical drawing towards a more general, expressive dimension, which in this case is intent on demonstrating the power of the toiling bodies. This theme would later intrigue Leonardo not only as a painter but also in relation to his work on human flight. Even in his drawings of the terrible scythed chariots (on a folio found in the Biblioteca Reale at Turin and another in the British Museum, London), the mechanical representation is transformed into a dramatic image emphasizing the horrible wounds the weapons would have been able to inflict. Images of human bodies torn to pieces, slashed and ripped to shreds, are accompanied by his annotation on these devices: 'Often they wreak as much havoc on friends as on foes.' This dual dimension is seen in an even more striking form from around 1504 in Florence: on a folio from the Codex Atlanticus (72v) the study for a firearm appears next to the drawing of a horse for *The Battle of Anghiari*, the large painting commissioned by the Florentine Republic for a room in the Palazzo Vecchio.

Some of the machines designed by Leonardo in the early part of his career are simpler, more practical and can easily be constructed: the designs for emergency bridges, swing bridges (Codex Atlanticus 55r, 855r) for quickly crossing bodies of water, the various forms of ladders for assailing a fortress (for example, Manuscript B, ff. 50r and 59v), and the numerous and unusual lance points (for example, Codex Ashburnham

2037). Here again, drawing seems to transcend practical application alone, and lances and ladders are transformed into anthologies of images inspired by an unstoppable inventiveness of form.

In 1499, when the French drove the Sforza family out of Milan, the entire political situation of the peninsula became increasingly unstable. Leonardo's contacts and the work he took on in the years immediately before finally leaving Milan are indicative of this. Before he left he may have come into contact with the French, who were preparing for a military operation in the southern part of the peninsula. Afterwards, Leonardo was consulted by the Venetian Republic on the problem of the military defence of its eastern territories and the danger posed by the Ottoman Empire. In 1502 he was working for Cesare Borgia, il Valentino, in connection with the conquest of the Romagna region. He was contacted, again for military reasons, by Jacopo IV Appiani, Lord of Piombino, and by the Florentine Republic, which was engaged in an ongoing war against Pisa.

Against this backdrop, Leonardo embarked on his new designs in military engineering, which are quite different from those of the Sforza years. This time he was faced with concrete problems relating to war, and compared with those of the previous period, the solutions he proposed were more rigorous, more thought-out and truly innovative. Having put aside gigantic crossbows and spectacular but improbable catapults, Leonardo concentrated on facing the great innovation of the century: the ever-increasing use of firearms with their destructive capabilities, which had already been defined by Francesco di Giorgio as a 'diabolical invention'. During the first few years of the 1500s Leonardo constantly confronted these new weapons, analysing both the defensive and offensive aspects. Some incredible designs for fortresses come from this period (for example, Codex Atlanticus 120v, 132r, 133r), where the shape of the edifices is designed to minimize the impact from artillery. Instead of straight, vertical walls, they had curved profiles to deflect the missiles and absorb the shock of the blows. There are also studies on artillery. The invention of a rotating armament made up of sixteen guns mounted on the same platform (Codex Atlanticus, f. 1r) may date from this period. The fundamental goal of the design was to provide as much firepower as possible, the same goal demonstrated in a few of his beautiful ballistic studies on defence systems for a stronghold (Windsor 12337v, 12275r, Codex Atlanticus f. 72v). It is stunning to observe Leonardo's skill in depicting the showers of shot and shells, accurately describing their parabolic trajectories. The tight, interwoven lines rendering the trajectories of the shots 'visible' are drawn with the sureness of one who has dedicated much time and attention to the subject.

Vinci, 1452

1460

1470

1480

circa 1482

1490

1500

1510

Amboise, 1519

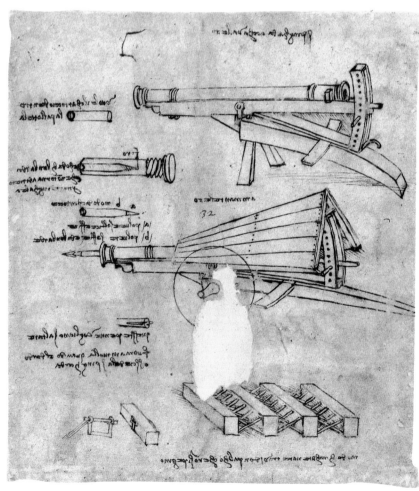

1

Springald

2

The calligraphy in the notes on this sheet is typical of Leonardo's earlier period, characterized by an elegant style with frequent flourishes and other graphic ornamentation. Nevertheless, it is the images that are important here: the written notes clarify a few details, but the description of the design for the springald (a type of catapult) is essentially expressed in visual language. Prior to Leonardo, some of the great artist-engineers of the *Quattrocento* had already begun to lay claim to the intellectual nature of drawing, and thereby to the scientific value in the invention and construction of machines. This process reached its zenith with Leonardo, as seen in this drawing from his early years.

At times during the Middle Ages machines were the subject of illustrations, with their exterior views depicted using a series of iconographical conventions. At times the unusual character of these images created amazement and marvel, conferring an almost miraculous quality on the machines. But completely missing from these pictures was information on the structure, the internal form, the relationship between the parts, the workings. Little or nothing was revealed about the machine itself, perhaps because it was considered to be a professional secret, or perhaps because what was truly important was the miraculous aspect of the device, independent of its reality.

In contrast, the drawings made by Leonardo on this sheet are meant to communicate by using the two main images to complement one another, while the details isolated from the main drawing show the number, form, function and most importantly, the reciprocal relationship between the various structural elements of the machine. The two main images show two views of the springald: above is the structural nucleus of the weapon (the cannon and its elevating arc, the tripod support and so on); the drawing below shows its protective roof, with the wheels used for moving the weapon barely hinted at. Some very important iconographical concepts are used here. In the lower figure, Leonardo delineates a simple circle around the axle to represent the wheel: a transparent image that is enough to express the way the mechanism moves. He leaves the structure behind the wheel in view, thereby showing the relationship between wheel and springald. Later, he would draw anatomical figures in transparency, attempting to show the relationship between the various organs of the body. In fact, many of the iconographical solutions he initially devised to depict machines were carried over into other areas of his research. Even the relationship between the two main images on this page anticipates some of the visual ideas he later applied to anatomy: the full image of the springald (below) is stripped (above) of its exterior components (cover and wheels), just as in the process of anatomical dissection.

fig. 1
An extremely clear drawing not requiring much explanation; just as Leonardo maintained, a picture is worth a thousand words.

fig. 2
The cannon has just been cast and is waiting to be mounted on the springald.

overleaf, following page, fig. 3
An overhead view of the springald; the lines and wedges helped anchor the tripod structure due to the powerful shot and recoil, and to facilitate the manoeuvres for aiming the cannon.

fig. 4
An exploded view of all the parts of the springald before being mounted.

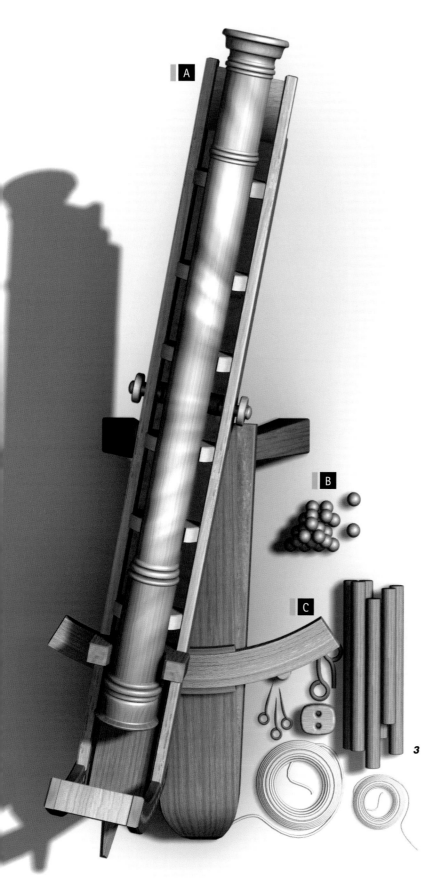

A The largest and most important element of the machine is certainly the massive cannon. It was placed on a very strong and moveable wooden structure so as to effectively aim the weapon. The innovative aspect of Leonardo's springald was precisely its mobility and the possibility of aiming in different directions without moving the entire cannon or tripod. In fact, presumably whoever used this firearm positioned himself on the battlefield and anchored it to the ground. Due to the fact that the recoil from the large cannon must have been very powerful, the frame could be anchored in place by lines attached to wedges planted in the ground. Tied down in this fashion the support structure was very stable; the cannon, however, could move freely from right to left, as well as up and down.

B Leonardo not only thought about solutions to improve and speed up the aiming phase, but he also came up with a system of fast-loading ammunition without intervening on the internal parts of the cannon. On the folio, he used more than one drawing to show this ingenious system; more than one person could manoeuvre around the springald. There was the person in charge of positioning and aiming (one or more given the weight of the structure), but there also was a person who prepared and loaded the ammunition into the cannon.

C The aiming of the springald was done with two slides, one vertical and one horizontal. The cannon could be moved and adjusted on these two planes, thereby covering an extensive firing range. The cannon had great freedom of movement, but it could not cover all the directions on the battlefront; we can imagine that in a hypothetical battle scene more than one springald may have been used, all aimed at the main targets. The complex orientation system for the cannon that Leonardo envisaged was probably more for taking precise aim than for choosing one target rather than another.

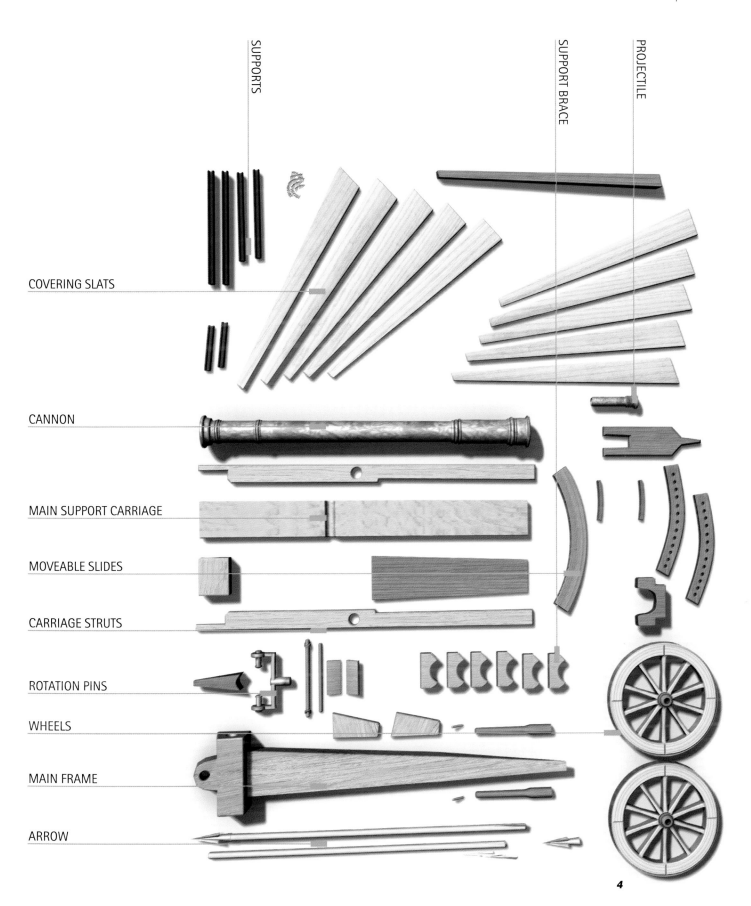

SUPPORTS

SUPPORT BRACE

PROJECTILE

COVERING SLATS

CANNON

MAIN SUPPORT CARRIAGE

MOVEABLE SLIDES

CARRIAGE STRUTS

ROTATION PINS

WHEELS

MAIN FRAME

ARROW

4

A The cannon could be moved both on a vertical as well as horizontal plane. The cannon was positioned horizontally by dragging the mount supporting the cannon housing along a curved wooden piece. Lubricated to slide more easily, the curved shape of this piece was also used as a guide in obtaining an even, quick rotation without jerking. The amplitude of its action could cover an arc of about 20 to 30 degrees.

B The vertical movement of the cannon was slightly more complex and the adjustments in this direction were less manageable. In order to regulate the firing elevation the entire cannon and its structure had to be raised; the tripod was the only piece of the springald anchored to the ground. The moveable carriage was pinned to the structure by a mechanical joint, and thus the movement of the cannon was surely much easier, but in order to raise it even a few degrees certainly more than one person would have been needed. Once the desired elevation was attained, a peg consisting in a simple cylinder made of wood or iron, was inserted in the appropriate holes, thus blocking the structure. This adjustment calibrated the range of fire, and was probably the first operation undertaken. Once the correct elevation adjustments were complete, the cannon could be turned from left to right much more easily.

C Leonardo designed some very interesting projectiles: they consisted of a detonation chamber filled with two different types of gunpowder and the shot. When ready, the cartridge was loaded, and could be quickly substituted with another round already prepared, avoiding reloading the cannon from the muzzle each time. The operators could prepare many rounds and breechload them very quickly from the rear of the cannon.

fig. 5
Diagram of the workings: the structure and the cannon were probably so heavy that more than one person was needed to operate it.

fig. 6
Leonardo's design is not only interesting in terms of how the springald was used but also because he devised different variations on the same machine: a fixed tripod with or without the wheels, closed under a covering, or in a open position. Also, this springald could fire iron or stone cannonballs as well as metal-tipped arrows. The image presents the composition on Leonardo's folio where we also see a strange wooden frame; with reference to this Leonardo wrote: 'Way to fit beams in a scaffolding so they won't bend'.

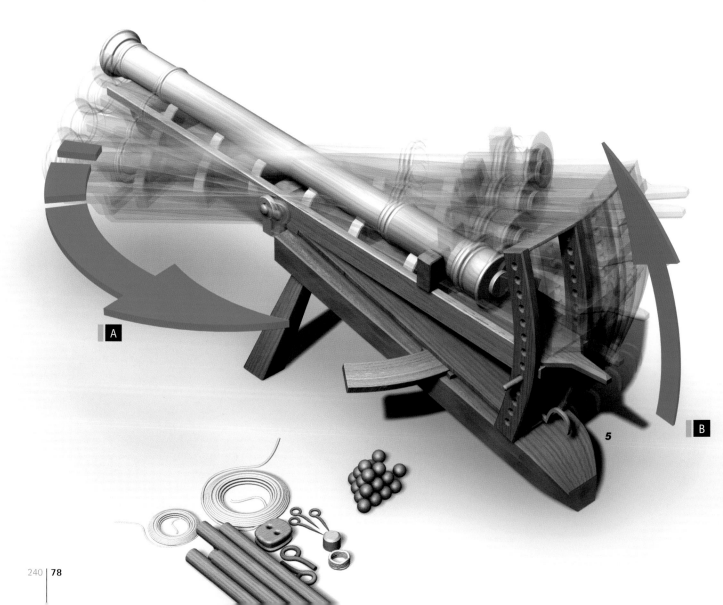

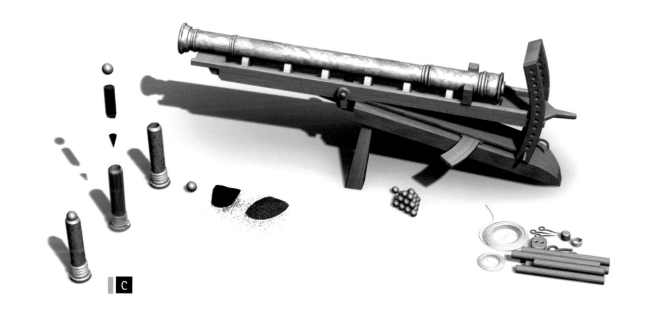

C

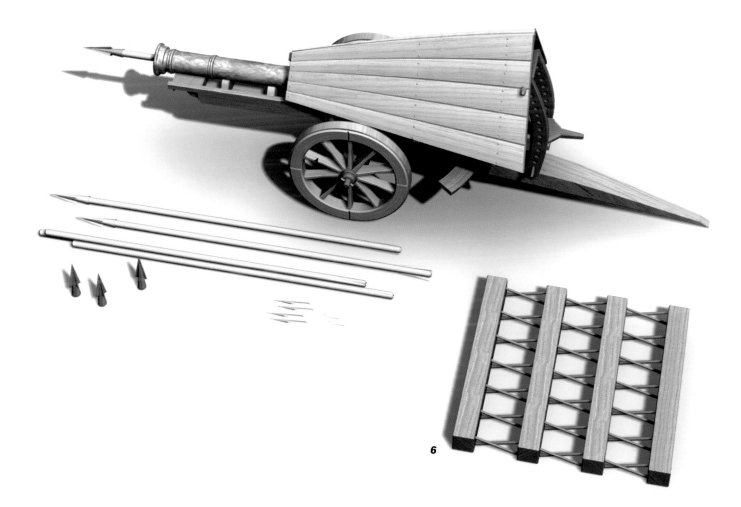

6

Vinci, 1452

1460

1470

1480

circa 1482

1490

1500

1510

Amboise, 1519

Codex Atlanticus, f. 157r

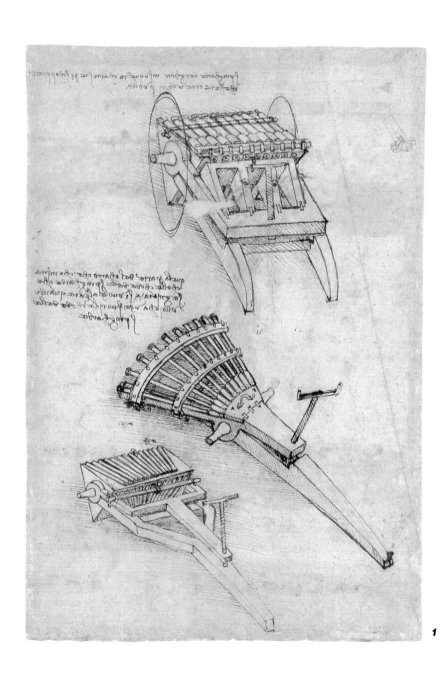

1

Multi-barrelled Machine Gun

2

This page shows three alternative versions of a machine gun. In presenting them, Leonardo does not use a consistent spatial perspective. Not only is there a size difference between the three drawings, they also seem different from an optical viewpoint. This creates a less orderly and systematic layout on the page, but adds movement to the presentation by emphasizing the variety in the designs, avoiding the kind of monotonous sequence of alternative versions found in drawings by other engineers and even on some pages by Leonardo himself. In the top drawing, a simple circle suggests the position and size of the wheel, with the parts for the wheel connection in transparency. Below, only the axle is drawn, merely suggesting the position of the wheel, while greater attention is given to the screw system regulating the height (in the upper version this seems fairly flat). The three images complete and complement one another, following a perfect system of visual shorthand that does not interfere with the specific details and individuality of each design.

Innovative design in firearms, then the most up-to-the-minute weapons, was an excellent way of creating interest and amazement in a prospective client. But for whom was Leonardo designing these lethal instruments? Based on the style of both the drawing and the writing, scholars date this folio to his period in Florence. At that time, around 1480, the political situation in the peninsula had not yet exploded. Lorenzo the Magnificent was the dominant figure in Florence, and thanks to a tightly woven web of diplomatic relationships he was also one of the mainstays of the period of relative peace. Nonetheless, as the bloody Pazzi conspiracy against the Medici demonstrated, tensions and hostilities were spreading, and even in Florence war was an immediate possibility. The greatest Florentine engineers and architects dealt with war, from Brunelleschi to Michelozzo, and even Verrocchio's workshop, where Leonardo was apprenticed, was capable of casting cannons and armour. Consequently, the young Leonardo's interest in warfare is totally understandable. But there is another, perhaps better explanation. Like other Tuscans, Leonardo could not wait to leave his homeland and go into the service of a powerful warrior-prince. Taccola had already dreamed of going into the service of the emperor of Hungary, and Francesco di Giorgio was very successfully working in Urbino under Federico da Montefeltro. We do not know if Leonardo had already decided to go to Milan when he made this fair copy of his military drawings. What is certain is that when he did decide to go his main calling card would be his warfare projects.

fig. 1
The sheet contains three separate designs for a machine gun, along with some handwritten notes.

fig. 2
A machine gun completed and ready for firing; from the design in the centre on the page.

overleaf, following page, figs. 3 and 4
Two of the designs on the page. The strong point in both solutions is the strength of their firepower, though using totally different working principles.

A The multi-barrelled machine gun was a weapon with remarkable firepower. But when analysed carefully perhaps the loading of the gunpowder and ammunition was, in truth, very complicated. The openings could fire singly as well as simultaneously based on the type of attack required; but once the shots were fired it took the operators a long time to reload all the barrels, presumably from a small door in the centre of the structure. The most interesting aspect of this design is the moveable main structure; the two large wheels allow the weapon to make practically unlimited horizontal movements. When a new target was sighted the soldiers could easily lift the carriage and make it turn on itself. The height was regulated by an ingenious mechanism worked with a worm screw. By turning a crank positioned on the rear the cannons could be inclined to calibrate the length and height of the shot, in some ways rather similar to modern-day cannons.

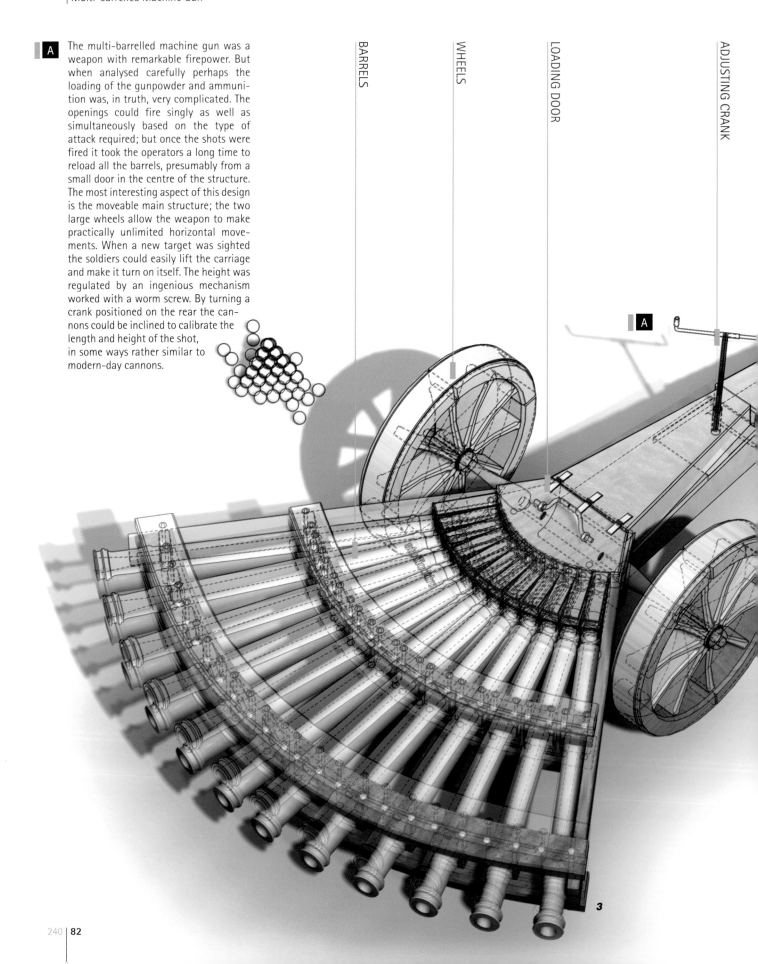

BARRELS

WHEELS

LOADING DOOR

ADJUSTING CRANK

A

3

B A second design on the upper portion of the page illustrates a different machine gun. In this case all the cannons fire in the same direction and they do not have as wide a range of action as in the previous design; the interesting aspect of this machine is the possibility of rotating the large triangular central body. On each side of this structure there are many cannons, all pre-loaded and ready to fire on the target. A rear bulkhead acts as support and block for the central body; in fact, when it is fired it turns around influencing the direction of the shot. Like the previous machine, this weapon required long reloading times.

BARRELS

CENTRAL ROTATING BODY

SUPPORT BULKHEAD

B

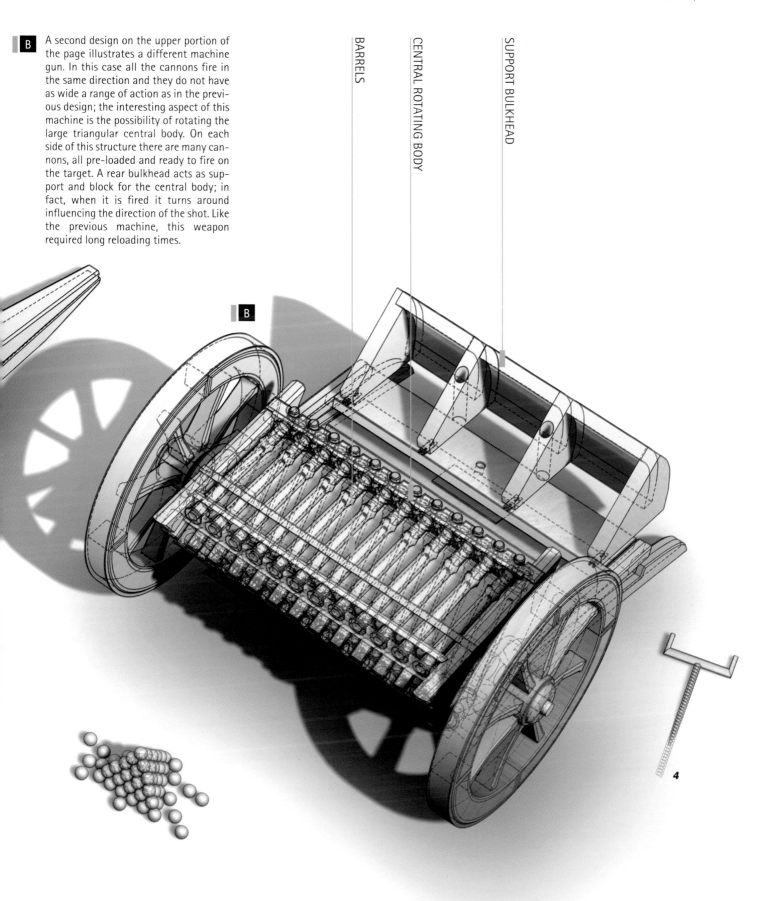

4

Vinci, 1452

1460

1470

1480

1482-1485

1490

1500

1510

Amboise, 1519

Codex Atlanticus, f. 139r

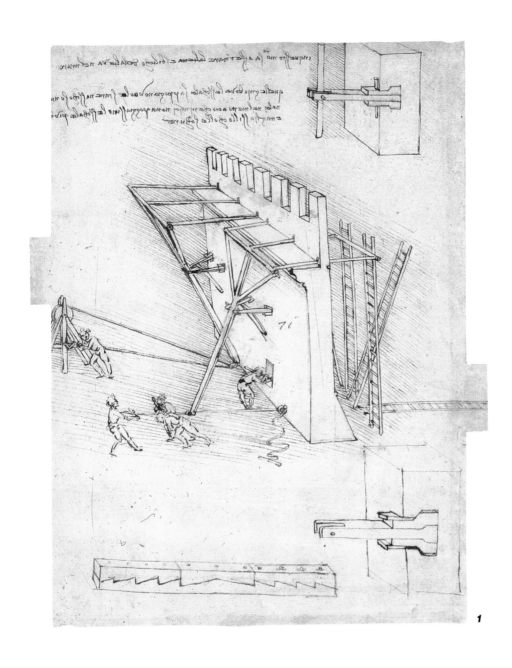

1

Defence of the Walls

Dating from Leonardo's early years of activity, this drawing belongs to a very special category of his oldest designs: the transformation of the mechanical drawing into complex action, featuring a small-scale drama with human protagonists and spatial references. One of the greatest Sienese engineers of the *Quattrocento*, Mariano di Jacopo, called 'il Taccola', created small vignettes with machines placed in different types of landscapes. But in Leonardo this contextual presentation is much more complex, and in a sense is the converse of the other iconographical innovation he developed: machines depicted in isolation from any environmental element.

This study is of a defence system for battlements, consisting of a beam hidden in the walls that can push off assault ladders, and here both iconographical concepts are present. In fact, Leonardo has created an image exemplary in its synthesis, giving maximum information in minimum space, while the men working the device create a highly dramatic and effective scene. Leonardo shows only part of the wall: the image is not realistic, but a technical and theoretical representation. In the same drawing he also presents two possibilities for operating the system: direct traction, requiring the strength of several people, or a mechanical system that one person can operate alone. Even the system of levers and beams is shown in both advanced and retracted positions. The enlarged details, above and below, complete the illustration of the mechanism.

There is a further aspect, however. The agitated movements of the small figures working the device are highlighted by the hatching. As in other comparable images, the vibrant hatched lines not only provide spatial indications, but seem to be the echo or outburst of the dynamism of the figures. Animated in this way the image is transformed into much more than a simple mechanical drawing. The minimal but very effective style, which with a few lines defines the form and movement of the various human figures, is the same we find in artistic drawings such as the studies made in this period for *The Adoration of the Magi*. In reality, the distinction that we make today between artistic and scientific or technical drawing was much less significant for Leonardo and his contemporaries. A technical drawing by Leonardo can also be enjoyed as a sublime artistic image.

fig. 1
The folio shows the moment of assault on the walls of a castle, while the people on the inside activate the mechanism devised by Leonardo.

fig. 2
The winch use to activate the system for the defence of the battlements.

A The assault on castles and fortresses using a rung ladder was a very frequent strategy during the 1500s; the assailants placed the ladders against the walls until they overran the battlements fighting against the defenders in great numbers. Once the walls were scaled and after heavy losses, the assault of the castle went on and the assailants, now inside, could destroy the gates letting in their fellow warriors. For the defenders it was therefore of vital importance to prevent the assailants from scaling the walls.

B Leonardo designed an ingenious system of defence to prevent enemies scaling the walls. A long beam, on the exterior of the walls, was pushed against the ladders by a series of winches attached to a system that functioned like a lever. When the beam pushed the ladders, having a capacity to push even more than one at the same time, they fell to the ground along with the assailants.

C The external beam was attached to the internal winch by a series of perpendicular beams that went through the holes in the wall. On the ground below, the lever transformed the traction of one or more persons working the winch into a sudden, powerful push externally. Once the push was made, and the desired results obtained, the beam was retracted taking it out of the range of any harm that could be inflicted by the enemy; in this way the device could have been used an unlimited number of times.

D The most ingenious aspect of this design is the way the supports are fitted to the lever. Leonardo resorted to a particular use of geometry: he needed the support beams to be fit into the walls in a secure system that could not be attacked from the exterior, and when needed, could be dismantled or repaired.

fig. 3
Detail of the system used for fitting the beams in the wall.

fig. 4
How the system worked.

figs. 5 and 6
Two views of the walls with their main parts; the first view is from inside the castle, the second is from the exterior, from the points of view, respectively, of the defenders and the assailants.

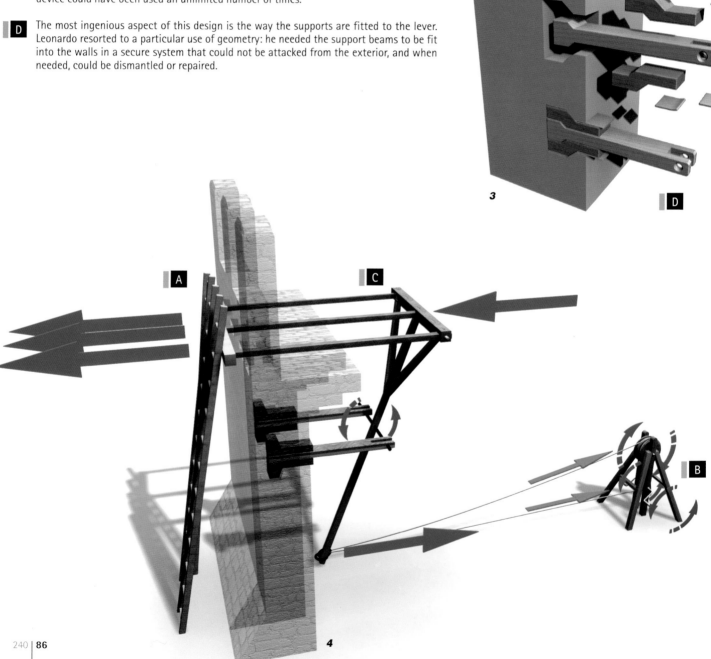

3

D

A **C**

B

4

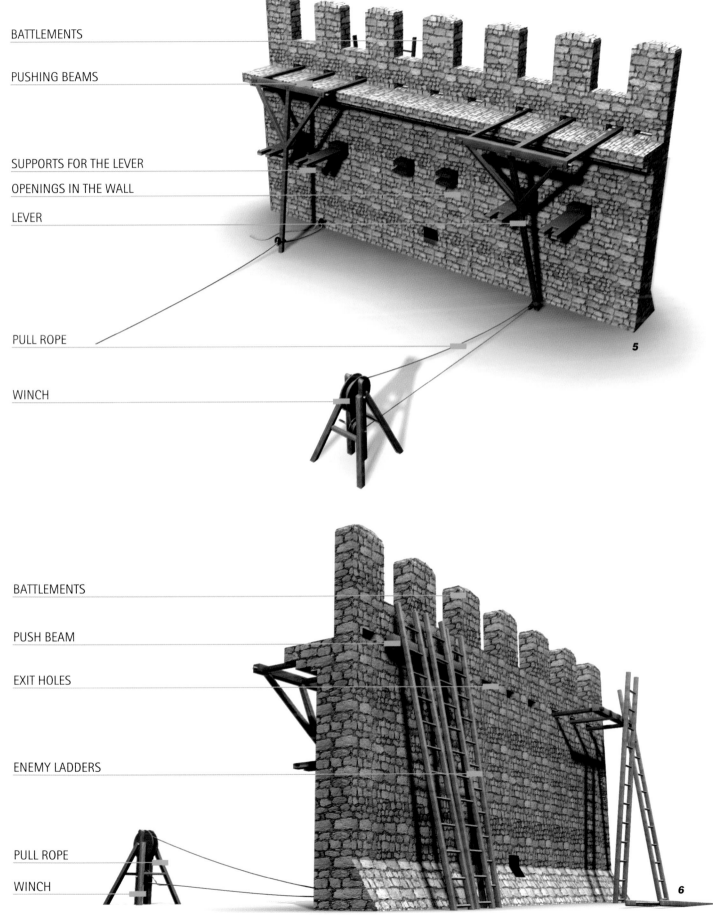

BATTLEMENTS

PUSHING BEAMS

SUPPORTS FOR THE LEVER

OPENINGS IN THE WALL

LEVER

PULL ROPE

WINCH

5

BATTLEMENTS

PUSH BEAM

EXIT HOLES

ENEMY LADDERS

PULL ROPE

WINCH

6

Vinci, 1452

1460

1470

1480

circa 1485

1490

1500

1510

Amboise, 1519

Turin, Bibl. Reale, f. 15583r

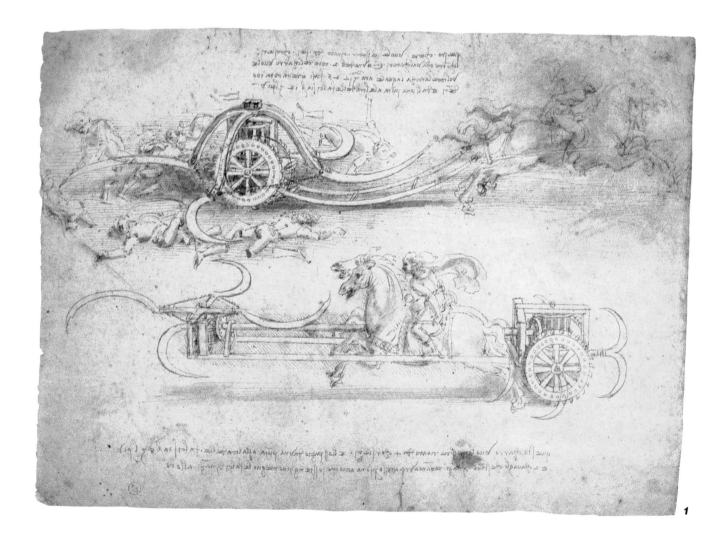

1

Scythed Chariots

2

Among Leonardo's most spectacular drawings for machines dating from the first few years in Milan there are two studies for carriages armed with scythes. War was the order of the day on the unstable political chessboard of Renaissance Italy and Europe. War machines were often at the centre of interest during this period, not only for their practical use but also for purely cultural reasons, such as the rediscovery of inventions from classical times. They were unusual and visually striking, regardless of whether they could actually be constructed. The famous frieze in the ducal palace at Urbino, with sculpted panels depicting a series of war machines, and the sumptuous albums consisting solely of images of machines with minimal text were created in this context. The image had the same value as the reality, and more than in any other age, we who live in a virtual era should know how to appreciate this aspect of the Renaissance.

Leonardo's two drawings on this folio, conserved in Turin, fit perfectly into this dimension dominated by the machine as a visual invention. Even though Leonardo has provided some information on the mechanical workings of the two war chariots, we have before us two images where the intent is to give a general idea of the weapon's lethal power. As in other drawings from this period, the mechanical drawing is transformed into a dramatic spectacle, dominated by the furious movements of the humans and animals that operate or fall victim to the machines. In this case there is even a sense of uneasiness about the machine as a cause of death, a sentiment expressed by Leonardo in a note, where he specifies that these contraptions 'often wreak as much havoc on friends as on foes'. Many years later, Leonardo would define war as 'beastly madness', creating a metaphorical image of this condemnation in *The Battle of Anghiari*, where the furious combatants adopt the movements and expressions of wild beasts. This vision is at the basis of Leonardo's mature work, and is already embryonically present in these two mechanical figures, especially in the upper drawing, where the lethal scythes have slaughtered a group of armoured soldiers.

Perhaps drawings like these accompanied the letter Leonardo presented to Ludovico il Moro upon his arrival in Milan. It would have been difficult for the powerful and bellicose Lord of Milan to grasp the subtle reflections in these drawings, and this is perhaps the reason why Leonardo's proposals for war machinery were not given consideration at court. Other engineers, less ingenious but more practical were preferred – at least for a while.

fig. 1
A very explicit depiction of two different models of scythed chariots in battle.

fig. 2
A spiked wheel as drawn on Leonardo's folio.

A In Leonardo's drawing there is a team of horses positioned at the centre of this scythed chariot. Putting aside the problems of space and peril, the hypothesis must be that once in battle, horses pulled the entire system.

B A team of horses pulled the chariot and traction was obtained by two large, spiked wheels. One of the wheels had rungs and it transmitted rotary motion to the main cage-shaped gear. There were also two rotating blades mounted on the wheels to prevent the enemy from approaching.

C The main cage-shaped gear, turned by the wheels, transmits rotary energy to the two blade systems, front and rear.

D The rotating dual blades prevent the enemy from approaching the carriage from the rear.

E By means of a long drive shaft, the rotary motion is transmitted to the front gear system that works the main weapon on the carriage, a structure composed of four scythe blades.

fig. 3
Detail of the structure with four rotating scythe blades positioned on the front of the chariot.

fig. 4
Exploded view of the scythed chariot.

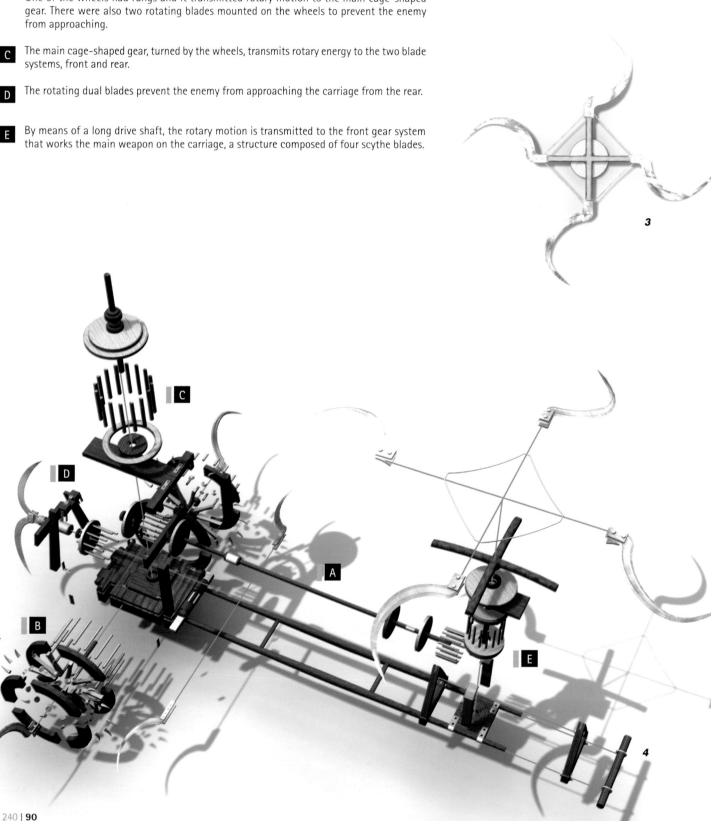

3

4

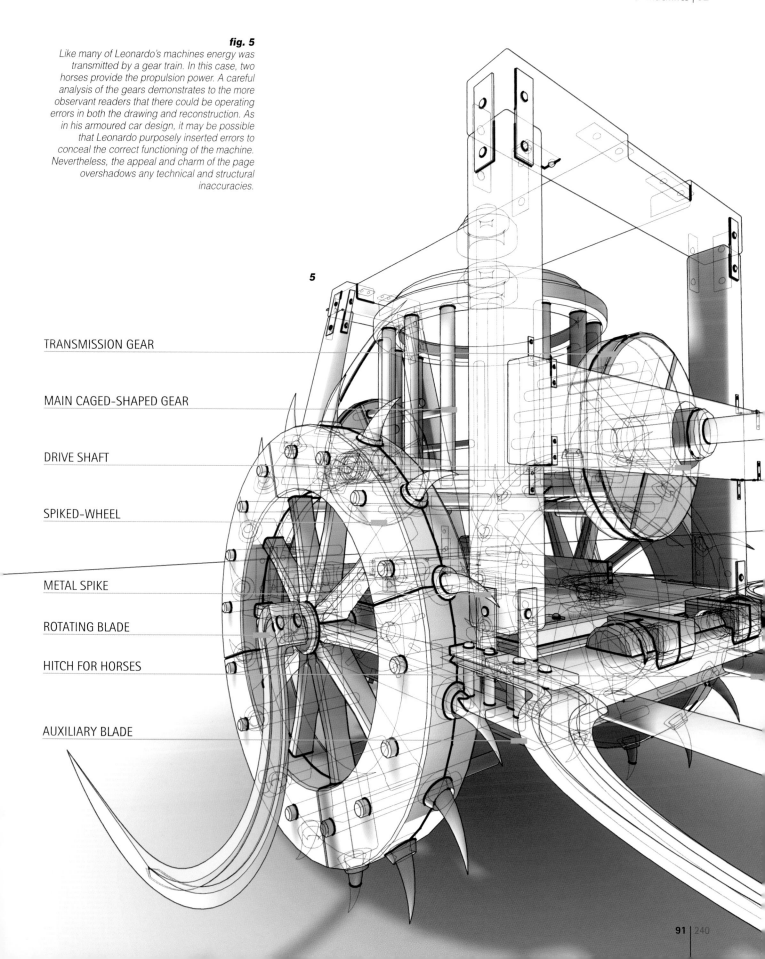

fig. 5

Like many of Leonardo's machines energy was transmitted by a gear train. In this case, two horses provide the propulsion power. A careful analysis of the gears demonstrates to the more observant readers that there could be operating errors in both the drawing and reconstruction. As in his armoured car design, it may be possible that Leonardo purposely inserted errors to conceal the correct functioning of the machine. Nevertheless, the appeal and charm of the page overshadows any technical and structural inaccuracies.

5

TRANSMISSION GEAR

MAIN CAGED-SHAPED GEAR

DRIVE SHAFT

SPIKED-WHEEL

METAL SPIKE

ROTATING BLADE

HITCH FOR HORSES

AUXILIARY BLADE

6

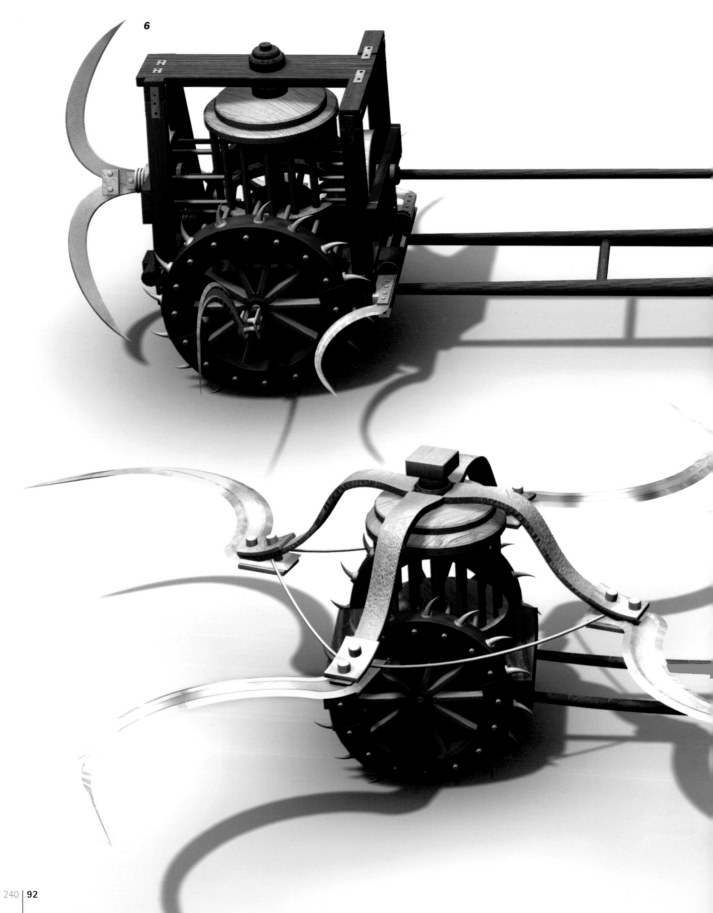

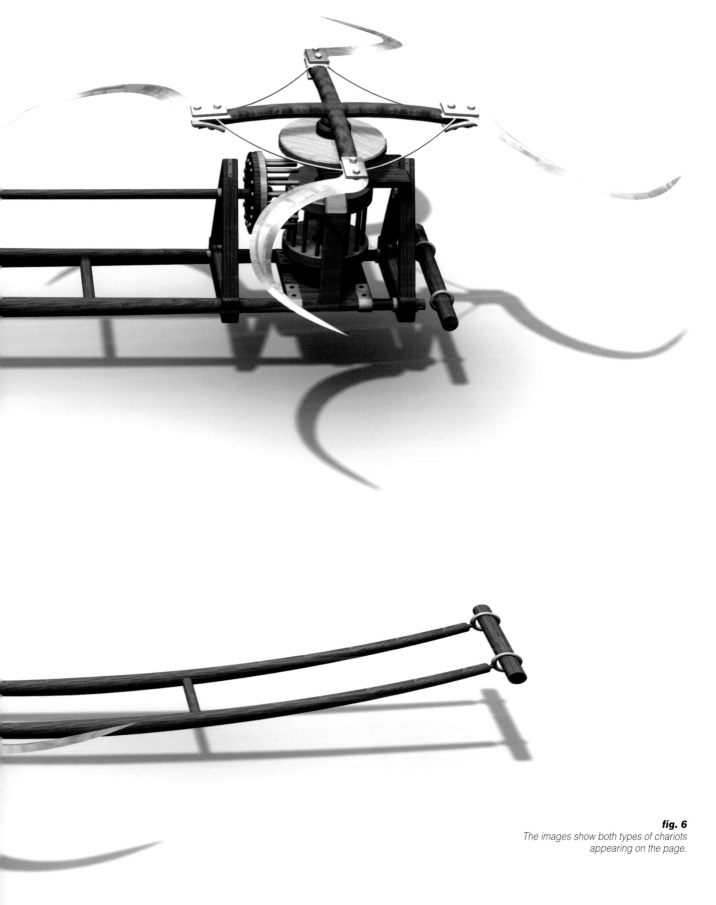

fig. 6
The images show both types of chariots
appearing on the page.

Vinci, 1452

1460

1470

1478-1485

1480

1490

1500

1510

Amboise, 1519

Codex Atlanticus, f. 154br

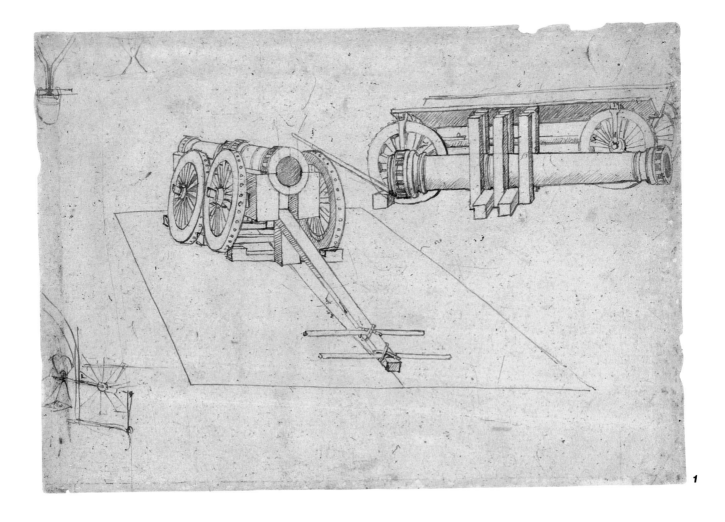

1

Dismountable Cannon

2

The history of the folio with the drawings for the dismountable cannon is an example of what happened to many of the da Vincian pages. This is a fragment of a page that was originally larger and was bound, along with other loose pages, in the Codex Atlanticus (ff. 154, perhaps 73 and others). At the end of the sixteenth century, Pompeo Leone acquired a large number of Leonardo's sheets and manuscripts, binding them together in a collection of completely disordered pages known as the Codex Atlanticus. The predominantly mechanical subject-matter of the papers was the only criterion Leone followed, and then only partially. He did not address the problem of the original order, or whether the pages might once have been part of an album or manuscript. He simply reorganized them purely thematically, in a way that may seem disrespectful to us today but was completely acceptable in the erudite and encyclopaedic collections of the era.

It is evident from the type of invention and the style of the drawing that Leonardo designed these two dismountable cannons during his early years. The draughtsmanship is not the best, and this fact might even tempt us to doubt Leonardo's authorship if it were not for the fact that the drawn line shows it was executed by a left-handed artist. It is a very well-finished drawing, not spontaneous but a fair copy of previous studies. Another theory that cannot be excluded is that it was copied from another maestro, perhaps with an original variation added by Leonardo.

But once the two drawings were finished the story of this folio had only just begun. Many years later, after 1500, on the fragment of the original page today gathered in the Codex Atlanticus and known as folio 154a, Leonardo once again took up the idea of the cannon drawn here. The style of drawing and handwriting, and above all the originality and maturity of the new designs, are remarkably superior. Nonetheless, there is a link to the older drawing. This gives us an insight into the way Leonardo used an 'open entry system' in his work. Leafing through his papers after 1500, his attention would have fallen on the old design, which he now took up again and developed. Or perhaps, when beginning a new design for a cannon, he returned to contemplate the older study, adding new notes to the old page. But that is not all. The page was circulated around his studio. Even though we can not exclude the possibility of an addition made in a later period, it is probable that one of the students inserted a quick sketch, obscene in character, very similar to others in the Codex Atlanticus: this type of sketch is found on other pages next to images with military studies (folios 132,133, 154b).

fig. 1
The page shows two distinct designs for dismountable cannons. The one in the centre is ready for use while the one drawn at upper right still has to be mounted.

fig. 2
A cannon just after manufacture.

A The page contains two different designs for dismountable cannons. The structure for transporting a cannon can be very simple, but because it is a fairly uncomplicated design Leonardo attempted to solve some of the aspects brought about by the presence of a large cannon. The first of these was transporting the cannon over long distances and perhaps keeping it concealed in as compact and unobtrusive structure as possible. The main problem was the mounting of the structure, and in particular the moving of the cannon and its placement inside the structure. A few boards of wood appear in the drawing that could have been used for both protecting and lifting the cannon using a practical lever system. This type of solution would allow the heavy metal body to be housed on a cart and transported to the battle site without the use of other machines such as cranes or winches.

B The cannon in the centre drawing seems to be already mounted and ready to be transported or fired. There is a rod with four handles for hauling the carriage, leading us to believe that four people were necessary to move and manoeuvre the machine; the rod is interesting because on the part nearest to the frame there is a wedge. When the rod was lowered, the wedge probably lifted the carriage keeping it solidly anchored to the ground. Once the carriage was anchored and lifted slightly off the ground, sturdy stays were positioned to block the wheels while the shot was fired, most likely quite powerful given the size of the cannon. The wheel axles are inclined and the metal hoops have spikes on them: Leonardo understood that by inclining the axles the structure was much more solid. Most likely the wheels had spikes because on the battlefield the cannons had to be moved quickly over impervious and often slippery terrain.

ROD FOR HAULING

REAR STAYS

WHEELS WITH INCLINED AXLES

SPIKED-WHEEL HOOPS

3

B

fig. 3
The dismountable cannon ready for use with a description of the main parts.

fig. 4
A representation of the drawing on the upper part of the folio, where the cannon still has to be mounted.

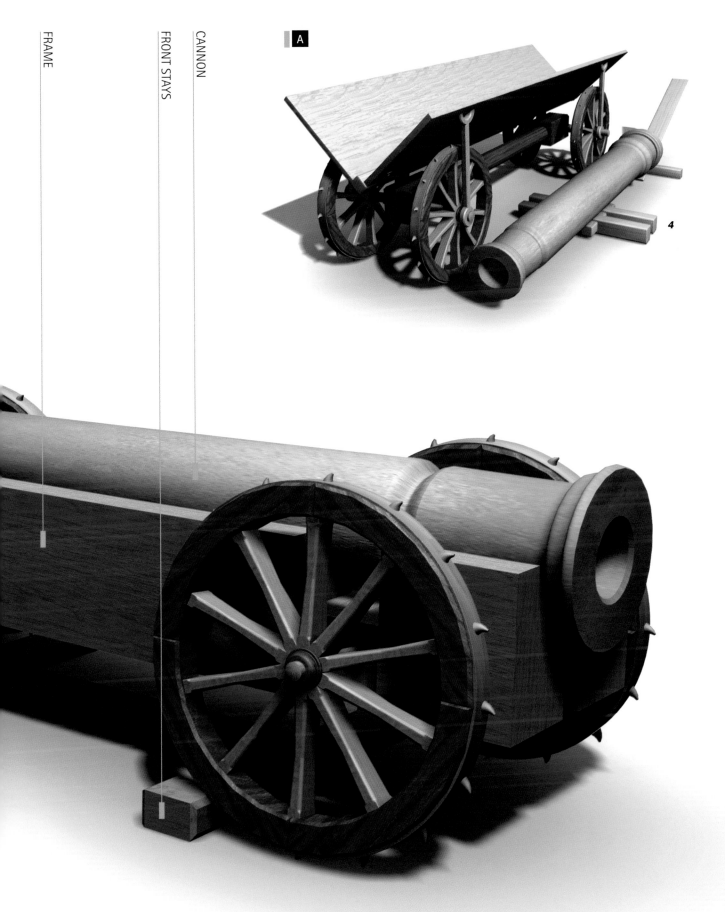

A

FRAME

FRONT STAYS

CANNON

4

Vinci, 1452

1460

1470

1480

circa 1485

1490

1500

1510

Amboise, 1519

London, British Museum, Popham no. 1030

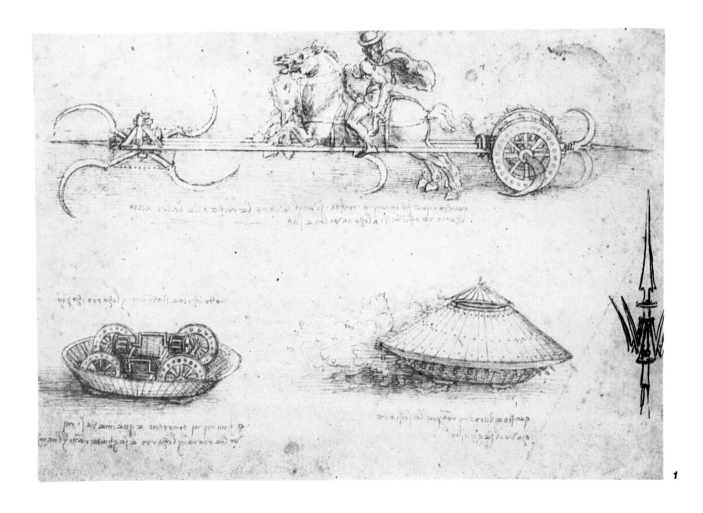

1

Armoured Car

2

Both the armoured chariot with rotating scythes and the covered tank armed with a series of cannons are examples of inventions with classical origins, which for Leonardo and his contemporaries were models to rediscover and emulate. In a note about the scythed chariot – 'These chariots were of various kinds [...]'– Leonardo clearly alludes to its ancient origin.

The attitude of Leonardo and the Renaissance artist-engineers to the classical world was not only one of admiration and imitation, however: they wanted to emulate and exceed it. The idea of an armoured car with a tortoise-like cover, dating from antiquity, had been known since the Middle Ages. Leonardo took this general idea and freely played with it, modifying and integrating it in his own design. Just as in painting, sculpture and architecture, the classical model did not suffocate the creativity of the Renaissance artist-engineer but instead stimulated it. Thus, Leonardo came up with an original way to move the tank (using men or animals), and designed a series of cannons mounted around its circumference.

From an iconographical point of view, in the drawings for both the armoured tank and the scythed chariot, we are in a dimension that is halfway between a purely technical and scientific representation of a mechanism and a dramatic scene. In the two images of the covered tank, Leonardo provides us with exterior and interior views of the machine and its structure, demonstrating its 'anatomy' and giving us information about the gears and the wheels in the drive system. However, the drawing on the left, which defines these parts, is little more than a sketch, while the right-hand drawing not only represents the tank in its complete form, but shows it in action on the battlefield with a cloud of projectiles and dust in its wake. Something similar happens in the drawing depicting the scythed chariot. In this case, the mechanical parts are shown in a very clear, decisive drawing. But the image is dominated by the dramatic representation of the human and animal figures: a horse with his head lowered, the rider suddenly turned to the rear, sensing danger. These movements fully express the excitement of battle, and once more the drawing goes beyond the simple, bare presentation of a mechanical device.

fig. 1
The page contains two drawings; the first shows the mechanisms for moving the car, the second is an armoured car in a most unlikely race across the battlefield.

fig. 2
View of the armoured tank at eye-level.

A

It must be premised that it would have been very difficult for this machine to have crossed over the fields of battle. Leonardo himself wrote: 'I will make armoured cars, safe and unassailable, which will enter the close ranks of the enemy with their artillery, and no company of soldiers is so great that they will not break through them. And behind these, the infantry will be able to follow quite unharmed and without any opposition.' The intent behind the design was probably to amaze and shock more than wreak true havoc on the battlefield. In theory, presumably eight men move the machine, manoeuvring the tank and loading the cannons from the inside.

The tank was driven by the activation of cranks and toothed wheels, but the force required to actually move the structure exceeded human power; for this reason the possibility of using horses or oxen was considered, but the presence of these animals in such a closed, restricted space was surely not possible.

B

The tank worked in a very simple manner. Operators turned the central cranks and the wheel began to turn. Once underway, and presuming a perfectly flat terrain, the tank would have made its way over the land. The greatest difficulty was in starting the machine; the scarce amount of available energy and the disproportion between the structure and its entire weight must have been remarkable. The tank was so high that inside ladders were probably used to reach the upper turret; this area was used for sighting and for signalling manoeuvres and artillery operations. The many cannons provided a firing range of 360 degrees.

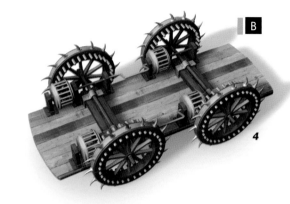

B

fig. 3
Semi-transparent view of the armoured car, where the complex interior structure and the number of parts are visible.

fig. 4
Drive mechanism for the tank, corrected with respect to Leonardo's drawing where an error is made in the working mechanism.

fig. 5
Exploded view and parts of the armoured car.

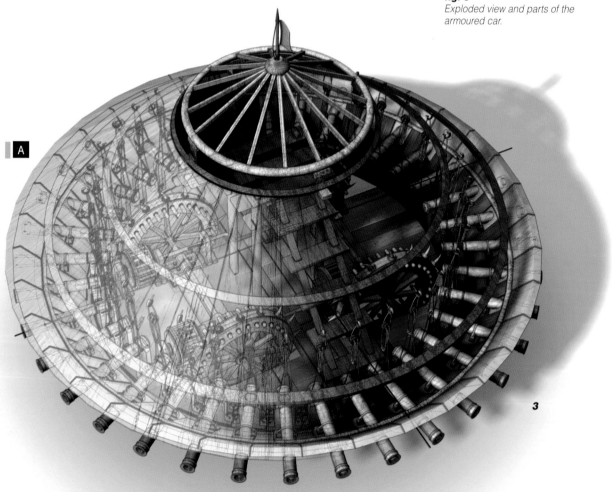

A

SIGHTING TURRET OPEN

COVERING

MAIN SUPPORT STRUCTURE FOR THE COVERING

LADDERS

CANNONS

MAIN SUPPORT STRUCTURE FOR THE CANNON

STRUCTURAL RINGS

LOWER COVERING

DRIVE MECHANISMS

WHEELS

BASE OF THE CAR

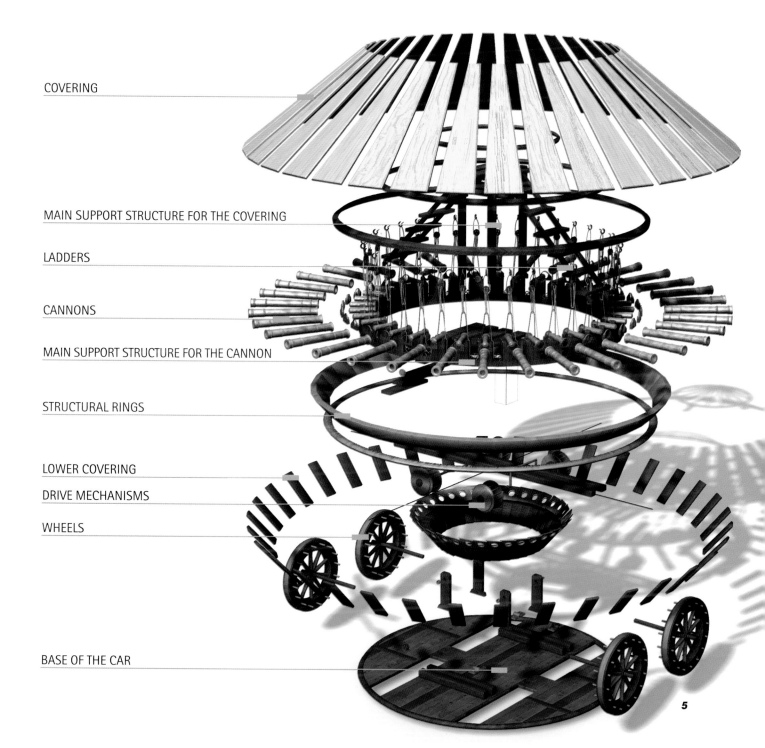

5

Vinci, 1452

1460

1470

1480

1485-1490

1490

1500

1510

Amboise, 1519

Codex Atlanticus, ff. 140ar and 140br

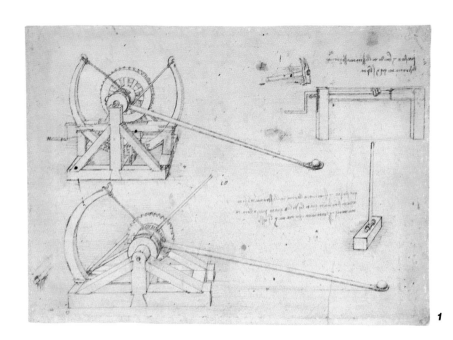

1

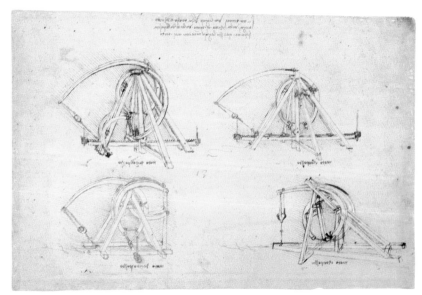

2

Catapult

Leonardo's designs for spring catapults date from about 1485-90. He placed them together on one page, which is now divided into two separate sheets. From a conceptual standpoint the drawings are very interesting, because on one hand they contain elements of Leonardo's early studies, and on the other, elements from the 1490s, the period in which he attained great equilibrium in many areas of his research, and devised some revolutionary solutions.

The drawings have some characteristics that echo Leonardo's youthful period. Catapults were war machines that were already well known. Though still used effectively on the battlefield next to the most up-to-date firearms, they were essentially objects of curiosity to the humanists, having been widely used during the classical era. This antiquarian aspect is present in these designs, echoing Leonardo's early studies, but is surpassed by an intense reflection on possible variations on the catapult's basic mechanism, the spring propulsion system. In essence, rather than being single designs for catapults, the true subject of these drawings seems to be the spring mechanism itself.

This aspect of the catapult drawings brings them closer to the da Vincian mechanical masterpiece, the *Treatise on the Elements of Mechanics,* a lost manuscript we know a little about from the notes in the Madrid I manuscript. Its most innovative aspect was a section on the study of single, basic mechanical elements such as the wheel, the screw and the spring. This was a fundamental form of theoretical development in mechanical design, freeing it from the invention of individual machines in order to study the basic elements that could be applied to all mechanisms. Even the style and the layout of the page reflect this new intellectual dimension, in which Leonardo was designing mechanical inventions. As well as the theoretical sections of the lost *Treatise on the Elements of Mechanics*, a more practical part was planned in which the laws of mechanics and the various elements (such as wheels and springs) would be applied to the construction of specific machines. The folio here, and in particular the illustration of the spring applied to war machines, gives us an idea of how this part of the treatise might have looked.

3

figs. 1 and 2
Two pages illustrating different designs for catapults that function on energy released from curved wood.

fig. 3
The catapult in the launch phase.

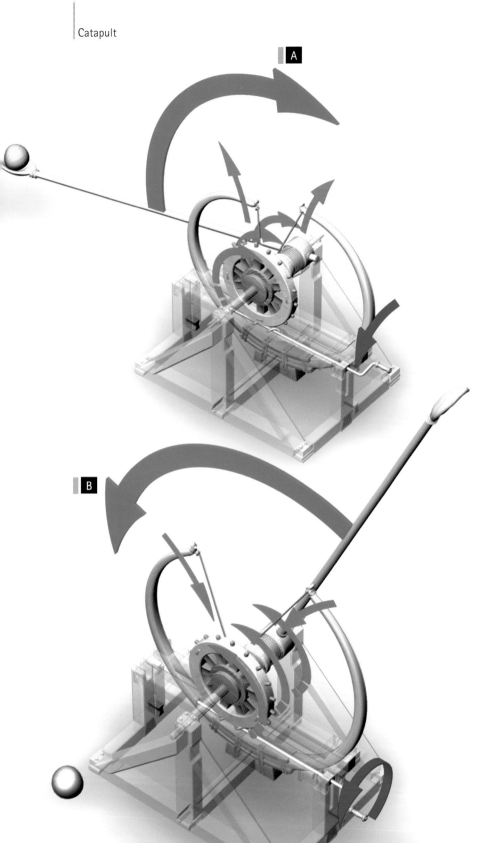

A The catapult had a considerable firing range and was therefore used for targets even very far away. In this design, Leonardo tried to increase the power and the practicality of this wartime tool. The two large leaf springs, presumably constructed in bent wood, ensured a very powerful thrust. When the leaf spring was loaded the two wooden arms were tensioned, curving back on themselves. Then, a weight was carefully placed in the spoon, and when everything was ready for the launch the operator only had to give a forceful turn to the front crank. When the mechanism freed the two bows, these suddenly returned to their resting position, releasing the lever and hurling the stone; these devices could also hurl incendiary projectiles.

B Once the launch operations were concluded, the catapult could be quickly reloaded. The operator who released the shot, turned the crank causing the two wooden bows to curve, closing up on themselves. Leonardo had also designed a self-blocking system for the reloading operations. Due to the fact that the springs were very rigid the loading operation could not be done using only the hand crank. It would have certainly snapped under the excessive strain. The toothed wheel on the inside most probably concealed one or more ratchet wheels, which blocked the movement of the bows while the catapult was being loaded. The loading operation was accompanied by the typical clicking sound of the ratchet. The amount of energy released was so forceful that the frame had to be anchored to the ground using lines and stakes.

fig. 4
Illustration of the various phases of launching and loading; the mechanism was very simple and the leaf spring could easily make repeated launches in a short period of time.

fig. 5
Illustration of the parts during launch.

following pages,
fig. 6
Representation of a possible attack on an enemy castle.

4

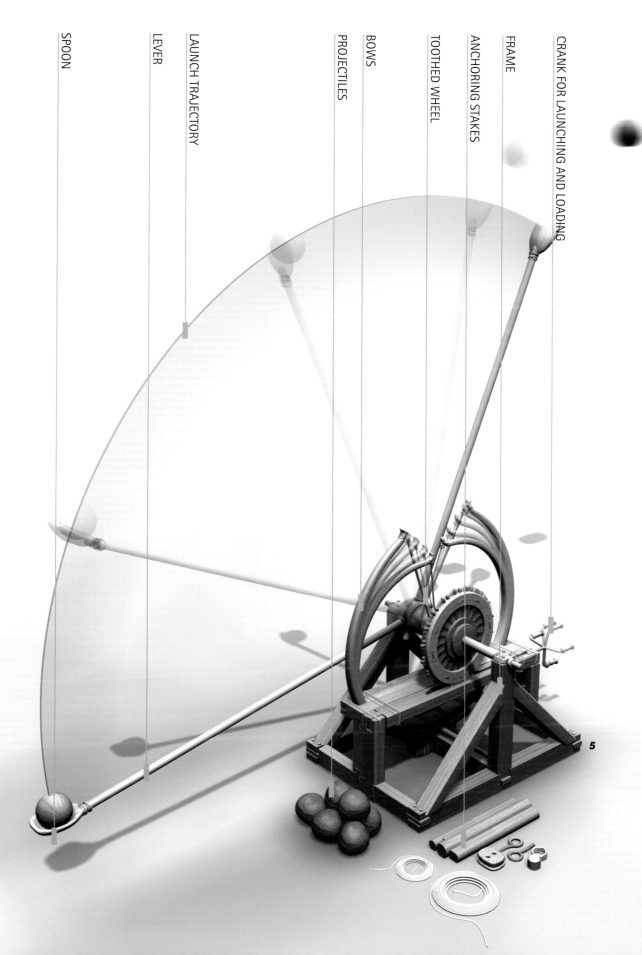

SPOON

LEVER

LAUNCH TRAJECTORY

PROJECTILES

BOWS

TOOTHED WHEEL

ANCHORING STAKES

FRAME

CRANK FOR LAUNCHING AND LOADING

5

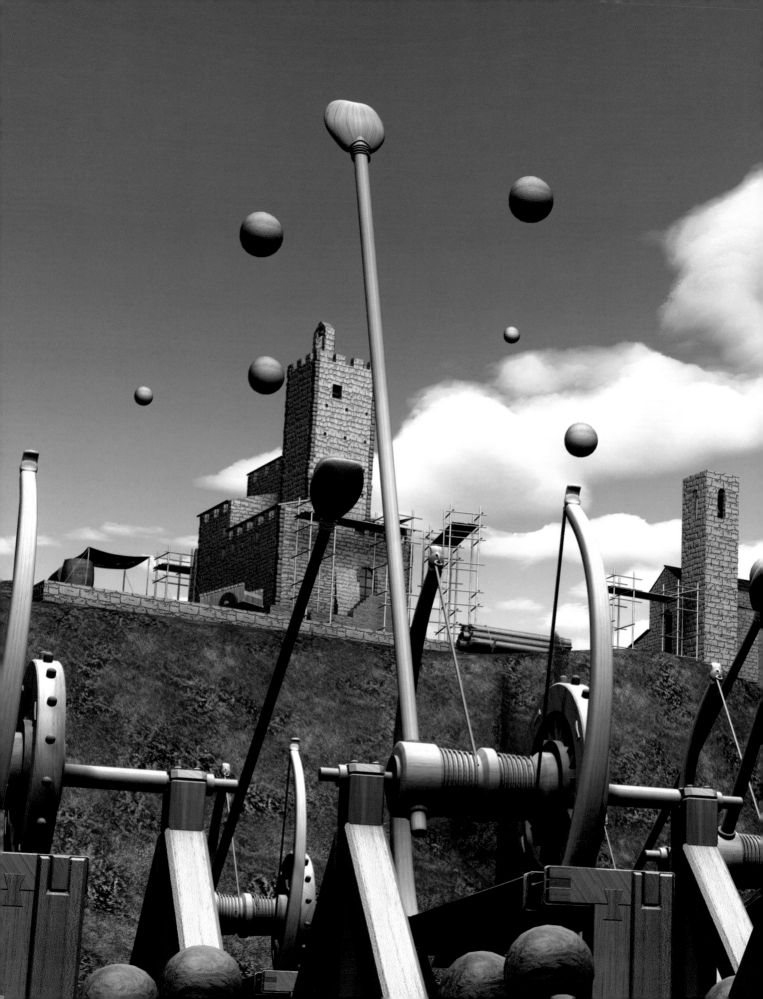

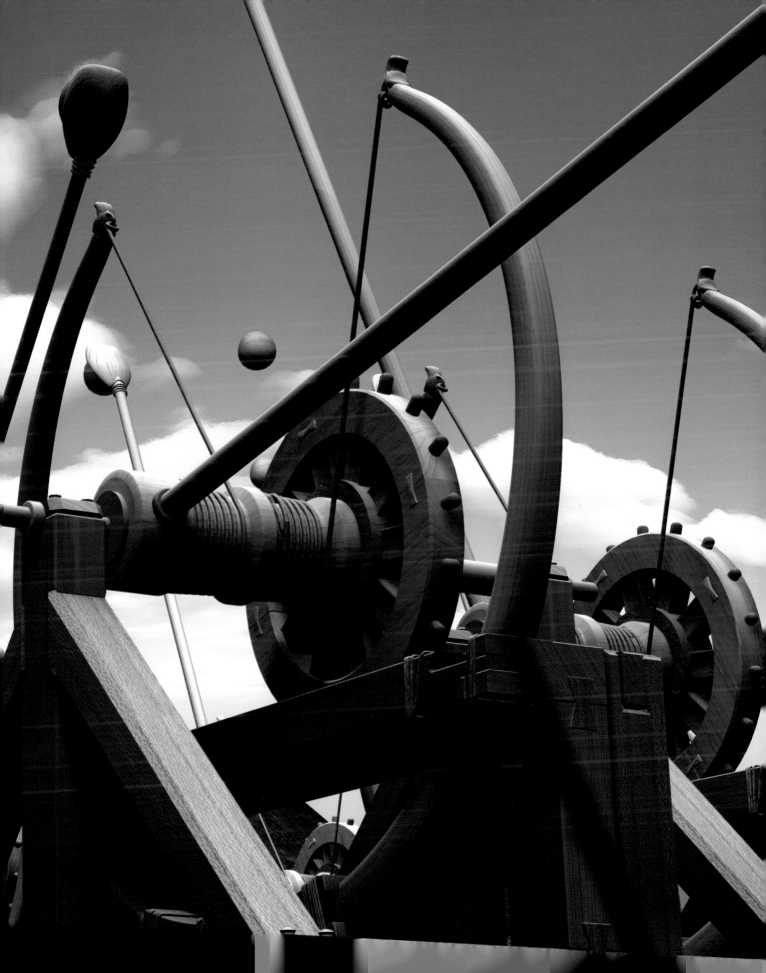

Vinci, 1452

1460

1470

1480

1490

1500

1503-1505

1510

Amboise, 1519

Codex Atlanticus, f. 1ar

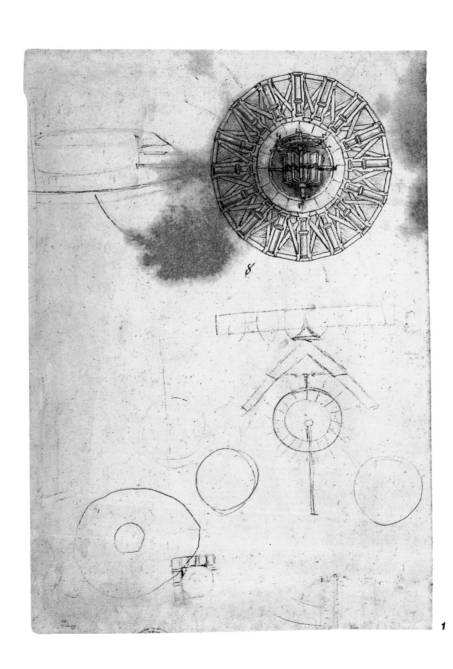

1

Barrage Cannon

2

This folio is part of the Codex Atlanticus, a collection of sheets put together not by Leonardo, but after his death at the end of the sixteenth century. In the upper corner, Leonardo has created a magnificent drawing of an 'encircling thunderbolt', the same term he used to describe another, very similar device found in Manuscript B. This 'circular-lightning' device is a multiple-barrelled bombard, with the gun muzzles positioned around a circular platform. It is a well-finished drawing that is the culmination of previous ideas and sketches, presented, as it were, as a fair copy. The various forms are clearly defined with precise lines drawn with a pen, and the line drawing is completed with hatching and an ink wash. It is evident that the lines were made by a left-handed artist from the way that they slant. By following their direction we can see that during the hatching process, Leonardo continually rotated the sheet of paper. The ink wash is used to highlight the volume of the cannons.

It is not possible to date this drawing firmly. A similar, but much simpler, circular-lightning device is shown on a warship in a drawing in Manuscript B dating from about 1485-9. But this drawing does not have Leonardo's regular, threadlike character of line typical of that period. Instead, its strength and content are reminiscent of the period while he was working on *The Battle of Anghiari*, around 1504. Despite its well-finished character, however, this drawing did not enjoy great good fortune. At some point various unrelated sketches were added to the page, only one of which (an architectural subject) can be attributed to Leonardo.

This drawing has a force greater than its mechanical content. Leonardo chooses to present the weapon from a very high vantage point, looking straight down on it. It is almost a plan, though this does not sacrifice detail and strength in the forms that make up the machine. The hatching and ink wash serve to regain the sense of volume in the forms that a plan would tend to flatten. At the same time, the drawing has both the crystalline clarity of a geometric diagram (a circle divided by a series of rays) and the power of a real structure. The forms of the cannons and the structures that hinge them together create a percussive visual cadence. The purpose of the machine – the series of shots fired from the cannons – seems to be transfigured into the image, translating ballistic rhythm into visual rhythm. Only many years later, towards the middle of the sixteenth century, would Michelangelo create forms capable of evoking such a powerful rhythm, in the tambour below the dome of St Peter's in Rome.

fig. 1
This design for a barrage cannon is drawn on the first page of the Codex Atlanticus; the most well-known and striking drawing is in the upper right corner, but a few less-visible lines in the same drawing conceal secrets and information that open the doors to many different interpretations.

fig. 2
An overhead view of the machine exactly as it appears on the Leonardo's page.

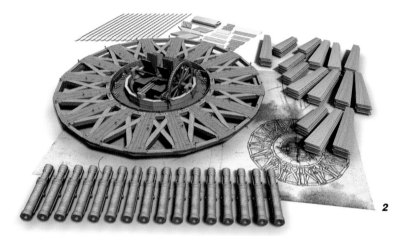

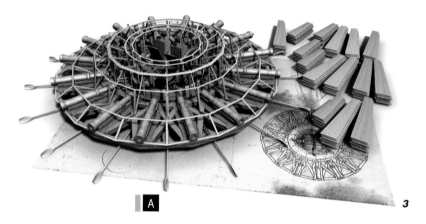

A

2

3

A On the upper right side of the page Leonardo presented a clear and distinct drawing, however, there are many barely sketched out drawings on the same page that open the way to a variety of interpretations. Historically, it has always been hypothesised that this giant structure was a sort of bombard that could be positioned on top of a tower, or on a land-bound civil structure. Under careful analysis, a sort of probable covering can be discerned, incoherent with the machine's interpretation. There also appear to be double lines close to all the construction rays in the main drawing. One of the possible interpretations for these faint but clear marks is that they represent oars for manoeuvring the machine on water. Its use on water would also furnish a coherent explanation of the central mechanism, the paddle wheels, an element for which it would be difficult to logically place the device on top of a tower. Difficulties in this placement would have also been encountered considering the weight and construction limitations imposed by the work. Nonetheless, it must be remembered that the barrage cannon on water is still only one of the possible interpretations for this design.

B The sequence illustrates the different phases in assembling the bombard. The cannons are positioned and fixed to a sturdy frame. Before Leonardo added the covering, sketched in the upper left of the manuscript, he constructed the frame. Below, the barrage cannon as it must have appeared after the construction was completed.

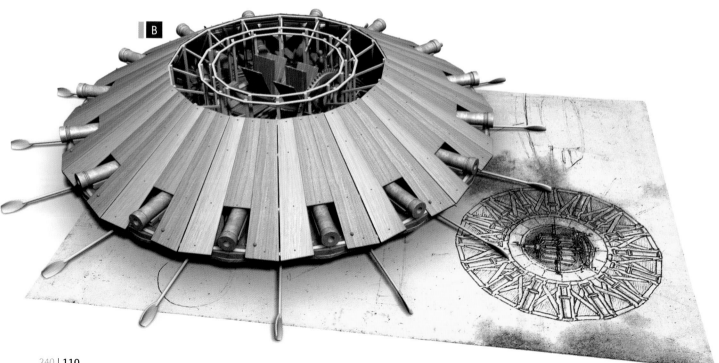

B

4

figs. 2, 3 and 4
*The sequence for assembling the entire structure,
following the indications suggested by the faint
sketch in the upper part of the manuscript.*

fig. 5
*An exploded view of a section of the bombard.
It takes sixteen sections to construct
the entire weapon.*

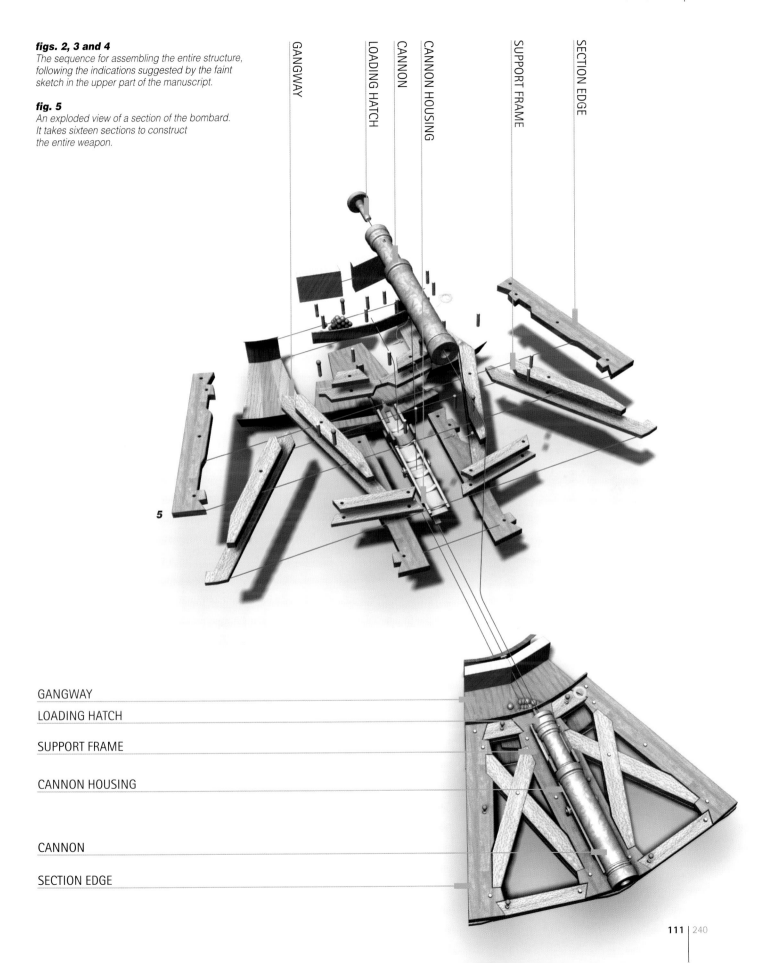

GANGWAY

LOADING HATCH

CANNON

CANNON HOUSING

SUPPORT FRAME

SECTION EDGE

5

GANGWAY

LOADING HATCH

SUPPORT FRAME

CANNON HOUSING

CANNON

SECTION EDGE

A The aquatic interpretation of the machine probably presents the most interesting aspect; its use on water explains the internal mechanisms that Leonardo designed for movement and manoeuvrability. By using a system similar to that for boats powered by paddles, the barrage cannon, which must have been very heavy, could navigate in a straight line in the water but could also manoeuvre with a fair amount of agility. The vessel could also turn around on itself; this manoeuvre simply required that one of the operators stopped turning his paddle, or that both paddle wheels turned in the opposite direction.

B Two operators moved the large drive wheel, and by turning the cranks the vessel began to move; this operation was not that easy because of the enormous weight and the inertia of the entire structure; the wheel and the crank would have broken. Leonardo came up with a gear reduction system that can slowly begin the motion for the entire machine. He designed two smaller cranks that turn two small cage-shaped gears. Once the motion was begun, the water resistance diminished and the operators could move to the larger wheel and continue the movement directly with this. This geared shield or barrage cannon could even reach considerable speeds for its size and bulk.

figs. 6 and 7
An exploded view of the motor mechanism, and, the system assembled. The interpretation of this device is the most interesting aspect of the entire machine.

fig. 8
How the finished machine must have looked, ready for navigation.

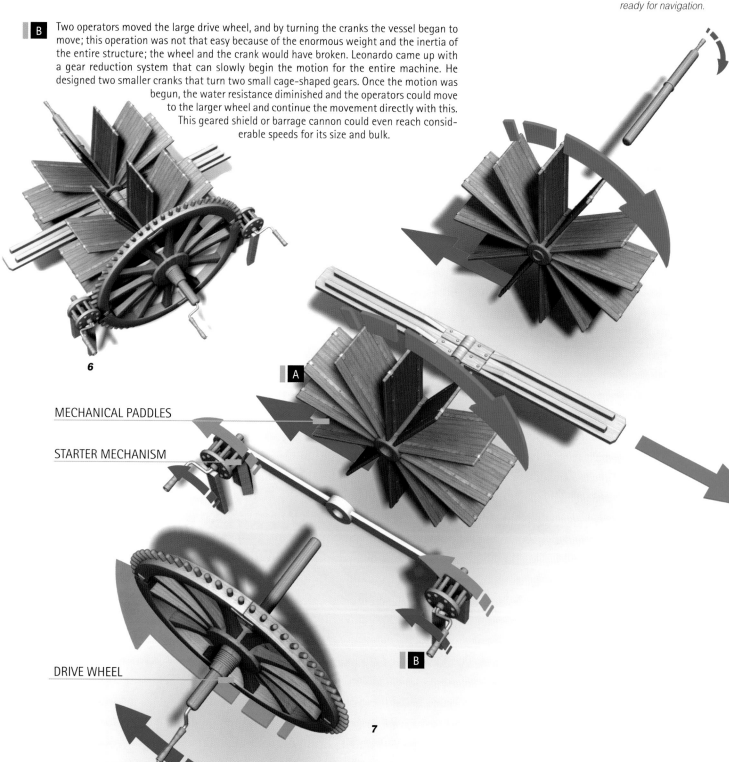

6

A

MECHANICAL PADDLES

STARTER MECHANISM

B

DRIVE WHEEL

7

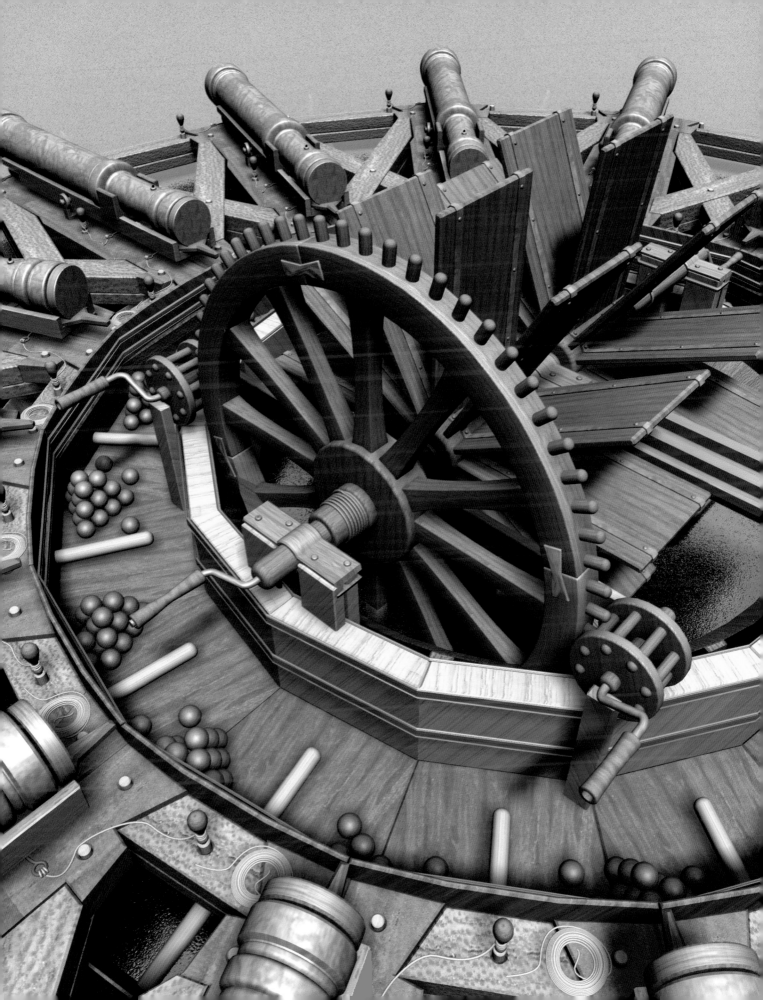

fig. 9
An exploded view of all the parts in the bombard-shield. The construction and launching onto the water must have been long and expensive undertakings, both in terms of human labour and in obtaining the materials: the wood, but especially the metal for the cannons.

following pages,
fig. 10
Leonardo himself appears aboard the bombard on its maiden voyage; it is almost certain that the machine was never actually made.

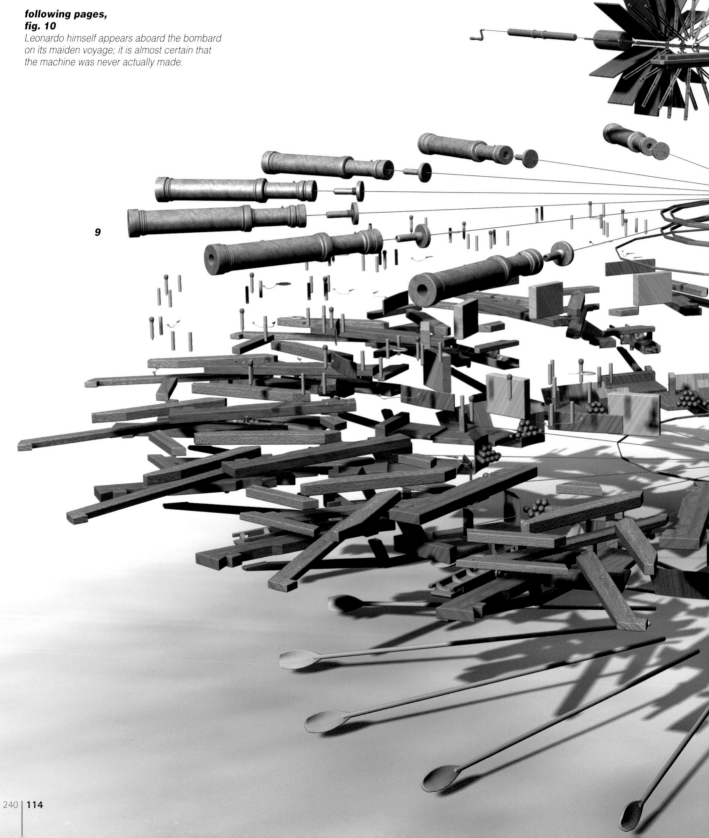

9

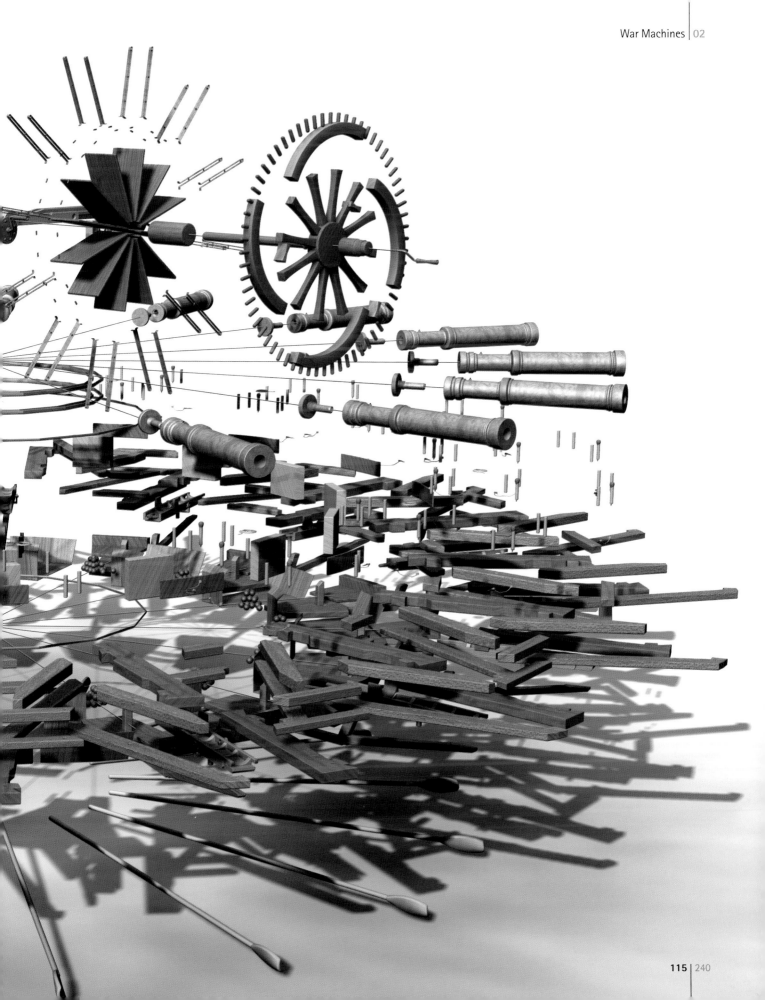

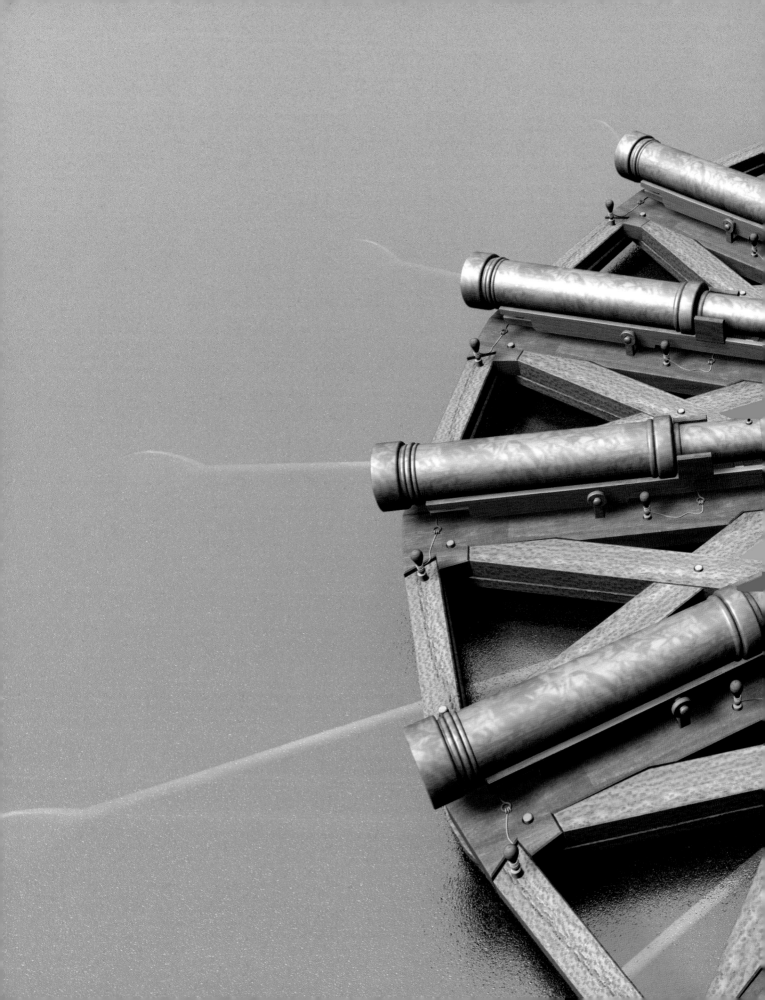

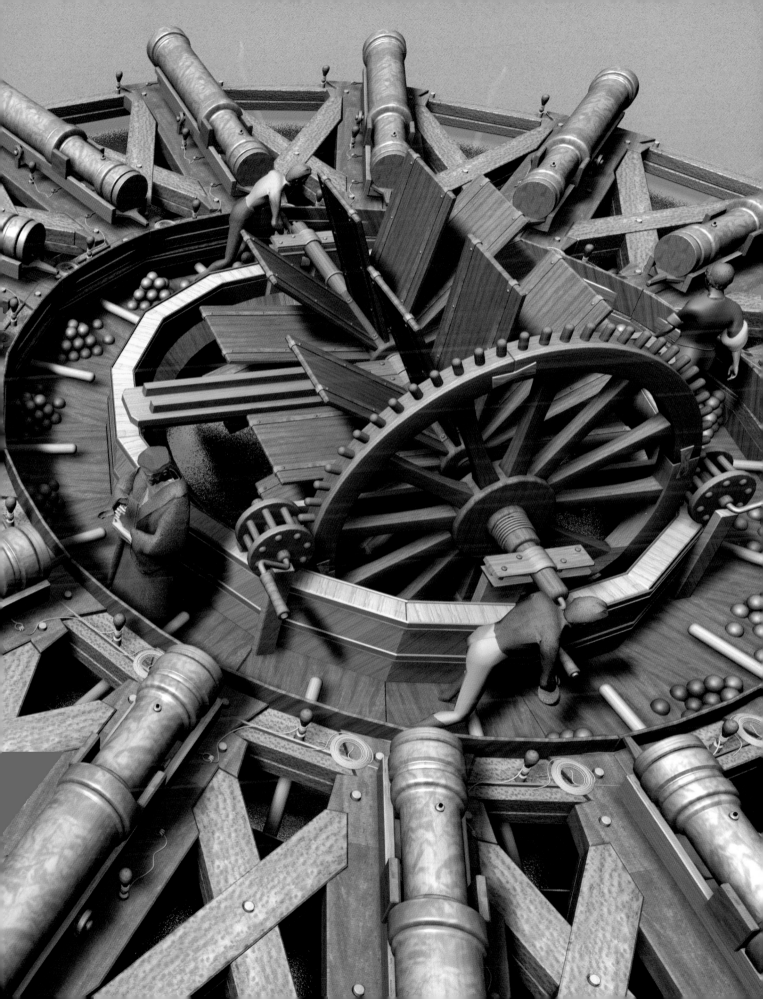

Vinci, 1452

1460

1470

1480

1490

1500

circa 1504

1510

Amboise, 1519

Codex Atlanticus, f. 33r

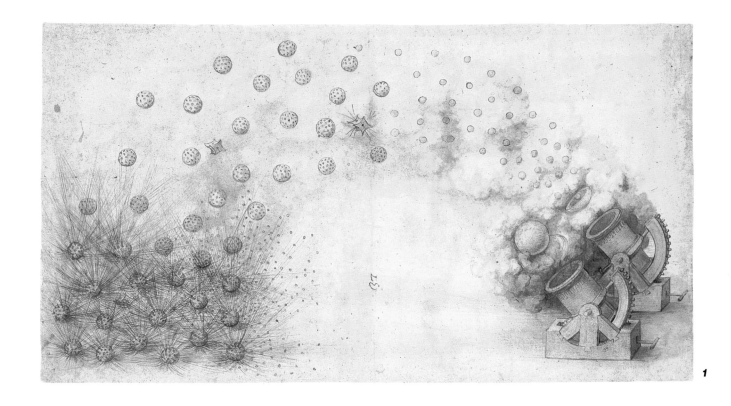

1

Bombards in action

This page from the Codex Atlanticus is not one of Leonardo's personal studies, but was drawn for presentation to a patron. The very finished style of the drawing and its technical complexity – combining a pen and ink drawing with an ink wash – together with the absence of written notes, all confirm the image's intended use. In his presentation drawings Leonardo often dispensed with written notes completely, or he included them in normal, left-to-right handwriting to enable them to be read by others. He was not the only one to use technical drawings as presentation images. With these and other drawings of machines, he followed in the tradition of the *Quattrocento* engineers. The manuscripts of Leonardo's two predecessors, Francesco di Giorgio and Taccola, were certainly not workshop manuals but rather refined collections of images and notes (in Latin) intended for a cultured readership.

We do not know for whom this drawing of bombards with exploding hailshot was destined, nor can the page easily be dated. The striking character of the image brings to mind Leonardo's early years: the clear layout of the design puts us in the 1490s, the period when Leonardo undertook his remarkable studies on ballistics. The stylistic characteristics, however, place us in the early 1500s, when he was working as a military engineer on various battlefronts – in the entourage of Cesare Borgia in Romagna, and in Tuscany for the Florentine Republic.

An intrinsically important element links this drawing to some other studies on bombards in action dating from about 1504 (Windsor Castle, no. 12275 and Codex Atlanticus, f. 72r): the ballistic aspect of the bombards undergoes an artistic transformation in these designs. In fact, the emphasis of the drawing is on the parabolic path described by the shots in their entirety, and especially (on the left side of the page) on the range and extension of each single shell after it explodes. Rather than drawing the exploded fragments of each shot, a very fine halo of lines is used to define the effect of each explosion. In the definition of these lines of force, we perceive the awareness of a scientist who was obstinately working at grasping the laws of ballistics by studying the interference of the air. But at the same time the delicate, taut rays also become images of incomparable aesthetic beauty. These mechanical drawings are to Leonardo's studies of ballistics just as the sublime drawings of floods are to his studies of hydrology: the lucid expression of a scientific law coincides with the creation of an artistic image, a feat that, to date in human history, only Leonardo has achieved with such comprehensiveness.

fig. 1
The drawing by Leonardo on folio 33r in the Codex Atlanticus.

fig. 2
Some projectile fragments.

A The bombard was a weapon already known at the time of Leonardo. The truly interesting aspects of this design are essentially the quality of the drawing, of unmistakable clarity, illustrating the bombards in action, and the studies in projectile fragmentation. Otherwise, the bombard drawn on the page does not contain any particular innovations; it was necessarily constructed of a sturdy base because of the great amount of energy released by the explosion upon firing. The bombard was most probably anchored to the terrain using stakes and lines.

The bombard had a single direction of fire, and the operator could regulate only the elevation of the shot. The direction of the shot depended exclusively on the position of the base, and because this was fastened to the ground it was difficult to move. There were probably a number of bombards positioned across a hypothetical battlefield in order to cover a greater attack area.

B The firing elevation could be easily adjusted by turning a crank; when the crank was turned, the operator could regulate the shot with great precision. The crank activated a metallic rod with a worm screw; the screw engaged the teeth in the toothed semiarc and the bombard moved up and down. Precision in this phase was of utmost importance; first of all with the short, stumpy barrel the shot trajectory was already fairly imprecise, and also because in a long-range shot even a few degrees variance made a big difference in its length.

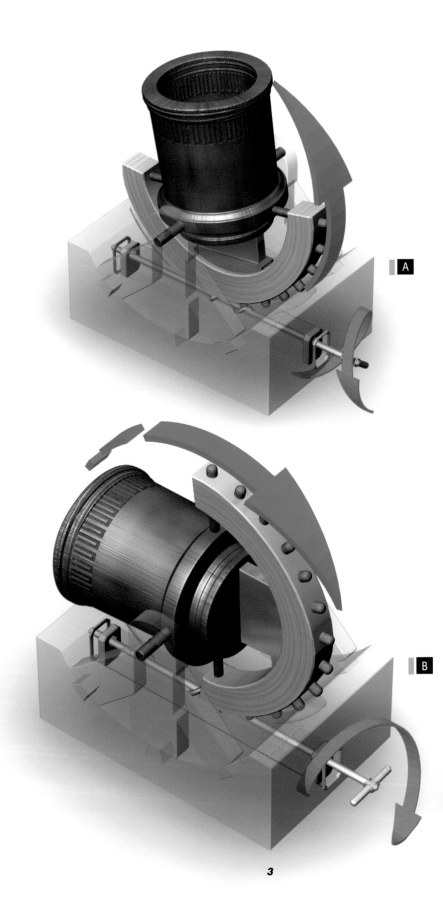

A

B

3

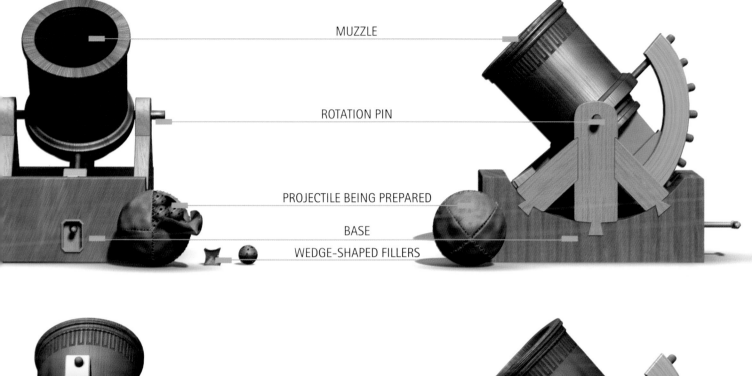

MUZZLE

ROTATION PIN

PROJECTILE BEING PREPARED

BASE

WEDGE-SHAPED FILLERS

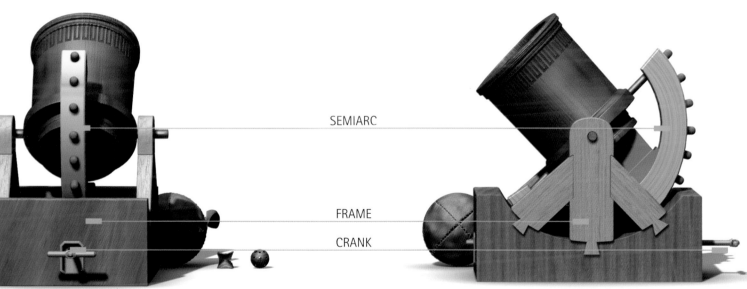

SEMIARC

FRAME

CRANK

4

fig. 3
Diagram of the functioning and adjustment of firing elevation.

fig. 4
Orthogonal views and description of the parts.

overleaf,
figs. 5 and 6
Exploded views of the bombard and hailshot.

A Visualization of the internal parts of an exploding cannonball: along with the mini-gunpowder shot there were wedge-shaped iron pieces that kept the round shot together in the shell. Leonardo's packing system was not the most effective, but during that period, without specific drafting tools it was difficult to represent and imagine other solutions.

B Once all the internal parts were assembled, the cannonballs were stitched up by joining the petal-shaped pieces together.

C Sewing the cannonballs was done by hand and it required precision and attention. The final sewing operation consisted in joining together the top part connecting all the pieces.

D Once the stitching was finished, the cannonball was ready to be loaded into the barrel of the bombard.

E Exploded view of the bombard. In this image it is important to note the complex structure of the weapon and some of it functional characteristics, for example the worm screw, used to adjust the inclination of the barrel that is worked by turning a rear crank.

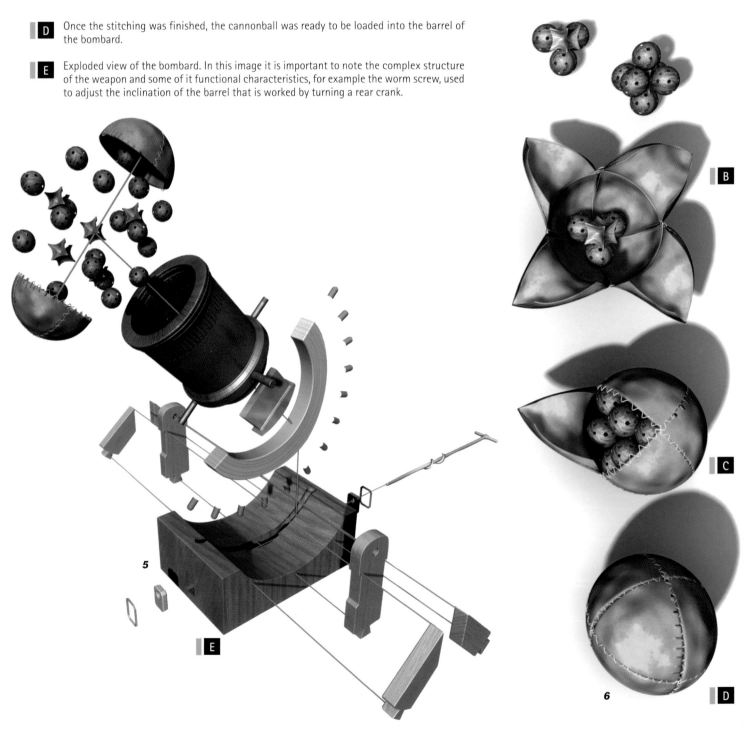

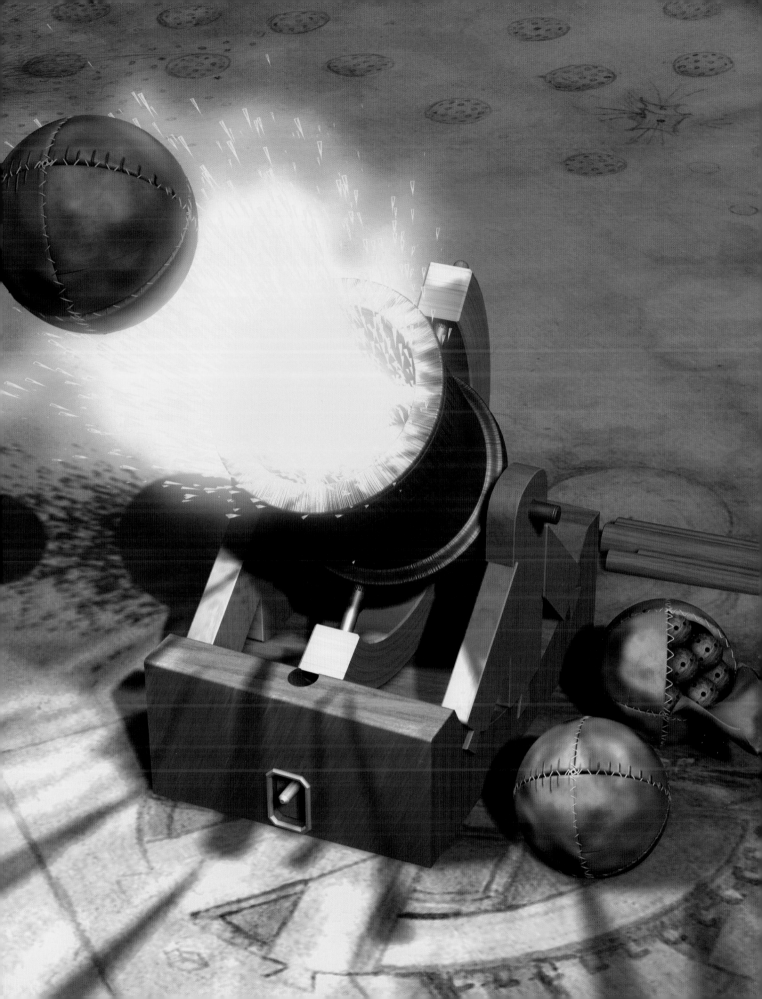

overleaf,
fig. 7
A view of the bombard in firing position.

fig. 8
The bombard placed on top of the folio faithfully replicates its position in Leonardo's drawing, leaving no space for other interpretations.

BASE

MUZZLE

CANNONBALL READY FOR FIRING

FRAME

PROJECTILE BEING PREPARED

HAILSHOT

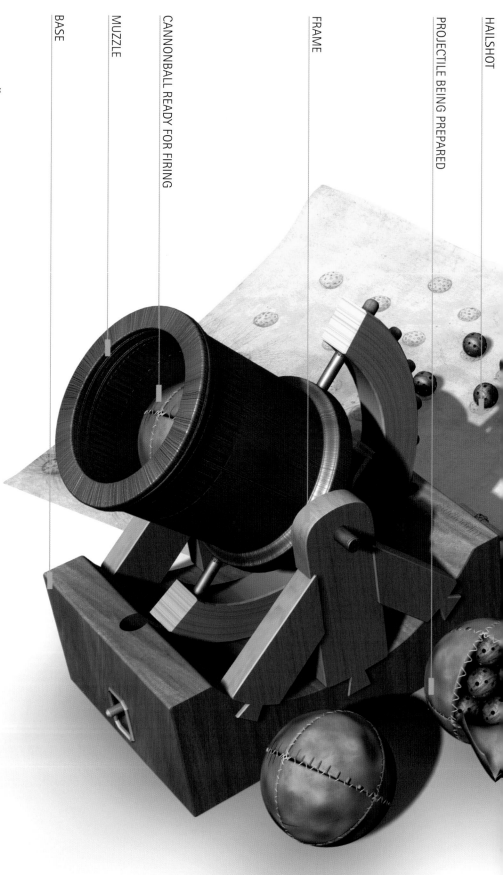

WEDGE-SHAPED FILLERS

ROTATION PIN

BARREL

SEMIARC

CRANK

TIE HOOKS

TIE LINES

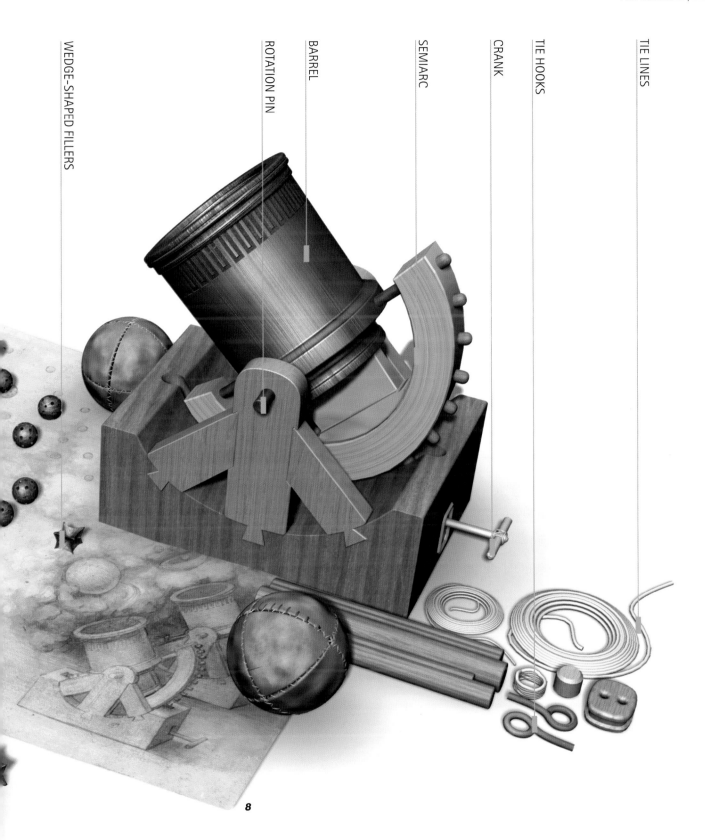

8

Vinci, 1452

1460

1470

1480

1490

1500

1507-1510

1510

Amboise, 1519

Codex Atlanticus, f. 117r

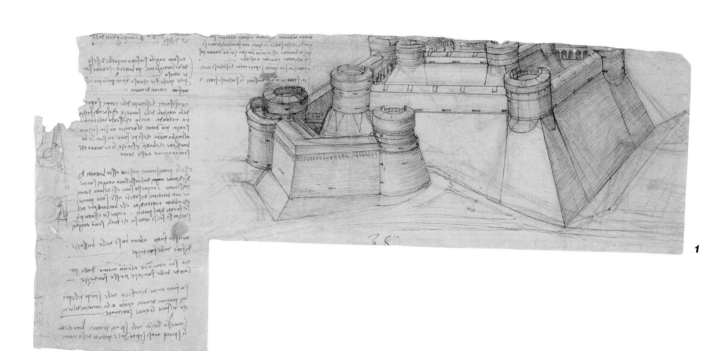

1

Fortress

The drawing of a fortress on this page in the Codex Atlanticus dates from the period of Leonardo's second sojourn in Milan, around 1508. The political scene had changed radically, and with the expulsion of the ruling Sforza dynasty, the French had taken control. Having worked previously for the Sforza, Leonardo now received important commissions from the French government, and was named '*ingénieur ordinaire*'. This design for a fortress was probably made for the French, in an era when the need to safeguard conquests militarily was becoming ever more pressing.

It was not the first time Leonardo had undertaken military assignments. Apart from some probably minor commissions from the Sforza, he had acted as consultant in this field for the Venetian authorities, and shortly afterwards he followed Cesare Borgia on his campaign for the conquest of the Romagna region. Just before his work for Cesare Borgia (in 1502, immediately before embarking on his artistic studies on the theme of warfare for *The Battle of Anghiari*), Leonardo had systematically addressed the important innovation of the day in warfare: firearms. He studied ballistics, designed firearms and, from a defensive standpoint, elaborated designs for fortresses and towers with a flattened form and a receding profile, minimizing the surface area vulnerable to enemy fire.

This design for a fortress, developed some years later, is contradictory in character. On the one hand, Leonardo applied some of the innovative architectural solutions he had devised in previous years: for example, the profile of some of the keeps corresponds to those concepts. On the other hand, however, the fortress has an almost medieval majesty about it and his plan is dominated by polygonal perimeter walls. Initially he gave a curved, convex shape to the ravelin (the wall outside the main gate), but changed this idea, giving this part of the fortress a polygonal, angled shape. This was the form preferred by Francesco di Giorgio in the many fortresses he designed and built in various parts of Italy, and he may have influenced Leonardo. Immediately after 1500, Leonardo had the opportunity to study a copy of the *Treatise on Architecture* by Francesco di Giorgio, in which he even inserted some of his own notes. It is also possible that the layout of the fortress, using innovative but less revolutionary forms, followed an explicit request from the patrons.

fig. 1
Folio with a clear drawing of the fortress and some annotations that recount a true incident regarding military treachery.

fig. 2
A view of the plan of the fortress.

A

This fortress was probably designed for a mountainous area; perched on to top of a mountain or hill, the dimensions and distinctive shape of the walls rendered the fortress practically storm-proof. The surrounding walls defend the central portion of the complex where the lord of the castle lived. About the mid-1400s the use of gunpowder and firearms was developed and all the systems of defence including the castle walls had to adjust to this new type of attack. Leonardo designs walls where the relationship between the layout and the vertical section of the walls is noticeably augmented. With this type of profile the walls, having increased structural consistency, can absorb the blasts of the new offensive weapons. The other innovation introduced into the design is the absence of traditional battlements: the profile of the walls becomes a rounded curve that can deflect the impact of cannon fire; small openings allow the defenders to keep the situation under control and respond to the firepower.

B

The geometrical configuration of the entire fortress is interesting, and very carefully planned. Believing the walls to be insuperable, Leonardo did not worry about covering one side of the fortress with natural structures such as slopes or ditches; on the contrary, he tried to free-up the perimeter of the castle, not so much to protect it as to cut off an easy escape. Once the enemy realized that the fortress could not be attacked, there would not be even a sheltered path of retreat.

fig. 3
The fortress was so imposing and inaccessible that any offensive initiative would have been in vain.

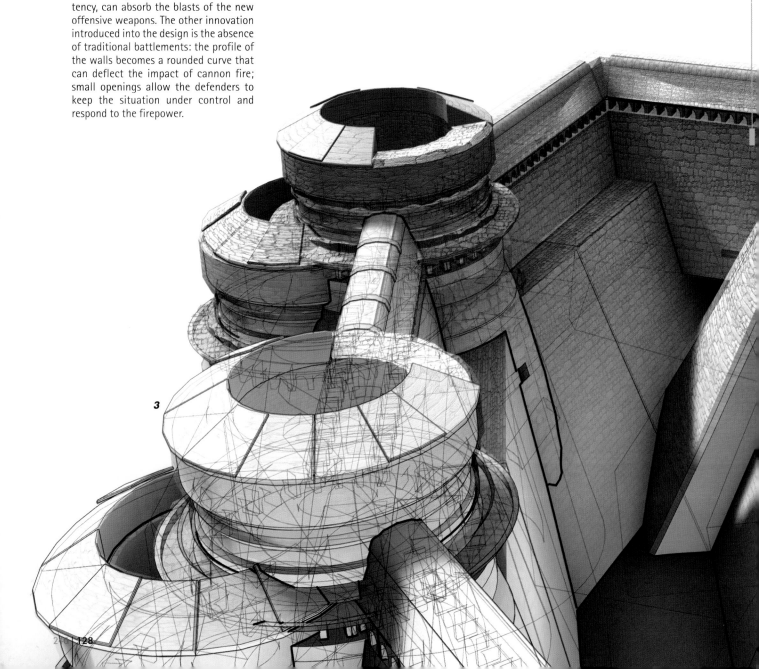

3

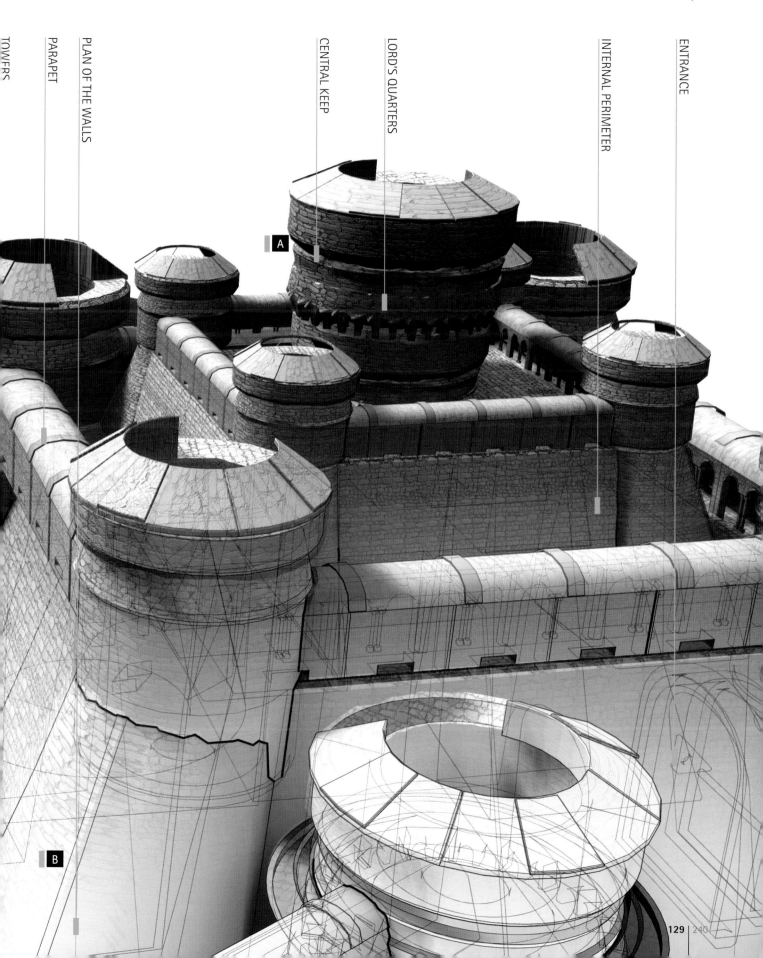

TOWERS

PARAPET

PLAN OF THE WALLS

CENTRAL KEEP

LORD'S QUARTERS

INTERNAL PERIMETER

ENTRANCE

A

B

003 Hydraulic Machines

Mechanical Saw
Paddleboat
Swing Bridge
Dredger

Leonardo often combined his study of water with that of air, designing both hydraulic and flying machines. He studied the waves on the sea to help him grasp the behaviour of the air, and some of his flying machines are reminiscent of boats in both form and mechanical concept (Codex Atlanticus, f. 156r and 860r). Still, from other points of view, the two areas are very far apart. The designs for the flying machine are entirely part of Leonardo's private world: there is no evidence to suggest that any of his clients took an interest in this realm of his creativity, and our impression is that Leonardo tended to keep this side of his inventive activity secret. Hydraulic engineering was perhaps the field in which Leonardo pursued his most sustained work, not only in his personal study but also in actual projects and important commissions from the rulers of the various places he lived in.

Vasari informs us that even while still in his youth, during the first period in Florence, Leonardo was consulted on a problem of public interest: 'And while he was still young, he was the first to propose making the Arno into a navigable canal between Pisa and Florence.' It is easy to understand why hydraulic engineering would be the field in which Leonardo worked most closely with his patrons (in this sense, it was rivalled only by military engineering). In addition to supplying a basic necessity of life to the cities, which could also be used as a driving force for various types of machines, in Leonardo's day water was the fastest means of commercial transportation.

Leonardo found himself working in two centres – Florence and Milan – that were both far from the sea, the main navigable body of water. Both cities were trying everything that imagination or money could procure to overcome this obstacle. Leonardo played his part in trying to resolve the problem, which was an ongoing challenge for generations of engineers. On one hand, he demonstrated interest for solutions already attempted or implemented, while on the other, he proposed new ideas. In Milan, the Navigli canal system used very advanced solutions, from which Leonardo would greatly benefit. In Florence, Filippo Brunelleschi had already addressed the problem of navigating the Arno, although with little success. He had designed a strange, large boat, known as il Badalone ('the monster') that he maintained would be capable of transporting heavy marble blocks from the quarries near the sea to Florence, but it sank or lost its load during the journey.

We have no drawings by the young Leonardo relating to the problem, but, according to one hypothesis, the drawing on folio 90v in the Codex Atlanticus, with its system of locks along a canal, could hint at the early design that Vasari mentions. We possess other drawings from Leonardo's early years relating to hydraulic problems, especially the drawings of

mechanical devices for lifting water in the Codex Atlanticus, the most famous of which is the so-called Archimedean screw (an arrangement of blades sealed inside a cylinder that, when properly inclined, drains water). In this case, once again, Leonardo made reference to what had already been invented by the Tuscan engineers, studying and analysing solutions from a highly regarded tradition while at the same time beginning to move away from it.

The design of hydraulic machines was an activity Leonardo increasingly tied to his research on the physical and dynamic behaviour of water, both as an element in and of itself and in its relation to other elements. In his studies during his later years in Florence, and just after his move to Milan (1482–3), he was already attracted by the analogies between water and air. He studied animals that seemed at home in both these elements, such as the flying fish, from where he took the idea for membrane-covered wings suitable for flying as well as swimming (the webbed gloves drawn on folio 81v in Manuscript B, around 1486–9). Apart from this more theoretical scientific work (then still in its infancy), in this period Leonardo also went beyond practical applications, giving full rein to his imagination by designing a submarine and a complex system for attacking enemy ships by breaching the hull underwater (Manuscript B, f. 81v and Codex Atlanticus, f. 881r).

A few years later Leonardo was once again caught up with design in a practical context when he hastily left Milan in 1499 to spend some time in Venice. In fact, the Serene Republic commissioned him to come up with an effective system of defence for its eastern boundaries, which were under constant threat from the Ottoman advance. Leonardo designed a defence system using palisades on the river Isonzo (Codex Atlanticus, ff. 638dv, 215r). While working on these designs, he often considerd their application to public works, as we deduce from a folio (Windsor 12680) on which he drew the course of the Arno River in the vicinity of Florence, indicating a chain system intended to stem the flow of the river, which was damaging the banks. The notations that accompany the drawing are not in the reversed handwriting so often found on his pages, but are written normally from left to right, a sign that these studies were intended to be seen by clients.

Leonardo returned to Florence in the early 1500s, and the authorities of the Republic involved him in at least three large hydraulic engineering projects: the ongoing problem of rendering the Arno navigable from Florence to the sea, the design to change the course of the Arno to leave the rebellious Pisa without water (in which, as in Venice, he combined hydraulic and military engineering), and finally, the attempt to improve the containment of the Arno in the section of the river near Florence.

After 1508, when Leonardo returned to Milan, now under French occupation, he became '*peintre et ingénieur ordinaire*' to the King of France. In addition to other tasks, he was assigned to design a navigable canal connecting Milan to the northern territories along the only partly navigable Adda River. For all these commissions, he designed various contrivances and hydraulic machines, all more or less original and all more or less practicable. It was during the years around 1508-10, and in the sphere of his personal studies, that the designs for hydraulic machines and devices yielded very interesting results. These studies are contained in the Codex Leicester and in Manuscript F. His personal studies were not always free from practical problems. Often the two strands of his work ran parallel with each other, and their co-existence constitutes one of the most interesting elements in Leonardo's work.

The perfect example of this co-ordination is in a series of notes and drawings where Leonardo constantly goes from a practical problem (the invention of machines for draining a pond) to a series of more theoretical and experimental reflections. Manuscript F (ff. 13v and 15r), contains a design for a machine for eliminating water from a pond using a centrifuge activated by wheels (either hydraulic, moved by the water in a river, or mounted on a boat and turned by animals); the water is sucked up as a result of the whirlpools that are formed. The idea behind this kind of device implies a theoretical study of the formation of whirlpools and their behaviour. At this point, Leonardo moved on to designing the centrifuges to be used in theoretical experiments, inventing machines that created whirlpools when placed in water. On folio 16r in Manuscript F he defines them as 'artificial vortices'. Thus he was dealing with machines whose purposes were purely experimental, a concept that would later become a foundation of the scientific revolution when, alongside his studies, Galileo Galilei set up a workshop to produce instruments to support his research.

During the final years of his career – between Rome (1513-16) and France (1517-19) – Leonardo continued to receive prestigious commissions related to hydraulic engineering as well as for mechanical designs. In Rome he was involved in the land reclamation scheme for the Pontine Marshes (Windsor 12684) and he also worked on designs for the port of Civitavecchia. A group of pages from his period in France (Codex Atlanticus, ff. 69br, 574, 790r, 810r, 1016r) includes inventions for a complex hydraulic system related to a fountain, which was probably intended for a grandiose pageant at Romorantin for François I of France, Leonardo's patron during his later life.

Vinci, 1452

1460

1470

circa 1478

1480

1490

1500

1510

Amboise, 1519

Codex Atlanticus, f. 1078ar

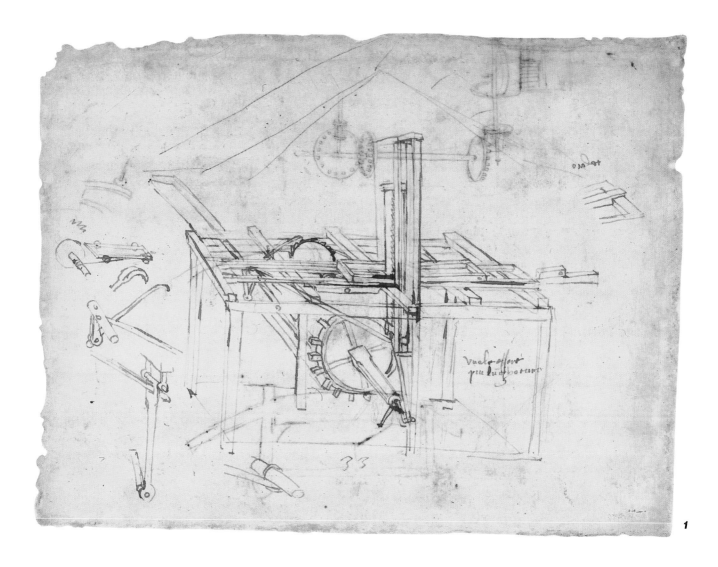

1

Mechanical Saw

In the mixed collection of sheets known as the Codex Atlanticus, mechanical drawings of inferior quality occasionally appear. It would be difficult to recognize Leonardo's hand in these drawings if they were not next to notes or other unmistakably autograph drawings. The drawing of the mechanical saw on this folio is an example. The pen and ink line delineating the frame for the mechanism is in a very laboured style. Rather than inventing, the individual responsible for this drawing seems to have been copying, placing one line after another as if to record an image of either a real machine or the drawing of one. The second hypothesis is the more plausible, especially if we attribute this drawing to Leonardo. The perspective is approximate and old-fashioned, reminiscent of drawings for machines by most of the *Quattrocento* engineers. These older images were meant to give a general idea of the machine, using visual conventions that glossed over correct perspective and spatial representation. Simply leafing through the treatises of an author like Taccola, we can find many mechanical drawings similar to this one in the Codex Atlanticus.

The suggestion that this drawing is a copy (with eventual modifications) of a device already in use in Leonardo's time, and that it was made from a drawing, is supported by the presence of a similar machine in the manuscript, now in Venice, by Lorenzo and Benvenuto della Golpaja, two well-known engineers of the period. Its attribution to Leonardo is based not so much on its graphic or conceptual quality as on its context. In the upper right there is a detail of the machine accompanied by the annotation '*telaio*' (frame) written backwards, in Leonardo's typical handwriting. On the back of the sheet (1078av) there is a drawing, barely more than a sketch, that has the sureness of line found in drawings firmly attributed to Leonardo. The legible note on the design for the saw, '*Vuole essere più lungo tutto*' ('Everything should be longer'), perhaps indicating a modification to the design, is written normally from left to right, as appears when Leonardo wants to share the drawing with someone. It also could be a note by someone other than Leonardo. Further, on a fragment of paper that was originally part of the page with the mechanical saw (folio 1078bv), there are drawings of Brunelleschian-type turnbuckles (mechanisms used by Brunelleschi in the dome of Santa Maria del Fiore and copied by other engineers), perhaps drawn by Leonardo, as well as letters and flourishes in a handwriting that does not belong to Leonardo. The nature of and the interest in this design are clear: it is a typical study made during his initial years of research before the period of innovation, and together with another young colleague Leonardo was studying the great traditions that preceded him.

fig. 1
Folio 1078ar in the Codex Atlanticus.

fig. 2
The mechanical saw on top of the folio in fig. 1.

2

A Upper carriage pulls the tree-trunk to be cut, by running along a track in the same direction as the cut and passing over the saw blade.

B System of pulleys attached to a crankshaft that automatically and gradually moves the upper carriage while the wood is being cut.

C Waterwheel that uses water in a small channel below the machine. A rotatory motion produces the mechanical energy transferred by various phases to the cutting device above.

fig. 3
View of the mechanical hydraulic saw as conceived by Leonardo.
The structural elements are in transparency; the cutting device and the waterwheel mechanism that transfers the energy to the cutting mechanism are highlighted.

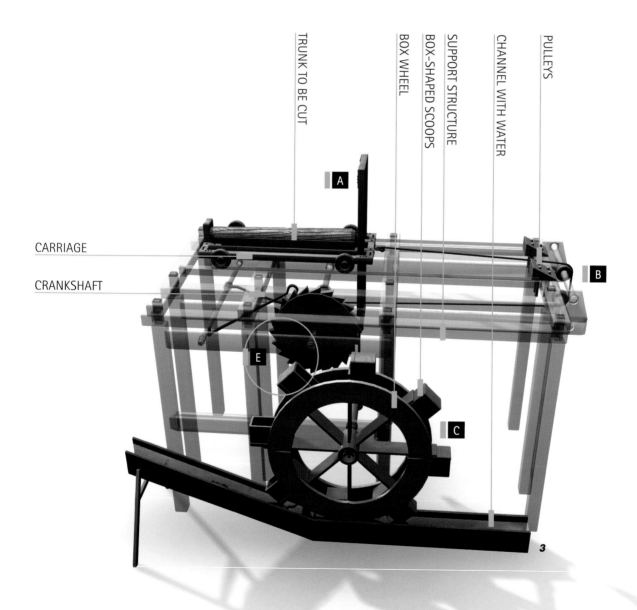

TRUNK TO BE CUT

BOX WHEEL

BOX-SHAPED SCOOPS

SUPPORT STRUCTURE

CHANNEL WITH WATER

PULLEYS

CARRIAGE

CRANKSHAFT

3

fig. 4
Front view of the saw showing the mechanism
that transforms continuous rotary motion
into reciprocating linear motion
(the up and down sawing motion).

fig. 5
Diagram of the workings of the hydraulic saw.

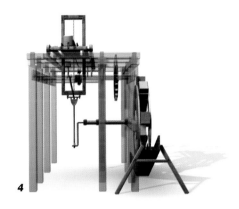

4

D The wheel with box-shaped scoops is put in motion by the running water in the channel below.
The turning axles transfer the energy produced by rotatory motion to the other mechanisms.

E This mechanism transforms the hydraulic rotatory motion into the energy necessary to work the system of pulleys and crankshafts that pull the carriage with the tree-trunk, keeping it moving at a constant speed in the direction of the cut.

F This phase transforms the original continuous rotary motion to linear reciprocating motion allowing the saw to make the up and down cut. A line governed by a pulley system is tied to the upper carriage and it pulls it along the frame to the saw blade.

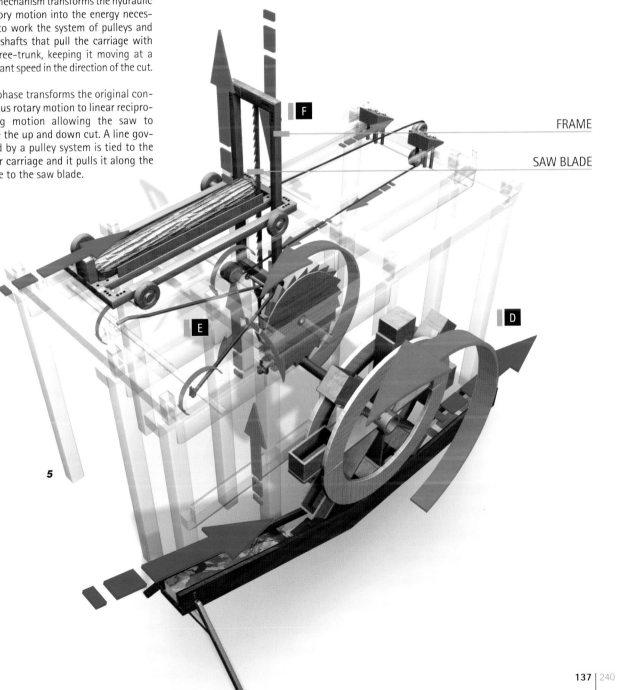

FRAME

SAW BLADE

5

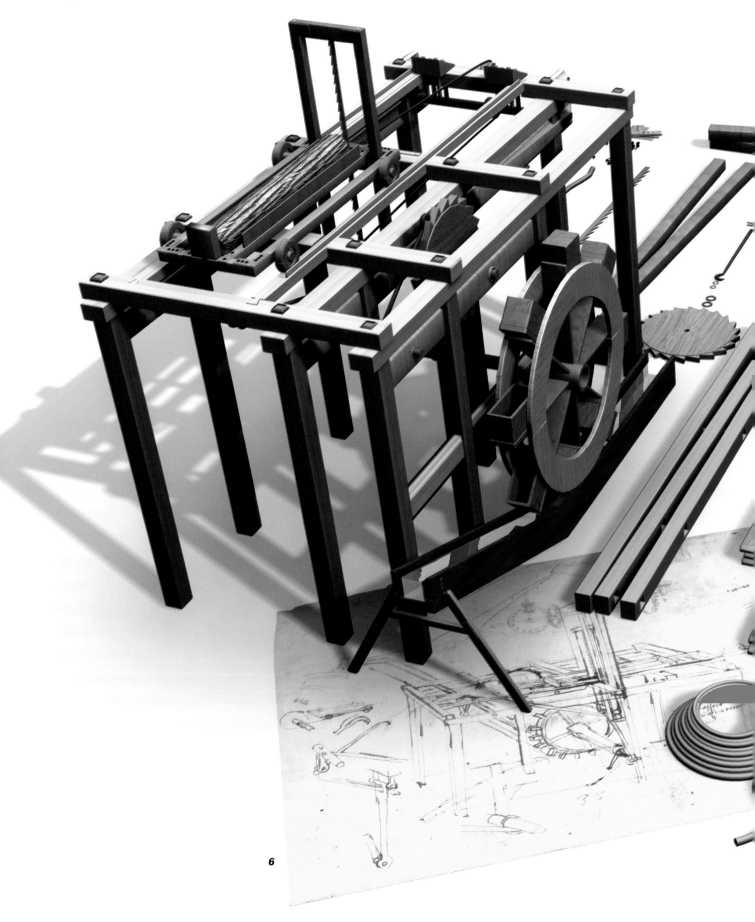

6

fig. 6
The image shows the mechanical saw
disassembled and surrounded by its parts:
structural parts, gears, joints,
couplings and mounts.

Vinci, 1452

1460

1470

1480

1487-1489

1490

1500

1510

Amboise, 1519

Codex Atlanticus, f. 945r

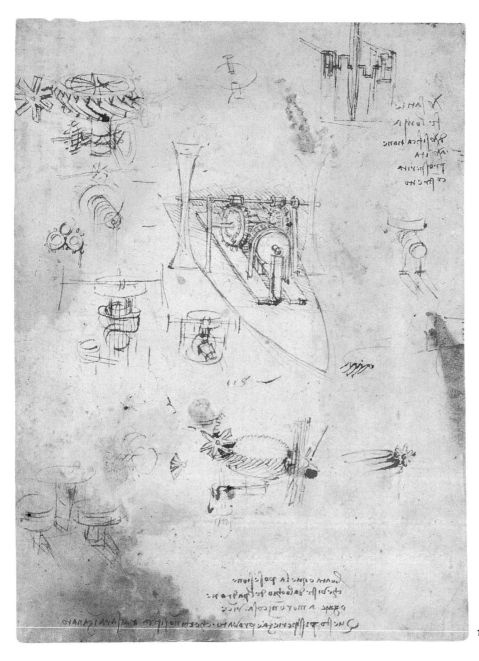

1

Paddleboat

2

Boats based on new systems of propulsion, underwater diving suits, submarines, mechanisms to attack enemy ships from under the sea: Leonardo was often interested by research in the nautical field, and he often came up with highly original solutions. Travel by sea and (where navigable) river was the fastest and most effective means of communication of the time. Cities such as Milan and Florence, without any direct link by water to the sea, endured this limitation with great difficulty, and used their political and economic power to strive to overcome it. Their efforts in this respect were made with military objectives (such as Milan's expansionistic aims towards the Ligurian coast, or the war constantly waged by Florence against Pisa), as well as in the field of hydraulic engineering. Often these efforts were at the limits of possibility, as in the case of the Florentine attempt to render the Arno River navigable to the sea.

The design of new types of vessels greatly occupied Renaissance engineers, especially with regard to ever-increasing commercial and wartime demands. The basic concept of a vessel moved by paddle-wheels was one that had already been amply dealt with by previous engineers, from Taccola to Francesco di Giorgio. Leonardo made notable improvements to the paddle-moving mechanisms and offered a new way of approaching the problem. Almost every new invention or design modification for one or other of the mechanisms is present in his disordered but very effective visual notes. In the manuscripts by engineers contemporary with Leonardo the designs for paddleboats are generally presented in their final form, without an indication of the research process behind them.

Leonardo had recently arrived in Milan when he made the drawings on this folio. A series of elements suggest the period to be 1487-9. Among these are the Lombard names on the reverse of the folio, in handwriting that is not Leonardo's. It is one of the many pages from the accounting ledger for Milan Cathedral that ended up in Leonardo's possession, and he added drawings and notes in the blank spaces. The other element that would confirm the dating of this folio is the list of words in the upper right: 'Fellonia. Diversificazione. Avversità [...]' ('misdeed, diversification, adversity'). Long lists of words in the manuscripts from this period (Manuscript B and Codex Trivulzianus) attest to the fact that once Leonardo reached Milan, not having had a regular university education and wanting to access the cultural sources of the era, he began the long exercise of learning languages, including Latin.

fig. 1
*The folio 945r in the Codex Atlanticus.
In the centre there is a pedal mechanism
for propelling the boat, a very important technical
device. Surrounding it are other construction
details and various notes.*

fig. 2
*Rotating paddle device activated
by the propulsion mechanism of the pedals.
The navigation of rivers and canals poses
different problems than sea navigation.
Once the flotation problem was worked out, the
vessel had to have a propulsion system allowing it
to move upstream as well as to quickly move
through the slow waters of the canals.
The use of a paddlewheel seemed to Leonardo to
be a better solution than the use of oars.
The basic idea in this innovation was to substitute
oars with wheels, using a working principle
opposite to that used in mills: not the action
of the water moving a wheel, but rather
the manual action of the paddle on the wheel
in the water making the vessel move.*

fig. 3
*Exploded view of all the parts
of the reciprocating-motion motor.*

fig. 4
*Diagram of the workings of the pedal
motor on the paddleboat.
The mechanisms for the left block
are in transparency, while the right
block (its workings are explained)
is highlighted. It is interesting to note
the use of systems that transform
linear reciprocating motion into
uniform continuous rotary motion.
This mechanism is similar to one
of Leonardo's drawings on folio 30v
in the Codex Atlanticus, with some
of the parts inverted.*

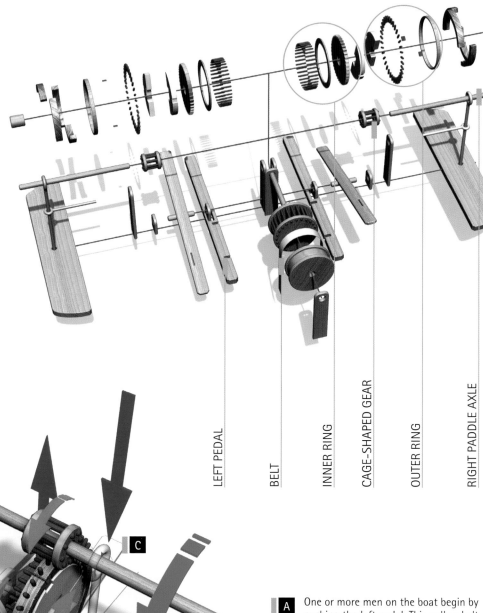

LEFT PEDAL

BELT

INNER RING

CAGE-SHAPED GEAR

OUTER RING

RIGHT PADDLE AXLE

4

A One or more men on the boat begin by pushing the left pedal. This pulls a belt that makes the centre mechanism rotate.

B Worked by the belt, the centre mechanism rotates clockwise, transmitting its movement to the inner right ring on the motor block. Two inner springs turn clockwise engaging and meshing the outer toothed-ring.

C The outer ring transmits the rotary motion to the upper gear that begins to rotate in a counter-clockwise direction. The motion is then transmitted to the right support axle, moving the paddlewheel that rotates counter-clockwise (green arrow). After this sequence, the right pedal is pushed and the process continues in alternation.

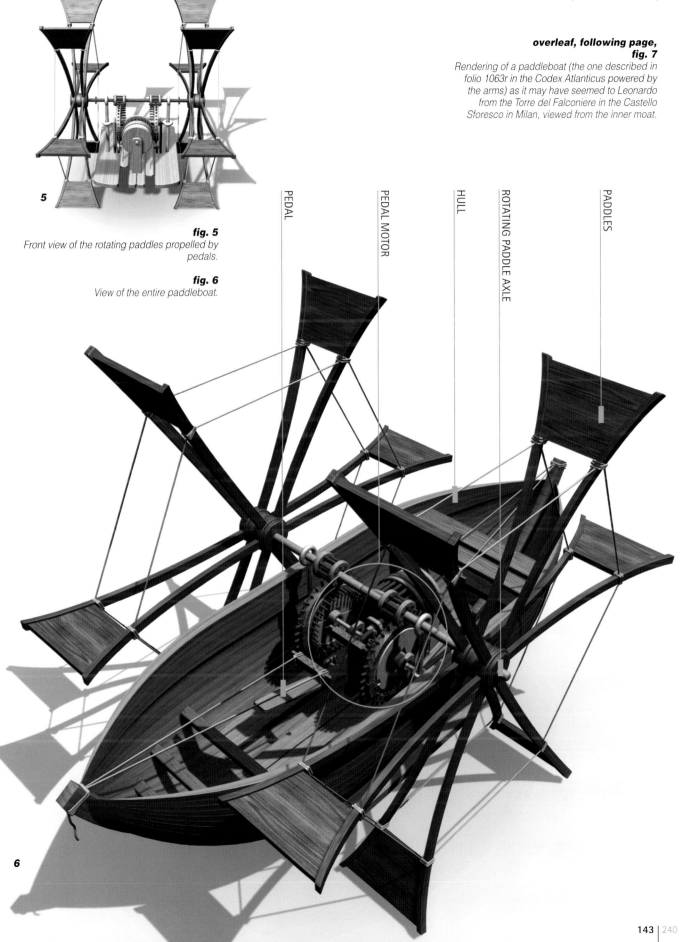

**overleaf, following page,
fig. 7**
*Rendering of a paddleboat (the one described in
folio 1063r in the Codex Atlanticus powered by
the arms) as it may have seemed to Leonardo
from the Torre del Falconiere in the Castello
Sforesco in Milan, viewed from the inner moat.*

5

fig. 5
*Front view of the rotating paddles propelled by
pedals.*

fig. 6
View of the entire paddleboat.

PEDAL

PEDAL MOTOR

HULL

ROTATING PADDLE AXLE

PADDLES

6

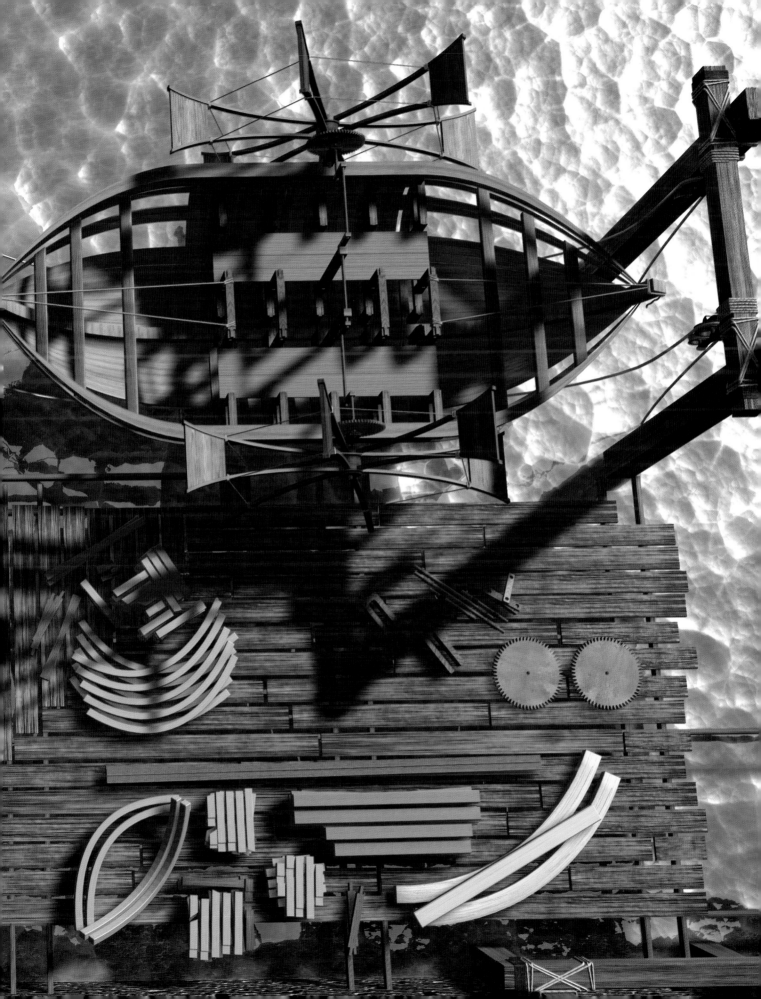

Vinci, 1452

1460

1470

1480

1487-1489

1490

1500

1510

Amboise, 1519

Codex Atlanticus, f. 855r

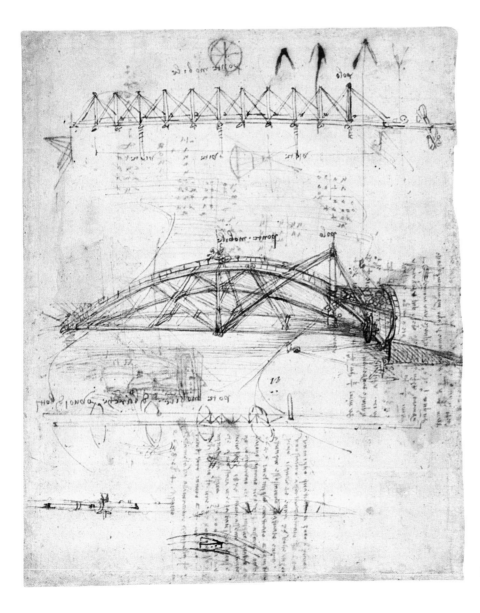

1

Swing Bridge

One of the most interesting chapters in Leonardo's work is the design of bridges to be used principally during wartime. In the letter of introduction he wrote to Ludovico il Moro after leaving Florence in 1482, he mentioned that he could build 'bridges that are extremely lightweight and strong'. We do not know if Ludovico il Moro put the young and ambitious Tuscan engineer to the test. Certainly, Leonardo's notes contain numerous drawings showing how to construct bridges with characteristics that were particularly useful during wartime: there are mobile bridges (the type of bridge reconstructed here), those constructed with very light materials, and those that could be assembled and disassembled easily and rapidly. The testimony of Luca Pacioli, the great mathematician and friend of Leonardo, is also very interesting. In his *De viribus quantitatibus* he mentioned a 'noble engineer' who, for Cesare Borgia, the ill-famed 'Valentino', had invented emergency bridges for use in battle that could be easily assembled without the use of tools such as cords or metal. It is not certain that Pacioli was referring to Leonardo, but the reference may well have been to him in view of the fact that Leonardo worked for il Valentino as a military engineer.

The three studies of bridges on this page present three variations: a bridge constructed from poles (the type easily assembled and disassembled), a swing bridge and a floating bridge resting on boats or pontoons. They are quick sketches, temporarily recording ideas for Leonardo to refine at a later time. Manuscript B contains many sketches of this type, and this folio from the Codex Atlanticus almost surely dates from the same period – the years just after Leonardo's arrival in Milan.

As was often the case with wartime devices, Leonardo drew in part on tradition. His floating bridge on boats has an almost classical feel about it. This is not a sign of lack of originality: during this period Leonardo was trying to make headway in the Milanese court and even for 'il Moro', as for the other warrior-princes of the time, the requirements and skills of the art of war were fused with a humanistic tendency to give the activity a dimension of reborn classicism. Adding hints of structures and ideas with classical origins to his innovative designs would have played in Leonardo's favour. Even so, the originality of these designs, especially in the moveable bridge, is dominant. Leonardo's notions related to statics are particularly remarkable. He used the term 'pole' for the vertical pivot around which the bridge rotates, and other contrivances (such as the caisson acting as a counterweight) relate to his theoretical ideas. The science of weight, the study of the static and dynamic behaviour of bodies, was one of the first theoretical areas broached by Leonardo after his arrival in Milan. His contribution to this field lay in applying science, traditionally confined to purely theoretical speculation, to the context of practical mechanics.

fig. 1
Folio 855r in the Codex Atlanticus. The three studies on this sheet present three variations of bridges: a bridge constructed with poles (the type easily assembled and disassembled), a swing bridge and a floating bridge resting on boats or pontoons.

fig. 2
Overhead view of the swing bridge.

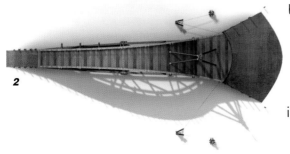

2

The drawing of this bridge dates from Leonardo's first period in Milan, and like the others is probably one of those designs he mentioned in the letter to 'il Moro' where he commended his capabilities in civil and military engineering. The main characteristic of this bridge is that it could be quickly closed and opened, making it an effective tool in halting the advancing enemy.

fig. 3
View of the swing bridge on the folio in which it appears, CA 855r in fig. 1 (previous page).

fig. 4
View of the swing bridge from below, showing some of the structural components and the respective functioning mechanisms.

SECONDARY RAMP

PAVEMENT

SUPPORT STRUCTURE

ARCHES

LOWER BASE

HANDRAIL

OPENING WINCH

CENTRAL PYLON

ACCESS RAMP

CLOSING WINCH

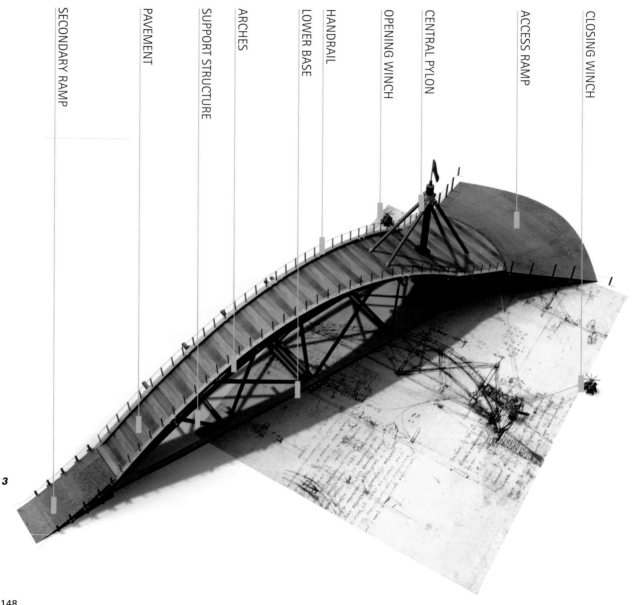

3

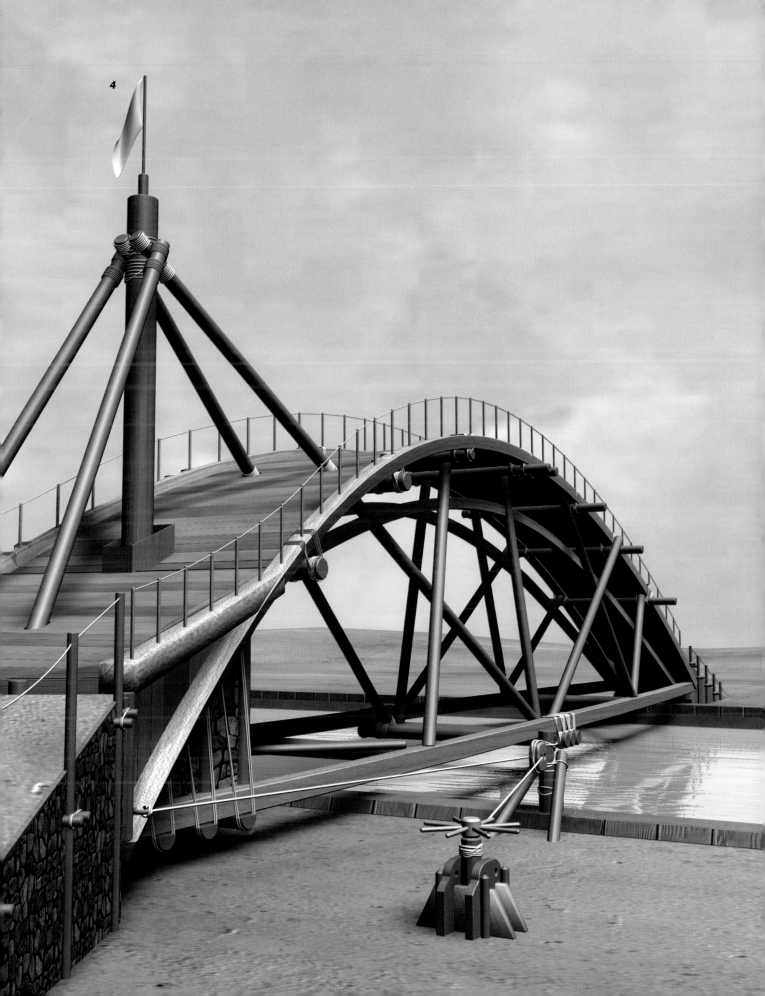

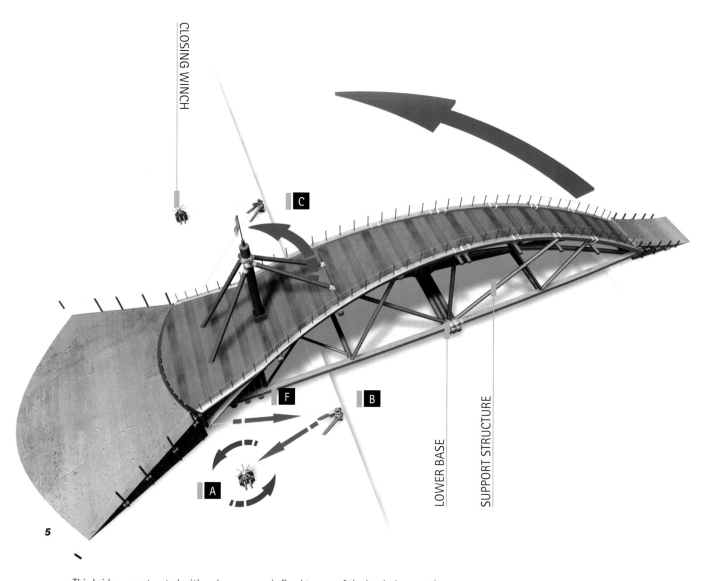

CLOSING WINCH

C

F

B

A

LOWER BASE

SUPPORT STRUCTURE

5

This bridge, constructed with only one span, is fixed to one of the banks by a vertical pivot that allows it to rotate. Using a system of cords, winches and rollers to facilitate movement, the bridge rotates so that vessels can pass, or so one side of the river can be isolated.

A Opening winch for the bridge: as it turns, the line connected to the bridge is wound in.

B A system of pulleys fixed to the bank keeps the line from slipping and determines the trajectory, optimizing the rotation the swing bridge has to make in order to open.

C By pulling the lines, the bridge is made to rotate on the central pylon, and thus suspended, opens the way for vessels to pass through. The pylon functions as a pivot pin, like on a balance.

fig. 5
Functional diagram of the swing bridge while opening.

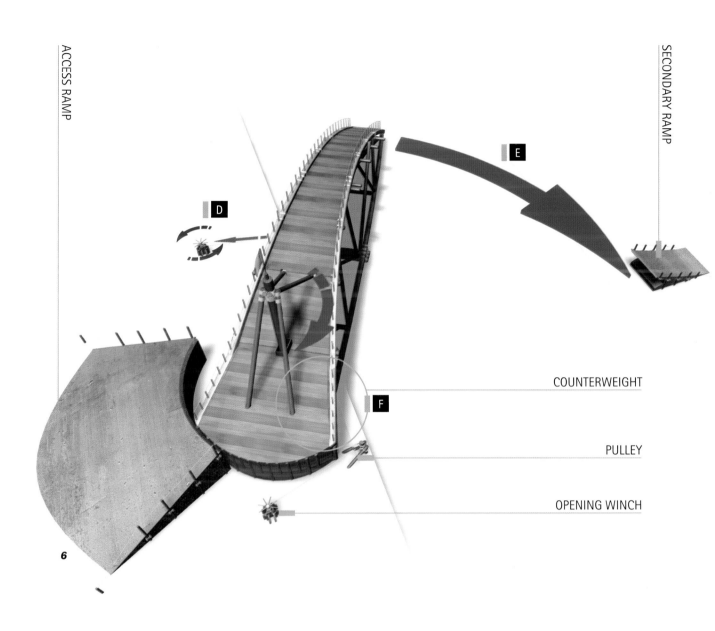

ACCESS RAMP

SECONDARY RAMP

D

E

F

COUNTERWEIGHT

PULLEY

OPENING WINCH

6

fig. 6
Functional diagram of the swing bridge while closing.

**overleaf, following pages,
figs. 7 and 8**
*Hypothetical images of the swing bridge
installed on a river.
In the first, all the parts of the bridge seen in
transparency are disassembled and placed next to it.
The second shows the bridge closed, as it would have
appeared to Leonardo.*

D In order to bring the bridge back to its initial position and allow for its crossing, the opposite winch, farthest from the pylon is activated. The line is wound in, pulling with it the end of the bridge.

E The end of the bridge is re-aligned with the secondary access ramp, placed on the opposite bank from the rotation pylon.

F To makes the opening of the bridge easier, Leonardo planned for a stone caisson to serve as a counterweight when the bridge is suspended and before it rests on the other bank

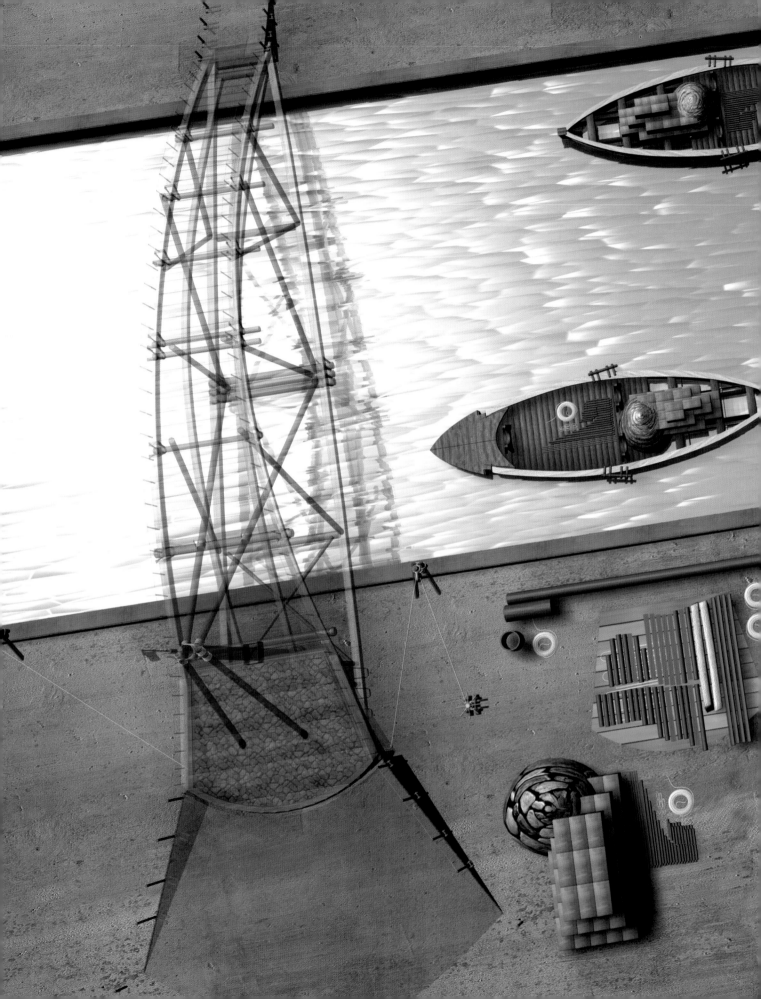

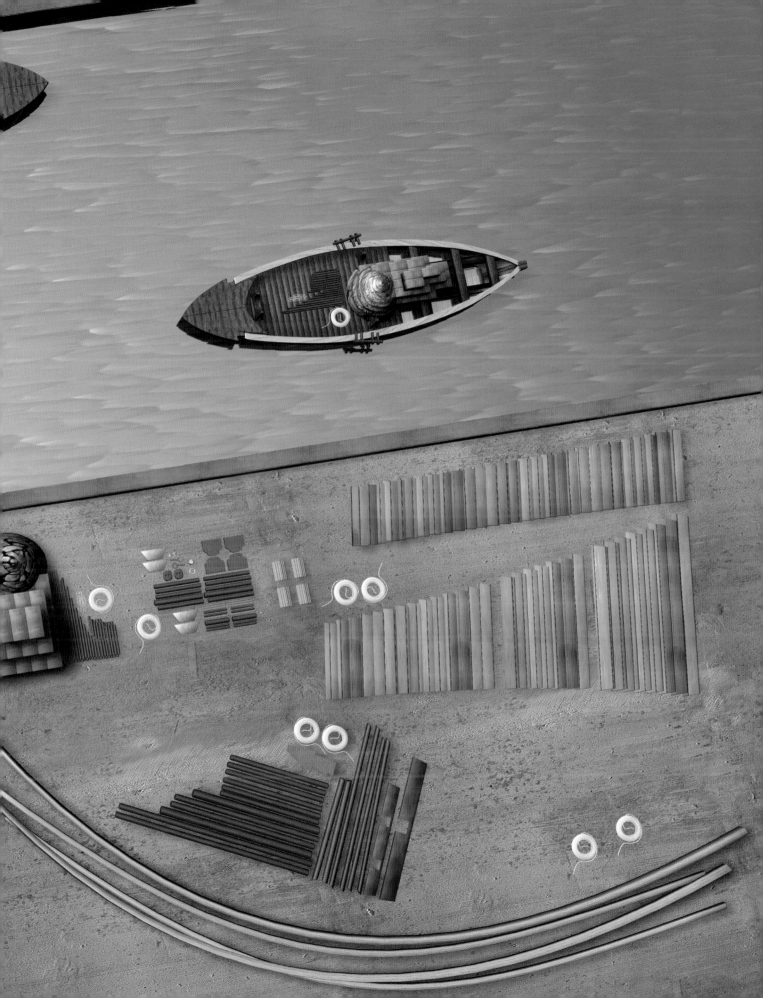

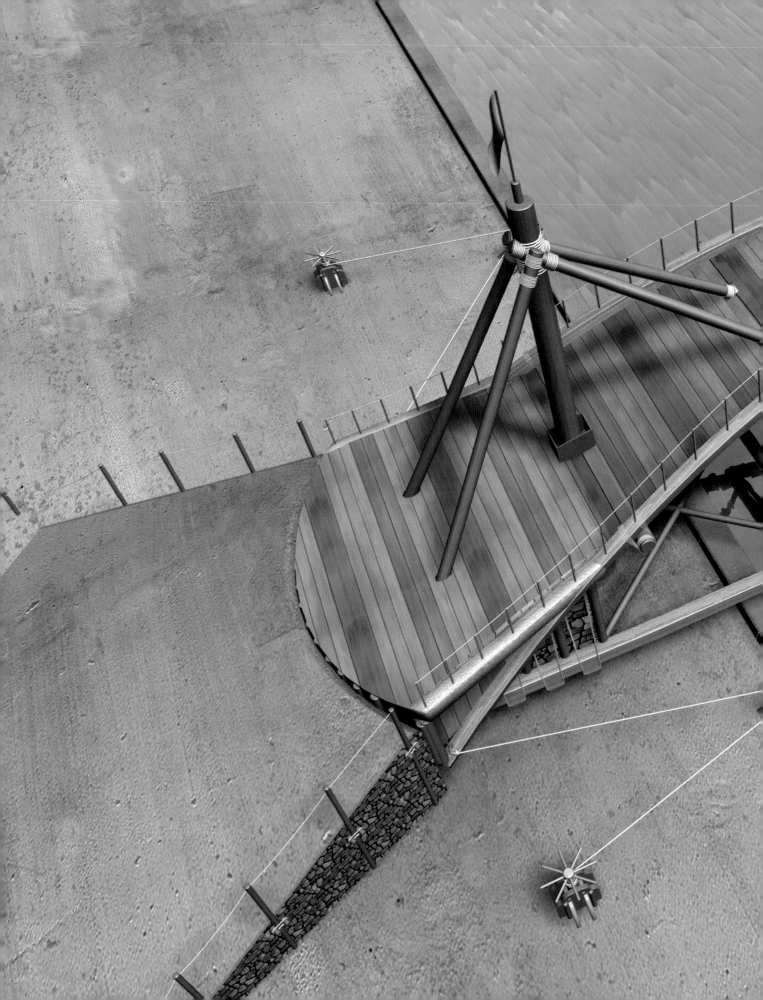

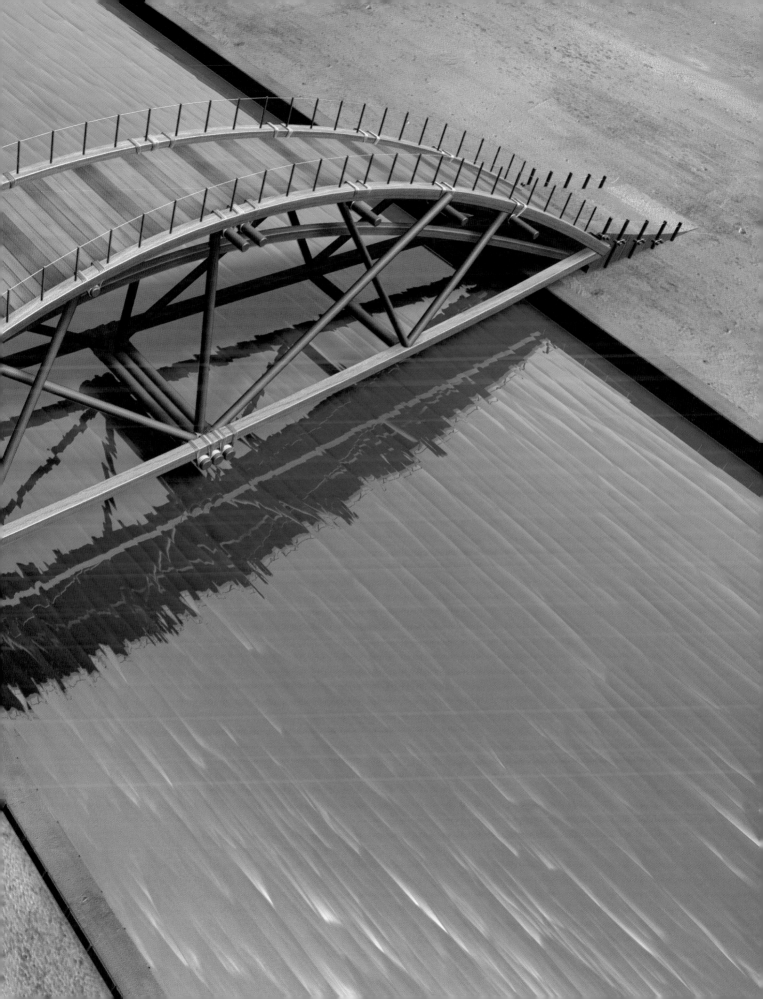

Vinci, 1452

1460

1470

1480

1490

1500

1510

1513-1514

Amboise, 1519

Manuscript E, f. 75v

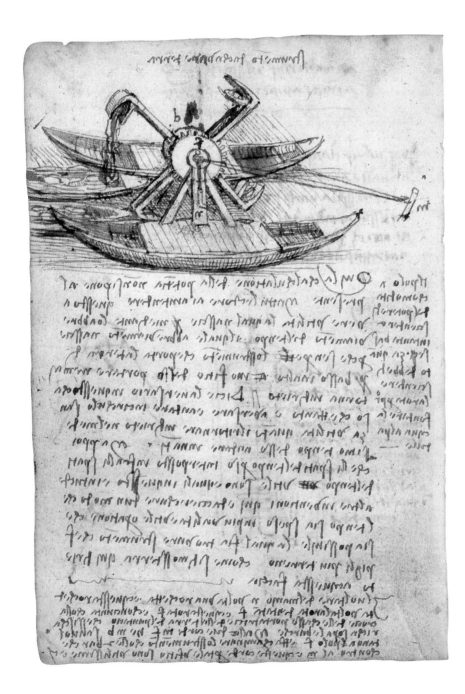

1

Dredger

2

The study for this machine, which dredges mud from the bottom of a canal, is inserted in one of the manuscripts that Leonardo used during the last years of his life. The manuscript is in a small format, and is composed of ninety-six sheets, like two other codices from the same period, Manuscripts G and F. It obviously represents a size that Leonardo considered to have the optimal number of pages for a small volume, while not being too heavy or cumbersome to carry. He travelled frequently, and the ease of handling the materials he needed to record his thoughts would have been important.

Manuscript E contains a relevant biographical note about Leonardo's transfer from Milan to Rome in 1513. Can we thus deduce that the design for the dredger also dates to the years he spent in Rome? We cannot be certain. The presence of a date in one of Leonardo's manuscripts does not exclude the possibility that he may have made earlier notes in the same manuscript. What is certain is that while in Rome Leonardo was involved in an undertaking for which machines like the one drawn in Manuscript E would have been quite useful: the grandiose land reclamation project of the Pontine Marshes, the area south of Rome between Sermoneta and Terracina, close to the Tyrrhenian Sea. In 1514, Pope Leo X gave his brother, Giuliano de' Medici, the task of initiating the land reclamation. A document mentions the 'highly skilled land-surveyors' – that is to say, the group of engineers undertaking the project. Leonardo was among these. Giuliano de' Medici, powerful brother of the Florentine pontiff, was Leonardo's patron in Rome. Also, among the folios by Leonardo kept in the British royal collections there is a magnificent drawing (Windsor RL 12684) giving an aerial view of the entire Pontine flatlands around Mount Circeo, the land reclamation area. Leonardo even indicated the work that had to be done: clearing the mud from Rio Martino that periodically overflowed, and carrying out a series of works that would contain this and other waterways by digging ditches and channels. Could it be that the dredging machine was part of these projects? Even while in Milan during the years immediately preceding this period, Leonardo worked for the French on the containment of waterways. Thus, it is certainly possible that the studies for the dredging machine, if not made during the Roman undertaking, were useful in Milan.

After making the drawing, adding the title at the top and the main notes below, limited space meant that to add further observations Leonardo was forced to use smaller writing, squeezing in a long note along the lower margin and another in the right margin.

fig. 1
*Folio 75v from Manuscript E.
The upper portion of the page shows
a carefully drawn dredger in action.
Below, an articulate series of notes
describes its structure and workings.*

fig. 2
*Overhead view of the dredger. The double-hull
boat structure can be clearly seen.
It stabilizes the flotation, similar
to the modern-day catamaran.*

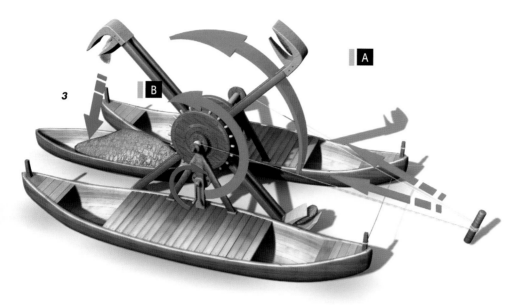

fig. 3
Diagram of the workings of the dredger.

fig. 4
Scoop wheel on the dredger.

fig. 5
View of the dredger as it dredges a riverbed, in a section diagram to show the riverbed.

fig. 6
Overall view of the dredger in action.

A The dredging machine is comprised of two boats parallel to one another with a large, scoop wheel in the centre that empties the material dug up from the river bed onto a barge.

B Leonardo designed a turn-crank mounted directly on to the axle of the scoop wheel that winds a cord around the hub. Because the cord is still anchored to the shore, the dredger automatically advances and the work progresses.

SCOOPS

MOORING

SCOOP WHEEL

RIGHT BOAT

BARGE

LEFT BOAT

CANAL

RIVERBED TO BE DREDGED

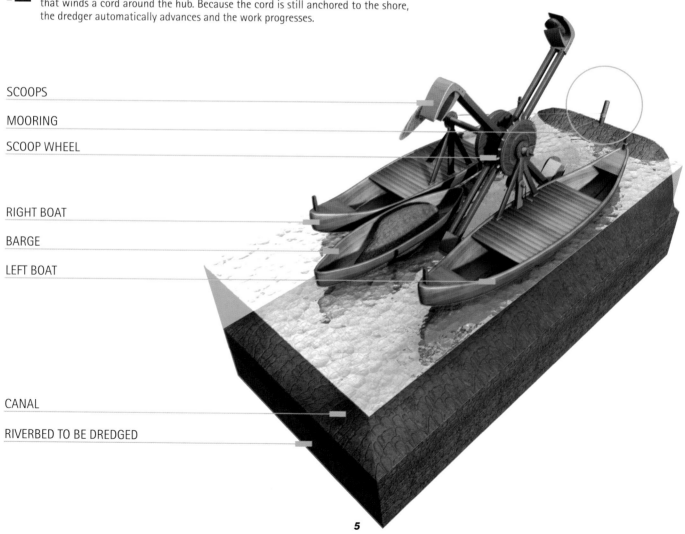

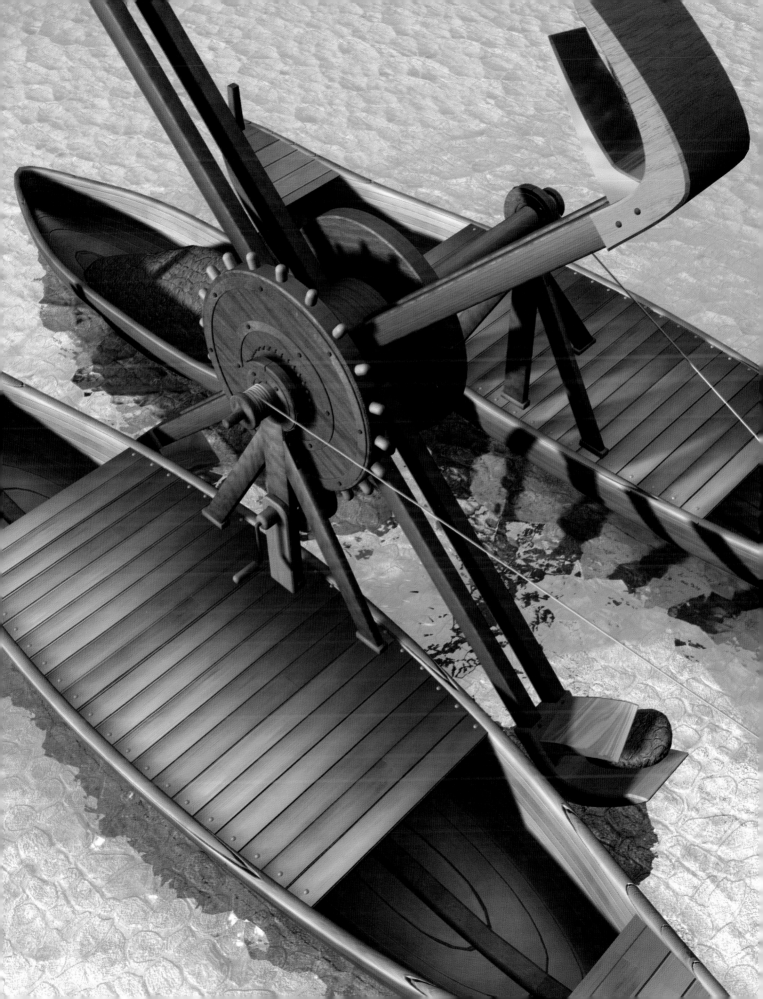

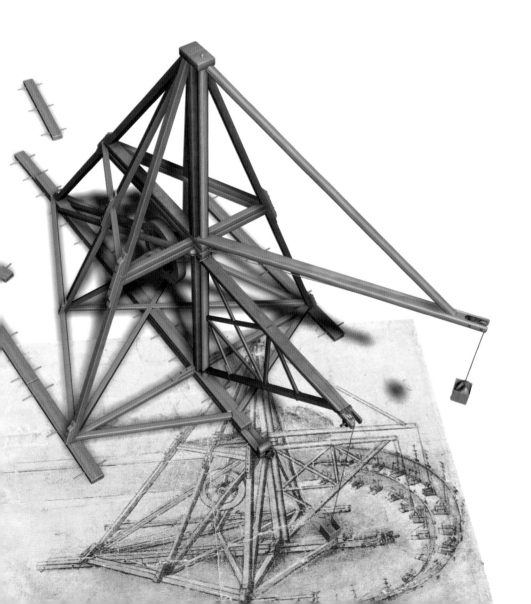

Metallurgy, hoists for lifting and placing materials on construction sites, machines for the textile industry: these were all different types of mechanical projects aimed at optimizing work efficiency that Leonardo worked on throughout his life. As in other areas of his work, before he could innovate he had to understand. During the late 1400s in Florence, Leonardo came into contact with two great schools of technical learning: Verrocchio's workshop, where he was apprenticed, and the Brunelleschi building site for the construction of the dome on the cathedral. Leonardo revealed the importance of Verrocchio's lessons in a late notation. On 27 May 1472, to the amazement of all present, Verrocchio completed Brunelleschi's great undertaking by placing an enormous copper-gilt ball on top of the dome. The casting of this sphere had been complex, and was carried out under the attentive eye of Leonardo. Forty years later, when faced with a similar challenge, Leonardo wrote: 'Remember how the ball on Santa Maria del Fiore was welded [...] in copper impressed in stone, like the triangles of this ball' (Manuscript G, f. 84v). Verrocchio's workshop produced not only sublime bronze statues but utilitarian objects in metal such as bells or armour. When he entered the workshop as an apprentice painter, Leonardo found himself in a very versatile environment. It does not surprise us, therefore, to find engineering designs by the young Leonardo for reverberatory furnaces and burning mirrors (for example, Codex Atlanticus, f. 87r). The practical purpose of these designs is quite clear: burning mirrors were used to fuse or weld metal through the concentration of heat produced by reflection, and reverberatory furnaces fused metals using the heat of the fire indirectly as it rebounded from the walls.

During this period, reflection was a phenomenon that greatly interested Leonardo from another point of view as well. At the basis of optics and perspective was the complexity of optical and geometrical laws relating to the natural appearance of objects and their pictorial reproduction. It is most likely that Leonardo's knowledge of the theory of perspective influenced his more theoretical studies linked to the practical designs for burning mirrors. For example, on folio 87r in the Codex Atlanticus he drew a grinding device, a machine designed to give the correct curvature to a mirror by creating a parabolic curve, as in the section of a cone.

The machines used by Filippo Brunelleschi, which were crucial elements in the construction of the Florentine dome and the success of the entire undertaking, constituted the other great learning opportunity open to the young Leonardo. The invention of new machines for the site, along with innovative construction techniques, made it possible to build

the enormous structure without the use of a temporary framework. Many of the projects in the Codex Atlanticus (for example, ff. 808r, 1083v, 965r, 138r) point to the young genius's interest in these devices.

Leonardo's most important projects for textile machinery date from his years in Milan. Generally, in both Florence and Milan, the raw material, wool, was imported from Germany and Flanders. It was processed in three phases – cleaning the fibre, spinning (stretching, twisting and winding on to a bobbin) and weaving – to obtain a piece of fabric. Dyeing was another fundamental process. Machines were necessary for each of these phases. As seen in some of the studies in the Codex Madrid I (*circa* 1495) or in the Codex Atlanticus, Leonardo primarily designed machines used for spinning. Here again, before innovating he studied what already existed, and it may be that a very beautiful drawing in the Codex Madrid I (f. 68r) is not one of his own inventions but a very careful study of a spinning machine used in a Milanese mill. Other designs in the same manuscript are ingenious studies that go beyond beautiful graphics, concentrating directly on the mechanical content of the drawing while attempting to optimize the efficiency and speed of the device. For example, the design for a flyer spindle assembly in the Codex Atlanticus (f. 1090v) attempts to synchronize three different operations: stretching the fibres, twisting them and winding the bobbin.

After 1500, during his mature phase, Leonardo more than once revisited his studies of metallurgy, cranes and construction-site machines, as well as textile machinery. By this time, however, his designs were increasingly intellectual and sophisticated. Some drawings of excavation machinery and hoists (Codex Atlanticus, ff. 3r and 4r) almost certainly date from the early 1500s. One of the machines operated by a treadle is slightly more traditional, and may have served as a point of comparison with a more innovative project where the problem of the driving force (lifting containers filled with earth from an excavation site) is solved by using weights and counterweights. The machine itself looks like an enormous set of scales, the materialization of one of Leonardo's studies on the behaviour of weights, *de ponderibus*, to which he dedicated himself with ever-increasing intensity. We are clearly beyond the empirical horizon of Brunelleschi's machines: in this machine, theoretical knowledge and the solution of practical problems are fully integrated.

A few years later, in Rome, around 1513-16, Leonardo's interest in metallurgy and textile machinery emerged in a new form. Manuscript G contains a series of notes on the construction of burning mirrors. More explicitly and systematically than during his youth in Florence,

this area of study was now enriched with theoretical content. Leonardo undertook complex research on reflection (for example, Codex Atlanticus, f. 750r), and in order to define the parabolic shape of the mirror with precision, he developed a complicated compass.

While at the Vatican, Leonardo had to be on his guard against unethical competition from a technician, a certain Giovanni degli Specchi (John 'of the mirrors'), who, like Leonardo, worked for Giuliano de' Medici, the brother of Pope Leo X. At one point in some of his notes on burning mirrors, Leonardo inserted coded words to make his designs less comprehensible. We do not know how knowledgeable Giovanni degli Specchi may have been, but the fact that he was German is significant. In fourteenth-century Germany metallurgy underwent important developments, correlated by the production of treatises. Only later in Italy were the works of the Sienese author Vannoccio Biringucci, and of course those of Leonardo, available to guide the scientific developments in this field. Thus, to have an untrustworthy German technician buzzing about must have created a sizeable problem for Leonardo.

It is possible that Leonardo's designs for burning mirrors were intended for the textile industry, which under the Medici pope was undergoing expansion in Rome. Nonetheless, it is interesting that in at least one case he envisaged a different destination for these studies: astronomy and the reflecting telescope (based on a note in the Codex Arundel, f. 279v). Leonardo also mentioned another cultural aspect of designs using mirrors, citing the way in which Archimedes had used them against the Romans in the defence of Syracuse. Even the two designs for twisting twine into very thick cords (Codex Atlanticus, ff. 12r and 13r) hold cultural significance. During this time Fra Giocondo dedicated the edition of the treatise with illustrations of machines by Vitruvius, *De architectura,* to Giuliano de' Medici. Leonardo, in turn, dedicated his two projects to the Medici and most likely to Giuliano, who was his patron and protector. On one of the two machines there is a handle in the shape of a ring set with a diamond: one of the most recognizable Medici symbols.

Vinci, 1452

1460

1470

1478-1480

1480

1490

1500

1510

Amboise, 1519

Codex Atlanticus, f. 30v

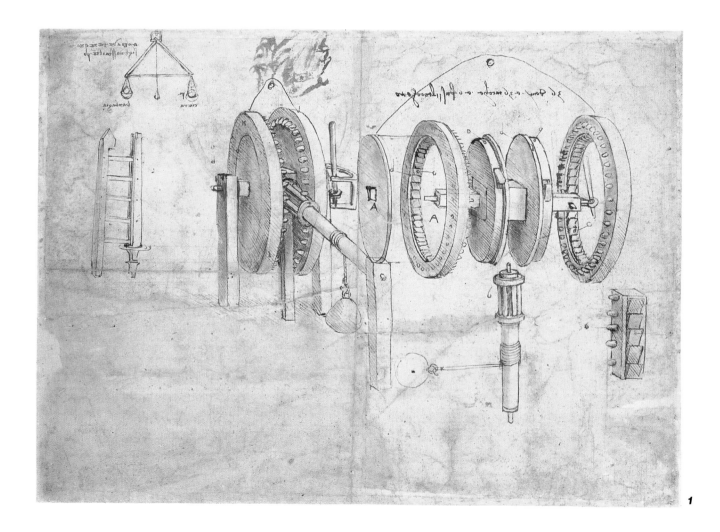

1

Reciprocating Motion Machine

It is probable that Leonardo initially drew only two designs on this page. The first is a hoist based on the transformation of the reciprocating motion of a lever into the rotary motion necessary to lift a weight. The second is a strangely shaped ladder, which appears to have no conceptual connection with the former. Both inventions, however, are presented in finished versions, with hatching and ink wash, and thus belong to the group of mechanical drawings used in presentations containing one or, at the most, two large-scale images (another example is found on folio 24r in the Codex Atlanticus). Francesco di Giorgio put together an album with similar drawings. As in other cases, the finished presentation represents a fleeting moment in his work and Leonardo has inserted a backward-written (and thus personal) note about the hoist. In the upper left corner he has also sketched an idea for a hygrometer, a system based on the use of a spongy substance capable of absorbing water on the left side of a balance, with a water-repellent substance – wax – placed on the opposite side. As the humidity in the air increases and water is absorbed, the scales tip further to the left, indicating a worsening in the weather conditions. Thus, before these additions, the folio was dominated by two magnificent drawings of machines, a traditional formula to which Leonardo has added his own radical innovations.

The design for the hoist is fully drawn with all the mechanisms fitted into one another. On the right side of the sheet, Leonardo shows these same mechanisms split apart, depicted in the same view and order of their relationship to each other. This is one of the first and most effective examples of an exploded view, an iconographical method that Leonardo would later apply systematically to other studies, including those on human anatomy. The presence of an exploded view in one of his youthful drawings for a machine brings up the question of cross-influence extending over various areas of his research. We have no anatomical drawings from this period (although various elements induce us to believe they existed). Nevertheless, based on the drawing here we can deduce that his machine design was at a reasonably mature level very early on, thus acting as a source of ideas for other fields: before human and animal anatomy, Leonardo drew the anatomy of machines. The relationship between the overall view and the exploded view is not the only revolutionary iconographical element used in depicting this machine. To the right, the shaft and a detail of the wheel are rotated and enlarged, and the repeated use of three letters suggests the main assemblage points between the various elements of the machine in the exploded view. Leonardo's visual language renders any additional text superfluous.

fig. 1
This folio contains one of the clearest and most explicit drawings by Leonardo. The full view of the machine is to the left, while the right side of the sheet shows an exploded view of the complex mechanism.

fig. 2
The reciprocating motion machine was an object of study. Based on the structure drawn on the folio, the device would have been able to lift considerable weight.

overleaf, following page, fig. 3
Working diagram of the machine.

fig. 4
An exploded view of the reciprocating motion machine, very similar to the one designed by Leonardo.

A

Essentially, the reciprocating motion machine was meant as a study tool: Leonardo wanted to find a way to transform reciprocating motion produced by an operator into continuous rotary motion. In this project the operator worked the lever moving it from right to left; each time the lever moved, the two large mechanical wheels rotated slightly in opposite directions, first one and then the other, but never simultaneously.

B

The two large mechanical wheels hide a complex system of concentric mechanisms enclosed in two circular housings. The internal gears are made up of a wheel similar to a large saw with a mono-directional profile and a mechanism attached to the lever consisting of an internal circumference and two metallic spring pawls. Each time the lever moves the internal teeth alternately engage the two large external wheels that transmit motion to the central axle. A rhythmic clicking noise is produced.

C

The opposite circular movements of the two large mechanical wheels engage a cage-shaped gear wheel mounted on-axis with the main shaft. This gear wheel turns only in one direction, alternately driven by both wheels. A line wound around the main shaft lifts the weight. Presumably, this project could have been used in civil mechanics, for example, in constructing a large-scale crane. A modern example of this machine is the mechanical jack.

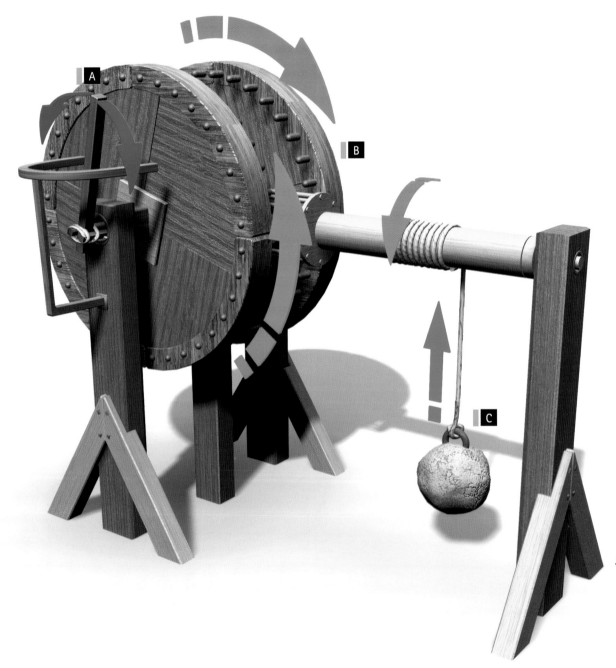

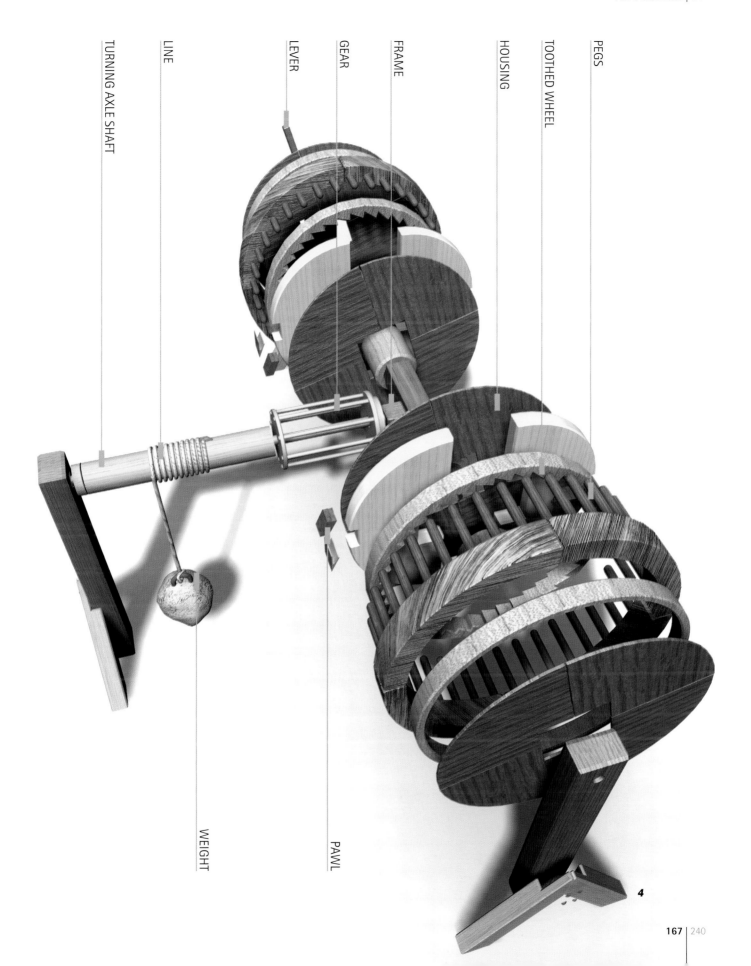

TURNING AXLE SHAFT

LINE

LEVER

GEAR

FRAME

HOUSING

TOOTHED WHEEL

PEGS

WEIGHT

PAWL

4

Vinci, 1452

1460

1470

circa 1480

1490

1500

1510

Amboise, 1519

Codex Atlanticus, f. 24r

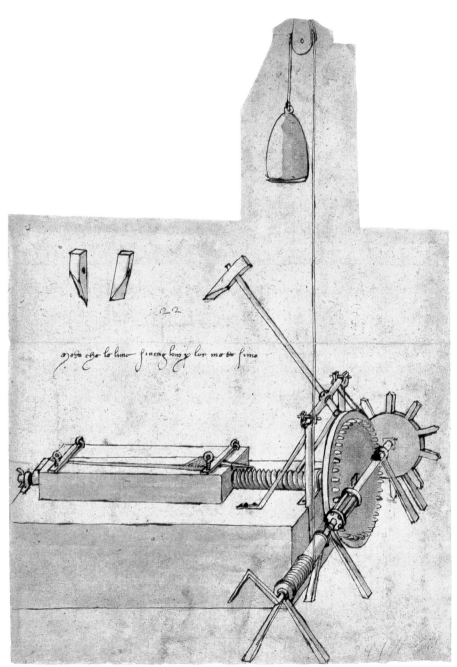

1

File-cutter

This folio contains a large, single drawing of a machine. The style of the drawing is well finished, with ample use of pen and ink and ink wash (a preparatory study is found on folio 1022v in the Codex Atlanticus). This page provides a perfect example of one of the ways Leonardo presented the drawings of his machines during the early years of his career. Although innovative in some respects, the different methods Leonardo uses to make presentation drawings are rooted in the great tradition of mechanical drawing. For the young Leonardo, as for the Sienese engineer Francesco di Giorgio, there were four principle forms of mechanical iconography: the private annotation (in the form of a sketch); the placement of a single machine on a sheet executed in a very finished style; the composition on a single sheet of many highly finished drawings of various machines (a sort of anthology of images); the integration of this combination with textual notes. Leonardo's drawing of a file-cutter is part of the second category of mechanical presentations.

The *Opusculum de architectura*, written by Francesco di Giorgio and dedicated to Federico da Montefeltro, Duke of Urbino, consists of a series of pages each with a very refined drawing of a single mechanical project. It is possible that Leonardo's drawing was conceived with a similar album in mind. Its use for presentation is confirmed by the fact that his handwriting for the caption goes from left to right ('*Modo che le lime s'intaglino per lor medesimo*'; 'Way to cut files'), adding a simple title to a page where the visual language of the drawing was intended to dominate and 'do the talking'.

The perspective used to depict the machine plays a fundamental role in the presentation of the image. The single viewpoint, from the upper right, permits a complete view of the machine, both in its form and the relationship of its parts. The use of perspective in mechanical iconography not only improved communication but also had significant cultural meaning. Just as in painting, machines benefited from the scientific value they acquired with the application of the laws of perspective, natural geometry and mathematics. This is one of the main advances introduced by engineers, artists and authors like Francesco di Giorgio. Before their time, a machine was depicted based on iconographical conventions. Francesco di Giorgio was the first to radically change the way machines were depicted by using perspective, thus clearly representing the reciprocal relationship between the various elements in the machine. As shown by his drawing of the file-cutter, even Leonardo moves in this direction, taking the process of culturally emancipated drawing to its zenith.

fig. 1
Leonardo's drawing is very clear and shows how the machine functioned and was used.

fig. 2
The height of the pulley was an important consideration in the correct functioning of the entire device.

2

A In order to work, the machine had to be wound up; an operator turned the crank thereby hoisting a weight attached to a line and pulley positioned above the machine. The height of the pulley ensured that it would continue to function for a period of time; the higher the pulley the more the machine was wound, thus functioning for a longer period of time. Presumably, an operator was not required except for winding the mechanism. In fact, once the machine was functioning it cut the files in a completely automatic fashion.

B As in many of his projects, Leonardo tried to automate production processes and relieve the burden on the operator. The purpose of this machine is to produce files. A piece of pre-cut iron is positioned and fixed with screw clamps to the moving bed; the bed slowly slides along the top of the machine engaged by a long, sturdy worm screw.

C A large worm screw turned slowly, and engaging with the threads in the bed, it gradually moved towards the right side of the machine.

D A heavy hammer fell at regular intervals and every time it struck the piece of metal on the bed it left a sharp incision. When the whole length of the iron piece was incised, the file was ready to use.

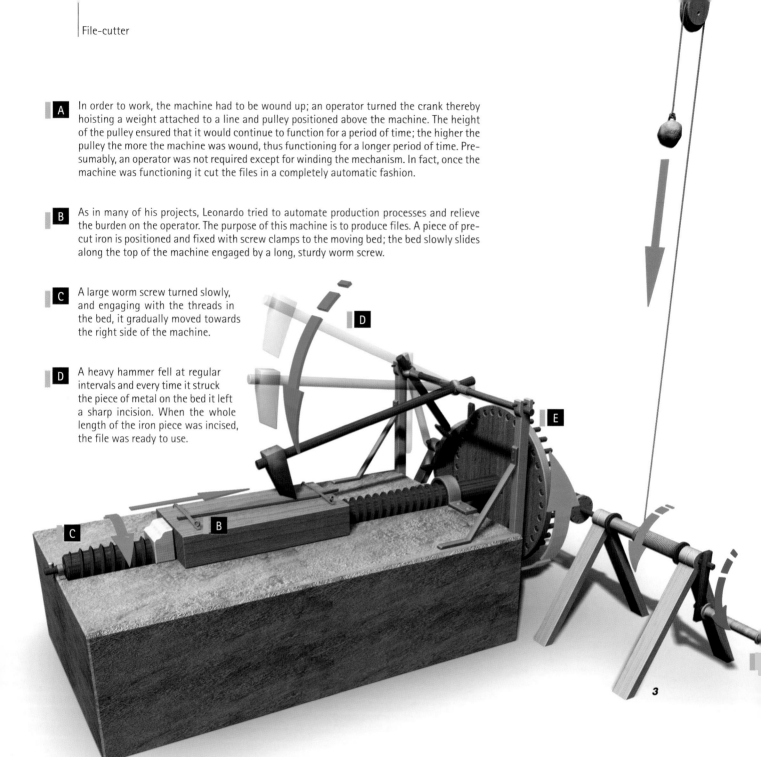

E The hammer falling on the file was regulated by a complex escapement system similar to the one used in watchmaking, but with much larger dimensions. A wheel periodically raised the handle of the hammer, but the same wheel once it finished its gear cycle let the hammer drop by gravitational force. The hammer was heavy and it struck the file with the force required to make the incision.

fig. 3
The diagram of the workings of the machine.

fig. 4
The main parts.

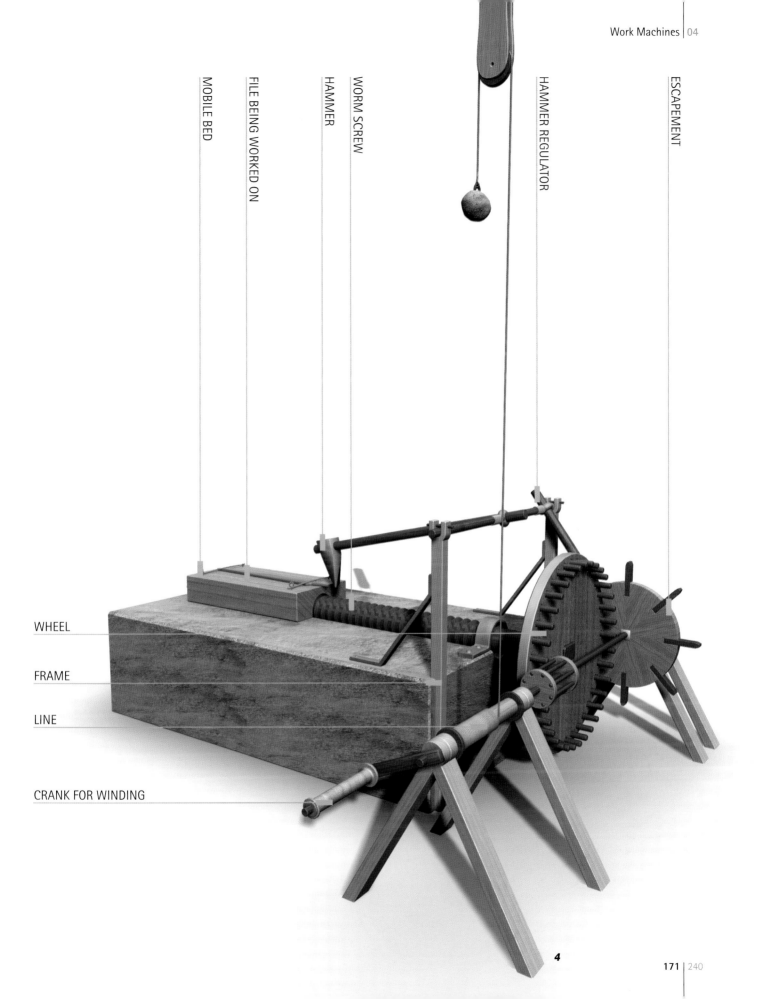

MOBILE BED

FILE BEING WORKED ON

HAMMER

WORM SCREW

HAMMER REGULATOR

ESCAPEMENT

WHEEL

FRAME

LINE

CRANK FOR WINDING

Vinci, 1452

1460

1470

circa 1480

1490

1500

1510

Amboise, 1519

Codex Atlanticus, f. 87r

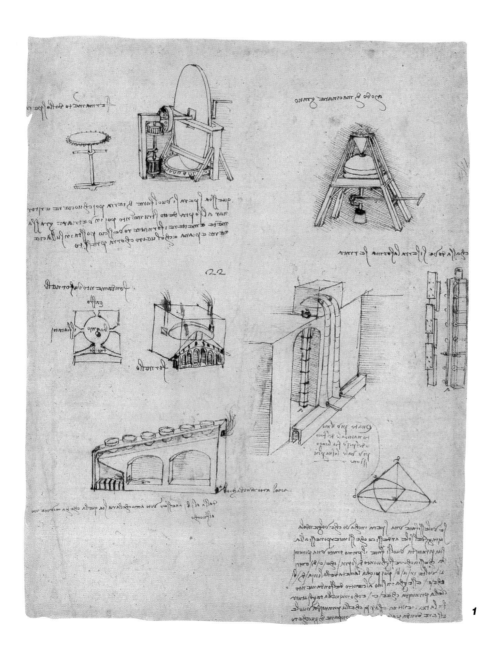

1

Device for Grinding Concave Mirrors

2

This page is typical of Leonardo's early years in Florence, where, in finished version and almost as an anthology of projects, he brings together various drawings. On this one page we find a grinding device used to make burning mirrors, a grist mill, and some ovens and burners. The disparate nature of the designs reveals their early, immature character. It was only later that Leonardo gave more theoretical rigour to his mechanical projects; for the moment he confronted every problem as a separate case, following an empirical scheme typical of the workshops of the time. Still, there are a few very interesting traces that seem to be steering Leonardo's thoughts towards the theoretical emancipation in mechanical design that would be fully realized years later.

The project in the upper left of the page deals with producing burning mirrors, used throughout Florentine workshops of the period. Verrocchio's workshop, where Leonardo did his apprenticeship, made and positioned the enormous copper sphere for the dome of the cathedral of Santa Maria del Fiore, and the sections of that sphere were welded together using a burning mirror. Leonardo himself recalled this memorable undertaking of 1472 when, old and famous, he made a note in Manuscript G referring to the experience as he returned to his studies on burning mirrors. The machine on this page certainly contains novel elements compared with what was used in workshops such as Verrocchio's. Nonetheless, even more surprising is the study on the lower right of the same page: a diagram indicating how Leonardo intended to define the curvature of the mirror geometrically, as a parabolic curve. He knew that paraboloids reflect the sun's rays by concentrating them in a point, or focus. 'Focus' is also a term used in perspective, the science based on optics, which for the artists of the *Quattrocento* was the principle tool of theoretical elaboration. Thus it is understandable that Leonardo tried to apply the geometrical certainty of optics and perspective to the construction of burning mirrors. A diagram on folio 1055r in the Codex Atlanticus seems to be a study in optics. In reality, it is a careful attempt to define the curvature of the burning mirror geometrically. These are only minimal attempts, brief out-of-bounds moments, but nonetheless meaningful given later developments. On the page with the design for burning mirrors and its relative geometrical diagram, there is also a design for a reverberatory furnace, which fires using reflected heat. This provides another example of theory spilling over from an area already recognized as science (perspective and optics for painters) into mechanical design, a field just beginning its journey towards that recognition.

fig. 1
In the upper part of the page there is a clear drawing of an automatic grinder for making mirrors; there are also a few handwritten notes.

fig. 2
The machine was used to make concave mirrors.

overleaf, following page, fig. 3
An image of the way the space around the machine may have looked, with an area for the finished mirrors, but also with heavy pieces of unworked stone.

fig. 4
The main parts of the machine.

A

When a man moved the lever, the various moveable parts of the machine were put in motion, completing their circular trajectories. But before working the grinder, the operator had to position a stone to be cut under the large millstone; the work involved to produce the concave stones must have been very tiresome due to the considerable weight that had to be moved. Once the lever was ready to be activated, the resistance and friction between grinding wheel and the mirror being worked must have been considerable. The interesting part of this grinder is the combined rotation of the grinding wheel and the stone; the rubbing of these parts evenly and uniformly smoothed the stone placed on the ground. Using an ingenious system of cage-shaped gears, one or more operators could make all these movements simply by turning the crank.

B

The grinder was a very heavy object. Presumably, given its resistance to movement, all the moving parts had to be lubricated. The grinding wheel, activated by the crank on the side of the structure turned very slowly. Because it was very large, however, the angular velocity of its perimeter guaranteed sufficient friction speed without having to turn the handle too quickly. The stone placed under the grinding wheel turned in a perpendicular direction, incrementing the friction speed between the parts.

C

Smoothing and polishing presumably could have lasted for several days. Once one job was finished the machine was ready for another smoothing. Most likely, Leonardo even thought of a system to change the stone using a toothed wheel housing; once the stone was in placed inside, it was positioned on the ground under the grinding wheel. Wedges, shown on the page, kept the pivot pin solidly in the ground.

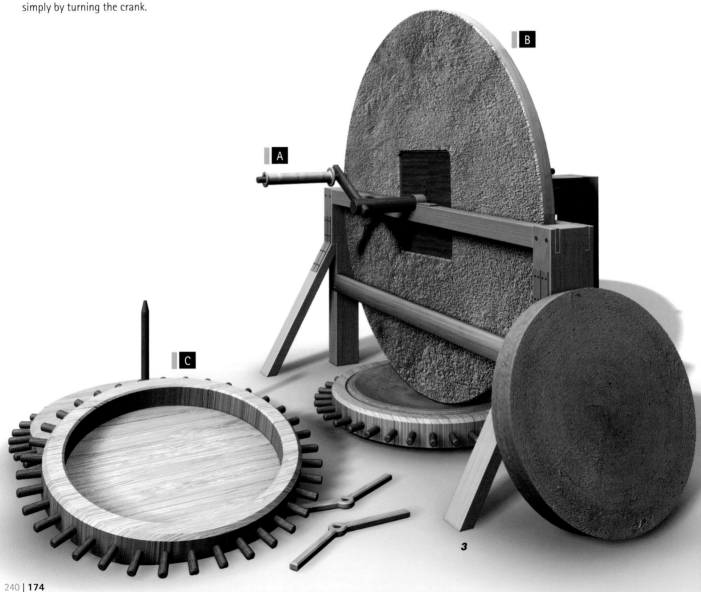

3

STRUCTURAL REINFORCEMENTS

FRAME

GRINDING WHEEL

TRANSMISSION

GEARS

STONE

CRANK

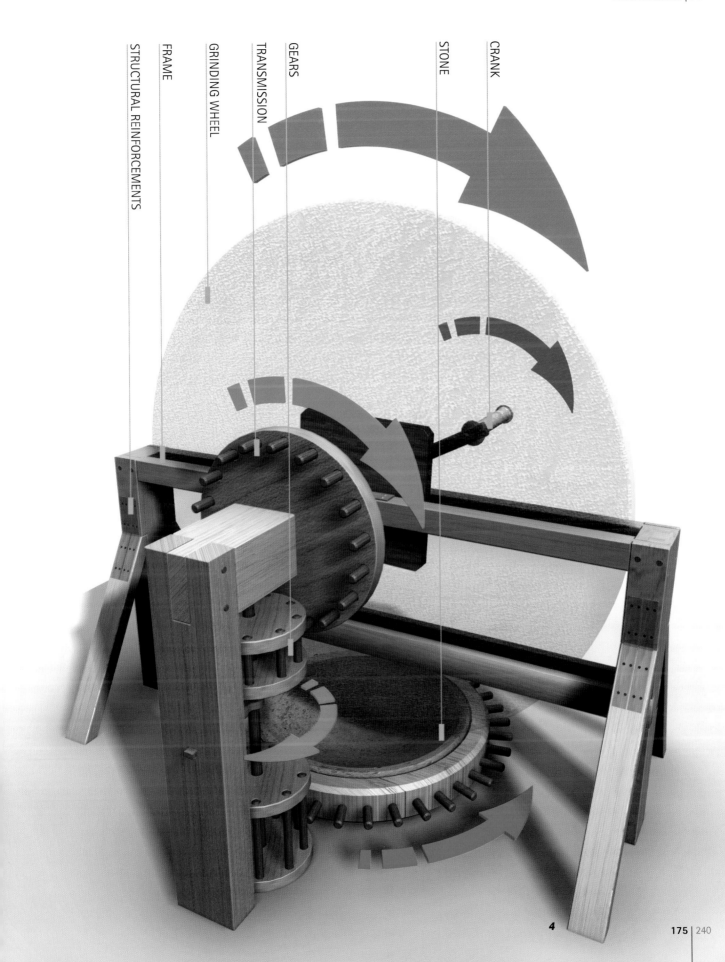

Vinci, 1452

1460

1470

1480

1490

1500

1503-1504

1510

Amboise, 1519

Codex Atlanticus, f. 4r

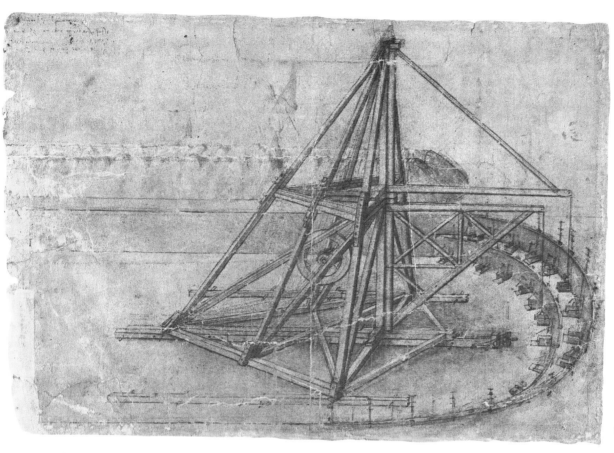

1

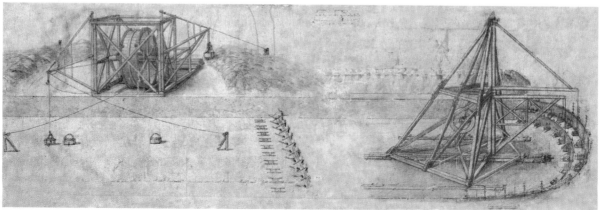

2

Canal Excavating Crane

This study, together with the analogous companion folio 3r in the Codex Atlanticus, is probably a demonstration model for a client. We know this because of its well-finished state. Leonardo first drew the general lines of the design in black pencil (traces of this first sketch can still be seen), then delineated the final drawing in pen and ink and finished with an ink wash. It is therefore a study that was not just jotted down, but a highly finished rendering. It was a common practice for engineers, sculptors and architects to create models before constructing a final work. By observing the model, the client could request changes, or accept a proposal and consent to undertaking the work. The designer could either create three-dimensional scale models, or make drawings, almost always finished in ink wash, accurate in the details and overall form. Some of Michelangelo's designs for Julius II's funerary monument, and for other architectural projects, were very similar in style.

It is probable that in using ink wash rather than his preferred technique of hatched rendering, Leonardo wanted to conform to the style normally used in presenting a drawing to a client. If the date of 1504 given to this folio is correct, the clients were probably representatives of the Florentine Republic. They had asked Leonardo to render the Arno River navigable, and thus this drawing would depict an excavating machine for a canal in the north of Florence, by-passing a section of the river that could not be navigated. In his youth, Leonardo had made comparable, highly refined drawings of machines set in the spatial context where they would function.

A characteristic of this drawing is the complete lack of any human presence. It is devoid of the agile figures that in earlier drawings transformed the presentation of a machine into a lively and animated scene. Leonardo portrays an empty construction site, emphasizing the intellectual character of this study: the machine has a calibrated, geometric form and is working on two very regular, curved levels of excavation. The containers are all evenly spaced and the excavation tools (some suspended in the air) give an exact idea of the number of workers required.

We do not know if Leonardo did, indeed, present these designs to prospective clients, or what their reaction may have been. This drawing, along with its pendant, remained with the maestro, who at some point inserted a notation on the page using his normal backward handwriting – a personal note regarding the two designs. Other less finished drawings for cranes from the same period are found on folios 905 and 944v in the Codex Atlanticus and on folio 96r in the Codex Madrid I.

fig. 1
Folio 4r from the Codex Atlanticus.

fig. 2
A digital reconstruction of folios 3r and 4r from the Codex Atlanticus. Some of the marks on the drawing lead to the supposition that the two pages were originally one; especially at the embankments of the excavation site where there is a perfect fit at the point where they could be joined together.

overleaf, following pages, fig. 3
Reconstruction of a hypothetical study model placed on the folio; it is very similar and surprisingly congruent with the 3D computer-generated view.

figs. 4 and 5
Diagrams for the workings of the crane.

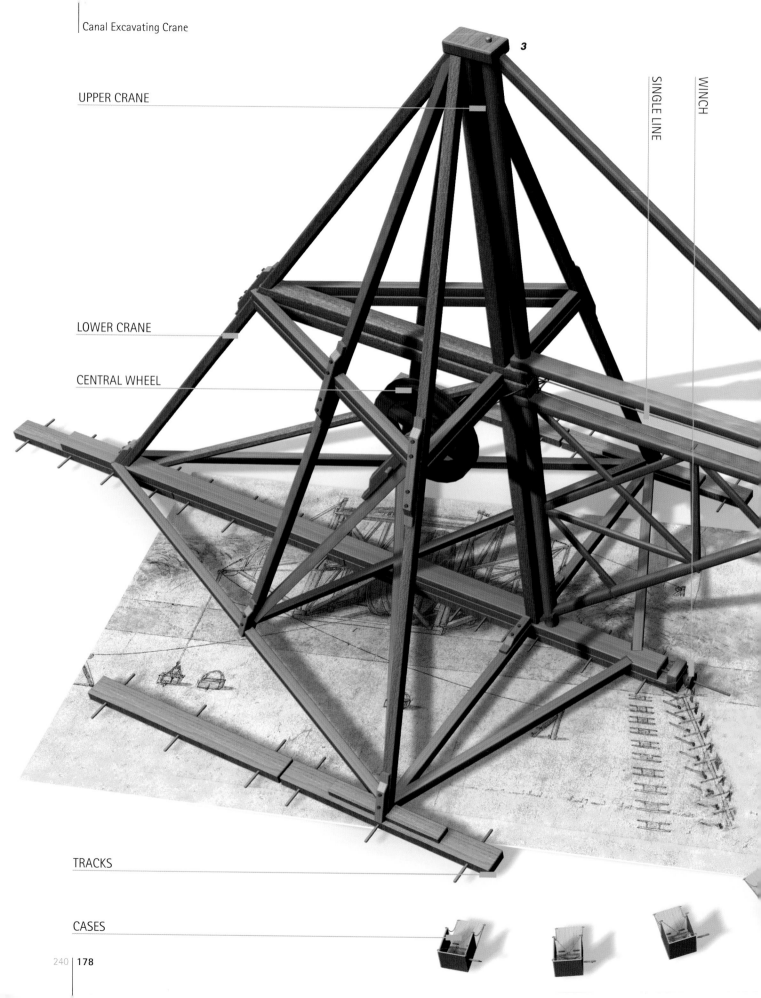

Canal Excavating Crane

UPPER CRANE

LOWER CRANE

CENTRAL WHEEL

SINGLE LINE

WINCH

3

TRACKS

CASES

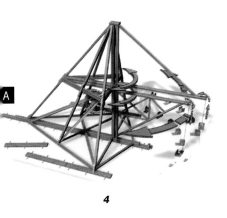

4

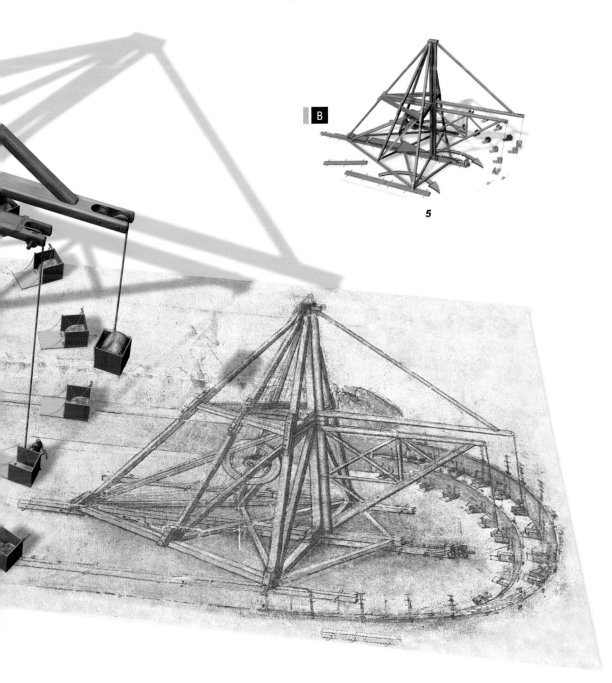

A Leonardo designed this machine to speed-up the time required to remove earth during the excavations for canals. Through an ingenious system of tracks and screws, the structure can be moved as the work advances. The machine consists in an enormous double-armed crane worked by a single cord and operating on the principle of a dumb waiter. The teams of diggers work on three levels, synchronizing their operations so that each time a container is filled with earth it is hoisted up, sending down the empty container with the diggers using it as a lift to return to their work stations.

B The work was organized as follows: while one team of diggers filled the containers at the bottom, another team emptied the container tied to the other end of the cord outside the canal. When the lower container was filled, the team on the outside – after having recuperated their energy – climbed inside the empty container to return to their work stations while the diggers on the bottom came up from the canal to empty the container filled with earth.

5

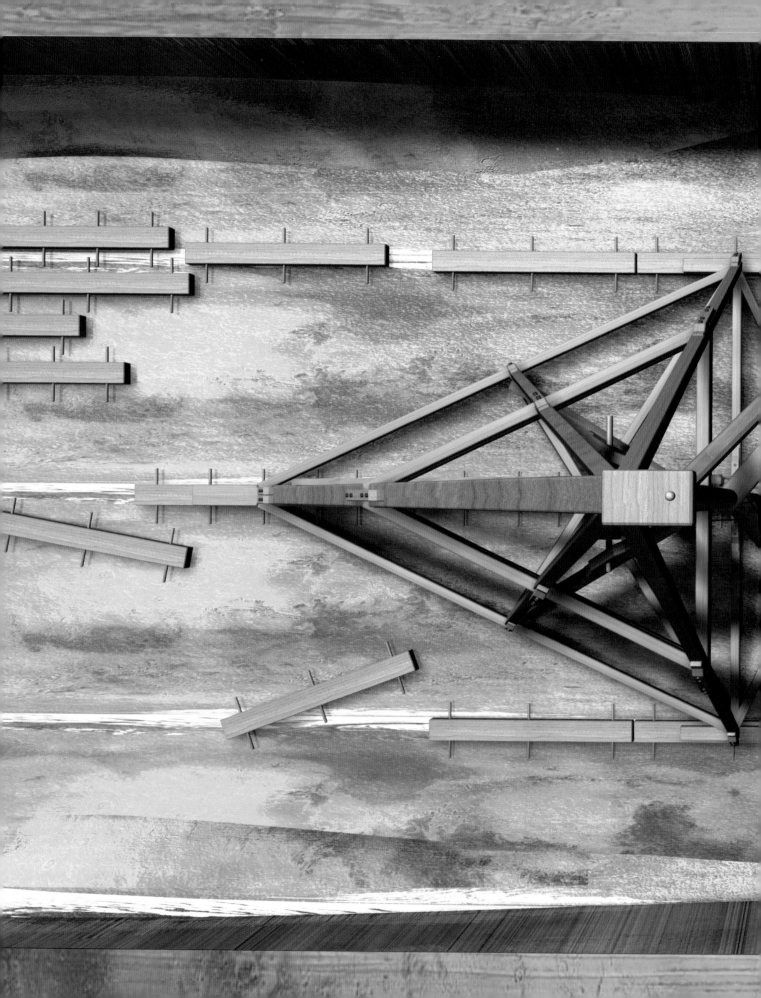

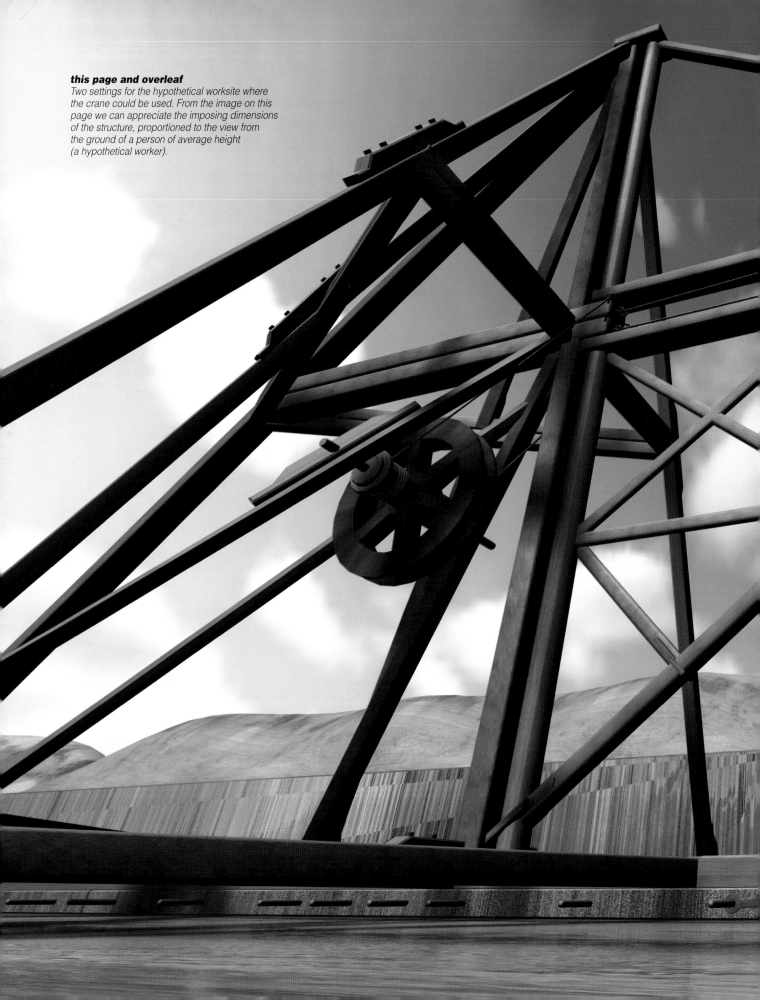

this page and overleaf
Two settings for the hypothetical worksite where
the crane could be used. From the image on this
page we can appreciate the imposing dimensions
of the structure, proportioned to the view from
the ground of a person of average height
(a hypothetical worker).

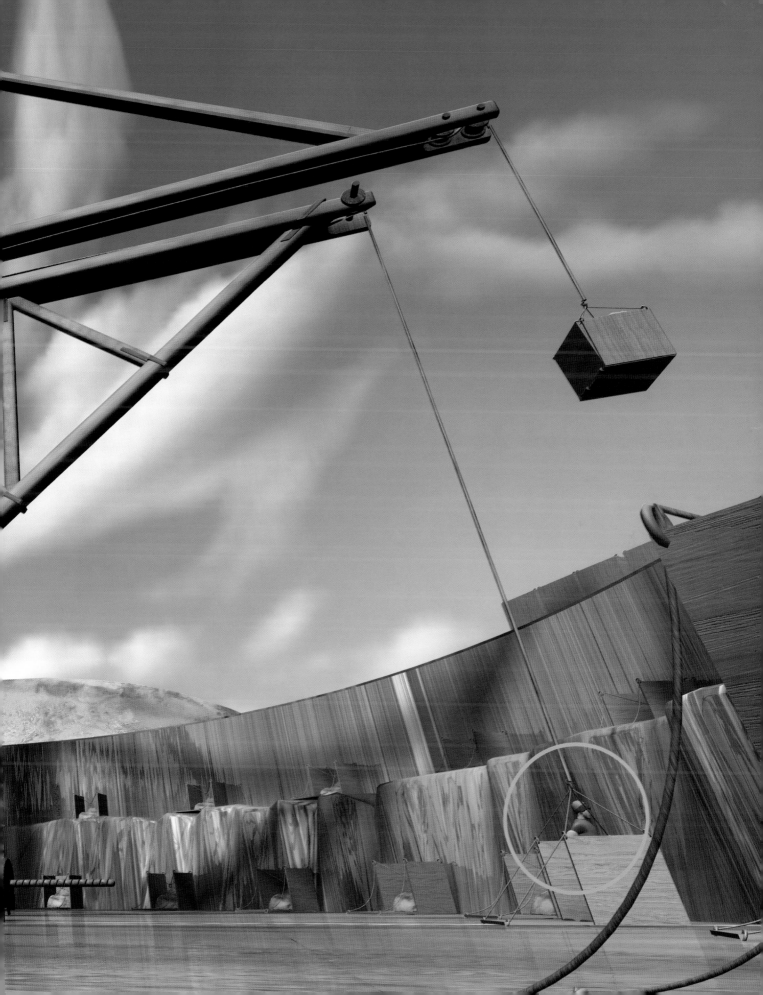

Self-propelled Cart
Theatrical Staging for *Orpheus*

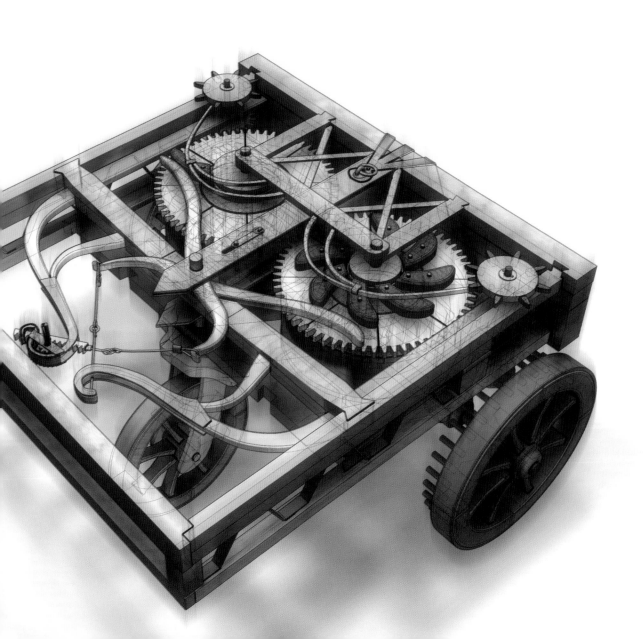

Many of the most important engineers and artists of the *Quattro-cento* were involved in making machines and stage settings for the theatre; they included engineers such as Giovanni Fontana and Brunelleschi, and artists ranging from Mantegna to Raphael. Leonardo was no exception. He designed theatrical devices and machinery even before leaving Florence; his talents in this field were used in Milan for the Sforza, as well as later in his life at the French court. Theatre during the Renaissance placed emphasis on the visual potential of dramatic productions, explaining the direct involvement of great artists and engineers. The set became a living painting, in which actors, artists and craftsmen all shared the same goal: to create a mimetic representation of reality, of an event. Normally, artists depicted reality through painting or sculpture; theatre offered the chance to create paintings or sculpture that imitated reality not only in form but also in movement. For this purpose, automatons were often used, not just in the theatre but also as part of festivals. In addition to the very popular sacred plays and pageants of the Middle Ages, secular theatre became well established. Previously, this type of theatre had been considered lowbrow. Now, however, it became the most widely appreciated form of dramatic presentation, especially among the more eminent levels of society.

It was natural, therefore, that all the great stage settings that Leonardo worked on were classical and secular in character (ranging from *Danaë* to the *Feast of Paradise* to *Orpheus*). Only during his earlier years in Florence do we find traces of interest in stage presentations of sacred plays. On the other hand, these religious productions did not come to an end with the emergence of secular theatre. In Florence, sacred plays and pageants continued to grow in popularity and fortune. We know that in 1471 Verrocchio's workshop, where the young Leonardo was apprenticed, was given the commission for the stage settings and scenery for some of the sacred plays performed for Galeazzo Maria Sforza during his visit to Florence. As we can well imagine, these sacred themes were the perfect stimulus for the inventiveness and imagination of the designers. Verrocchio was required to stage scenes in which structural elements or actors would be capable of special movements, such as ascending and descending from heaven. With these factors in mind, it is not unlikely that the first flying machine designed by Leonardo would have been for a stage set: a diabolical machine with webbed wings that simulated flight on cable supports.

The importance given to moving scenery and sets in the tradition of Florentine set designers would be fundamental to later developments in the da Vincian concept of theatre. As with the expression of other aspects of his creativity, in this area Leonardo progressed from a static

and harmonious concept to one that was more dynamic and naturalistic. In order to understand this development, it is important to mention another innovation introduced in theatre during the Italian Renaissance. In the sacred plays of the Middle Ages, while one scene was going on various scenes set in different environments, such as Pilate's palace or the garden of Gethsemane, would appear as 'side scenes'. The action in the various environments on stage infringed the Aristotelean principle of unity of action and place, and in Renaissance theatre these visually fragmentary spectacles were replaced by a unified scene, conceived and based on the criterion of perspective. The 'perspective setting' or 'urban scene' was developed by authors such as Baldassarre Peruzzi and Sebastiano Serlio, following the precepts of the great classical architect Vitruvius. The comic or tragic action of the dramatization was staged in an urban environment, with houses, piazzas and palaces seen in perspective. Leonardo seems to have reflected, and in a sense anticipated, this type of theatrical setting in a small drawing on folio 996v from the Codex Atlanticus. The perspective is the one that most probably characterized the scenery for the *Feast of Paradise*, a dramatic performance staged by Leonardo during the 1490s for the Sforza court. Leonardo had astonished the audience by depicting Paradise by means of a large hemispherical canopy in which actors rotated, each representing a planet. In the best Florentine tradition it was a dynamic structure, which must certainly have favourably impressed the Milanese court, unaccustomed to such conceits, with its extraordinary motion. Nonetheless, based on the descriptions, we can say that despite its dynamic motion the device was dominated by a strong sense of order and harmony, in keeping with the nature of the subject matter: the Aristotelean concept of the movement of the spheres through the heavens.

The 'perspective stage setting' elaborated during the Renaissance presented a very static environment and, like perspective itself, was ruled by geometric order. Many years later, again in Milan, which was dominated by the French who had driven out the Sforza, Leonardo created a stage setting for the myth of Orpheus, and we are presented with just the opposite concept. Leonardo had returned to dealing with theatrical spectacles, as attested to in a page of the Codex Madrid I (folio 110r). In this case he designed a theatre consisting of two semicircles that, while rotating, could be transformed into an amphitheatre. This mobile theatre combined in one structure the two main forms of classical theatre: the semicircle of Greek origins, used for

theatrical, musical and literary events, and the amphitheatre, with its Roman origins, designed for gladiatorial spectacles. It was not an original invention, but rather an attempt – if only academic – to reconstruct Gaius Curio's hemispherical theatre, a mobile wooden structure described by Pliny the Elder in *Naturalis Historia*.

In this context, Leonardo's interest in the dynamic aspect of theatre should be stressed. A good number of drawings are still extant relating to the staging of *Orpheus* (Codex Arundel, ff. 231v, 264r; Codex Atlanticus, f. 363 and a folio once part of the Atlanticus, recently found in a private collection). It is clear from all these sketches that Leonardo's concept of a stage setting was now the opposite of that held by the theoreticians of Renaissance 'perspective staging', at one time cherished by Leonardo himself. The *Orpheus* setting is strongly naturalistic: there are no buildings, but instead a series of mountains and valleys. On the other hand, it is very dynamic in character: at one point, one of the mountains splits open and the terrifying figure of Pluto (or Hades) and other diabolical creatures arise from the underworld. Even if these quick sketches do not specifically depict it, it is possible that the figures were winged, perhaps with flapping wings like those he designed in his youth in Florence. Thus, Leonardo's conception of stage settings was developing along naturalistic and dynamic lines, completely consistent with the other areas of his research during this period (for example, the evolution from geometric perspective to aerial perspective).

During the last years of his life, Leonardo continued to work on inventions for pageants and stage events. For example, for a festival in Lyons put on by Florentine merchants in honour of the new king of France, François I, Leonardo designed an automaton, a lion, which after advancing, opened its chest spilling lilies on to the stage. Just like his work machines from this period, such *ingegni* for the theatre are packed with symbolism revolving around the complex games of political power: the lion is the symbol of Florence and at the same time refers to the French city of Lyons; the lilies are the symbol of the King of France. The message is clear, and the purpose is to thank François I, on behalf of the Florentines and thus the Medici, for having advanced into Italy and reconquered Milan. Perhaps even some of the last, sublime drawings made by Leonardo in France contain references to the theatre: on one side drawings of figures dressed in various costumes, on the other, drawings for an equestrian monument (both conserved at Windsor Castle). The former may be studies for theatrical costumes, the latter the design for an equestrian monument to be used as a background set for a pageant or spectacle.

Vinci, 1452

1460

1470

1478-1480

1480

1490

1500

1510

Amboise, 1519

Codex Atlanticus, f. 812r

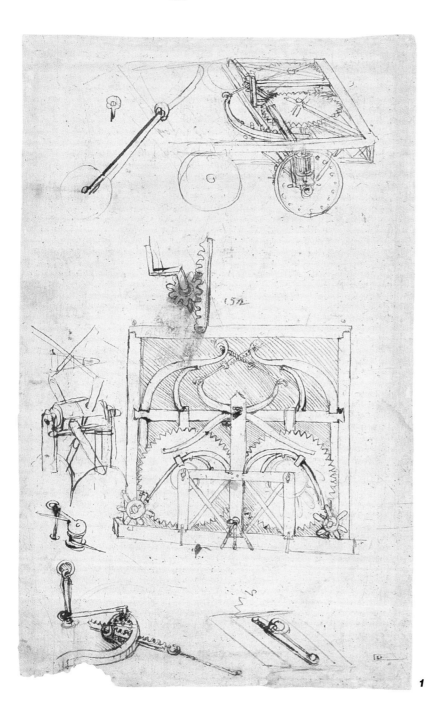

1

Self-propelled Cart

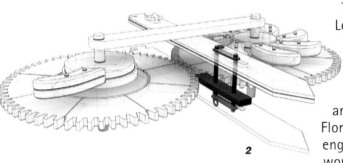

2

Though it is no more than a hypothesis, the use of Leonardo's famous 'automobile' in a theatrical setting is a very interesting possibility. The first ideas for the flying machine were also conceived in Florence during Leonardo's formative years, and appear in the margins of studies and designs for the mechanical wings of angels and devils in religious dramas, a very popular genre in Florence during the 1400s, involving first-class artists and engineers such as Filippo Brunelleschi. This folio is a typical working page, and just like more finished drawings meant for public presentation it shows the importance that visual language, transmitted through drawing, had for Leonardo.

The 'work-in-progress' nature of these drawings, and the fact that not all the details are fully drawn, have created difficulties for both past and present interpreters of this design. Leonardo drew an idea and then elaborated just a few of the details involved with that phase. More than with the presentation drawings, which often ended up appearing either whimsical or heavily theoretical, here we feel the concrete presence of a workshop. In fact, these drawings seem to be conceived as clarifications – for himself or others – on how to put together various parts of the mechanism.

Leonardo worked on locomotive systems in other contexts. War machinery was certainly an area where he often had to solve problems quickly, such as those posed by the transport of heavy cannons. In this field he introduced various innovations related, for example, to the wheel sections or their alignment. He also worked on locomotive systems themselves, and one of the devices he used most often was the three-wheeled cart. In an early drawing (Codex Atlanticus, f. 17v) he contrived an interesting method of auto-locomotion, worked by one or two men placed inside the cart through an ingenious system of dynamic transformation and multiplication. However, even though this was more advanced than the improbable sail-carts pushed by air that appear in the manuscripts of a few of his fifteenth-century predecessors, it was still based on gears made from wheels and pinions, and the friction would have been too great to be overcome by the operators. The system of the self-propelled vehicle proposed here is based on the use of springs, a mechanical component Leonardo was to analyse carefully in the *Treatise on the Elements of Machines*, and would apply to some of his studies for the wings of the flying machine.

fig. 1
One of Leonardo's most interesting, fascinating and well-known designs is on folio 812r of the Codex Atlanticus. For years it was interpreted as 'Leonardo's automobile'; only recently has it revealed its true nature.

fig. 2
A technical image of Leonardo's complicated project.

A

Two large spiral springs underneath the horizontal cogwheels provide the motive power. The springs are enclosed in a wooden drum and are wound in inverse direction. Leonardo often used spring-propulsion systems, especially for watch mechanisms.

The two drive springs, directly connected to the horizontal cogwheels, release the accumulated energy rotating them inversely. The two wheels are coupled and transmit the accumulated energy to other mechanisms on the cart. Their direct coupling excludes any possibility that Leonardo had conceived of a differential mechanism. A single spring would have sufficed to propel the vehicle, however, two springs give a more elegant, symmetrical solution; also, their energy is added together.

B

The devices on the corners of the cart transmit motion to the wheels as well as setting off a pair of leaf springs that can be seen on the top of the cart. The pins of the two corner wheels rhythmically hit the ends of the two leaf springs. The corner device on the left side represents a system of escapement similar to that used in watches. The system regularizes the release of the drive springs. Leonardo was well aware that the energy released by a spring is not constant. In order to avoid a jerky start followed by speedy deceleration, he has equipped the cart with an escapement that guarantees a uniform release of power, marked by the rhythmic, audible 'clack' of the pins striking the end of the leaf springs.

C

A small drawing represents a device that is essen-tial for the functioning of the cart: the remote control handbrake. This consists in a fillet, mo likely made of wood, that slips along a mouldin The fillet is pushed into the teeth of the two ho izontal wheels. Thus, after the drive springs ha been wound, the two horizontal wheels are pr vented from rotating and the cart remai stationary. A cord can be attached to the ring the sliding moulding to release the horizont wheels and put the cart in motion.

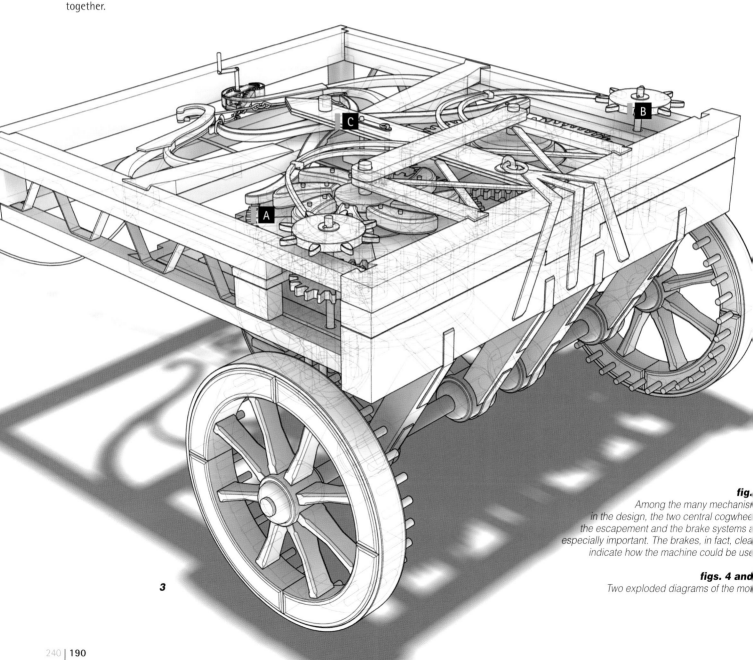

fig.
Among the many mechanis
in the design, the two central cogwhee
the escapement and the brake systems a
especially important. The brakes, in fact, clea
indicate how the machine could be use

figs. 4 and
Two exploded diagrams of the mo

3

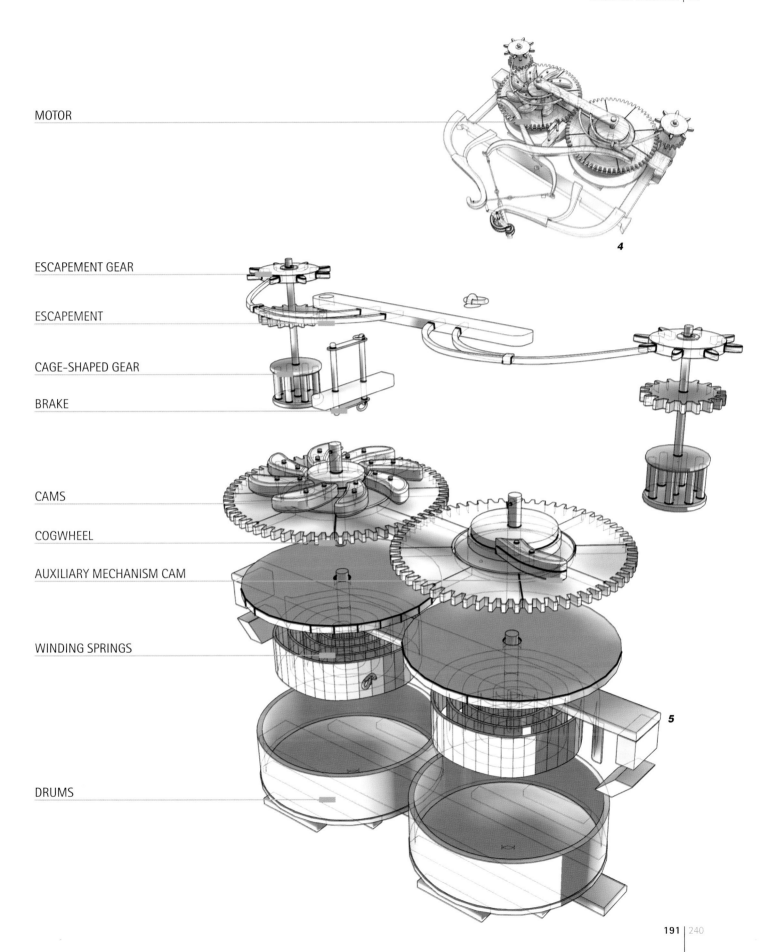

MOTOR

4

ESCAPEMENT GEAR

ESCAPEMENT

CAGE-SHAPED GEAR

BRAKE

CAMS

COGWHEEL

AUXILIARY MECHANISM CAM

WINDING SPRINGS

5

DRUMS

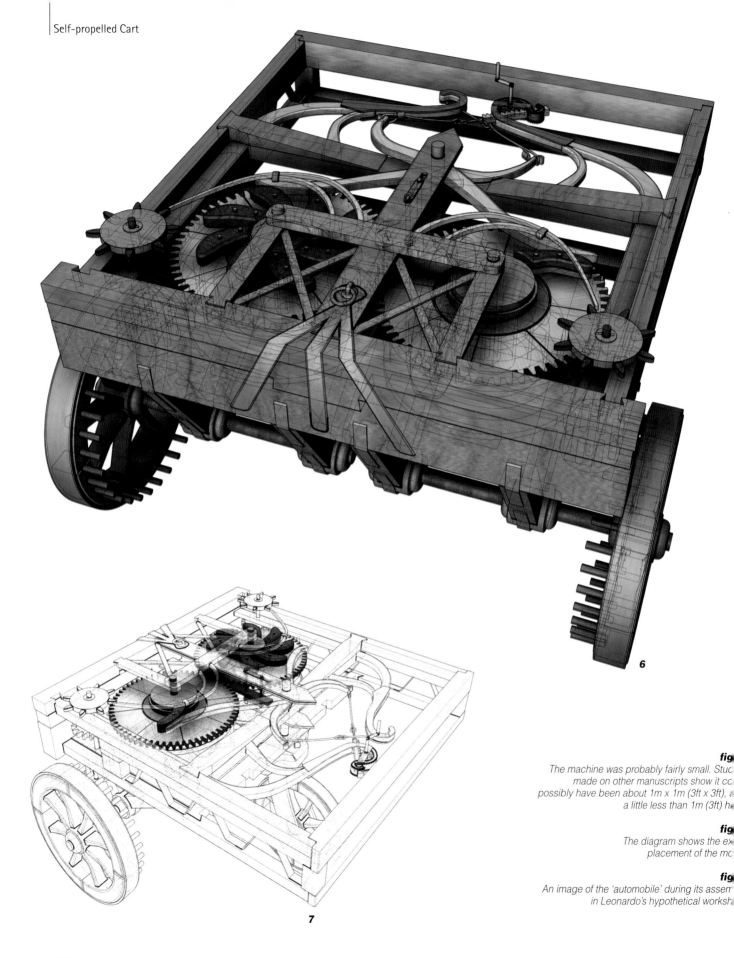

6

7

The machine was probably fairly small. Stud
made on other manuscripts show it cc
possibly have been about 1m x 1m (3ft x 3ft), a
a little less than 1m (3ft) h

The diagram shows the ex
placement of the mc

An image of the 'automobile' during its assem
in Leonardo's hypothetical worksh

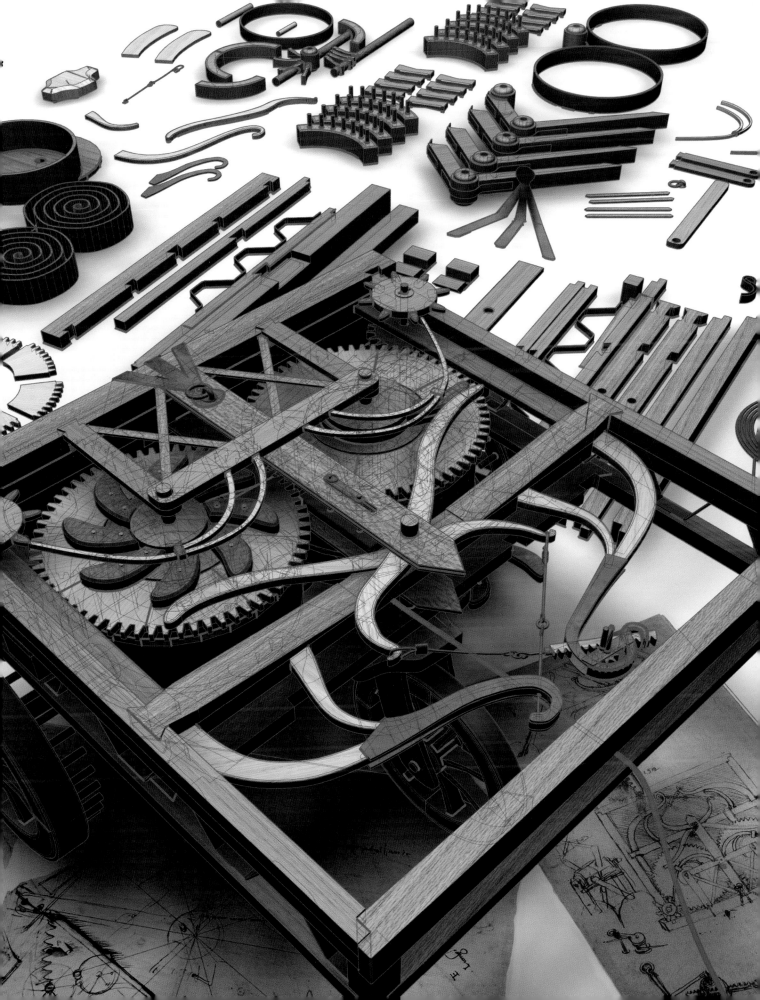

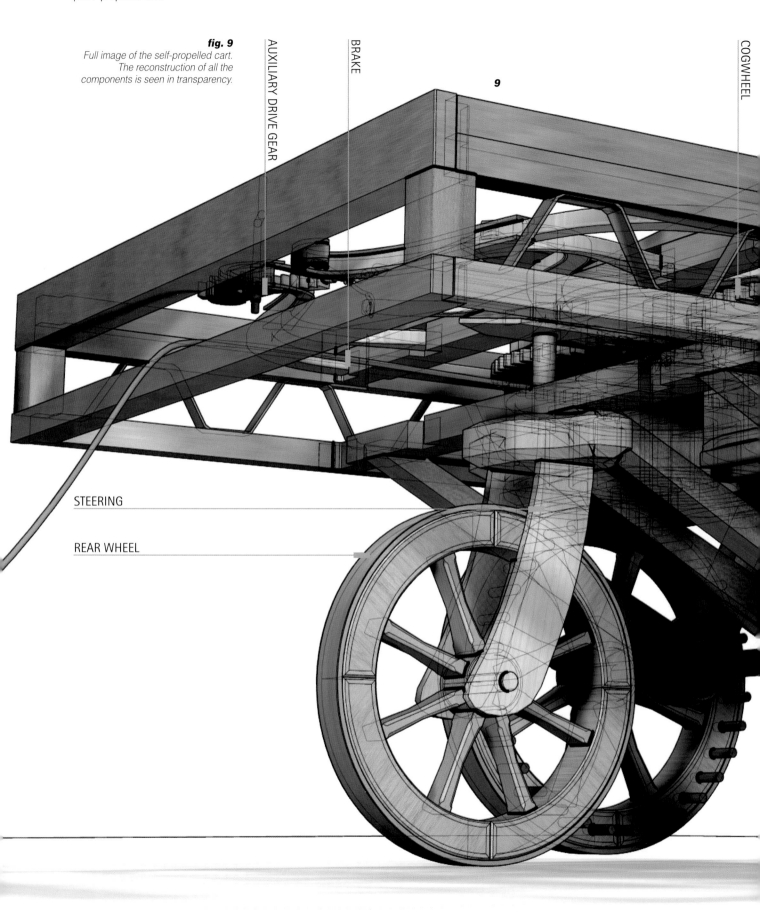

fig. 9
Full image of the self-propelled cart.
The reconstruction of all the
components is seen in transparency.

AUXILIARY DRIVE GEAR

BRAKE

9

COGWHEEL

STEERING

REAR WHEEL

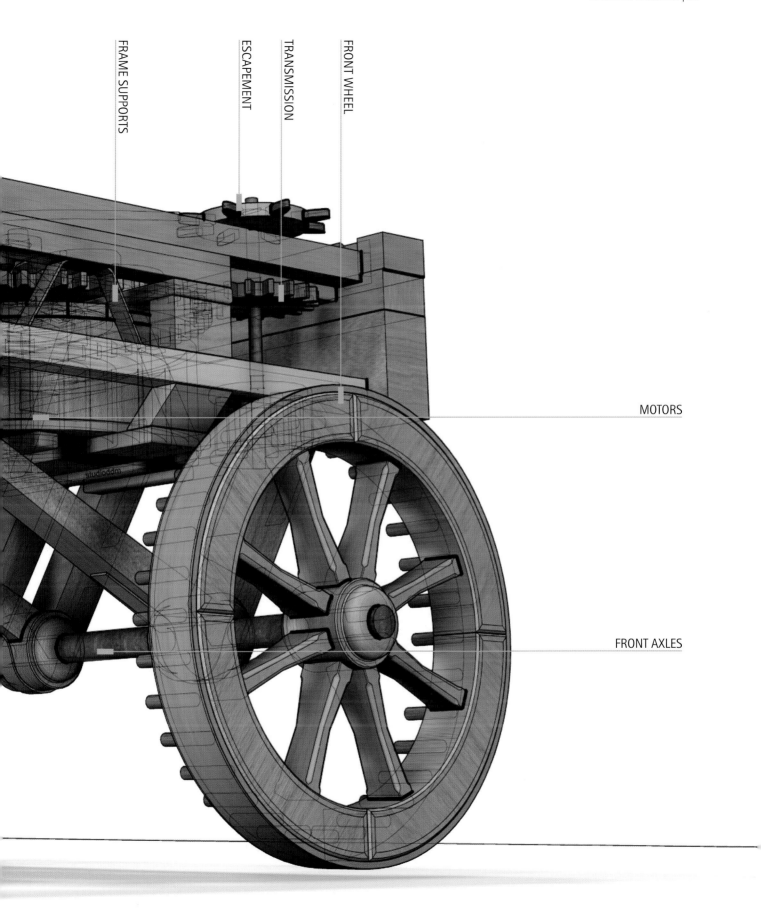

FRAME SUPPORTS

ESCAPEMENT

TRANSMISSION

FRONT WHEEL

MOTORS

FRONT AXLES

Codex Arundel, f. 231v

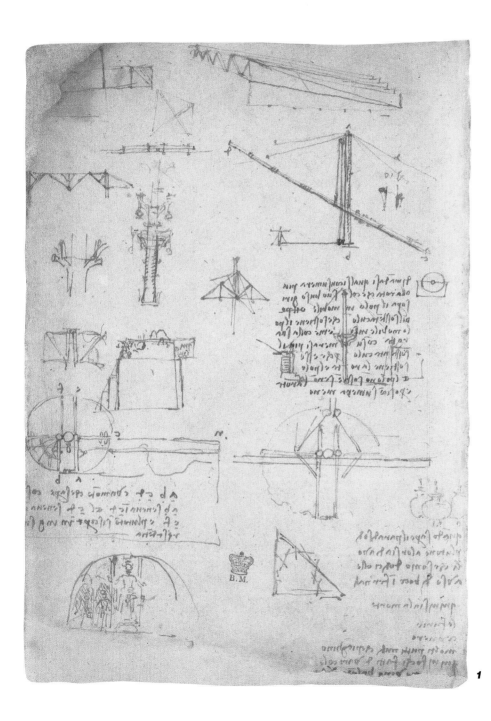

1

Theatrical Staging for Orpheus

One of the activities for which Leonardo must have been most highly appreciated by the various courts that employed him was the staging of theatrical spectacles. The ephemeral character of these stage sets means that we have little evidence of one of the most fascinating aspects of his work. One of the very few works for which there is still some trace is the staging of the myth of Orpheus – the tale that recounted the tragic love of Orpheus and Eurydice. The spectacle was produced during Leonardo's second stay in Milan, and was therefore put on for the recently installed French government. Evidently, Leonardo's fame as a director of theatrical spectacles for the Sforza had brought him this commission from the new rulers.

The setting designed by Leonardo has been handed down in a series of sketches on two pages of the Codex Arundel, a page in the Codex Atlanticus and another that is part of a private collection. Two fragments from this last page have recently come to light and show drawings for a mountain and female figures, perhaps the Erinyes (or Furies) swooping down on Orpheus. All these fragments give us a fairly precise idea of the type of staging Leonardo had in mind, and two elements characterize the scene: naturalism and dynamism.

In order to understand the originality of this design, we should remember that the most popular staging during the Renaissance was the so-called 'perspective setting', dominated by a series of buildings in perspective. The perspective scene was essentially urban and static. For the drama of *Orpheus*, Leonardo created a naturalistic space, with valleys and mountains, in which the first, bucolic part of the drama, the courtship of Orpheus and Eurydice, would unfold. At a certain point, the scene would open up, the mountains fade into the background and from the depths of the earth Pluto would emerge with his infernal entourage; the setting for the second, tragic part of the tale was the underworld itself. Leonardo described this moment of the drama very effectively in a note on folio 231v: 'When Pluto's Paradise opens, let there be devils with bellowing infernal voices. Here also Death and the Furies, Cerberus, many naked *putti* who are sobbing; also flames made of various colours [...] that dance about.' Pluto's 'Paradise' is of course hell, and the whole scene recreates a moment in the myth of Orpheus and Eurydice just as Poliziano had described it in *Orpheus*, a dramatic work that was already renowned for its famous staging in Mantua in 1490.

fig. 1
Interspersed among Leonardo's various codices there are designs for theatrical machines; opposite is a drawing from the Codex Arundel, but there are others in the Codex Atlanticus and in private collections.

fig. 2
A part of the set illustrated in the Codex Arundel and in other codices.

overleaf, following page,
fig. 3
Workings of the mechanism on the set. The blue arrow indicates the movement of the machine when weights or two to three people are placed in the container.

fig. 4
Sequence showing the three working phases of the theatrical scene: curtain closed, opening, and completely open, with the appearance of the actor on stage.

fig. 5
Main parts of the theatrical staging.

2

A The sequence of images here shows in simplified form the opening of the theatrical staging. While the play was going on, the dome was part of the mountain scenery. Of course, instead of being perfectly spherical, it could be made in various shapes out of papier mâché and painted very realistically. Also, due to its light weight, it could be constructed with very large dimensions. The models of mountains hid from view the complicated system of pulleys and tie-rods that allowed the whole system to move.

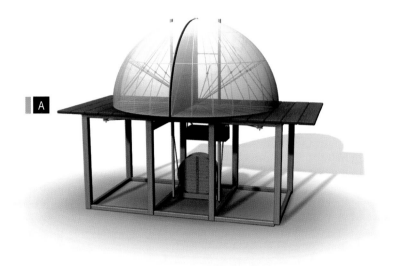

B At a precise moment, and with considerable theatrical effect for the times, the entire set was made to open, revealing a second stage. The circular movement of the two enormous domes not only opened on to a new scene, but also brought the protagonist on stage. In fact a platform with the actor 'waiting in the wings' emerged on to the scene.

C Once the two large domes had finished their movement they were entirely opened to the public, creating a new acting space for the actors and the new character who had just appeared before the audience.

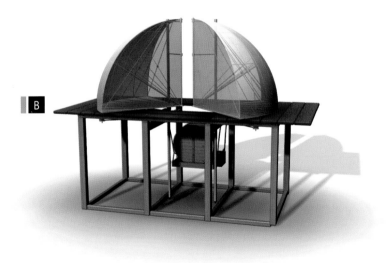

D The working of the mechanism was very simple. Initially, the actor was in position below the stage on a small platform that worked like a lift. Behind, stage operators were ready to load a container with weights. Once loaded, like a counterweight, the container dropped while at the same time lifting the protagonist on the platform and moving the entire mechanism that opened the domes. Another possibility is that it was the operators who lowered themselves into the container at the right moment.

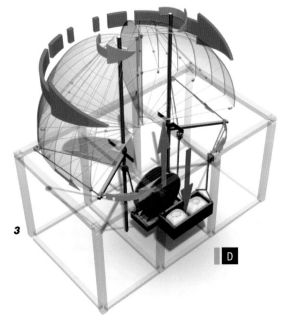

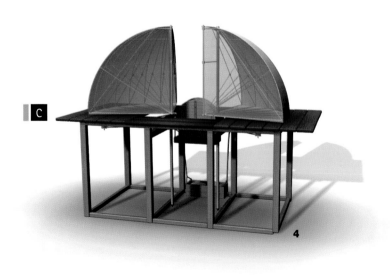

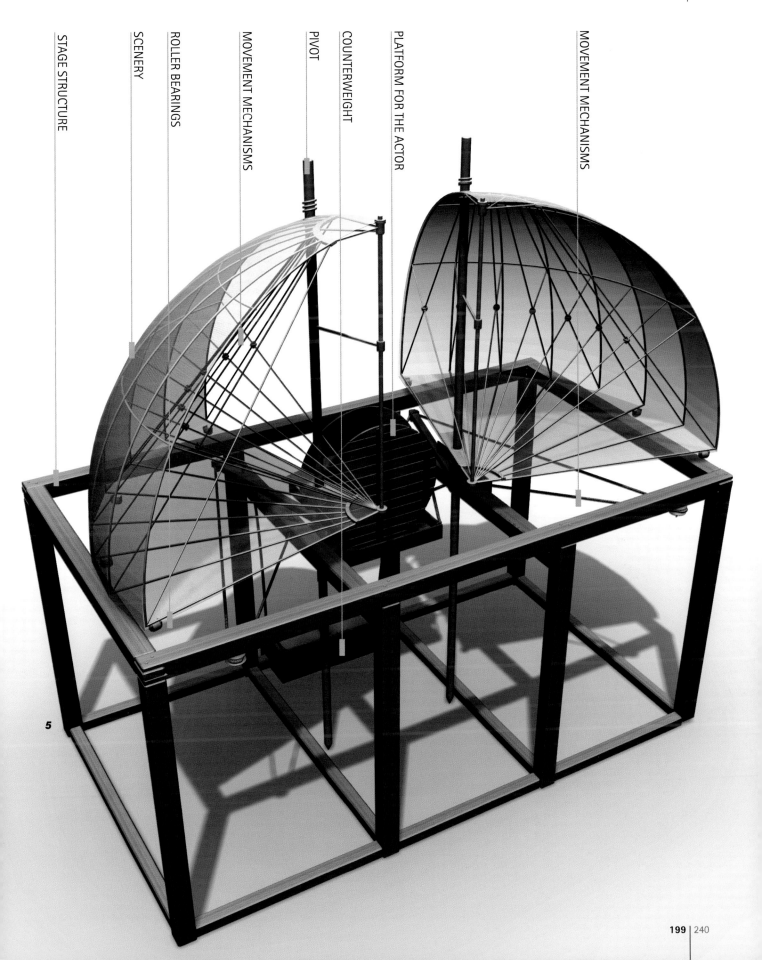

STAGE STRUCTURE

SCENERY

ROLLER BEARINGS

MOVEMENT MECHANISMS

PIVOT

COUNTERWEIGHT

PLATFORM FOR THE ACTOR

MOVEMENT MECHANISMS

5

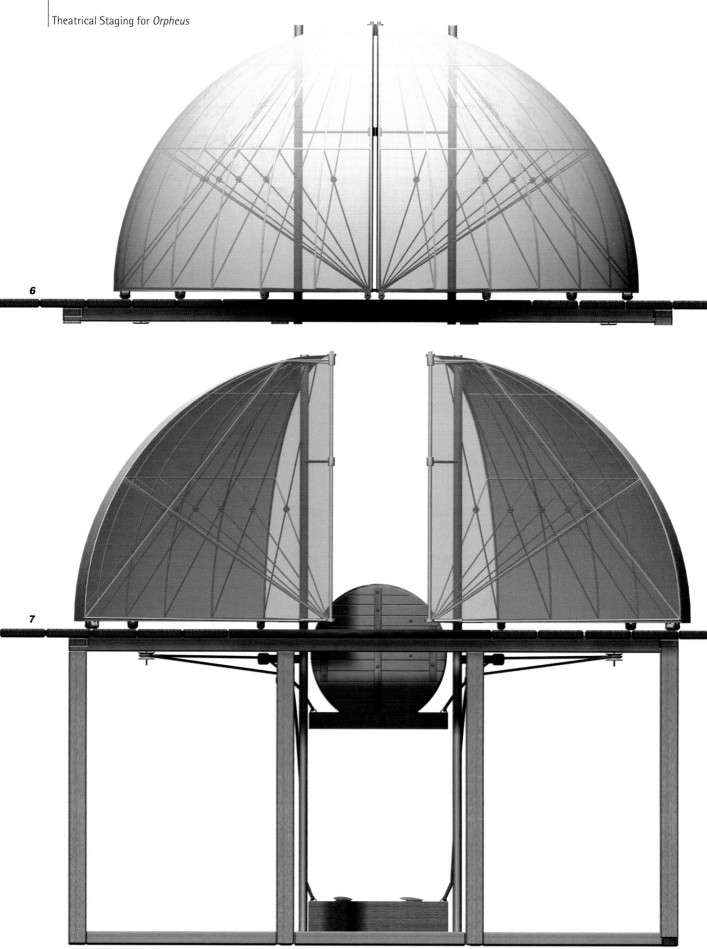

6

7

figs. 6 and 7

The theatrical staging as seen by the audience, closed and while opening. Under the lower edges of the two domes there is a system of roller bearings on which the entire structure rested and rolled, maintaining the correct trajectory.

fig. 8

On a folio that belongs to a private collection a very explicit drawing of the same project can be seen. The drawings are so clear that it is assumed they were meant for a client or a builder. The details for the pulleys and the system of counterweights moving the lift and going up to the stage can be seen.

COUNTERWEIGHT

SUPPORT STRUCTURE

DETAIL OF A PULLEY

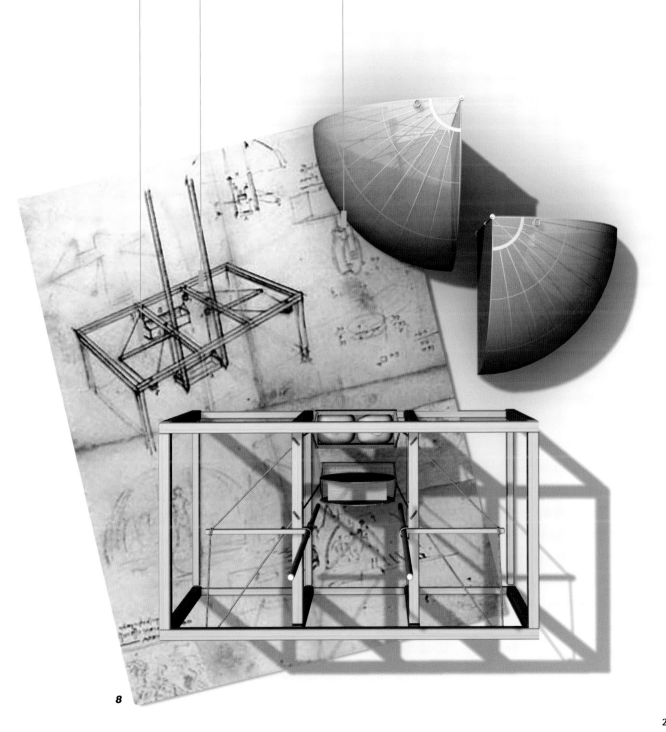

8

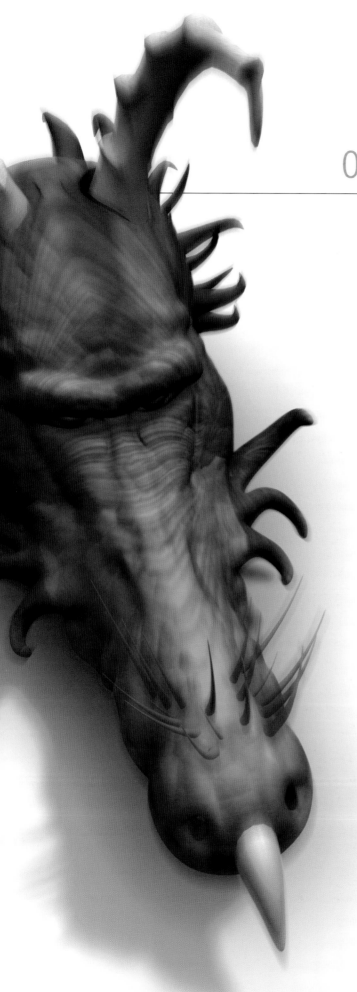

Skull-shaped Lyre
Mechanical Drum
Viola Organista

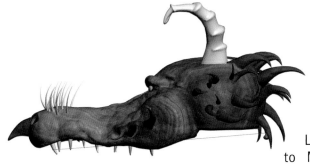

Biographers through the centuries have agreed on Leonardo's great skill at playing musical instruments such as the lyre. Traces of another aspect of Leonardo's work in the field of music also exist. It is certain that, at about thirty years of age, Leonardo had many reasons to leave Florence and go to Milan. Nonetheless, it is significant that the biographers of the time tie in his musical activities with his move to the capital of the Sforza duchy. Supposedly, Lorenzo the Magnificent gave Leonardo the honour of bringing a lyre he had constructed to Ludovico il Moro. It was a bizarre instrument, shaped like a horse's skull and made in silver. In addition to the value of its material and the originality of its shape, Vasari stated that it was made in such as way 'that the sound should be more sonorous and resonant'. And he added that Leonardo played on this lyre so wonderfully that his performance was superior to that of any other musician at Ludovico's court. For this reason, the Sforza duke, who was aware of Leonardo's many abilities, kept him in Milan.

Based on what we know from the biographers and the letter of introduction Leonardo wrote to Ludovico il Moro, his move to Milan, which was a decisive event in his life, was instigated not by his work as a painter but rather by his abilities as a musician and inventor of musical instruments, not to mention his prowess as a military engineer. This is perfectly understandable if we place ourselves in the historical context of the period: war was always at the forefront, and by presenting himself at the Sforza court as a military engineer he would have had more chance of success. As for music, its importance in Renaissance courts often takes on surprising dimensions. The princes launched 'acquisition campaigns' in order to employ the most famous composers and musicians. Once they were taken on, they received enormous salaries and were sometimes even given lands, private incomes and every kind of benefit.

At the end of the 1400s, when the Sforza lost their power and were exiled from Milan, Ercole d'Este, Lord of Ferrara, sent his agents to Milan in order to procure the famous musicians retained by the Sforza. After numerous difficulties, they succeeded in hiring Josquin des Prez. Like many other great musicians of the time, he was a foreigner: until Monteverdi came on the scene, music was a field dominated by northern Europeans. Among the great Italian musicians of the fourteenth century was Franchino Gaffurio (1451-1522), and according to one hypothesis, he is the figure portrayed by Leonardo in the painting found today in the Ambrosiana Gallery in Florence. Composer, organist,

author of treatises on musical theory (*De Harmonia*), Franchino Gaffurio was active in Milan, where he was chapel master in the cathedral. The figure in the portrait by Leonardo is holding a slip of paper with the inscription 'Cant Ang', a possible allusion to one of Gaffurio's famous compositions, the *Angelicum ac divinum opus musicae*. The princes were ready to pay enormous sums for compositions of this kind.

The fact that Leonardo possibly knew Franchino Gaffurio is another link in his relationship with the musical world, a relationship that was particularly intense during his years in Milan under the Sforza. It should also be remembered that for many years during the 1480s Leonardo was active at the Sforza court not as a painter, but as a director of festivals and spectacles. (His famous painting of 1483, *The Virgin of the Rocks*, was not commissioned by the court but by a private brotherhood). The festivals at court may well have included musical interludes, calling for the creation of compositions and the invention of instruments. This seems to confirm what has previously been written about Leonardo: that, at least initially, he was esteemed as a musician and designer rather than as a painter and scientist.

The musical instrument designs in a codex dating from the period with the Sforza seem to echo this early activity in Milan. One of the instruments from Ashburnham 2037, formerly part of Manuscript B, shows a lyre in the form of an animal's skull, a direct reference to the instrument attributed to Leonardo and given as a diplomatic offering to the Sforza. From what we can now discover, Leonardo produced original designs for all the main types of musical instruments of the period.

It is difficult to make accurate reconstructions of the types and variants of musical instruments from Leonardo's time, or to verify the way they were played. In the first place, very few original instruments have survived until today. The most useful sources for reconstructing Renaissance instruments are the treatises that, especially during the sixteenth century, were dedicated to music or to individual instruments. The other important source is the depiction of instruments in paintings, marquetry and other art forms of the period.

During the course of the Renaissance, the increasing use of musical instruments, and the frequent use of music to accompany every private and public event in the life of the court, stimulated the invention of new instruments and the modification of those that already existed. In Leonardo's time, stringed instruments with medieval roots, such as the vielle and the rebec, were still in use, though parts were not being written for them in the new field of published music. They were giving way to more advanced instruments such as the lira da braccio

and the family of viols – the viola da braccio and the viola da gamba (as shown in the decoration in Giorgione's house, *circa* 1500). Like other instruments, the viols were constructed to sound in the principle registers of the human voice – soprano, alto, tenor and bass – and were played in 'families' of different dimensions, in which the smallest instrument had the highest tonality. The modern violin, viola and cello are derived from the corresponding Renaissance stringed instruments.

The lute had the principle role in the other large category of stringed instruments: those with plucked strings. The Arabs imported the lute into Europe, and it became totally assimilated into Western musical culture. The first music specifically written for the lute was composed and printed in 1507, confirming its primacy among musical instruments. Between the end of the fifteenth and the beginning of the sixteenth centuries the technique used to play it underwent a radical change: the strings began to be plucked with the fingers of the right hand, though the plectrum, part of its Middle Eastern inheritance, was also still used. The use of the fingers to pluck the strings allowed the lutenist to play polyphonic music, and for most of the sixteenth century the lute was strung with six pairs of strings, tuned in unison or in octaves. Another very popular plucked stringed instrument was the harp. Both the harp and the lute accompanied the court singer, but they were also depicted in religious iconography as instruments played by angelic choirs.

There was a conspicuous use of percussion instruments (drums, tambourines and triangles) at popular events as well as civil and military feasts and celebrations held at court. Another area of musical evolution was in the use of keyboard instruments. In addition to the organ, in which the sound is produced by air pressure in the pipes, the clavichord, harpsichord, spinet and virginals were all being developed. In the latter group, sound was produced by the pressure of the fingers on the keys, which indirectly and mechanically vibrated the strings.

The very few, but interesting, traces in Leonardo's work that relate to this mechanical 'environment' concern these instruments. His innovation in the area of string and keyboard instruments was the viola organista, which introduced an original use of the keyboard. He also worked on the mechanization and emission of rich and varied sounds in the area of percussion instruments, as evidenced in a project for a drum found in the Codex Atlanticus (f. 837r). Finally, in the field of wind instruments, Leonardo created original projects based on older ideas: simpler designs appear in the Codex Ashburnham 2037, and later, more complex ones in the Codex Madrid II (f. 76r), among which there is a double drone bagpipe worked using the player's elbow.

Vinci, 1452

1460

1470

1480

1485-1487

1490

1500

1510

Amboise, 1519

Ashburnham I, f. Cr

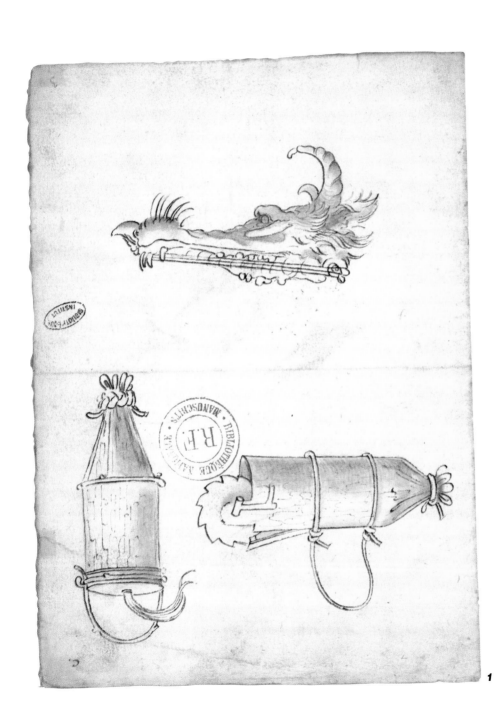

1

Skull-shaped Lyre

The lyre in the shape of an animal's skull on this folio is a stylistically simple drawing, like those of other musical instruments in the manuscript Ashburnham I (formerly part of Manuscript B). If it were not for the fact that they appear in one of Leonardo's manuscripts, it is more than likely that they would not have been attributed to him. The simple style suits the popular character of some of the instruments represented, such as the flutes. Due to its particular form, the lyre drawing not only implies a more sophisticated cultural context, but also evokes a crucial episode in Leonardo's life: his move from Florence to Milan. Two biographers of the time gave the lyre a central role in their reporting of the event. The sixteenth-century account known as the Anonimo Gaddiano describes Leonardo's transfer to Milan thus: 'At thirty years he was sent by the magnificent Lorenzo to the Duke of Milan, along with Atalante Migliorotti, to present to him a lyre, being unique in playing said instrument.' The snippet of information that Leonardo was thirty years old, given the date of his birth, tells us that his move to Milan was made in 1482. Leonardo was not alone; with him was a student, a Florentine named Atalante Migliorotti who was also a musician. Years later, he would turn up again in Rome as an architect. According to the anonymous biographer, Leonardo was on a very specific cultural-diplomatic mission: Lorenzo the Magnificent, Lord of Florence, was sending a gift to the Duke of Milan. Not an ordinary gift, but a musical instrument – a lyre. Thus the episode is part of the shrewd political web of alliances nurtured by Lorenzo the Magnificent. Giorgio Vasari's account confirms the story: the lyre was made of silver, and had been constructed by Leonardo himself in the shape of a horse's head. The drawing on the folio shown here was made by Leonardo some years later and illustrates a similar instrument: the strings are held taut between the teeth and the vertebrae of the head of an imaginary animal.

According to the two sources, Leonardo's artistic and musical gifts were the reason for his trip to Milan. Leonardo did not stop at presenting the gift, but was also involved in a competition of court musicians and singers. The instrument in question was in fact the lira da braccio, a kind of viola, an instrument often used for an entertainment that was very fashionable in Renaissance courts: the improvization of poetry with a musical accompaniment. This in itself was a form reborn from classical antiquity: improvised poetic compositions by the ancient bards, accompanied by the lyre, were the basis for the great Homeric poems.

fig. 1
The folio (for ease in viewing, reproduced here upside-down) presents three drawings for popular instruments, meant perhaps to produce loud noises rather than musical melodies. One of these is a type of lyre made from the skull of an animal.

overleaf, following page, fig. 2
Images suggesting how the entire instrument may have appeared complete with strings, rudimentary keys, and probably a small soundboard.

Leonardo probably intended the skull-shaped lyre as a theatrical prop rather than a popular instrument. With respect to his other projects for musical instruments, this one is not particularly interesting either technically or musically. The idea of making musical instruments from the organs and bodies of animals dates from prehistoric times. Nevertheless, there are a few refinements here that the inventor himself may have added. For example, using the cartilage in the palate to interrupt the strings (the frets on the modern guitar), using the teeth as types of rudimentary tuning pegs (as on the violin) and using the cranial cavity as a soundboard.

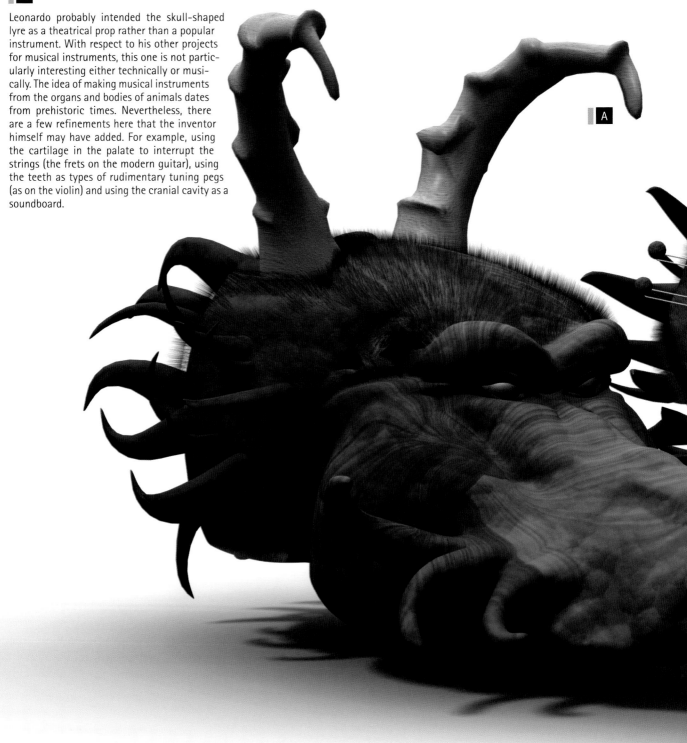

SOUNDBOARD

STRINGS

FRETS

PEGS

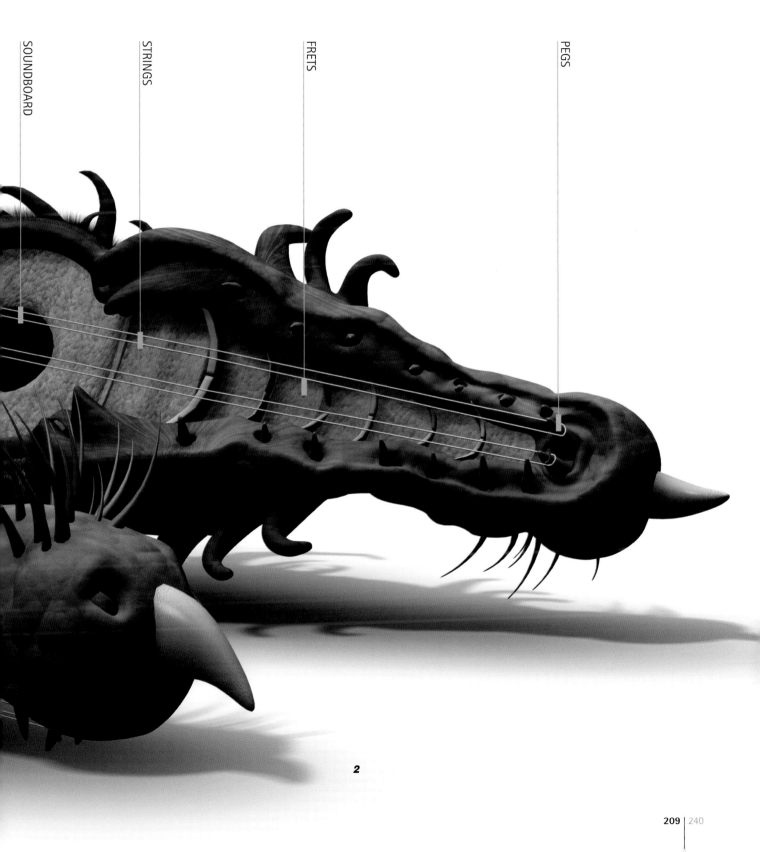

2

Vinci, 1452

1460

1470

1480

1490

1500

1503-1505

1510

Amboise, 1519

Codex Atlanticus, f. 837r

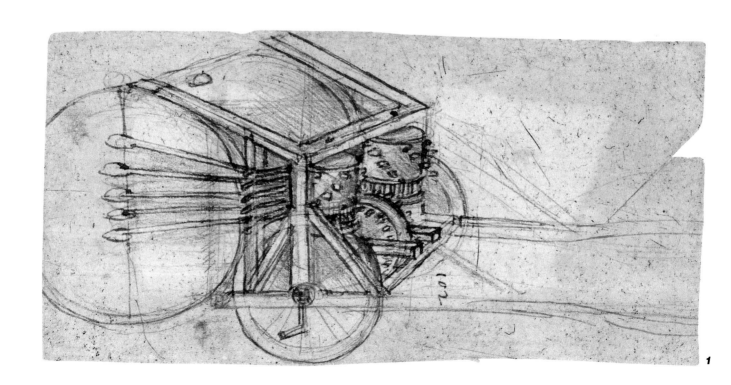

1

Mechanical Drum

2

The drawing of a mechanical drum on this folio is only one of the many examples of Leonardo's studies dedicated to this type of instrument. Percussion instruments are less complex, clearer and perhaps even more useful than stringed instruments (to which he also devoted much attention). Percussion instruments represent one of the richest chapters in Leonardo's studies on musical instruments. The forms he proposed are well beyond what was in use at the time, and his research essentially concentrated on two objectives. First, he wanted to make an instrument in which the timbre and sound could easily be changed at will, using various systems such as transforming and then reversing the shape and size of the drum, changing the tension on the head, lining up a series of drums, and so forth. Second, he wanted to create automatic mechanisms. For the most part, the drawing on this fragment from the Codex Atlanticus deals with the latter aspect.

Leonardo's great interest in percussion instruments cannot be explained only on the basis of the development of musical instruments, a process that would reach maturity during the course of the sixteenth century. It was then that instrumental music, which had functioned mainly as an accompaniment for vocal music, became increasingly prominent in its own right. This development is underlined by treatises dedicated entirely to musical instruments, which also give evidence of a certain marginalization of percussion instruments. In his treatise *Musica Getutscht* (1511), Sebastian Virdung even described the timpani as an invention of the devil, and later writers, such as Agricola, followed similar lines. It is therefore possible that the amount of attention Leonardo paid to percussion in his research on musical instruments must be explained in another way: in relation to stage events and pageants, and above all, in relation to their use in war.

The design that appears on this folio, a red chalk drawing reinforced with ink, was probably connected with warfare. On another page from the Codex Atlanticus (folio 877r) there is a series of quick sketches relating to this type of drum. This drawing is not a fully defined composition, but reflects an intermediate stage between a sketch and a finished design. (In general, Leonardo used red chalk more for sketches than for final drawings). The ultimate use for the complex automatic drum was most probably to create a thundering noise in battle. The tone and purpose are reminiscent of various mechanical projects, all bordering on the fantastical, that Leonardo designed for one of the most practised and important arts of the Renaissance: the art of war.

fig. 1
The original folio presents a very clear, explicit drawing. Careful analysis shows two versions of the same machine; the first has wheels and the second has a crank that replaces the wheels.

fig. 2
A suggestion of how the cart may have been used.

A

Leonardo presents two different solutions in the same drawing. The lighter line of the drawn wheels and the right side of the page represent two different configurations for the cart: moveable and fixed. In the mobile version, the cart was pulled by a man whose movement turned the wheels and consequently all the mechanisms connected to them. A toothed wheel in the centre and two large, programmable rollers activated the drumsticks that rhythmically struck the head of the drum. In addition to functioning automatically by the movement of the wheels, the most fascinating aspect of this machine is that it could be programmed. The pegs inserted in the two large rollers could be placed in different beat sequences, thus producing different rhythms.

B

A second interpretation of the drawing places it in a stable configuration, where there is no movement of the vehicle itself. The various mechanical parts are put in motion by the two levers on the sides, replacing the wheels.

This version of the cart could be used for events in enclosed areas or in situations with limited space where it could not be moved.

fig. 3
Two carts in different configurations: A, pulled version; B, fixed version.

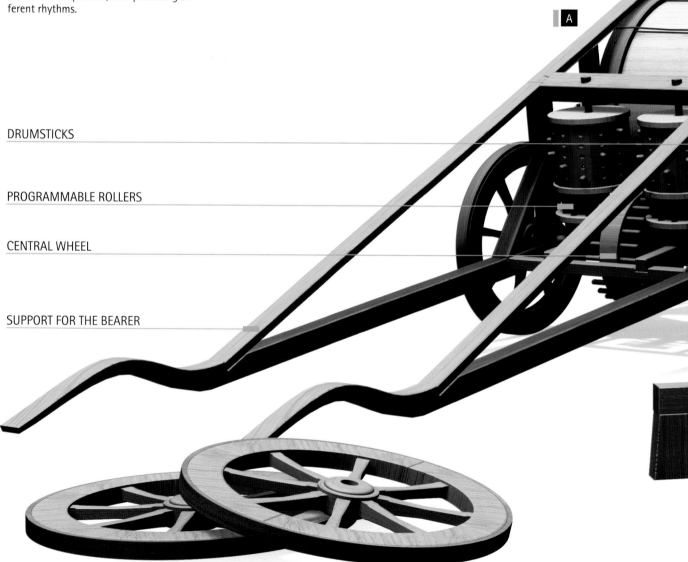

A

DRUMSTICKS

PROGRAMMABLE ROLLERS

CENTRAL WHEEL

SUPPORT FOR THE BEARER

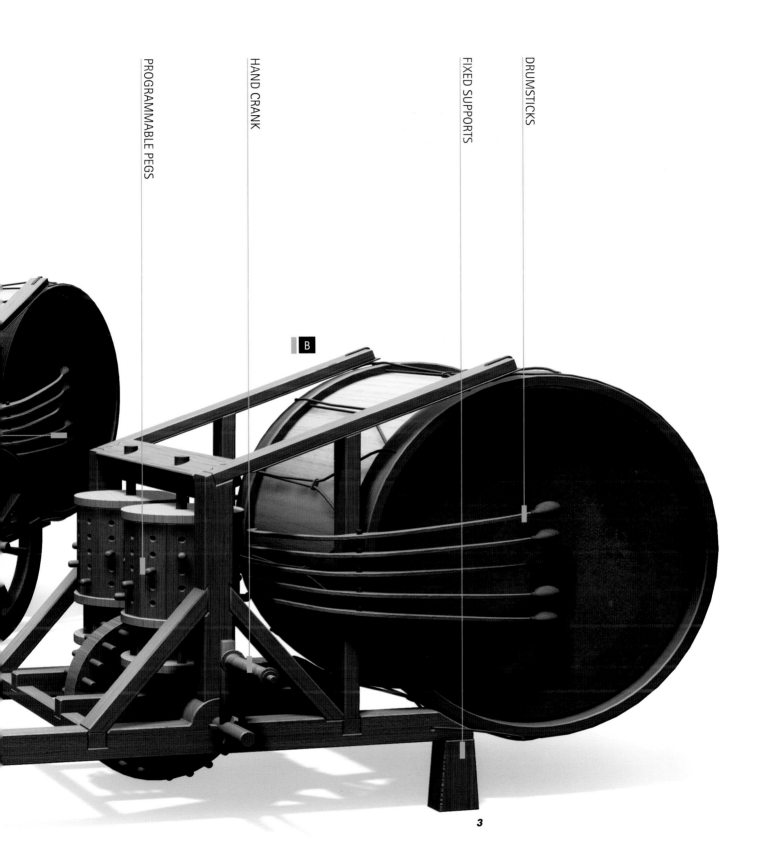

PROGRAMMABLE PEGS

HAND CRANK

FIXED SUPPORTS

DRUMSTICKS

B

3

C The interesting and innovative aspect of this machine is in the automated mechanisms, but especially that the rhythm can be programmed. The 'musician', or the operator who works the mechanism, can set the machine to the desired rhythm. Once it is programmed he just has to keep the speed of the motion constant.

The range of the programmes was fairly limited. In fact the pegs could be placed in a linear sequence producing a continuous rhythm, or it could be multiplied, simultaneously accentuating one beat rather than another. Naturally, without pegs the mechanism produced no sound whatsoever.

fig. 4
Illustration of the mechanisms in motion. The movement of the operator pulling the cart, or turning the hand crank replacing the wheels, puts in motion the large, central toothed wheel attached to the wheel axle. This engages the housing mechanism underneath the programmable rollers. The pegs that can be positioned at different points in holes on the rollers strike the drumsticks, rhythmically beating against the head of the drum.

fig. 5
The peg is the part of the cart that can be programmed. Before moving the cart, the pegs are inserted in holes on the rollers in a definite sequence that determines the rhythmic beat.

fig. 6
The programmable roller is divided into two parts: an upper part where the pegs are inserted, and a lower cage-shaped gear that is engaged by the central toothed wheel put in motion by the wheels.

fig. 7
A view of the main parts dismantled.

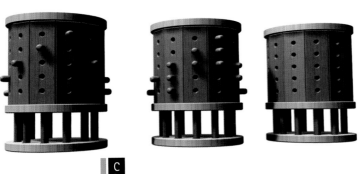

C

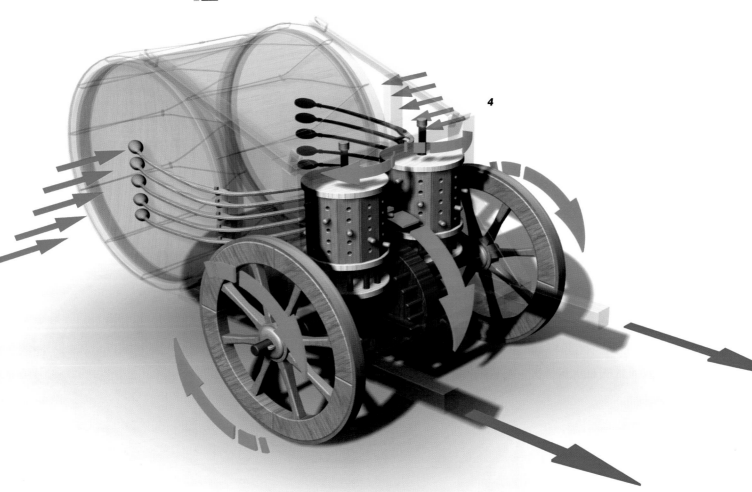

4

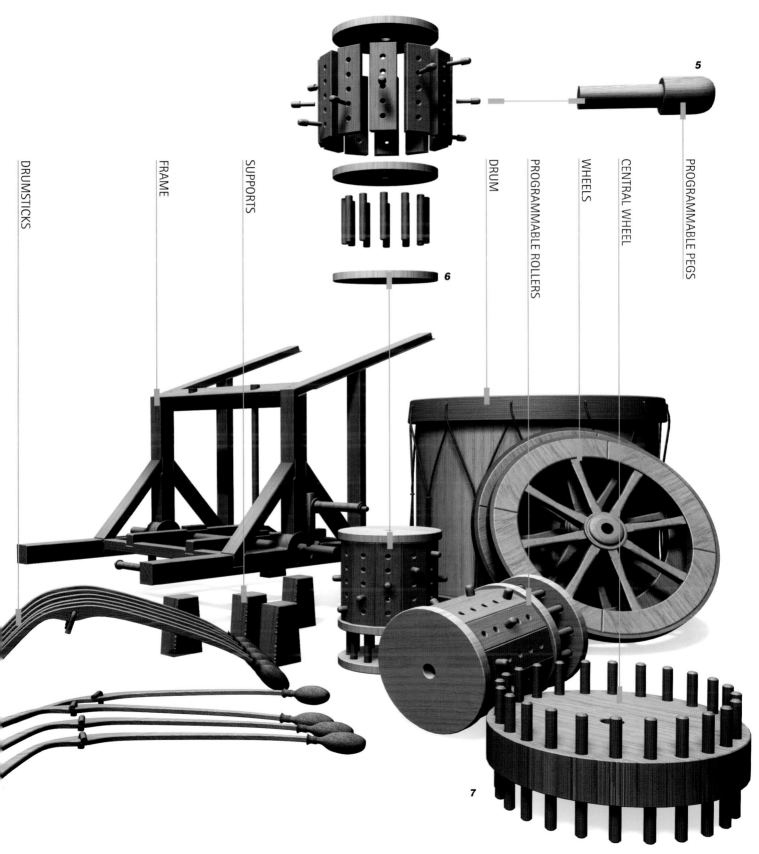

5

DRUMSTICKS

FRAME

SUPPORTS

DRUM

PROGRAMMABLE ROLLERS

WHEELS

CENTRAL WHEEL

PROGRAMMABLE PEGS

6

7

Vinci, 1452

1460

1470

1480

1490

1493-1495

1500

1510

Amboise, 1519

Codex Atlanticus, f. 93r

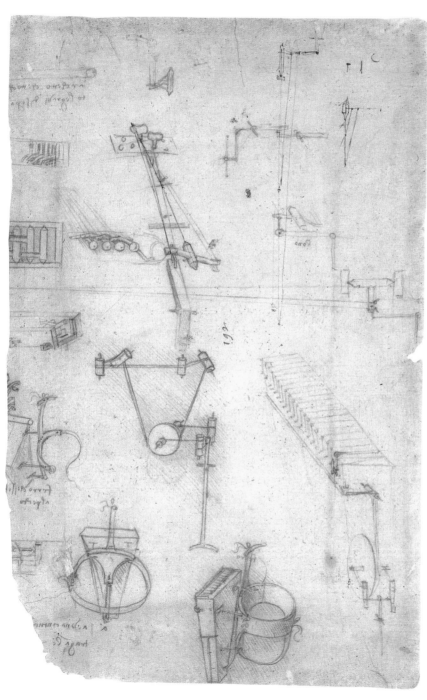

1

Viola Organista

2

Leonardo made these drawings using 'sanguine' or red chalk and they signal an important change: from the use of pen and ink to black pencil or red chalk. The general effect of this change, which occurred during the 1490s and became established after 1500, was a move from the crystal clear, rational approach of pen and ink drawing to a more pictorial, warmer dimension. This is not a minor detail. All the major artists of the *Cinquecento* preferred to draw in pencil, which had not been the practice in earlier periods. Pencil allowed them to express their new vision of the world: more complex, more sceptical, more metaphorical. Leonardo was the first to make this change, and it can be seen in every area of his studies: from the scientific to the mechanical, as here. However, it should be pointed out that because these drawings were made at the beginning of this process, he uses the chalk with the clarity of a pen tip.

The various drawings on this folio are almost all related to the same project: an instrument that was well known during the period, the viola organista, in which the strings were moved mechanically. Leonardo tried to modulate the sound generated by the instrument, and to do so he proposed various ideas, none of which is truly complete. One of the studies where the design is more finished is this folio from the Codex Atlanticus, where Leonardo includes not only drawings relating to the mechanism that would have worked the viola organista, but also details the manner in which the instrument would have been attached to the player's body (at the lower left of the folio). The page is mutilated, and probably originally contained even more studies, forming a more complete idea of the workings. A greater synthesis here should not surprise us. During the 1490s, the period from which this folio dates, Leonardo reached a major point of equilibrium in all areas of his research. This is the period of the sharply drawn mechanical elements from the Codex Madrid I, studies where Leonardo isolated the basic parts of machines, such as wheels and screws, following a very theoretical conception of mechanical design. The clear delineation of the parts in this musical instrument (especially the centre drawing on the folio) recalls this theoretical strand. Leonardo invented this particular musical instrument putting together mechanical elements such as wheels and cords, and this explains its close resemblance to other devices, such as the automatons in human form or the flying machine.

figs. 1 and 2
Left, folio 93r in the Codex Atlanticus contains many sketches and projects for a musical instrument. On the lower left there is a fairly complete sketch of the instrument. Above, the way the finished instrument could have appeared.

overleaf, following page, fig. 3
How the player of the instrument might have looked. Leonardo's project allowed the player to walk and play at the same time.

figs. 4 and 5
The instrument as it appears on the folio. In this version the motion lever is placed above; this would limit the use of the instrument making it necessary to work it using one hand on the keyboard and the other keeping the lever moving; this in turn kept the fly-wheel with the horsehair in motion.

3

A In the more complete drawing on the lower right of folio 93r in the Codex Atlanticus the rod appears, presumably attached to the right side of the instrument. By using alternating rotary motion, the rod kept the flywheel inside the soundboard moving. It is interesting to note how Leonardo designed this part using different solutions. In fact, in the other parts of the manuscript this 'rod' is oriented towards the lower part of the instrument.

We can imagine that when the player had the instrument harnessed to his body he could activate the rod by moving his legs. By hitting against the lever while he walked, the flywheel would have been in constant motion as well as the internal parts connected to it.

B To carry the instrument a harness was required. The player could easily walk while playing the music, having both hands free.

C The keyboard is similar to that of a piano, and has a three-octave range, enough to play a fairly complex piece. Precisely for this reason, Leonardo seems to try to free up both hands of the player of the instrument. The player's lower limbs generate the energy necessary to put the mechanical parts in motion.

D The soundboard holds the sound-producing mechanisms, the strings and the complicated pressure parts, the filament that produced the sound. Presumably, this filament was made of horsehair, as in modern violin bows. Also inside the case were the mechanical parts, put in motion by the alternating movement of the external rod and the flywheel.

BRACES

KEYBOARD

HARNESS

SOUNDBOARD

DRIVE LEVER

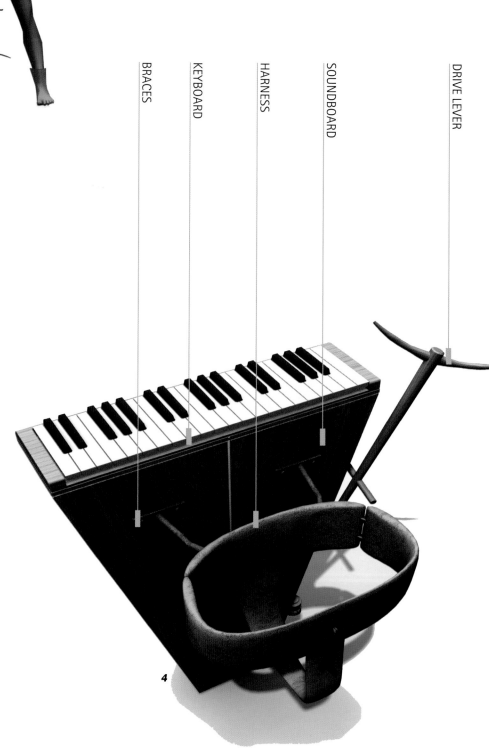

4

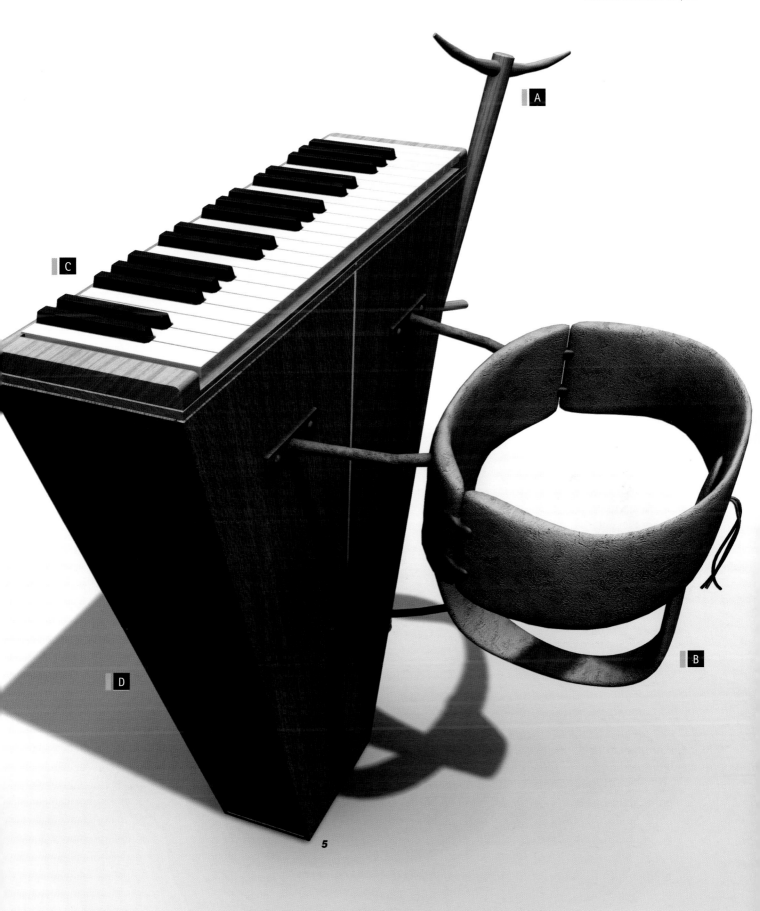

5

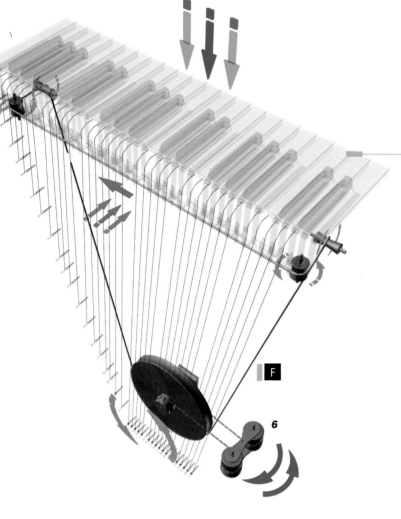

DETAIL OF THE MECHANICS

7

8

fig. 6
Detail of the percussion mechanism of the strings.

figs. 7 and 8
Workings of the mechanical parts.

fig. 9
The viola organista in a more plausible configuration, with the lever of the rod placed towards the ground. There must have also been an opening in order to tune the instrument. The tuning pegs drawn on the upper part of the manuscript are in fact located inside the soundboard.

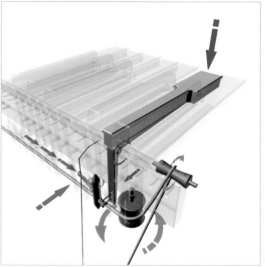

F The horsehair is put in motion by the alternating movement of the rod, periodically struck by the musician's legs. Thus, the horsehair has a continuous, one-direction linear motion. Additionally, it can be presumed that the flywheel was fairly large and had the necessary inertia to supply movement to the horsehair for a few seconds.
Pressure on the keys (fig. 9) activated a mechanism that, with a small, precise arm, engaged the string, drawing it near the moving horsehair; the two parts (string and horsehair) rubbing against each other produce a dynamic sound that is proportional in intensity to the pressure on the keys.

E Leonardo probably thought of different configurations for the instrument. In this version the rod lever is placed towards the bottom of the instrument (also in fig. 4). This configuration allows the operator to move the lever, thereby putting in motion all the mechanisms connected to it, simply by walking or marching. Presumably, during a parade the musician could march through the city streets playing with both hands. In fact, the horsehair like a violin produces sound by the rubbing against the strings, and being in constant motion it produces sound every time a string, activated by the keyboard, brushes against it.

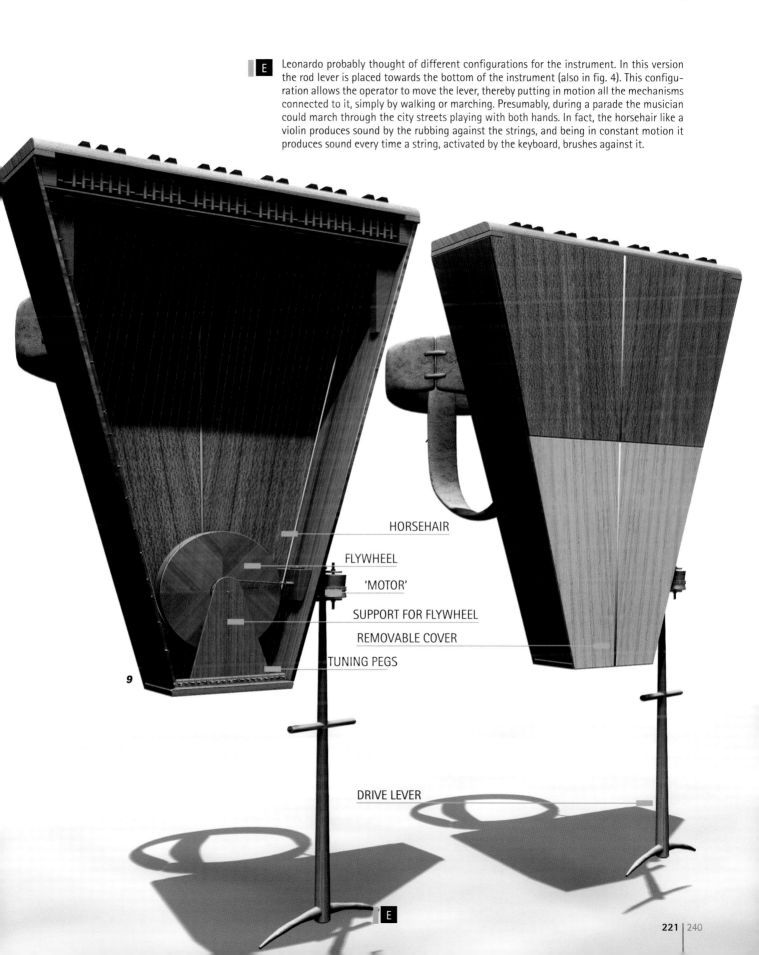

HORSEHAIR

FLYWHEEL

'MOTOR'

SUPPORT FOR FLYWHEEL

REMOVABLE COVER

TUNING PEGS

9

DRIVE LEVER

E

007 **Other types of machines**

Printing Press
Odometer
Compasses & Dividers

The Codex Madrid I comprises two main parts: projects for machines, and more abstract studies related to the behaviour of weights on inclined planes and the laws of statics and dynamics. The Codex 'On the Flight of Birds' is similarly structured: next to the part dedicated to the study of natural flight, as applied to the design of the flying machine, we find a more theoretical section dealing with statics and dynamics.

For many centuries there was a fairly clear-cut division between mechanical theory (the study of statics, dynamics and kinematics) and mechanical design. The former was developed as an abstract discipline, while the latter was mainly empirical in nature. One of the innovations introduced by Leonardo was an attempt to unify mechanical theory and applied mechanics. The more theoretical sections of the Codex 'On the Flight of Birds' and the Codex Madrid I are not studies for mechanical projects in themselves, but are more like appendices or propositions on the topics of statics and dynamics, which Leonardo often applied directly to the mechanical designs or to the understanding of natural flight.

The other fundamental innovation that Leonardo made was to undertake studies that went beyond the single machine meant for this or that specific function. He made a systematic study of the basic components that make up all machines: the screw, the wheel, the spring, the roller, the cords and so forth. Leonardo called these mechanical elements and in his writings he often referred to a *Treatise on the Elements of Machines*. During the 1960s, when two codices by Leonardo were found in Madrid, one of the two, the so-called Madrid I, seemed to some scholars to correspond with the treatise mentioned by Leonardo, which was otherwise unidentifiable. However, it is apparent from the statements made by Leonardo himself that in reality this treatise was structurally much more complex than the Madrid I. It consisted of a broadly theoretical section dedicated to geometry, statics, dynamics and kinematics, and a more practical part dedicated to the simple elements of every machine (such as wheels and screws) and to machines in and of themselves.

This study of the fundamental elements common to every machine is typical of Leonardo's general attitude towards research. For example, in anatomy he also made a series of comparative studies between humans and animals, or between various animal species, in order to identify their fundamental and shared biological traits.

By uniting theoretical and practical mechanics, as well as his thoughts on mechanical elements, Leonardo attempted to give machine design an enhanced status, overcoming the centuries-old

distinction between the mechanical and liberal arts. Historically, the term 'mechanical arts' indicated all human activities using the hands, from painting to goldsmithing, from sculpture to construction engineering. Everything that was based on manual work was considered culturally and socially inferior. This created problems for physicians and surgeons, for example, who struggled throughout the Middle Ages to achieve the dignity of a science for their discipline, because it was founded not only on the intellect but also on the use of their hands. During the *Quattrocento* the painters, sculptors and engineers also tried to vindicate the scientific component of their work. Through the study of the laws of geometry used for perspective in order to represent space correctly, the study of anatomy in order to depict bodies naturalistically, and the study of proportion in order to create harmonious figures, the painters and sculptors gave a scientific foundation to their art. By the first half of the 1400s, the engineers were transformed from artisans to authors of treatises, and with his writings Leonardo put the finishing touch to this process of cultural emancipation.

That Leonardo raised machines and their components into a theoretical dimension becomes even more evident with the extreme accuracy of his drawings, giving them intellectual and demonstrative value. This emerges in the passages Leonardo devoted to mechanical elements, a field more consonant with traditional science. As we read in this passage on screws: 'Here the nature of the screw is demonstrated and how it should be used in pulling as well as pushing; and how it is stronger single rather than double, and thinner rather than thicker, when being moved by equal lever lengths and equal force. And some discussion will be made of the number of ways to use it and how many endless types of screws there are [...] and on the nature of the threads [...]' Leonardo was describing a simple screw, and previously a description so highly elevated in tone and structure had been reserved only for theoretical subjects such as Aristotle's laws of statics or dynamics. Leonardo approached the study of the dynamic properties in springs in the same manner, submitting these mechanical elements to quantitative considerations on the relationship of time, motion and force, which up to that point had been considered only in relation to topics such as light, water and more general dynamic forces.

From the 1490s on, Leonardo fine-tuned the theoretical approach he took to mechanical design. Subsequent refinements continued until years later they were expressed in written thoughts entitled *De' poli* (On Poles), dealing with friction,

or envisioned as a full treatise or book with the title *De confregazione* (On Friction), which at one point Leonardo declared he wanted to write.

The complex theoretical dimensions of Leonardo's mechanical designs are not always so explicit. In this regard, his project for a pedometer (Codex Atlanticus, f. 1rb), a device for counting the number of steps covered on foot, is a good example. Another project appearing on the same page shows an odometer, an instrument for calculating distance covered, which probably had a specifically practical purpose, given the frequent measurements that needed to be made around the walled fortresses Leonardo constructed as military engineer for Cesare Borgia. It is likely that the pedometer had a similar practical purpose. Nonetheless, the idea of measuring and quantitatively analysing an action made by the human body, such as walking, emerged more or less at the same moment that Leonardo was studying the body and making a systematic geometric analysis of its movements (as seen in the drawing found in the Codex Huygens dating from the sixteenth century, but inspired by lost studies made by Leonardo).

It is clear that practical use is a goal that Leonardo tries to keep in sight even in his most theoretical studies. For example, in the studies in the Codex Madrid I dedicated to the elements of machines, the ultimate aim of his analysis of pulleys and tackles is to increase the efficiency of the force needed to lift heavy weights. Many of the analyses he made on the wheel are directed towards similar ends, and with the invention of the system preventing a wheel turning in the wrong direction (the ratchet wheel, or as Leonardo calls it, the 'servant') a practical use is immediately obvious.

There is a third dimension in Leonardo's mechanical design: alongside the practical and theoretical aspects, there is often an aesthetic dimension. In addition to being intelligent and useful, his machines are at times also beautiful. His designs for dividers and compasses are among some of the most spectacular examples. These instruments had a specifically practical use, especially important in Leonardo's own studies. Nonetheless, for some of these objects, technological research goes hand in hand with aesthetics. For example, one of the requirements in compass design is that once opened it remains in a fixed position. For this to happen the friction between the two legs must increase with the size of the arc, and this can be accomplished by increasing the number of hinges. As seen in the drawings in the Codex Atlanticus (f. 48 recto and verso), Leonardo not only meets this objective but uses it as an opportunity to give the compass heads an original and elegant shape. In this fascinating aspect of his mechanical drawing, he takes the subject 'from the minor arts to industrial design'.

Vinci, 1452

1460

1470

1478-1482

1480

1490

1500

1510

Amboise, 1519

Codex Atlanticus, f. 995r

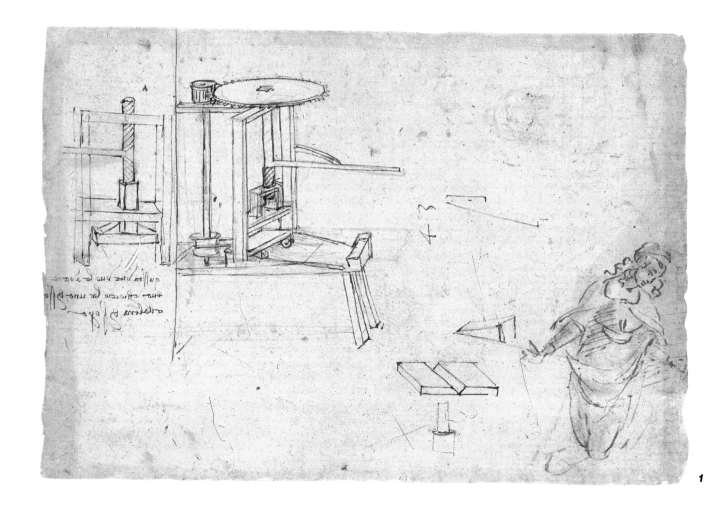

1

Printing Press

2

This folio could be compared to a still from a video on the cultural environment in which the young and promising artist from Vinci found himself in the vibrant city of Florence during the *Quattrocento*. The folio is fragmentary: the original sheet could have contained other notes and drawings. It is noteworthy that next to the drawing of a Madonna there is a project for a printing press. It is not certain that the former drawing is by Leonardo. This uncertainty is based on the direction of the hatched lines on the bust of the Virgin, going from upper right to lower left; Leonardo was left-handed and his hatched lines usually went in the opposite direction. In favour of a positive attribution to Leonardo is the strength of the drawing itself, delineated in a few swift lines, and the Virgin's expression and pose. Even if the attribution of the drawing is uncertain, the presence of an artistic study alongside an engineering study is important. It would be normal, in a workshop such as Verrocchio's, to find military arms and bell casts next to sculpture pieces. For a person in the Renaissance, the idea of art covered both aspects, while science dealt with all types of theoretical knowledge. The scientific emancipation aspired to by many artists was not in associating mechanical inventions with artistic creations, but rather the basic theoretical or scientific research involved in both these activities.

The artistic workshops of Florence around the 1470s were in turmoil due to the appearance of the first printing presses. Other than a few private initiatives, it was the Dominican monks of Santa Maria Novella who first set up a printing-house in 1476. This makes sense because the religious houses of the time were the principal means for the diffusion of culture in the form of costly manuscripts. The introduction of the moveable-type press, and the use of paper rather than parchment, allowed books to be produced much more cheaply. This made it easier for the superior class of artisans to gain access to knowledge and culture, encouraging them to hope to give a scientific foundation to their manual activity. Leonardo's curiosity about printing is therefore understandable. In printing as in other fields, he attempted to increase the level of automation, saving both time and labour. Even though we have no proof that he ever did in fact print any of his sheets, later on, in an anatomical page from Windsor Castle (no. 19007v), he poses the problem of how to print his drawings most faithfully, preferring the more costly but precise copper-etching technique to the coarser wood-cut. The possibility that one of the studies in the Codex Madrid II (f. 119r) represents an original system of printing text and images simultaneously is also under debate.

fig. 1
Two distinct projects can be seen in Leonardo's drawings. On the right there is a mechanical press worked with a single lever. In the drawing on the left Leonardo has sketched a variation of the same machine with a double worm screw; it is interesting to note the analogy of the latter with the mechanisms he studied and developed for the flying machine.

fig. 2
The mechanism of the lever that activates a worm screw and the press.

CAGE-SHAPED GEAR

WORM SCREW

TOOTHED WHEEL

INCLINED BED

FIXED BED

MECHANICAL LEV

VERTICAL PULLEY

MOVEABLE BED

SHEET OF PAPER

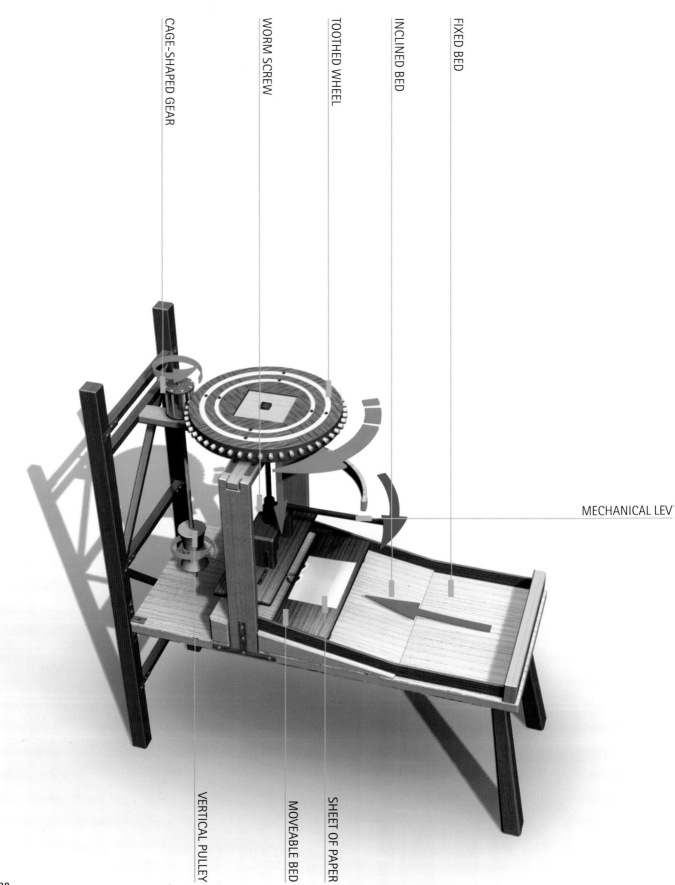

A

When the operator moved the mechanical lever the gears were put into motion and the machine carried out various movements. The press was slowly lowered by the worm screw and printed the sheet of paper placed under the carriage. A large toothed wheel on the upper part of the press moved the other mechanisms in addition to a vertical pulley. A line was wound around it and attached to a moveable carriage. When the mechanism was put in motion the pulley wound in the line, causing the carriage and page to be moved closer to the press. When this process was finished, the carriage returned and the press lifted.

B

Leonardo drew a curve close to the lever, probably made of wood, that could presumably be used both as a guide and a rest for the motion of the lever, or was perhaps also meant to protect the operator. The printing process could also be quite repetitive and hard, and the force exerted by the operator must have been fairly intense. A reason for this type of bulkhead may have been to keep the body away from the machine during the printing.

C

An interesting aspect of the machine is the moveable bed. As in many later versions of the typographical press, the page is brought under the press without the use of the hands. A carriage with small wheels slides along the bed of the structure and, pulled by a line and a pulley activated by a single mechanical lever, it is lifted up to the press. When the press itself is only a few centimetres from coming in contact with the page, the carriage stops. Once the page is printed, the carriage slides back to its initial position with the printed sheet. All this is accomplished in a single movement by a single operator.

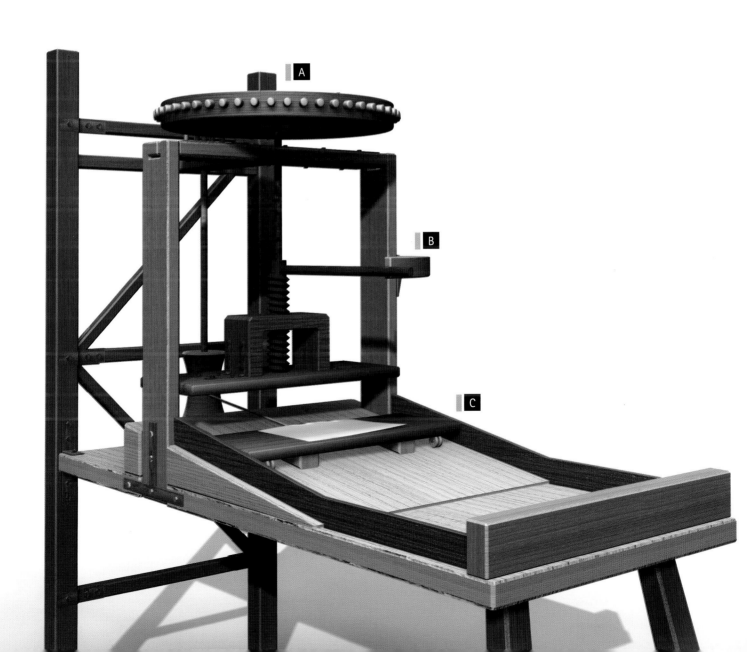

Odometer

Codex Atlanticus, f. 1br

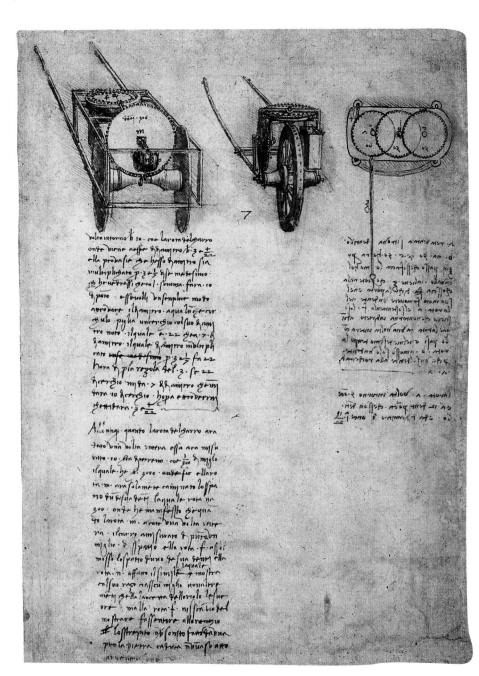

1

Odometer

2

This folio contains one of Leonardo's most complete presentations for a mechanical project. The very clear style of the drawings, the text arranged in two regular columns, the writing (at least in the left-hand column) following the conventional style (left to right), all contribute to an unusual phenomenon in Leonardo's work: a page ready for publication, in manuscript or printed form. Is this a plausible hypothesis? The question also arises in the studies for mechanical elements found in the Codex Madrid II. Leonardo dealt with typographical problems, and in the margins of an anatomical page from around 1510, he mentions a printing technique capable of faithfully reproducing the complexity of his designs. Nevertheless, there is no certain answer. It could be that Leonardo presented the graphic elements for these studies so clearly for a specific reason, such as a demonstration for a patron interested in odometers (which recorded the distance covered by a cart) and pedometers (which counted the number of steps walked). There is an underdrawing, demonstrating that Leonardo first sketched in the lines and then went over and refined them, a normal procedure for presentation drawings meant to be used out of the context of private notes. However, the note underneath the pedometer on the right side of the page is written in Leonardo's usual right-to-left handwriting, which is certainly not an easy read. It may be that Leonardo added the drawing and note on the right at a later point in time. The drawing of the pedometer is drier and more schematic than the other designs. It is possible that once he had presented the two designs on the left, Leonardo decided to use the available space for a new drawing, more consonant with his own personal study, and thus did not need to worry about some form of publication.

The beauty of the two drawings is remarkable. We can appreciate the optimal use of hatching with the use of ink wash, the two main techniques used for defining the form and enhancing the volume of figures. Here they are combined to render every detail accurately. The two drawings of an odometer deal with the mechanical nucleus of the device attached to a cart. As elsewhere, the hatching points up the analytical nature of the designs, and their parts dismantled from the whole and waiting to be assembled. Leonardo has identified a theoretical nucleus, a fundamental device (in two variations) that can be applied to individual concrete situations, as well as to the cart drawn on folio 855v in the Codex Atlanticus.

fig. 1
Two designs for odometers are on this folio; the third is a drawing for a pedometer.

fig. 2
The most important element of this project for Leonardo was the large central wheel on the odometer; all the holes in the disk containe pebbles that fell into a container below once the wheel finished its rotation.

A

The odometer is an instrument for measuring distances. There are different types, ranging from very small sizes used to measure distances directly on a topographical map, to very large dimensions. In Leonardo's project, the odometer resembles a cart. The operator would pull the cart directly over the territorial distance to be measured.

The vertical wheel transmitted the movement of the cartwheels to the various other mechanisms. When the main axle rotated the large wheel engaged with a worm screw mounted on the axle itself. The toothed wheel activated a front cage-shaped gear and two small toothed wheels mounted on the rear of the odometer. The function of this gear was clearly to activate the large, central wheel. The movement of the rear mechanism, however, is open to interpretation. Presumably, the teeth in the lower gear train hit against small metallic rods attached to the frame, producing a regular ticking sound indicating the correct functioning of the device.

B

The most interesting component of the cart is the central wheel. A series of holes made internally were constantly filled with markers, probably simple pebbles or small wooden spheres. Each time the wheel completed a turn, a marker fell through the single hole, falling into a container below. Once the entire distance for measurement had been covered, the operator had only to count the pebbles in the box to calculate the length of the area covered.

C

The frame was a simple, fundamental structure. While the odometer was in use, it is presumed that an animal or person drew the vehicle while an operator, walking alongside, continually filled the holes in the central wheel with markers. Naturally, each hole held a single marker at a time.

D

There was a large container attached to the frame, into which the markers dropped each time the central wheel completed one full turn. The longer the distance to measure, the more the box filled up.

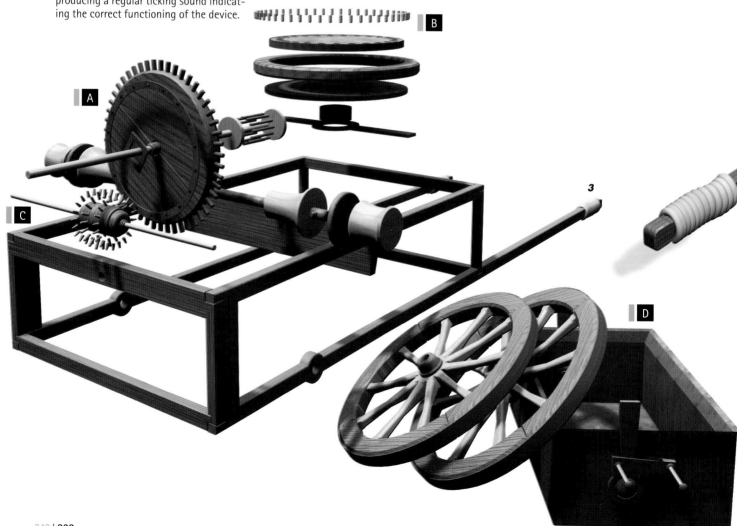

240 | 232

fig. 3
A view of the dismantled odometer.

fig. 4
The main components of the assembled odometer.

FRAME

MOTION TRANSMISSION WHEEL

WHEELS

CAGE-SHAPED GEAR

HOUSINGS FOR THE MARKERS

CENTRAL WHEEL

CONTAINER

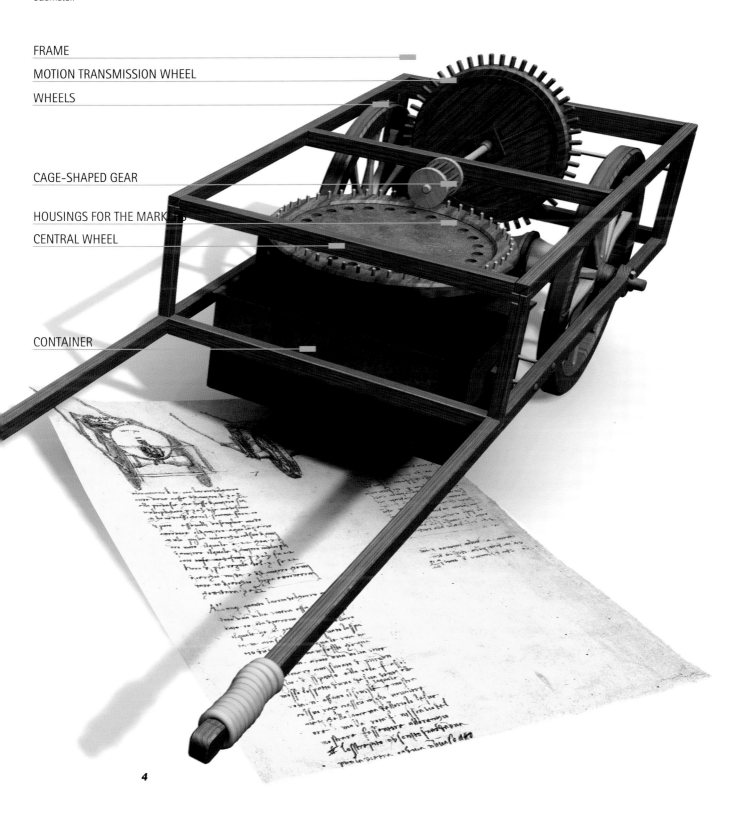

4

Vinci, 1452

1460

1470

1480

1490

1500

1510

1514-1515

Amboise, 1519

Codex Atlanticus, f. 696r

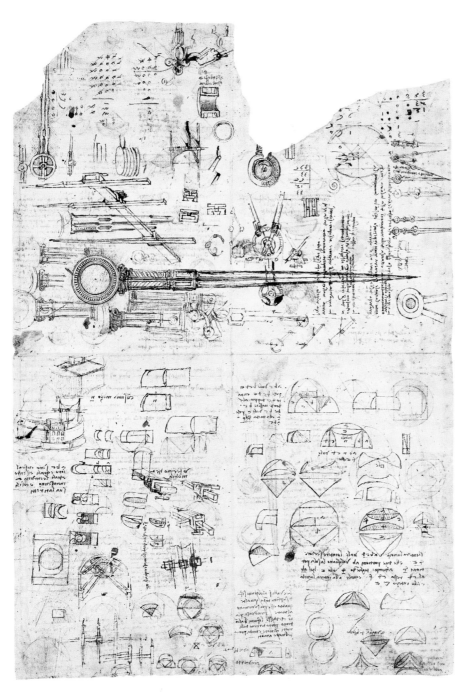

1

Compasses & Dividers

2

This folio from the Codex Atlanticus is a miscellany of notes typical of Leonardo's later years. Geometric studies are intertwined with architectural and engineering projects. For example, at the lower left there is the study for a roof truss, similar to those he made while he was in Rome, where not far from his studio in the Vatican the new St Peter's Basilica was under construction. In the upper portion of the folio there are numerous studies for compasses and dividers. The main drawing and most of the smaller ones deal with simple, two-legged compasses or dividers, but there is also a beam compass, with two sliding points on a long, horizontal beam.

One of the most fascinating aspects of many of Leonardo's inventions is the marriage between aesthetic form and function, especially in the design of arms and artillery and work objects. Many designs for lance heads or cannons have such a richness and variety in shape and form that at times the game of 'inventing' goes well beyond practical ends. The same is seen with the design for work tools, such as the compasses and dividers shown here. It is possible that Leonardo actually made and used some of these instruments (for example in describing the circle with the human figure in the drawing of the *Homo Vitruvianus*: marks from the compass, which were traced over with a pen, are still evident).

The large drawing of a two-point compass or divider that appears on this folio of the Codex Atlanticus is one of the most beautiful. The purpose of the design was to guarantee the stability of the instrument once the legs were open by increasing the contact surface of the hinge points or even their number. The latter system is shown in some of the secondary drawings on the page but in both cases, the technical device becomes a point of departure for creating hinges and joints with odd and interesting shapes and configurations. Research on the functional efficiency of the instrument becomes a springboard for its aesthetic elaboration, almost in the spirit of industrial design.

The main drawing of the two-point compass on this folio was copied in a manuscript, now in the Marciana Library in Venice, containing drawings by Lorenzo della Golpaia and his son, Benvenuto. Lorenzo was a well-known engineer working in Florence, and he certainly knew Leonardo because they both sat on the committee to decide where to place Michelangelo's statue of *David*. It is interesting to note the curiosity that this famous engineer had for what we would now consider a minor aspect of Leonardo's work; nonetheless, it could still astonish an illustrious contemporary.

fig. 1
A page where the drawings for dividers and compasses are mixed together with architectural drawings. The uniting of technical-scientific knowledge and aesthetic considerations in the design for a working tool like the compass makes this page especially interesting.

fig. 2 and following pages
Some hypothetical dividers and compasses designed by Leonardo.

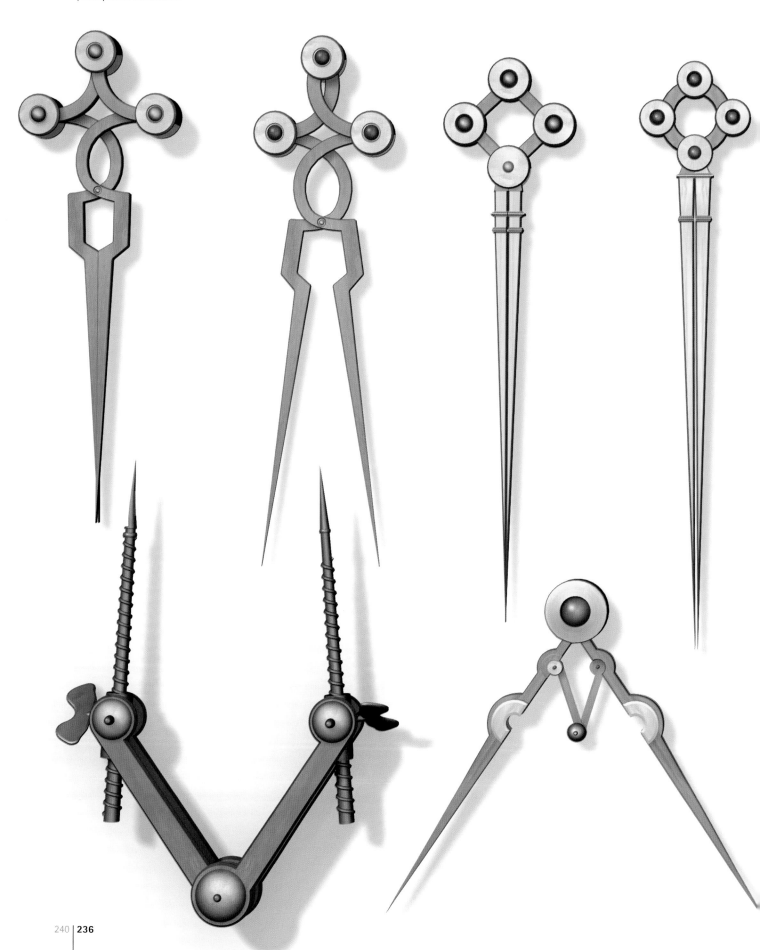

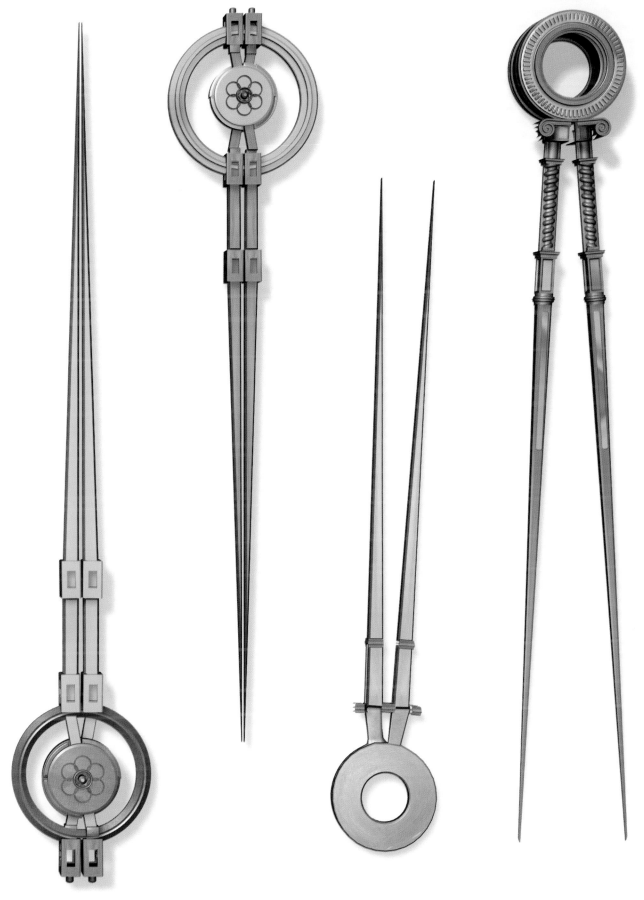

Bibliography

T. Beck, *Beiträge zur geschichte des Machinenbaues,* Berlin, 1900 (1st edition 1899).

L. Beltrami, *Leonardo da Vinci e l'aviazione,* Milan, 1912.

F. M. Felhaus, *Leonardo der Techicher und Erfinder,* Jena, 1913.

I. B. Hart, *Leonardo da Vinci as a pioneer of aviation,* 'The Journal of the Royal Aeronautical Society', XXVII, London, 1923, pp. 244-269.

I. B. Hart, *The Mechanical Investigations of Leonardo da Vinci,* London, 1925, (re-edited in Idem, *The World of Leonardo da Vinci,* London, 1961).

R. Giacomelli, *Leonardo da Vinci e il volo meccanico,* 'L'Aerotecnica', VI, 1927, pp. 486-524.

R. Marcolongo, *Le invenzioni di Leonardo da Vinci. Parte prima, Opere idrauliche, aviazione,* 'Scientia', 41, 180, 1927, pp. 245-254.

R. Giacomelli, *Les machines volantes de Léonard de Vinci et le vol à voile, Extr. du tome 3 des Comptes rendus du 4.me Congrès de navigation aérienne tenu à Rome du 24 au 29 octobre 1927,* Rome, 1928.

R. Giacomelli, *I modelli delle macchine volanti di Leonardo da Vinci,* 'L'Ingegnere', V, 1931, pp. 74-83.

R. Giacomelli, *Progetti vinciani di macchine volanti all'Esposizione aeronautica di Milano,* 'L'aeronautica', 14, 1934, 8-9, pp. 1047-1065.

R. Giacomelli, *Gli scritti di Leonardo da Vinci sul volo,* Rome, 1936.

G. Canestrini, *Leonardo costruttore di machine e di veicoli,* Milan-Rome, 1939.

A. Uccelli, *Leonardo da Vinci. I libri di meccanica,* Milan, 1940.

R. Marcolongo, *Leonardo da Vinci artista e scienziato,* Milan 1950, pp. 205-216.

C. Zammattio, *Gli studi di Leonardo da Vinci sul volo,* 'Pirelli', IV, 1951, pp. 16-17.

A. Uccelli (with the collaboration of C. Zammattio), *I libri del volo di Leonardo da Vinci,* Milan, 1952.

I. Calvi, *L'ingegneria militare di Leonardo,* Milan, 1952.

L. Tursini, *Le armi di Leonardo da Vinci,* Milan, 1952.

M. R. Dugas, *Léonard de Vinci dans l'histoire de la mécanique,* in *Léonard de Vinci et l'expérience scientifique au xvie siècle,* Congress Proceedings, 1952, Paris, 1953, pp. 88-114.

C. Pedretti, *Macchine volanti inedite di Leonardo,* 'Ali', 3, 1953, 4, pp. 48-50.

C. Pedretti, *Spigolature aeronautiche vinciane,* 'Raccolta Vinciana', XVII, 1954, pp. 117-128.

C. Pedretti, *La machine idraulica costruita da Leonardo per conto Bernardo Rucellai e i primi contatori ad acqua,* 'Raccolta Vinciana', XVII, 1954, pp. 177-215.

C. Pedretti, *L'elicottero,* in *Studi Vinciani,* Geneva, 1957, pp. 125-129.

L. Reti, *Helicopters and whirligigs,* "Raccolta Vinciana", XX, 1964, pp. 331-338.

I. B. Hart, *The world of Leonardo da Vinci man of science, engineer and dreamer of flight,* London, 1961, pp. 307-339.

B. Gille, *Les ingénieurs de la Renaissance,* Paris, 1964.

M. Cooper, *The Inventions of Leonardo da Vinci,* New York, 1965.

C. H. Gibbs-Smith, *Léonard de Vinci et l'aéronauthique,* 'Bulletin de l'Association Léonard de Vinci', 9, 1970, pp. 1-9.

Leonardo, edited by L. Reti, Milan, 1974.

Leonardo nella scienza e nella tecnica, Atti del simposio internazionale di storia della scienza (Florence-Vinci 1969), Florence, 1975, pp. 105-110.

C. Pedretti, *The Literary works of Leonardo da Vinci edited by J. P. Richter. Commentary,* 2 vols., Oxford, 1977.

G. Scaglia, *Alle origini degli studi tecnologici di Leonardo,* 'Lettura vinciana', XX, 1981.

Leonardo e l'Età della Ragione, edited by E. Bellone, P. Rossi, Milan 1982.

E. Winternitz, *Leonardo da Vinci as a musician,* New Haven-London, 1982.

Laboratorio su Leonardo da Vinci, exhibition catalogue, Milan, 1983.

Leonardo e gli spettacoli del suo tempo, exhibition catalogue edited by M. Mazzocchi Doglio, G. Tintori, M. Padovan, M. Tiella, Milan, 1983.

M. Tiella, *Gli strumenti musicali disegnati da Leonardo,* in *Leonardo e gli spettacoli del suo tempo,* exhibition catalogue edited by M. Mazzocchi Doglio, G. Tintori, M. Padovan, M. Tiella, Milan, 1983, pp. 87-100.

M. Tiella, *Strumenti musicali dell'epoca di Leonardo nell'Italia del Nord,* in *Leonardo e gli spettacoli del suo tempo,* exhibition catalogue edited by M. Mazzocchi Doglio, G. Tintori, M. Padovan, M. Tiella, Milan, 1983, pp. 101-116.

Leonardo e le vie d'acqua, exhibition catalogue, Milan, 1984.

P. C. Marani, *L'architettura fortificata negli studi di Leonardo da Vinci. Con il catalogo complete dei disegni,* Florence, 1984.

C. Hart, *The prehistory of flight*, Berkeley, 1985.

M. Carpiceci, *Leonardo. La misura e il segno,* Rome, 1986.

P. Galluzzi, *La carrière d'un technologue*, in *Léonard de Vinci ingénieur et architecte*, exhibition catalogue, Montréal, 1987, pp. 80-83.

M. Kemp, *Les inventions de la nature e la nature de l'invention*, in *Léonard de Vinci ingénieur et architecte*, exhibition catalogue, Montréal, 1987, pp. 138-144.

M. Cianchi, *Le macchine di Leonardo da Vinci,* Florence, 1988.

G. P. Galdi, *Leonardo's Helicopter and Archimedes' Screw: The Principle of Action and Reaction*, 'Achademia Leonardi Vinci', IV, 1991, pp. 193-201.

Prima di Leonardo. Cultura delle macchine a Siena nel Rinascimento, exhibition catalogue edited by P. Galluzzi, Siena, 1991.

M. Pidcock, *The Hang Glider*, 'Achademia Leonardi Vinci', VI, Florence 1993, pp. 222-225.

P. Galluzzi, *Leonardo da Vinci: dalle tecniche alla tecnologia*, in *Gli Ingegneri del Rinascimento da Brunelleschi a Leonardo da Vinci*, exhibition catalogue, Florence 1996, pp. 69-70.

D. Laurenza, *Gli studi leonardiani sul volo. Spunti per una riconsiderazione*, in *Tutte le opere non son per istancarmi. Raccolta di scritti per i settant'anni di Carlo Pedretti,* Rome 1998, pp. 189-202.

C. Pedretti, *Leonardo. Le macchine,* Florence, 1999.

D. Laurenza, *Leonardo: le macchine volanti*, in *Le macchine del Rinascimento*, Rome, 2000, pp. 145-187.

S. Sutera, *Leonardo. Le fantastiche macchine di Leonardo da Vinci al Museo Nazionale della Scienza e della Tecnologia di Milano. Disegni e modelli,* Milan, 2001.

Leonardo, l'acqua e il Rinascimento, edited by M. Taddei, E. Zanon, text by A. Bernardoni, Milan, 2004.

D. Laurenza, *Leonardo. Il volo*, Florence, 2004.

D. Laurenza, *Leonardo: il disegno tecnologico,* in E. Bellone, D. Laurenza, P. C. Marani, *Breve viaggio nell'universo di Leonardo,* Genoa, 2004, pp. 25-50 and 69-91.